A FLICKERING REALITY

Cinema and the Nature of Reality

F. David Peat

A FLICKERING REALITY

Cinema and the Nature of Reality

Pari

Publishing

A catalogue record for this book is available
from the British Library

ISBN 978-88-95604-09-1

Printed and bound in the United States

Book and cover design by Andrea Barbieri

Publishing

Pari Publishing

Via Tozzi 7, 58045 Pari (GR), Italy
www.paripublishing.com

For Max

Acknowledgements

I would like to thank Susi Graf, director of the documentary *Lost in the Crowd,* for her very creative comments on this book. Also Andrew Fellows for his thorough reading of the manuscript and his most helpful suggestions.

Contents

Introduction

Film is one of the most important art forms to have emerged in the modern age. It is important because, while film can be pure diversion and entertainment, it can also tell us some profound things about reality, about the ways in which we see the world and what our future could become.

It is also significant because it connects us directly with the very origins of human consciousness in our deepest and most archaic history. It is a link to that time when our remote ancestors went deep into their caves and covered the walls with paintings of animals, with deer and bison and bear, animals with spears in their sides, animals hit by arrows. Was this the work of shamans, of leaders of the hunt, or those who had eaten psychedelic plants and mushrooms? By the light of burning torches the first humans gathered together to look at those images as they flickered and moved. Who knows what magic they experienced, what enchantment transcended the boundaries between dream and reality, between the darkness of the cave and the vitality of the hunt, between the inner world of private imaginings and the social world of the first human groups?

People have referred to cinema as 'dreaming together in the dark.' This is also what the first humans did tens of thousands of years ago, and that is what we still do today in front of a screen. It is a contemporary event that links us to the origins of our consciousness. That is why film is so vitally important. It is teaching us something about the world and the structure of our minds; it has the ability to question reality and open new doorways into that world.

Yet another reason why film is important is because historically it evolved in parallel to revolutionary changes in the way we understood the world. It is perhaps no coincidence that the advent of cinema virtually coincides with one of the most dramatic changes in our view of the ultimate nature of reality—the birth of quantum theory (1900) and relativity theory (1905). How closely those dates match that of 28 December, 1895 when a series of short films was shown in the basement of a Paris café. The one that created the most attention was that of a train arriving in La Ciotat station in Provence, France shot by the Lumière brothers. The audience was so shocked that some of them hid under the seats, believing that the engine would run over them. Another short film showed workers leaving a family factory. Cinema had been born with the very first documentaries. As few years later, in 1902, Georges Méliès exhibited the first fantasy or science

fiction film *Le voyage dans la Lune* (*A Trip to the Moon*); no longer a documentary, this film was another milestone in cinema, for it showed how film could be used to create an alternative form of reality.

It is difficult for most of us to imagine what those first audiences experienced when they watched the Lumière brothers' films. But for me the memory of my first visit to the cinema remains graphic. As a small child growing up in Liverpool, and before the days of television, I had heard about what were called 'moving pictures.' I tried to imagine what a moving picture could be. I knew about the pictures we had on our walls at home and I would stare at them and imagine what it would be like if the figures in the pictures began to walk, or if the river would flow and the trees wave. Moving pictures must be something like that, I thought, involving a wall on which a large picture was hung. You would stand in front of it and suddenly parts of it would begin to move. I even began to have dreams about the pictures in our dining room and how the objects in them would move.

Then one day my mother and father took me to the cinema. I entered a very large hall full of people in seats. The lights went down and suddenly, in front of me were enormous moving figures that seemed to fill the entire space. I began to scream in terror and had to be taken home. It was some time before I could enter a cinema again for regular weekend visits to the News Theatre in the center of Liverpool with my aunt and uncle to see the Saturday afternoon cartoons.

Few people today first experience film in such a graphic way. But that is not to say that the magic of cinema is lost, for as we watch in the dark of a cinema multiplex or on our TV screens at home we are subtly being drawn into a different yet compelling reality.

This book is by no means an academic text; rather it is simply a book written for people who enjoy films. It is also a film book written by someone who not only loves films but has spent his life thinking and writing about the nature of reality, particularly about the way our perception of that reality has been changed through revolutions in science. This book is therefore about the things we can learn from films, about the ways films mirror what it is like to be in the world, and how our eyes and brains are constantly creating the world for us. And when we recall our favorite film, the most compelling shots and the directors we admire, we are also learning something about the reality of the world we inhabit.

I.
Reality

Films not only reflect the times in which they are made but can also anticipate the future. When we look at F.W. Murnau's *Nosferatu* (1922), Robert Wiene's *The Cabinet of Dr. Caligari* (1919) and other examples of German Expressionist cinema, we sense the foreshadowing of the Nazi insanity that was to sweep through Germany. What better metaphor than the plague of rats that leave the ship carrying the vampire Nosferatu and infest the city?

The movies from the Cold War era showed Earth being invaded by alien beings or threatened by a species mutated by radiation, such as the giant ants running wild in the American southwest in Gordon Douglas' *Them!* (1954). There was also the fear that individuals and indeed entire communities could be brainwashed into mindless subservience, as in Don Siegel's *The Invasion of the Body Snatchers* (1956).

So what of today? As I look at my shelves of DVDs I am struck by the large number of films that question our take on reality. Just what is real and what is illusion? What can we believe about the world that we touch and see? How valid are our memories? How can we really know what is happening on the other side of the world? Can we believe what the newspapers, television and the Internet tell us? In 2001 the world saw images of two planes flying into the twin towers of the World Trade Center. Within no time there was a variety of conspiracy theories, some even going so far as to suggest that the towers collapsed via a controlled demolition engineered by the US government.

There have always been conspiracy theories doing the rounds, particularly on the Internet, some of them pure fantasy, others based on more solid ground. Are the Illuminati attempting to control the world? What is the truth about the events surrounding the assassination President Kennedy? Was the motivation for the Gulf Wars and the invasion of Iraq simply 'wars for oil'?

On the one hand people increasingly feel themselves to be manipulated in the service of vested interests. On the other, we are all the inheritors of postmodernism with its notion that reality is purely a social construct. Combining the two was the philosopher Jean Baudrillard who, writing in the French news magazine *Libération* in 1991, questioned the existence of the reality

of the Gulf War. Things certainly happened in that region of the world and people were killed, but it was not, he argued, an actual war. Rather it was a virtual war involving information and electronic images in which journalists 'at the front' were actually getting their information from CNN!

This is remarkably similar to Barry Levinson's *Wag the Dog* (1997) in which the President of the United States has committed a serious indiscretion during a visit of girl scouts to the White House shortly before an election. A spin doctor (played by Robert De Niro) is called in to deflect negative publicity and hits on the idea of creating a war. Of course it won't be a real war, but one using dramatic images created in the studio. After all, the spin doctor asks, what do people remember of world shattering events?— just the images in newspapers and on their TV screen. The war can be anywhere, so why not Albania? It would be a good choice because most people know nothing about the country or even where it is situated on the map. Central to the war will be the image of a young girl fleeing from her village and carrying...what? A cat? A dog? The choice of animal becomes crucial in order to create the maximum effect in the public's mind. And then, to make the war even more dramatic, a brave American soldier will be 'saved' from behind enemy lines and returned safely to his homeland. *Wag the Dog* was released just one month before the Lewinsky scandal broke, seriously hindering US President Bill Clinton's efforts to take military action against terrorist networks in Afghanistan in case he was accused of attempting to deflect public attention away from the growing scandal—a situation bearing an uncanny similarity to that portrayed in the film. Seeing the film today, after a real war justified on the grounds of non-existent 'weapons of mass destruction' and the banning of images showing coffins returning from Iraq on American television, it all seems more and more credible.

Back in the real world all manner of conspiracy theories continue. There used to be one involving Stanley Kubrick: Human beings did not land on the moon in 1969, it went, instead the whole thing was faked in the studio by Kubrick, who the year before had exhibited his skills in *2001: A Space Odyssey*. Proponents of this theory point to 'errors'; for example, they claim to see the flag on the moon waving in the breeze. There is even the 'conspiracy of conspiracies' theory. This argues that the US government is actually manufacturing large numbers of conspiracy theories so that the public no longer takes them seriously. Of course embedded in such a network of theories will be one that is totally genuine, but now hidden with the 'noise' of the others. But then not all conspiracies are so fantastical. In the case of Nixon and Watergate the conspiracies were only too real.

The manipulation of reality by means of visual images was in existence long before the era of computer-generated images. It is evident that as early as the 1860s there was tampering with photographic images. The

iconic photograph of Abraham Lincoln standing in his office is a composite. Stalin, Mao Zedong and Hitler routinely airbrushed out those who had fallen out of favor. Reality was becoming less concrete. Thus in so many ways we appear to be leaving a 'hard and fast' reality behind and moving towards something that is less tangible and almost illusionary, a world that is more and more being reflected in cinema.

Scientific reality

When we think of this shifting reality we must also take into account the considerable intellectual shocks that arose from science during the twentieth century—these included the abandonment of our conventional assumptions about space and time following Einstein's theory of relativity, the acceptance of inherent uncertainty within quantum theory, and the presence of chaos at the heart of order as shown by chaos theory. Add to this such technological innovations as virtual reality and a world circumnavigated close to the speed of light by the Internet, and it is no wonder that our senses are reeling and our hold on reality is weakened.

And this is just what cinema can do best—it can explore the limits of reality, it can bring us face to face with other worlds and other modes of perception. Take Richard Linklater's *Waking Life* (2001), for example. It is a film that explores the age-old philosophical question that has cropped up in all the world's traditions: Are we awake or is this all a dream? The Armenian mystic Gurdjieff compared us to people who are asleep on a runaway horse. It is possible to wake the rider and alert him to the precarious nature of his position, but then, just as quickly, he falls asleep again.

So is this world of ours totally concrete? Is reality totally independent of our desires and wishes? Is it somehow a construct of our minds, an illusion, a waking dream? These are the sorts of questions posed in *Waking Life* and enhanced by a particularly brilliant touch. The film was made conventionally using actors but then each frame was animated—what is more, the nature and style of the animation changes dramatically during each scene. Thus we experience the very phenomenon that the film is questioning. We know we are seeing a simulation of events, something created by animation artists, but behind that surface we are aware of something even more real—the facial expressions and body movements of the filmed actors. The result is to intensify our own question about life as a dream or an immediate experience.

The same effect is used in Richard Linklater's *A Scanner Darkly* (2006) based on the novel of the same name by Philip K. Dick. And here I should add that, of all authors, Dick must be at the top of the list for the number of his novels and short stories that have been made into films (*A Scanner Darkly*, *Blade Runner*, *Minority Report*, *Paycheck*, *Impostor*, *Screamers*, *Total Recall* and *Next* to date, with others in the works). In many ways *Scanner* is an autobiographical work, written just after a period when Dick's home had become an open house for drug users and he felt he was under surveillance by the FBI. (Dick's house had been burgled and one theory had it that Dick himself had staged the robbery.) After spending time in Canada, where he was on a suicide watch at a rehabilitation center, he returned to California where he experienced what—a vivid hallucination? the voice of God? a transmission from an alien intelligence? At all events this and his other experiences were transmuted into some remarkable fiction.

In *Scanner* Bob Arctor is living with drug-taking roommates in more or less the same situation as Dick in the late 1960s. But Arctor also has another life. He is an undercover narcotics agent, Officer Fred, who wears a 'scramble suit,' one that hides his identity. Following a tip-off Officer Fred is assigned to survey who else but Arctor and his friends, and holographic cameras are secretly set up in Arctor's home. So Arctor is now leading a schizophrenic life. Part of the time he is having off-the-wall conversations with his stoned friends, and part of the time he is watching tapes of a man called Arctor having stoned conversations. In the novel itself we become aware of the way in which Arctor's mind is increasingly divided, questioning where reality lies. In the film, the use of animation over the actors' bodies and locations creates a similar tension in the mind of the viewer.

The quantum world: A veiled reality

When we hear the word 'movies,' associations such as thrillers, comedy, suspense, romance, glamour and stars may spring to mind. We think of the Oscars, gossip columns, ratings in film books, and movies that get 4½ stars. We imagine relaxing in front of the television after a day at work, or going out with a group of friends. We remember discussions about *The Godfather* trilogy: was *Part 2* the best of the three, or *Part 1* that starred Marlon Brando?

Of course we watch films for thrills, laughs and entertainment, but there is also something more, for in increasingly subtle ways films can help

to illuminate the reality of the world around us. For example, film can tell us something about the way the brain, vision and consciousness work, as well as how we can project things about ourselves onto other people and situations.

Maybe film is deepest when it is commenting directly on the nature of reality. If one looks to other cultures, particularly those from the East, there is the suggestion that the hard and fast reality we experience around us is a form of persistent illusion, in Sanskrit—*maya*. In ancient Hindu philosophy a god can cause a human being to believe as real what in the end turns out to be an illusion—which, after all, is nothing less than the plot of the Wachowski brothers' *The Matrix* (1999).

In the West such notions never really caught hold except amongst some academic philosophers. Western science, which arose after the Renaissance, dealt with a concrete world of cause and effect taking place in a linear time and against the backdrop of fixed space. Newton's laws accounted for all events in the cosmos and scientists spoke of the Newtonian clockwork. Everything from the fall of an apple to the phases of the moon could be explained in purely mechanical terms.

But the twentieth century saw the rise of quantum theory and with it a radically different vision of the world. The first hint came when Werner Heisenberg set down the equations of quantum mechanics. The mathematics told him that there would always be an essential uncertainty when it came to knowing both the speed and the position of the electron—the Heisenberg Uncertainty Principle. But why should this be? Heisenberg reasoned that each time we make a measurement of a quantum system our intervention acts to disturb that system. Measure position and we disturb speed, measure speed and we disturb position. We simply cannot learn about the quantum world without interfering with it.

When Heisenberg visited Copenhagen he explained this idea to Niels Bohr who told him that he had made a deep and profound mistake about the nature of the quantum world—one that still rings in our ears today. Heisenberg's error, Bohr argued, was to assume that an electron *has* a position and *has* a speed. But such 'possession' only applies to objects in the large-scale world. At the quantum level we cannot even say that an electron 'occupies' a particular location in space that is totally independent of our observing it. Bohr even went so far as to point out that if we see an electron at point A and sometime later at point B we cannot even say that the electron 'took a path' from A to B. All that we know is the result of two observations, but we can make no assumptions as to what happened in between. This was something that profoundly disturbed Einstein who once remarked 'I refuse to believe the moon isn't there when I'm not observing

it.' The quantum world is a far cry from the hard and fast reality in which he believed we were living. The physicist Bernard d'Espagnat referred to it as a 'veiled reality'; that is, a reality we will never be able see face to face. In this sense d'Espagnat goes back to Plato and his image of people watching shadows cast on the wall of the cave—a notion that resonates very deeply with that of a cinema audience 'dreaming in the dark.'

It would be easy to say that this 'veiled reality' need be of no concern to us in our daily lives because it is only relevant to the scientist in his or her laboratory, to the sort of person who does experiments with elementary particle accelerators. However, I don't think this is the case. It is my opinion that these insights into the nature of the quantum world have begun to permeate our everyday consciousness. Or to put it another way, for two hundred years we had been taken in by a simplistic mechanistic explana-tion of the world, one that claimed that everything that happens can be explained away in terms of hard and fast objects, clearly located in space and interacting with each other via mechanical pushes and pulls. But life isn't really like that, our daily experience is not of that nature, our interac-tion with people is subtly different, as are our dreams and desires. Maybe the reality we experience is closer to that veiled reality of the quantum world. And that is where films enter because they reflect the nature of that deeper reality. They sensitize us to it. They cause us, if only for a moment, to question the reality of our senses and ask what may lie behind the veil. (Yet ironically certain films can also de-sensitize us since our empathy may be reduced when certain events, in particular those associated with violence, are repeated.) And so in this book we will be meeting films that call into question the very nature of reality.

Reality and film

THE TRUMAN SHOW

Many of us will have experienced a moment when things do not seem quite real, or have had the sense that we are partly living in a dream. Others may believe that, when they enter a room the people there have been talking about them. There are also people who occasionally hear voices. These experiences are all perfectly normal. In fact a therapist friend of mine monitored a number of healthy and creative

people and discovered that over time they experienced, but only in fleeting ways, many of the symptoms associated with the more serious mental disorders. The point is that our mental experiences are probably much richer than we care to acknowledge but most of us are not trapped by them; they don't keep recurring. Paranoid schizophrenics hear voices to the point where they believe, for example, that the government has planted a radio in their heads or that the people around them really are persecuting them. The rest of us may have some fleeting vision, hear a voice, suspect that people are looking at us, have a sense of the unreal and so on, but then it passes. The effect does not stick.

But what of the reverse situation? What if a person who is totally normal happens to live in a world that is abnormal, one that is a carefully created illusion? This is the theme of both the film *The Truman Show* and Philip K. Dick's story *Time out of Joint* written in 1958. In the novel Ragle Gumm lives in small-town America in 1959 with his sister Margo and her husband Vic. He is the reigning champion of a local newspaper competition 'Where will the little green man be next?' repeatedly winning the cash prize. Gradually he comes to question the reality of the world in which he lives. He hears people talking about him on the radio, for example, and discovers a magazine that features someone called Marilyn Monroe of whom he has never heard. His attempts to leave the town fail until finally he escapes only to discover that the year is 1998 and his job has been to plot missile strikes. Horrified at his work, he had retreated into a childhood fantasy of still being in 1959 and the government had built a fake town, along with actors, to support his fantasy. When he is working on the newspaper competition, although he does not consciously realize it, he is in fact continuing to plot missile strikes.

There is also a striking similarity between Dick's novel and *Living in Harmony*, an episode from the British cult TV series of the sixties *The Prisoner*. The basic plot of the seventeen-episode series was that, following his resignation, a secret agent wakes to find himself in the artificial surroundings of 'the Village' and is given the name 'Number 6.' By means of a variety of techniques, including brainwashing, attempts are made to break his spirit and extract valuable information. There are even times when he is allowed to escape only to find himself back in the Village again. In the *Living in Harmony* episode, Number 6 finds himself in the small town of Harmony in the Wild West. Like Gumm, he attempts to leave only to be brought back and made sheriff. At the end of the episode we discover that Number 6 has been in 'the Village' all the time, and subjected to hallucinatory drugs, and that the people he encounters in Harmony are all acting specific roles designed, albeit in vain, to break him down.

The Truman Show opens with a shot of an ideal seaside town and then a television studio lamp falling from the sky onto the road. Truman Burbank is married and goes to work each day, greeting his neighbors and colleagues. He is a happy man with no worries, except that he does have a fear of the sea that can be traced to a traumatic event in his childhood when his father died in a boating accident. Truman is attracted to a young woman, Lauren, who is trying to tell him something important but then disappears from the town. He also has a friend, Marlon, in whom he can confide when they have a drink together.

Everything proceeds normally until one day Truman's car radio picks up a station that is apparently giving information on where Truman is driving. This leaves him puzzled. He is just an average insurance adjuster, so why would people be interested in him? On another occasion he wanders into a building he does not usually visit and discovers that behind what appears to be a normal elevator door is a backstage area for actors.

Truman is now truly paranoid. Things in the town certainly do not seem to be as they appear. He attempts to leave, with his wife driving the car, but when they reach the outskirts they are turned back by police with a story about a radiation leak. Eventually Truman learns the truth of his situation. He is the star of a 24-hour, seven-days-a-week reality show. Indeed he has been the star since his birth, and even before when he was in his mother's womb. The town is located under a vast dome and Truman is being monitored by thousands of cameras located all around the town. What's more his wife, his best friend, and everyone else in the town are actors, and the various situations in which he finds himself have all been scripted in order to maintain a dramatic line for the watching audience. From time to time one of the characters will show the label on a bottle of beer, or Truman himself encounters someone who stands him next to a poster—all advertising for the millions of viewers of the show. Only Lauren was willing to warn him about his true situation, but she was promptly removed from the show and now watches Truman on TV. In addition, the trauma of his father's death was just a ruse to keep him away from the sea.

The film intercuts between Truman, the viewers, and the technicians running the show under the supervision of its creator Christof. Christof gives an interview about the history of The Truman Show, and Lauren confronts him during a phone-in. Christof denies that Truman is living in an unreal situation because 'we accept the reality of the world we are presented with.' Moreover, he argues, 'the place you live in is the sick place.' In other words, what we normally take as 'reality' is far less than ideal.

Truman now realizes his fate and the show's producer, Christof, speaks to him from his control room, telling him that millions are watching him

and that he is the star of his own ideal life. Truman makes the decision to leave on a yacht, at which point Christof's technicians create a large storm, but Truman refuses to turn back and finally reaches the edge of the dome and exits into the real world.

The Truman Show was released in 1998, and who at that time would have guessed at the extent to which 'reality shows' would really take off? *Big Brother*, for example, was first aired in the Netherlands in 1999 and has since had variations and spin-offs all over the world. And so ordinary people, and B-list celebrities, agree to be locked up in a house or abandoned on a desert island where they can cooperate, quarrel, make love and fight under the unblinking eyes of television cameras.

An article in *The Guardian* (22 October, 2004) stated that the idea had even gone to the next stage—a reality show that would never end. Television channel RTL in Germany was actually building a community where people would live, not for a week or two, but for decades, possibly their entire lives—working, marrying, having families, watching their children grow up, divorcing, dying. A forest was planned, a town square complete with daffodil beds, stores, a bar, a church tower, schools and businesses. The producers hoped to lure in businesses to employ the residents, teachers to teach them and doctors to care for the sick.

In fact, despite being described as the 'most sex-fuelled yet, with lesbian kisses, stripteases and X-rated whirlpool antics,' (*The Guardian*, November 2005), it lasted less than a year after failing to attract a sufficient number of viewers. But *The Truman Show* differed from the unsuccessful TV show in two key ways. As the movie's tagline put it, Truman was 'On the air, unaware,' as opposed to *Big Brother*'s highly camera-conscious contestants and, even more importantly, the viewing public was actually interested in Truman's world.

MEMENTO

 Another way in which film can question the nature of reality is when it places the viewer in the same position as the protagonist, rather than as a dispassionate observer. In *Memento* (2000), for example, the director, Christopher Nolan, adopts a device that allows us to experience what it is like to live with short-term memory loss. Rather than 'explaining' the disorder, he allows us to feel what it would be like at first hand.

Memory is one of the great mysteries of consciousness. If memories were stored in a specific location of the brain, as data are stored at specific addresses on a computer's hard drive, then we would expect a person with brain damage caused, for example, by a stroke or an accident, to lose specific memories and retain others. It doesn't work that way. Memories appear to be stored right across the brain. It is even the case that if damage occurs to the left hemisphere, which controls movements of the right arm, a person will eventually recover their signature when written with the left hand and therefore controlled by the undamaged right hemisphere.

There is, however, one area that plays a significant role in laying down new memories, and that is the hippocampus. A person with damage to the hippocampus still retains all their old memories. They can ride a bike and recognize their spouse's face, but new experiences simply do not register. It is not so much that the hippocampus stores these memories but that it is the essential processing unit involved in laying down new memories.

Suppose we are in the car with a friend who asks us to phone a certain number. We pull over into a parking space, take out a cell phone and dial the number. It has been registered in our short-term memory. An hour later we may have forgotten that number, but if it is repeated and the person who owns the number has particular significance to us, it may pass into long-term memory and we can recall it months later.

The BBC documentary *Man Without a Memory* featured the case of Clive Wearing whose hippocampus was damaged during an illness. Wearing is a British musicologist and conductor who, following a virus attack, was unable to form new memories—a condition called anterograde amnesia but now dubbed the 'memento' syndrome after the Christopher Nolan film. Wearing was perfectly able to play or conduct a piece of music he already knew from memory, but every time his wife entered the room, even if she had only slipped out for a couple of minutes, he would greet her as if seeing her for the first time that day. (For a video clip visit http://migenteunida.org/en/clive-wearing-the-man-with-no-short-term-memory.) This is the same condition shared by Lenny in *Memento*.

Memento is the story of Lenny, an ex-insurance investigator who can no longer build new memories following a head injury sustained while intervening in his wife's murder. The only meaning he can now give to his life is to track down his wife's killer. But how can he do this if he can't retain memories from one moment to another? The answer is to have the important clues tattooed onto his body and to constantly write notes to himself. Another tactic is to take Polaroid photographs of his car, his motel, and the people he meets, and to write a name or fact on each photograph.

The movie intercuts between color and black and white sequences. The black and white sequences move forward in chronological order, but the color sequences proceed in reverse chronological order. The forward black and white scenes and the reverse color scenes alternate until they meet at the end of the film. The colored scenes also use flashbacks involving memories of Lenny's wife and the day she was killed—but at the end of the film even these are called into question. By adopting this device the director both gives us the sensation of what it must be like to live without any short-term memory and, at the same time, is able to create an ingenious mystery story.

Lenny appears to have two friends. One is Teddy who is around to help him, but on the back of Teddy's photograph is written 'Don't trust his lies.' The other is Natalie who appears to have been beaten up. On her photograph is written that she has lost someone and will help him. Of course each time he meets these two characters he can only recognize them by referring to the photographs. During the opening credits (which portray the end of the story), we are shown that Lenny has just killed Teddy for the murder of his wife based on information provided by Natalie.

The film is constructed in such a way so as to put the viewer in a similar condition to Lenny—someone who is struggling to understand the flow of time and the sequence of events. This is most graphically shown in three scenes at the crux of the film: Natalie gets out of her car and bursts into her apartment with her face badly bruised and tells Lenny that Dodd (a man she claims is harassing her for money) has beaten her and is out to kill her. Lenny must stop him. There is a short cut to a black and white section and then to the color sequence that occurred a few minutes *before* Natalie entered the house. At this point her face is not bruised and she removes all the pens and pencils in her apartment and then taunts Lenny to the point where he hits her. She leaves the house for a few moments while Lenny searches in vain for a pen so that he can write down what has just happened. A moment later, with Lenny's memory gone, Natalie returns to the house with a bruised face to tell Lenny that Dodd has beaten her.

As the film progresses—or is 'unfolding' a better term to use since time is moving in two different directions—we realize the extent to which Lenny has been manipulated by both Natalie and Teddy. In one scene they are using him to kill a drug dealer who has a large stash of money. Only at the end of the film do we learn from Teddy that Lenny has already eliminated his wife's killer a year ago. Indeed, Teddy was the policeman who investigated her murder and led Lenny to the killer. Since then Teddy has been using Lenny for his own ends. Teddy also hints that Lenny's wife may have survived but been unable to live with his condition and that Lenny has tried to create a meaning for his life by setting up this elaborate mystery to solve.

But then, as Teddy says, you won't even remember what I'm telling you now. Lenny does, however, remember enough to return to his car and write down Teddy's license plate number. He may not remember what was said to him but now there is a new meaning to his life. He will become happy again by tracking down Teddy and killing him. And so we understand the meaning of that first scene. Teddy was never the killer of Lenny's wife, but someone to track down in order to give a meaning to Lenny's existence.

The idea of the 'arrow of time' has become fundamental in physics and is the assumption upon which our everyday sense of reality is based. But there have been other instances of a story that moves backwards in time. Martin Amis' novel *Time's Arrow* (1991) adopts this device as the central character moves backwards in time to confront an exceptionally traumatic occurrence in his earlier life. Harold Pinter's stage play and subsequent film adaptation *Betrayal* (1983) begins with an incident set in the present and, through a series of scenes, unfolds backwards in time to explain the origins of that incident.

The director, Christopher Nolan's first film *Following* (1998) also disrupted the audience's perception by showing events out of sequence. His most recent *Inception* (2010) is based around the notion that it is possible to enter people's dreams, extract information and plant new ideas. And for the audience who are watching the film, it is no longer clear which is 'waking reality' and what is 'dream.' Again film is being used to probe that age-old question of the true nature of 'reality'—as something truly hard, fast and objective or as an unfolding of the veils of *maya*. Whereas philosophy has traditionally done this via discussion and argument, film has the capacity to present the world as an experience of sensory disorientation, one in which the senses of hearing and sight may be at odds with the mind's attempt to create a coherent sequence of events according to our accepted concepts of ordered space, time and causality.

ETERNAL SUNSHINE OF THE SPOTLESS MIND

In *Memento* Lenny's short-term memories do not exist because of a brain injury. With Michel Gondry's *Eternal Sunshine of the Spotless Mind* (2004) we encounter another type of memory loss, a future world where people can have areas of their memories that are too painful removed. The title is taken from the poem 'Eloisa to Abelard' by Alexander Pope, the story of a tragic love affair where forgetfulness became the heroine's only comfort.

In this film Joel and Clementine meet by chance. They fall in love to the point where they finally move in together, but gradually the relationship turns sour and they decide to split up. This proves to be so painful that it would have been better if they had never met; better if they did not have all those hurtful memories of each other. Clementine hires Lacuna, Inc. (*lacuna* means a gap or missing part) and each decides independently to undergo their 'targeted memory erasure' program.

Their lives can go on as before, unencumbered by any hint that they ever knew each other until one day, the two meet by chance and are attracted to each other! In other words, the scenes at the start of the movie all occurred after the original memories of their relationship had been wiped.

Eternal Sunshine is yet another take on the nature of reality. How much of it is our hard and fast encounter with the immediate physical world and how much of it is generated through the memories of our experiences? And what if those memories are fallible, can be manipulated, or erased altogether?

An article in *Scientific American* in 2005 stated that 'neuroscientists know how to erase memories of the recent past, while leaving well-established memories intact. And new research suggests that even long-term memories could be deleted.' Victims of rape or violence, accident victims, and those who suddenly lose a close family member or suffer post-traumatic stress disorder, it was suggested, could benefit from memory erasure.

TOTAL RECALL

 Paul Verhoeven's 1993 *Total Recall* is based on the theme of a Philip K. Dick novel *We Can Remember It For You Wholesale*. Not everyone can go to Mars, but it is possible to have a false memory implanted so that a person is able to recall an expedition in space. This is what happens to a bored sales clerk, Dennis Quail, who decides to pay to have a false memory implanted. But things become complicated when we learn that Quail was really a secret agent who had been sent to Mars on a sensitive mission. Following the mission his memory was wiped but now the false memory is beginning to play tricks on him.

This again is an interesting excursion into the meaning of reality. If false memories really could be implanted, then how would we ever distinguish them from real ones? Indeed, did some of the events we remember ever happen? Towards the end of *Memento*, Teddy mocks Lenny for having no

short-term memory. He points out that he can say anything he likes to him and Lenny will never remember. To this Lenny replies that real memories are no more reliable. As police officers know only too well, the memories of witnesses are notoriously unreliable—memory can, for example, change the recollected color of a car or the type of clothing worn by a suspect.

In later life some people retrieve deeply buried memories of traumatic events that occurred earlier in life such as incest and childhood sexual abuse. In many cases, and with the help of a therapist, such individuals are able to come to terms with these and even confront the perpetrator to the point of reporting them to the police. However there is also a condition termed False Memory Syndrome in which memories of events that may never have occurred are evoked. This can even go as far as an innocent family member being accused of abuse. In some cases it has been suggested that subtle clues provided by the therapist or the use of hypnosis may begin to give rise to some half-remembered events which are then confabulated into the story of incidents of abuse in early childhood.

A paper in *Nature Reviews Neurosciences* (30 July, 2008) argues that the famous Indian Rope Trick is a key example of misdirection to create a false memory. Many people claim to have seen the boy climb the rope. The magician follows him up the rope, dismembers him and throws the body parts to the ground. The magician descends to reconstruct the boy. Since the trick has not been performed for decades, people who claim to have seen it performed are relying on past memories of their time in India along with accounts they may have read of the trick. Indeed one version has it that the whole thing was a hoax perpetrated by the *Chicago Tribune* in 1890 in an effort to increase its circulation.

Another false memory (or rather urban myth) is that of eating live monkey brains in China. I have been told on more than one occasion by a Chinese person that this is quite factual. A monkey is strapped into a special chair or table with a hole to accommodate the top of its head. The top of its skull is cut off and people then eat the live, warm brain. This story has circulated to such an extent that many people claim that it is true, that they have seen it happen or know someone who has seen it. However the whole story began with what amounts to a hoax newspaper article in the British Sunday newspaper *The People* in 1952 and is probably based on the distorted amalgamation of historical facts. It is a fact that such tables do exist for serving food, but certainly not monkey brains. It is also true that, to avoid poisoned food, the Emperor did eat live foods such as fish. It is a small step from a fish to a monkey. And so an urban myth grows and people really do believe that they have firsthand, or very reliable second-hand, evidence of its existence. A great deal of our 'reality' is constructed in this way.

FIGHT CLUB

 The convention of placing the viewer in the same psychological dilemma as the protagonist, forms the key to David Fincher's *Fight Club*. It is a film that certainly divided the critics. While *Time Out's Film Guide* put it in their top 50 and suggested it was the only essential Hollywood film of 1999, Mick Martin and Marsha Porter's *DVD and Video Guide* listed it as a turkey that was appalling and grotesque. So what was all the fuss about? Cornelius (Edward Norton) is a highly neurotic and upwardly mobile young man who is a slave to what he terms 'IKEA nesting,' in other words filling his apartment with items from the IKEA catalogue. Contentment involves finding exactly the right sofa, bed, or place settings. But Cornelius is by no means content. He suffers from insomnia and is barely aware of the world around him. His doctor won't help him, and when Cornelius complains that he is in pain the doctor suggests that to understand real pain he should visit a testicular cancer support group.

Cornelius visits the group and discovers that, during the hugging sessions, for the first time he is able to release his feelings and cry. Now instead of IKEA he has become addicted to a variety of support groups. As part of the subplot he also encounters Marla Singer who is similarly addicted to such groups.

Another aspect of Cornelius' life involves innumerable plane journeys in which he passes through different time zones. On one of these he notices that the man sitting next to him has an identical brief case. They get into conversation and he realizes that Tyler Durdon (Brad Pitt) is everything that Cornelius would like to be—assertive, in control and with a clear perception of the world around him. Cornelius returns to his apartment block that night to discover that there has been an explosion and all his IKEA belongings are scattered on the street outside. On impulse he rings Tyler who lets him stay at his squat. But there is one condition—Cornelius must punch Tyler and thus Cornelius becomes involved in his first fight. Cornelius learns that Tyler is the quintessential urban myth, the subversive element in a bourgeois society—the cinema projectionist who splices a pornographic frame into a family movie, the waiter in an exclusive restaurant who projects his body fluids into the soup.

The fights continue and eventually Fight Club is formed with members who are similar to Cornelius—ineffective and unable to cope with life. Under Tyler's direction it becomes an underground anarchist movement that is dedicated to the destruction of consumer society by blowing up the headquarters of major credit card companies.

Part-way through the film Tyler leaves and Cornelius attempts to re-trace his steps, only to discover that Fight Clubs have sprung up right across the United States. What is more, the people he meets address him as Tyler. Finally Tyler turns up again, this time to reveal that he is none other than Cornelius' alter ego—Cornelius wanted to change his life but could not, the only way was to invent another personality, the one that he would really like to be. But now the deadline for bringing down the US economy is rapidly approaching and Cornelius pleads with Tyler to call a halt—it is not what he wants, but Tyler points out that this is exactly what Cornelius does want.

In the end Cornelius attempts to disarm a bomb in the basement of an office tower. Tyler tries to stop him and we watch the scene directly and via a surveillance camera. In the direct view we see Tyler beating Cornelius, while via the surveillance camera we see Cornelius alone, flinging himself down a staircase and dashing himself onto the floor. Finally Cornelius takes a pistol from Tyler and shoots himself in the mouth. Tyler dies and Corne-lius, badly wounded, is joined by Marla Singer. They stand hand in hand as they watch the office blocks of the city being demolished around them. A frame from a pornographic film is inserted into the closing sequence.

So what are we to make of this? Is it exploitation, an appeal to rage and violence, or a comment on the deeper meanings of life in a consumer society?

THE MATRIX

With Andy Wachowski's *The Matrix* (1999) we come to not only a highly popular film, with a strong cult following, but also one which also raises some of the deepest and most in-tractable questions that have been asked by philosophers from all cultures and ages; questions that have become even more significant in an age of virtual reality, advances in the neurosciences and the dream of artificial intelligence. Before we revisit the plot of *The Matrix* let us look at some of the underlying philosophical questions the film raises.

» What is the ultimate nature of reality?

» What is the nature of our subjective experience of the world, and how does that relate to the structure of the physical brain and body?

» Will science ever solve the question of the nature of consciousness?

» Is there a genuine possibility that true artificial intelligence will be achieved so that machines will be equal in abilities or even superior to humans?

A variety of other films have posed similar problems. The final question is the subject of such films as *Artificial Intelligence: AI* (2001), *I, Robot* (2004) and *Bicentennial Man* (1999). The nature of consciousness and subjectivity is touched on in such films as *Eternal Sunshine of the Spotless Mind, Memento,* and *Being John Malkovich* (1999). The notion that reality is not quite what it seems or could even be a construct of some *deus ex machina* is in part the premise of *The Truman Show, Vanilla Sky,* and *Waking Life (2001),* and is also touched on in *Rosencrantz and Guildenstern are Dead* (film released 1990, first staged 1966), *The Sixth Sense* (1999) and many more.

To this list could have been added all those films in which a central character turns out to be radically different from the one we have been led to believe in, such as the Kim Novak figure in Hitchcock's *Vertigo* (1958) which we will meet later. Even this highly abbreviated list of films above suggests that we have an underlying concern about the world we live in and the reality of the people that surround us. It is almost as if a postmodern condition—that there is no unique reading of any novel, work of art, or aspect of reality—has entered deeply into the way we view the world. And of course here I am referring to the everyday experiences of ordinary people as they go about their lives, rather than those who believe that the CIA has put radios inside their head, or that they are being manipulated by aliens.

As for the plot of *The Matrix*, I'm focusing on the first of the trilogy because it puts the viewer in a somewhat similar position to that of the central character, Neo, played by Keanu Reeves. It is more skillful and disorienting when the audience identifies with the protagonist who believes that the world around him is hard and solid; for example, that John Nash's roommate in *A Beautiful Mind* (2001) is real rather than an hallucination, or that the therapist in *Sixth Sense* is interacting with the people around him, rather than being a ghost, or that Truman lives in a real town with a real wife and friends in *The Truman Show*, or the US Marshal Teddy Daniels in Scorsese's *Shutter Island* (2010).

Neo finds himself in a similar situation. He is grappling with a deep puzzle—to discover just what is really going on around him. The mystery of the nature of Neo's reality is revealed within the film *The Matrix* and therefore the sequels, *The Matrix Reloaded* (2003) and *The Matrix Revolutions* (2003), despite the elaborate special effects and a stunning car chase on a specially built highway, were (for me at least), somewhat of an anticlimax. Once the key to Neo's reality had been revealed, the only direction in which the films could develop was that of a conventional adventure story—admit-

tedly set in a cyberspace of the future—in which the 'good guys' battle the 'bad guys.' Nonetheless, as we shall see, the philosopher David Chalmers has an interesting twist on who is good and who is bad!

Returning to the plot of *The Matrix*, Thomas Anderson works as a computer programmer in New York in the year 1999, but in his evening hours he is a hacker who uses the alias Neo. We first meet Neo when he is asleep in his room with messages flashing across his computer screen. One is 'Knock, knock...' at which point there is a knock on his door. Neo goes out with his friends and meets a young woman, Trinity, who knows his name and warns him that he is in danger and that she knows he is searching for answers about something called the 'Matrix.'

Next morning at work Neo, or rather Thomas Anderson, has a cell phone delivered to him. It rings and a man who identifies himself as Morpheus tells him that agents are looking for him and tries to give him directions on how to escape. But Anderson (or Neo) is caught and interrogated by Agent Smith who points out that, as a hacker, Neo has broken every law in the book, but will be given amnesty if he helps the agents to capture Morpheus. When Neo asks to make a telephone call he finds his mouth has fused shut.

Waking up in his apartment, he believes that the whole thing had simply been a nightmare until the phone rings and Morpheus arranges to meet with him. At the meeting Morpheus explains that the world around Neo is not real and concrete but a clever illusion. References are made to *Alice in Wonderland* and, like Alice, Neo is offered the choice of two pills; the first will allow him to continue in the false reality, while the second will cause him to wake up. Neo takes the second pill and wakes to find himself inside an embryo pod. It is one of countless thousands of pods located in a vast power plant. This is where the human race has ended up, their bodies maintained artificially while their minds are linked to a vast synthetic and illusory world—the Matrix.

Neo is rescued by Morpheus and his companions and shown the world as it really exists. He is not on Earth in 1999 but on the desolate planet Earth of 2199. The city and time in which Neo has been living is nothing more than a simulation created by highly complex machines, artificial intelligences that were once built by the human race but now employ human bodies as nothing more than power sources—living batteries. But Neo has been marked out as the chosen one who can save the human race. From this point on, and in the two films that follow, we witness the battle between the few freed humans and the machine intelligences that create the Matrix, and their servants such as Agent Smith. Along the way Neo learns how to bend the rules around which the Matrix has been created. In essence this

means convincing his brain that it is possible to defy gravity when practicing martial arts. (The elaborate fight scenes in the Matrix series were choreographed by Yuen Woo-ping who also choreographed the fights in *Crouching Tiger, Hidden Dragon* (2003) and the *Kill Bill* films of 2003 and 2004.)

Now let us look at some of the questions posed by *The Matrix*. What follows is some pretty hairy stuff about philosophy, reality and illusion and the limits of computers.

Artificial Intelligence

The notion of intelligent robots and machines that can think was originally the stuff of science fiction. The term 'robot' itself comes from a Czech play *R.U.R. (Rossum's Universal Robots)* by Karel Čapek about a factory that turns out 'robots' or artificial humans that premiered in 1921. It ends in a robot rebellion that destroys the human race. During the 1940s, Isaac Asimov published a series of stories about robots in American science fiction magazines that were eventually collected into a book *I, Robot*. Later some of these stories, such as *Bicentennial Man* and *I, Robot*, were made into films. The stories trace the evolution of robots from elaborate machines into sophisticated entities, and finally into a robot that has such human qualities that it can request the courts that it be allowed to die just as humans do.

Alan Turing, the inventor of the first electronic computer, ACE, that was used to crack the German Enigma code was also thinking far ahead. In fact the very first computer had been envisioned in the 19th century by Charles Babbage and programmed by Ada Lovelace, Lord Byron's daughter, but the world had to wait until the invention of the vacuum tube before Turing's more sophisticated ACE could be built. Turing believed that computers would become ever more complex. But could they ever truly be called 'intelligent'? And how could we assess whether a computer should be called intelligent? Turing developed the following test: A human uses a keyboard to send questions into another room and then reads the replies. If, after a long period of questions and answers, he/she cannot distinguish if the entity in the other room is another human or a machine and it is indeed the latter, that machine has passed the 'Turing Test' and must be judged to have qualities of human intelligence.

The next step occurred in the summer of 1956 when a group of computer experts, including Marvin Minsky and Claude Shannon, met at Dartmouth College to set a goal for the future. Their predictions were that by 1970 computers would be producing original mathematics, composing music, beating a Grandmaster at chess, speaking and understanding language as well as making translations between languages, and would be able to build up a picture of their environment. Minsky himself had a fantasy of being the reincarnation of Rabbi Loeb of Prague who created the Golem!

1970 came and went, as did 1990 and talk of 'fifth generation machines,' and now in 2010 many of those goals still lie unachieved. Certainly visual recognition has improved, as has chess playing. And as computers have become more powerful, there have been improvements in speech recognition and language translation too. But all in all the true goal of artificial intelligence still appears to be out of reach.

By way of example, let us see how well one machine translation works by translating the above paragraph into Japanese and back again into English:

> *Going to come in 1970, and 1990 fifth-generation aircraft 'stories as,' 2010, many of these goals are still long-awaited next. It is certainly better visual recognition, playing chess has. And that is more powerful computers has improved speech recognition and language translation, too. But everything appears out of reach to the goal of all true artificial intelligence.*

It is often said that all computers are programmed and therefore are only doing what a human being tells them to do. But this is not totally true. In the case of what are called 'neural networks,' a vast system of electronic connections can be made automatically. Such a system can, for example, play game after game of checkers and is rewarded each time it wins. By playing many, many games the various nodes or connections in the network for successful strategies are enhanced, and those that lead to losing games shrivel away. In this sense the computer network is learning from its environment and is in fact programming itself.

Nevertheless, while some scientists believe that artificial intelligence (AI) will be achieved some time in the 21st century, others, such as the mathematician Roger Penrose, believe that there are fundamental reasons why this will never happen. One of these is the famous theorem of Kurt Gödel, which proved that any axiomatic system—that is any system that proceeds via a set of rules such as the steps and iterations in a computer—must be incomplete. In other words, there will always be things that human mathematicians can do, in particular theorems that they can set down, that will never be reached by a computer, no matter how sophisticated. These arguments appear in Penrose's book *The Emperor's New Mind*.

I recall a meeting at which Penrose was the first speaker and made his arguments for the limits of AI. The second speaker was Minsky who began his talk by saying he had not read Penrose's book since he didn't make it a practice to read science fiction!

Yet another argument put forward against true AI is that we don't really know how human beings function. The philosopher Michael Polanyi referred to what he called *tacit knowledge*. We may have explicit knowledge of how to do long division or read a map, but can we tell anyone how we 'know' how to ride a bike? It is something we learn to do as a child, and we retain the skill even if we have never ridden for many years, yet we could never explain verbally how we do it in any explicit way. Most of the really smart things we are able to do on an everyday basis involve tacit knowledge—recognizing a friend after twenty years, being able to cook a dish that is vastly superior to anyone else's, and so on. This is hidden knowledge, knowledge that almost comes out of the physical body itself rather than the brain alone. Set beside this sort of knowledge and skill, doing long division or playing checkers is rather trivial—it's the sort of thing a computer could do. If we don't really know how we do all the most important things we do every day of our lives, then how on earth can we expect to create a computer that will do them as well or even better than we do? Or to put it a different way, while we are incarnate beings we don't quite know *how* we are incarnate.

A brain in a bottle

The Matrix presents a variation on the old paradox of what would happen if the brain and brainstem were removed from a person and hooked up to various types of sensors. Consciousness would persist with a brain receiving inputs from the outer world. This may sound like science fiction, but in the late 1930s a Russian scientist, Sergei Brukhonenko, developed the first primitive heart-lung machine which would allow animals, and body parts, to be kept alive when isolated from the heart. In one or more experiments he apparently succeeded in keeping a dog's head alive. (A film of this experiment has been widely circulated on the Internet but there is some controversy surrounding its authenticity as it may have been a reconstruction of one of Brukhonenko's accounts rather than an actual experiment.)

In humans there are real-life examples of what is called 'the locked-in state.' In some forms of brain damage—whether due to accident or

stroke—the patient is in a deep and persistent coma. The higher brain functions have been damaged and only the brainstem functions, keeping the heart beating and the lungs breathing. But there is also the reverse of this condition, one in which the higher brain functions are intact but the brainstem is damaged. Such a person remains fully conscious but is not able to send brain signals to command his or her body. They cannot speak or even use a joystick to operate a wheelchair or computer. They are truly 'locked in.' One remarkable case is that of Jean-Dominique Bauby, former editor of the French fashion magazine *Elle*, who suffered a stroke so severe that he retained only the ability to blink his left eye, but through extreme persistence was able to work out a code of blinks in order to spell out words. He eventually wrote a book, *The Diving Bell and the Butterfly*, about his locked-in experiences. Sadly, he died two days after the book was published. In 2007 the book was made into a film of the same name, directed by Julian Schnabel.

This locked-in state is the situation in which the Earth beings in *The Matrix* find themselves. Their bodies are kept alive as power sources for a future world of machines while their brains are all connected into the Matrix. The philosopher John Chalmers has given some thought to this question: how do we know that we are not 'envatted' (disembodied brains floating in a vat inside a scientist's laboratory)? How do we know that our brains are not suspended in some vast matrix? After all, some Eastern philosophy has it that the world is one vast illusion, and in the West there have been a number of speculations as to the ultimate reality of the world. One recent scientific hypothesis has it that the world is some sort of expression of vast computations. The physicist John Wheeler argued that the world is created out of mathematical logic, and logic is 'the nuts and bolts of the universe,' and the physicist David Bohm and his colleague Basil Hiley sought to derive pre-space out of algebra. So while it may appear improbable, it is certainly not illogical to argue that some vast computational civilization has created a simulation universe in which our brains now exist. We ourselves could be a part of some enormous simulation in which we believe we have bodies and exercise free will. And this is where Chalmers comes in.

Some commentaries on the film point to a religious aspect, with Neo as the Christ-like figure who has come to save the human race from the robots that have envatted human minds. If this is the case, then Morpheus, who heralds the coming of Neo, is to be identified with John the Baptist. However, Chalmers, best known for his key paper 'Facing up to the Problem of Consciousness,' takes the point that it is not illogical to suppose that the world is the result of underlying computations, a world created out of information. Our minds could interact with this world and be given the impression that we are physically embodied and surrounded by chairs, tables, automobiles and other objects. In other words, the world was cre-

ated by a vast computation. If this is true, then the gods of *The Matrix* are the machines that created it, and the Christ-like figure is none other than Agent Smith whose mission is to save the world of the Matrix from those who wish to destroy it. What is more, Smith is killed and resurrected in the second film.

Consciousness: The hard problem

Before leaving *The Matrix* behind, let us reflect a little more on the true nature of consciousness and our subjective experience. Thanks to sophisticated monitoring devices and signal processing, the neurosciences have made enormous strides over the last decades. Scientists are able to follow electrical activity across the brain as certain tasks are performed. For example, they can detect which areas of the brain are particularly active while listening to music or when speaking. In many cases, the 'correlates of consciousness' have been pinpointed. In other words, neuroscientists have a very good idea what is happening inside the brain when we walk, see, hear, solve a puzzle or raise a finger. But does that really tell us anything at all? Does it give us the slightest hint of what it is like to *have* a subjective experience? The answer is 'no,' we can't simply reduce the quality and nature of our inner experiences to electro-chemical processes. This is yet another reason why the dream of AI has not been achieved.

The present state of this area of science suggests three possible outcomes.

a. It is only a matter of time before we solve the problem of consciousness.

b. Some truly vital step is missing in our understanding of the world and consciousness will not be solved until that missing step is discovered. An analogy is sometimes made with the physics of Newton which could explain more or less everything except for the nature of light, magnetism and electricity. It remained to Faraday and Maxwell to add something radically novel to the Newtonian universe— electromagnetism. Maybe there is some equally fundamental discovery to be made about our own universe—one in which mind and consciousness will be an essential part.

c. We will never understand the mystery of consciousness.

So are films such as *I, Robot* and *A.I.* predictions about our future world or fictions that will never exist? It is my belief that many of the films we have been discussing here are all trying to tell us something about the nature of reality—about subjectivity and illusion—and in that sense they are important contributions to our general culture.

NIRVANA

 The nature of virtual reality is also the subject of *Nirvana* (1997). In an interview the director Gabriele Salvatores invites viewers to look beyond the science fiction surface of his film to what is really happening beneath—a request that puts the viewer very much in the same position as one of the protagonists, Solo. We first meet Solo in a room above a Chinese area of a megacity of the future. In this future one has no need to go to, for example, North Africa, Asia or the United States to experience different cultures because they can all be found living within the different quarters of one vast city. Solo finds a piece of paper with a telephone number, notices a pistol on the table, then calls the number on a video telephone and speaks with a young woman. During the conversation a man enters the room and shoots and kills Solo. The scene is intercut with shots of the other protagonist, Jimi, who has created a new video game called Nirvana and which is about to go on the market where its sale will generate a great deal of money.

The film cuts back to Solo talking with the woman. During their conversation he tells her that he has a sense that all this has happened before. When the man with the gun walks in, Solo shoots him whereupon the figure dissolves into pixels. The film then cuts to Jimi who is testing the virtual reality of the Nirvana game. When he moves his hand, Solo stands. Jimi also gives Solo verbal instructions, telling him to pick up the paper and read the telephone number. At this point Solo says 'No!' and stares into the screen asking what is going on. He asks who is commanding him to do these things and if Jimi is the person who created this reality. At the same time Jimi receives a message saying that the Nirvana game has become infected with a virus and that Solo has now become autonomous.

Solo says that he doesn't want to continue acting in this way and asks if the game can be canceled. Jimi tells him that a great deal of money rests on the game, and that in a sense they are both playing a game in their own respective realities. And indeed this is what takes place, for Jimi in his world is being pursued by people who have a financial stake in the game—he is as

much a player in his reality as is Solo in his. Thus to reach, as the director suggests, beyond the surface is to question the whole issue of the nature of reality. To what extent is it totally objective, and to what extent is it our construction? Indeed, it leads us to question the freedom of our choices and how our choices truly affect the events that surround us.

This is brought home in a particular incident that occurs when Solo reaches the second level of the game. Jimi warns him to be on the lookout for a man with a jacket, so when a man with a jacket and camera approaches him, Solo shoots him. Jimi protests that he has shot an innocent tourist. Solo recycles to this incident again, but this time he warns the tourist to leave. At that moment a man in a jacket raises his gun. Solo tries to shoot him but his bullet hits the tourist. It is almost as if, despite Solo's freedom to choose, the same event must be played out.

As the game continues, Solo attempts to persuade the young woman who accompanies him that the whole thing is an illusion. He even shows her the back door into their virtual reality, a portal from which they can view the program in operation, but he fails to convince her. He appeals to the various characters who want to shoot him that the whole thing is a game, and that they are only shooting him because of the enjoyment it provides to people who play the game. He pleads with them to simply stop playing the game and do something different.

Solo is like one of Gurdjieff's characters who awakes in a world where everyone else is asleep and dreaming and attempts in vain to shake people out of their dream. Likewise, in his own reality Jimi attempts to enter into the heart of the computer system owned by the company that will be releasing Nirvana. As he moves through its various firewalls in virtual reality he finally reaches the core that is protected by a series of 'devils.' One of these is his father who pleads with Jimi not to leave him, while another is the woman with whom he was deeply in love. Finally Jimi reaches the core to cancel the game and tells Solo he will become a single snowflake in the sky. At the same moment agents from the company are about to burst through the door and shoot Jimi. The game is canceled and snow falls. It is clear that Salvatores is exploring similar issues concerning the nature of reality to those touched on in *The Matrix* as well as in Hindu philosophy. Is the world around us concrete and real, or does it only appear so? Are we autonomous agents or, as Shakespeare puts it in *King Lear*:

> As flies to wanton boys, are we to the gods:
> They kill us for their sport.

A magic show

Let us approach this whole issue of reality from yet another angle. It is certainly something that has engaged philosophers for centuries and, more recently, has become the subject of investigations in the laboratories of psychologists and neuroscientists. However, the real experts in the manipulation of reality are stage magicians who appear to confound the laws of nature on a nightly basis. And, as an article in *New Scientist* of 20 December, 2008 points out, this is now being recognized by the scientific community who are inviting professional magicians into their laboratories.

Magic tricks are based on a variety of principles. One is that of misdirection which entails focusing the audience's attention in a particular direction so that they don't actually 'see' the trick. For example, a magician tosses a ball into the air and follows it with his eyes. On the third toss he retains the ball in his hand but his eyes continue to follow the imaginary ball. The audience therefore 'sees' a ball thrown into the air and then vanish.

When eye movements were tested in the laboratory it was found that for the first two tosses the eye followed the ball, but at the third the eye remained focused on the magician's eyes and the brain filled in that there was a ball present. One explanation is that social clues are so important that they can overrule our visual system. Another factor is that information falling on the retina takes 100 milliseconds to reach the brain, so in order to compensate the brain predicts what the future will look like and hence produces the impression of a rising ball.

Indeed the brain often resorts to confabulation, covering up its mistakes with plausible explanations. Under hypnosis a person can be told that there are certain objects in an empty room. Out of the trance that person may then be asked to walk across the room and exit by a door. The path they take will be a zigzag in order to avoid the objects that were suggested to them, but when asked for the reason why they did not walk straight to the door the subject will attempt to explain this away claiming, for example, they had a leg cramp, or that they noticed something out of a window and went over to look. Thus the brain works hard to create a plausible reality for itself.

Misdirecting perception can be taken to extreme lengths. In a 1999 experiment at the University of Illinois, volunteers were asked to watch a video of six people bouncing two basketballs and to count the number of bounces. It turned out that half the volunteers failed to notice a man dressed in a gorilla suit who walked through the middle of the game beating his chest. By focusing on the bouncing ball they restricted their ability to take in the whole scene.

Subjectivity and objectivity and the New Age

The fact that a number of people failed to see a man in a gorilla suit does seem to accord with the 'New Age' movement's claim that 'Hey man, we all make our own reality.' They argue that there is really no hard and fast objectivity out there, and that everything boils down to the individual and how he or she sees the world. So it is worth spending a few moments to examine this argument, beginning with the words 'objective' and 'subjective' which, in the English language, have each gone through a reversal of meaning. Nowadays 'subjective' refers to how things appear as filtered through a person's emotions and prejudices; it is the opposite of objective. Yet its original meaning referred to how a thing exists within itself, quite independent of our perception of it, while objective originally meant the way something appears to us!

Even with the current meanings of the words objective and subjective the question remains: do we create our own reality? And if so, is there really any objectivity to the laws of physics. Here the answer is clear: they are indeed objective, as are the facts associated with them—once, that is, they have been formulated. Take for example the notion of an experiment to determine the boiling point of water. No matter if you are a Buddhist in India, a born-again Christian in New York or an atheist in London you will find that pure water, at normal atmospheric pressure, boils at 100 degrees Celsius and no amount of meditation or incantation or prayer is going to change this.

So does this mean that everything is totally objective and all the theories of physics are objective? It is not quite as simple as that, because the theories of physics are constructed out of the sorts of questions we ask about the world, and those questions come out of the society in which we live, with all its aims, aspirations and belief systems.

In turn, theories can also be thought of as ways of seeing. A particular theory will influence us to look at a certain aspect of the natural world. For example, until the 1980s scientists looked at systems that were in balance, in equilibrium, and at things that changed gradually. Phenomena that did not fit these criteria tended to be ignored. But then Chaos Theory came on the scene and suddenly people were looking at things like shock waves, sudden changes, chaos, so-called 'butterfly effects' and self-organization. Metaphorically speaking, they had been given a new set of spectacles that enabled them to study everything from the stock market to changes in weather.

Therefore a theory is something that arises out of the particular concerns and values of a society that in turn becomes a new way of seeing. Take, for example, one of the cornerstones of physics, the Second Law of Thermodynamics which tells us about the relationship of heat to work. One of the pathways to this law originated after the French Revolution when French engineers discovered that their English counterparts were far more advanced when it came to building engines—after all, the English had been through the Industrial Revolution. And so French engineers tried to create ever more efficient machines until they ran into a barrier: in every machine not all of the heat goes to produce work because some of it gets dissipated in what is known as entropy. As a result, the engineer Sadi Carnot was able to relate the efficiency of a machine to the temperature difference between the source of heat (the fire under the boiler) and the outside temperature. The bigger the difference the more efficient the machine—in other words he had formulated the Second Law of Thermodynamics.

Clearly this law and its predictions are totally objective. On the other hand, the law itself was born out of the belief systems and aspirations of the society of the time. So to speak of the objective and the subjective in science is subtler than first appears. But what if some of these beliefs happen to be what we would call 'New Age'? The results can be seen in Grant Heslov's *The Men who Stare at Goats* (2009). As I began to watch this film, with George Clooney and Jeff Bridges in leading roles, I found the notion of the US Army having a secret unit that handed out flowers, sat cross-legged in meditation, was encouraged to dance, and prayed to the earth and sky in order to replace warfare with love and compassion, hilarious. But as the film continued I began to develop a sense of déjà vu. Maybe it was not so absurd after all!

The New Earth Army of the film is based on real-life Lieutenant Colonel Jim Cannon's First Earth Army that was founded on New Age principles and included 'Warrior Monks' who would develop their psychic powers. Moreover several of the figures in the film are based on actual characters associated with this movement.

Pretty soon the US Army—for real, not just in the film—was performing experiments in remote viewing, training 'Jedi Warriors,' and seeking to develop various psychic powers including telepathy and out-of-body experiences. And why did all of this seem so familiar to me? Because during the 80s, as a physicist I had been to a number of meetings and conferences with other respected scientists at which some curious characters would turn up to talk about making psychic visits to other planets, visualizing the subatomic world, creating healing water, locating underground streams the other side of the globe, seeing newspaper headlines a year into the future, repairing someone's DNA and even harnessing 'the vacuum energy of the

universe.' Then there were those who announced that the next great evolution of the human brain was about to take place via the ingestion of 'heroic amounts' of psychedelics. I'm sure such people are still around today, though maybe the world at large has become preoccupied with other issues. But certainly *The Men who Stare at Goats* brilliantly captures an era. For those who would like to know more, I recommend Jon Ronson's book of the same title, or the three-part British TV documentary *The Crazy Rulers of the World* (2004).

Leaving aside staring at goats, even making a simple laboratory measurement may not be as obvious as it looks at first sight. Take for example Newton's apple. Theory tells us that after one second it is falling at a speed of 32 feet per second. But as the apple falls it accelerates, so after two seconds it is falling at 64 feet per second, and so on.

So why not set out to make a really accurate measurement of how an apple falls? This was attempted at one of the world's major standards laboratories. Of course they did not use an apple but a spherical metal ball. The first step was to eliminate air resistance by having it fall in a vacuum. But what if there were stray magnetic fields around? These would have an attractive effect on the ball—and a laboratory is filled with electrical equipment. And what if the temperature in the room fluctuated—this would cause the metal cylinder to expand or contract. So the cylinder containing the vacuum and the ball had to be very carefully isolated and shielded. But what about the floor? If it shifted ever so slightly because of people moving or machinery operating in the building then, in effect, the cylinder's distance from the center of the Earth would be very, very slightly altered so that the pull of gravity would fluctuate. The answer was to mount the apparatus on a column of cement that went deep down into the ground. Finally, what about the highway that ran some distance from the laboratory? When trucks went past they caused a slight vibration that was transmitted from the ground to the column of cement.

Try as they may to isolate that little metal ball from the rest of the Earth, each time there was an additional very tiny effect. The end result was that in repeated experiments the acceleration of the ball was always slightly different. There appeared to be no such thing as a totally reproducible measurement that was completely objective and independent of the environment in which the experiment took place.

Parallel universes, wormholes and the rest

In the previous sections we have explored some of the deep questions about the nature of our perceptions and experiences of reality, and even asked if that reality is something hard and fast or something closer to a dream or illusion. While these are ancient questions and the stuff of Eastern philosophy, they have also been given a new edge thanks to the 'veiled reality' of the quantum world.

But there are yet other curiosities waiting for us, namely parallel universes and wormholes. The former is the subject of Peter Howitt's *Sliding Doors* (1998), while both occur in Richard Kelly's *Donnie Darko* (2001). Again, as science questions reality, those same questions occur in film.

In our everyday world the lights in our room are either on or off. It is either light or it is dark. In our world a cat, for example, is either alive or dead. But in the quantum world all possible combinations of on and off lights, alive and dead cats, are possible. This was put most forcefully by one of the fathers of quantum theory, Erwin Schrödinger, who in a thought experiment considered a cat sealed in a box along with a radioactive isotope, a Geiger counter, a hammer and a bottle of cyanide. Suppose there is a 50% chance that the isotope will decay within the hour. If it decays, the Geiger counter clicks, triggering the hammer to hit the bottle, thereby releasing the cyanide and killing the cat. If the isotope does not decay then nothing happens and the cat lives. In our everyday world there can only be two possibilities at the end of the hour—in one a live cat is inside the sealed box, in the other a dead cat is in the box.

But quantum theory allows for all possible combinations of solutions as well. According to the theory, the cat could be 50% alive and 50% dead, or even 99% dead and 1% alive, and so on. Yet whenever we, in our large-scale world, open the box all we ever see is a single outcome—a live cat or a dead cat. So how are we to resolve this paradox?

One school of thought, represented by the physicists Eugene Wigner and Henry Stapp, has it that human consciousness, in the act of observing inside the box, acts to 'collapse' all possibilities into one—a live cat or a dead cat. The other school of thought, called 'multiple worlds' and associated with Hugh Everett and John Wheeler, argues that each outcome actually takes place, but does so in a parallel universe. In other words, at some point the universe splits so that in one universe there is a dead cat, and in the other a live cat. Likewise you, the human observer, will also split and, with a total continuity of consciousness, you may open the box to see a live

cat, while the other 'you' in another universe, sees a dead cat. This, I should emphasize, is not the stuff of science fiction but is taken quite seriously by many mainstream physicists.

Two parallel universes form the plot of Peter Howitt's *Sliding Doors*. Helen Quilley is about to step onto a train on the London Underground. In one universe she enters the train and returns home to find her boyfriend cheating on her with his ex-girlfriend. In the other universe she misses the train, gets mugged and ends up in hospital. The parallel worlds continue to evolve; in one Helen enters into a loving relationship with a new man, in the other she struggles to support her boyfriend.

Multiple worlds as tangential universes also enter into Kelly's *Donnie Darko*, as do wormholes in space-time. So what are wormholes—are they factual or the stuff of science fiction?

Einstein's theory of relativity describes a four-dimensional space-time that is curved by the presence of matter and energy. The more matter or energy there is around, the stronger is the curvature. In turn, curved space-time is experienced as gravity. For example, the Earth is trying to move in a straight line but ends up making an elliptical orbit because the sun's mass has curved the fabric of space-time in which it moves.

Likewise the Earth's mass curves space-time and a rocket needs to accelerate fast enough to escape this gravitational pull and fly off into space, rather than falling back to the surface. The speed needed is called the 'escape velocity.' But suppose that a star were so massive that its escape velocity exceeded the speed of light. The result would be a black hole. Everything is sucked into the black hole and nothing, neither matter nor even light itself, could ever escape. In a black hole space-time is curved so dramatically that its very fabric breaks down—it contains what mathematicians call a 'singularity.' In other words, it is a tiny mouth into which matter and energy can fall, a hole in the fabric of space-time, the mouth of a wormhole. But what about the other end of the wormhole? The tail may emerge into some other region of space-time in which matter is being spewed out of the hole. Instead of being a black hole the tail is a white hole. Hence the notion that somehow matter could travel vast distances in a split second by falling into a wormhole and emerging at some far distant part of the cosmos out of a white hole. But for those thinking of a quick trip to some outer galaxy there is little problem. Anyone entering a black hole would be torn apart by enormous tidal (gravitational) forces.

This was a theory created specifically for the movie *Donnie Darko* by an eccentric character called Sparrow. It suggests that an instability in space-time could cause a parallel universe to appear, but one that would

be inherently unstable and could only last for days or weeks. This is the universe which one of the Donnie Darkos inhabits. So far I don't think this idea has made it to mainstream theoretical physics.

DONNIE DARKO

 For whatever reason, Donnie of the film finds himself in two parallel universes. In one universe he was in his bedroom when an aircraft engine crashed through the roof and killed him. In the other universe he was sleeping on a golf course at the time of the crash and was unharmed. The film developed quite a cult following with a website that won a number of awards, and appears near the top in various lists of the best films to see. The Pioneer Theatre in New York City's East Village, for example, began midnight screenings of *Donnie Darko* that continued for 28 consecutive months! In addition the director has added his own interpretations of the meaning of the film. Two points could be made here. One is that a film whose central character is a troubled but highly intelligent teenager, in conflict with authority figures, who comes to believe that he has discovered essential truths that others cannot see is bound to appear attractive to an audience of a certain age group. The other is that, in the director's cut in particular, a large number of hints as to the meaning of the film are given and probably require more than one viewing to appreciate—for example, Donnie as 'The Living Receiver' and such figures as 'The Manipulated Dead' and 'The Manipulated Living' all within the 'Tangential Universe.' There is even the hint that Donnie has the obligation to preserve the original universe when the Tangential universe collapses. All this makes for a great deal of mystification and puzzle solving, in particular sharing that information and clues with others—which is another attraction of a cult film.

Time's arrow

The film *Donnie Darko* not only involves wormholes and a parallel universe, but also another favorite subject of science fiction, and of films such as Rupert Zemeckis' *Back to the Future* (1985)—time travel. But is this scientifically possible?

In fact time is one of the great, unresolved mysteries of physics. To begin with it is a variable 't' (like x or y) in the equations of physics. Another variable would be 'T' for temperature. But while temperature in our world is a measure of how hot or cold something is, time is something very different. It is dynamical, it is moving. It is pushing the world along. The physicist John Wheeler used to suggest that the world's top physicists each write their favorite equations on pieces of paper and place them on the floor. Then we wave a magic wand and command 'Fly!' but the papers simply remain on the ground. Yet, as Wheeler pointed out, the universe flies. And so there is something profoundly missing in our notion of time in physics—it simply does not fly.

But there is more, for the equations that explain our world are what is termed 'time reversible.' In other words they allow time to go in either direction. Switch on a light bulb and light travels out from the bulb to hit the walls a tiny fraction of a second later. But an equally valid solution is to have light from the future flow in from the walls and intersect the bulb at the exact moment the light is switched on.

So both directions of time are allowed in physics, one being time that flows from the future into the present and the past, yet in our world we only see time flow in one direction from past to present to future. Physics has offered a number of hypotheses as to why time has this 'arrow' associated with it. Maybe it is to do with the expansion of the universe or something to do with the production of entropy. Left to their own devices systems move from order to disorder over time—the universe rusts!

But leaving aside the problem of time reversibility, would it be possible to travel backwards in time, or to isolate oneself from the rest of the universe so that the time-reversed solution applied? One famous objection to time travel is that it would create paradoxes in the past. Suppose you travel back to a period before you were born and accidently hit and kill your mother while driving a car. This means that you could not exist in the future from which you travelled.

Yet another paradoxical situation occurs with an extension of that 'collapse of the wave function' we encountered in the case of Schrödinger's cat. In the famous 'delayed choice' experiment the wave function is collapsed sometime in the present but acts back to affect events in the past. One thought experiment, proposed by the astrophysicist Fred Hoyle, seems like pure science fiction. Suppose there are highly advanced beings in the distant future who have the technology necessary to perform a delayed choice experiment that collapses wave functions around the time of the Big Bang. Such experiments are designed to adjust the fundamental constants of nature so that a universe will evolve in which life will appear and evolution

proceeds to the point where there are highly advanced beings in the distant future who have the technology necessary to....

THE JACKET

 A form of time travel occurs in John Maybury's 2005 film *The Jacket*. In *The Jacket* time travel is supposed to occur when a person is subject to a severe psychological stress to the point where he experiences an out-of body state in which he appears to be living in the future.

Jack Starks, played by Adrien Brody, is shot in the head by a young Iraqi boy while serving in Iraq in 1991. Starks is presumed dead by the medics until he blinks his eyes. Suffering from post-traumatic shock, he is sent back to the States and on one particular day is caught up in a curious series of events. First he encounters a stalled car, the driver of which is a very badly drunk young woman. Her young daughter explains that the car won't start. Jack fixes the engine and gives his dog tags to the little girl.

A little later, a young man offers him a ride until they are pulled over by a police car. The next thing Jack remembers is being arrested for the murder of a policeman. What actually happened is that the driver shot the officer and abandoned Jack at the scene of the crime along with the murder weapon but, suffering from shock, Jack has no memory of the events.

At Jack's trial he is committed to an asylum for the criminally insane where he is subject to a highly unorthodox treatment by Dr. Thomas Becker. This involves strapping him into a straightjacket and locking him for several hours in what is essentially a mortuary drawer. The first time this happens, Jack remains in a state of extreme panic, but with subsequent treatments he begins to have out-of-body experiences. In one of these he finds himself outside a diner on Christmas Eve where a young woman who works there, Jackie Prince, offers to give him a ride and later suggests that, as he has nowhere to go and it is Christmas, he should spend the night on her sofa. As he looks around the room Starks finds a photograph of Jackie as a child with her mother, and also discovers his own dog tags. His sense of confusion increases when Jackie tells him that the year is 2007 and that Jack Starks died back in 1994. What is more, her mother burned to death in bed while drunk and smoking. Jackie sees Starks as a madman or a con artist and asks him to leave.

However, with subsequent treatments Jack returns to 2007. He convinces Jackie that he is genuine, and together they attempt to figure out the circumstances of his own death. But on visiting the hospital it becomes clear that there was a cover-up concerning the circumstances of the head injury that caused Jack's death. However, everything that he learns from the future during his out-of-body experiences is knowledge he can take back with him to 1994, including information that will help another doctor, Beth Lorenson, to cure a young patient she is working with. Finally, as the day of his death approaches, he pleads with Lorenson to allow him to visit the home of little Jackie and hands her mother a letter in which he tells her what will happen to her and her daughter unless she turns her life around.

Arriving back at the hospital on that icy afternoon, Jack slips while getting out of Lorenson's car and injures his head. Although he is dying, his last request is to be put back in the straitjacket and the mortuary drawer. His final out-of-body experience takes him back to the diner on Christmas Eve, 2007. Jackie Prince drives past and offers the stranger a lift. While in the car she receives a telephone call from her mother who tells her she is late for work at the hospital; clearly in this future the mother is no longer drinking. The car is suddenly illuminated with light, and the film ends.

This time, without the need for time travel machines, parallel worlds or precognition, the film explores the old paradox that, if we did truly know about the future, we could take action in the present that would change that future.

Yet another variant on this theme is explored in Stephen Spielberg's 2002 film *Minority Report*, based on the Philip K. Dick short story. What if precognition really worked to the point that someone operating in the present could predict a crime in the future? By acting now and arresting the perpetrator, the nature of the future could be changed. Of course there is a twist in the plot since the investigating officer is himself accused of committing murder in the future

K-PAX

 We've had wormholes, parallel universes and time travel, so why not aliens? Most scientists are open to the idea that life may exist on planets scattered across the universe. So if there could be life on other worlds, will we ever be contacted by alien intelligences? Certainly this possibility is taken very seriously by scientists

working on the SETI Program (Search for Extra Terrestrial Intelligence) who believe that any first contact will most probably be via radio transmissions from the distant stars.

So how did life itself originate in the cosmos? Following the Big Bang and a period of accelerated expansion, called inflation, the universe began to cool down to the point where clouds of hydrogen gas could condense. As the hydrogen nuclei in the gas began to cluster due to gravitational attraction, they traveled faster and faster, colliding with each other until nuclear fusion occurred and the first stars were born. These stars continued to 'burn' their hydrogen, and in the process converted it into helium which then 'burned' in another type of fusion reaction to produce heavier elements. As the stars aged, some cooled to become red giants, some exploded as supernovas, while others condensed to become neutron stars or even black holes. And with the first generation over, a second generation of stars began to form, and in their nuclear furnaces they created more and more of the chemical elements.

We now live in a cosmos in which there are millions of galaxies, each containing millions of third-generation stars. Some of these stars will have planets circling them, and these planets will contain all the elements necessary to form life. And of the origin of life itself? Some believe it began as more and more complex molecules formed on the surface of clays. Others have argued that they formed in comet tails, and that when comets pass through the upper atmosphere of a planet they act to 'seed' it with life. It seems inevitable there will be life on other planets that surround other suns, and that on some of these evolution will have produced intelligent beings, some with minds equal to our own and others with abilities and technologies that far exceed ours. If they were to try to communicate across the galaxy, with what better way than with modulated radio signals?

The problem with such messages and contact is the distances involved. The nearest star to Earth, apart from the Sun, is four light years away. This means that a message received in, say, 2010 would have left that civilization in 2006. But what of other, more distant stars? Then we could be talking about messages that left in 1910 or 1810, in which case it would be several hundred years before they received our reply, and who knows what would have happened to their civilization in that time period? As for us, we have only had radio for approximately one century and even towards the end of that century it looked as if it were possible for human civilization to destroy itself via a nuclear holocaust.

A related problem is travel. Einstein showed that the velocity of light is a limiting speed—develop more and more powerful rocket engines and we can accelerate a rocket to higher and higher speeds. But as speeds approach

that of light the mass of the rocket increases until, at the speed of light, it would be infinite.

Aliens are also the stuff of science fiction such as H.G. Well's classic *War of the Worlds* which also saw two film versions in1953 and 2005. Aliens feature in such blockbusters as *E.T. The Extra Terrestrial* (1982), *Close Encounters of the Third Kind* (1977) and many others. They are in the tradition of bug-eyed monsters, but what of an alien who looks, behaves and speaks like an ordinary human being? This is a dilemma posed by a character called Prot in Ian Softley's *K-Pax* (2001).

Prot is first discovered in a railway station where he just appears; for one moment he is not there, then the next he is. Through a random incident, Prot is mistakenly arrested and then sent for a psychiatric evaluation. He appears highly intelligent and claims that he is not from Earth at all, but from a planet called K-Pax.

To the therapist this is simply a delusion—the sort of situation where a person believes they are Julius Caesar or Christ. He asks why, if Prot is really an alien, does he look just like everyone else. Prot replies by asking why is a drop of water round. The answer is, of course, that this is the most economical form that a drop can take because of surface tension. Likewise, when Prot is on Earth, the most economical form he can take is to look like an Earth being. When the therapist also asks how it is possible for Prot to travel such distances, Prot replies by pointing to a beam of light reflecting in a glass object on the desk. And this is where we need a slight scientific diversion.

Not only do objects become more massive when they travel close to the speed of light, but clocks slow down. In fact if it were possible for a clock to travel at the speed of light, it would stop altogether. In other words, for the clock the amount of time taken to complete the journey would be zero—instantaneous connection. Clocks are ordinary physical objects and could never be accelerated to such speeds without becoming infinitely heavy, but coherent light—laser light—can be used to convey information. After all, fast broadband connections are made via optical fibers in which complex information is transmitted at the speed of light. Would it then be possible to transmit from a distant star system the information needed to reconstruct a being on Earth? If we add in something called 'quantum teleportation' we have a device not unlike the transport system used on the fictional Starship Enterprise—'Beam me up Scotty'—and, indeed, with future technology it may be possible to transport a being to a distant planet. For us back on earth that journey would take hundreds or thousands of years, but for that being transmitted at the speed of light the trip would be instantaneous.

While, for the therapist, Prot's story is clearly a delusion, he can't help but be impressed by the consistency of Prot's answers. In the end he arranges for Prot to meet a group of astronomers at a planetarium where they have set up Prot's particular star system. They know this system does have a planet, but have not worked out its orbit. Prot sketches out a fairly complicated orbit, and their calculations then confirm that this is valid. This certainly shocks the astronomers since information about the star system has not even been published in any scientific journal. On another occasion Prot says he must go on a trip and vanishes from the hospital, only to be found some days later up a tree. Prot also has a significant effect upon the other patients, giving them hope and promising to take one of them with him.

The therapist attempts to regress Prot, and learns of his attachment to an amateur astronomer who Prot claims to have visited in the past. Prot also refers to a specific date when he will be leaving Earth. The therapist feels that there is something significant about the date and the person Prot referred to. Finally he tracks down that date as the anniversary of the day on which Prot's Earth friend discovered his family murdered and then went missing himself. Clearly the trauma of the murders has created a flight from reality and the delusion that the man is from another planet.

The fatal date arrives; Prot is in his room looking out of the window. Suddenly he can no longer be seen through the window in the door and, when the staff enter his room, the occupant is lying in a catatonic state on the bed. The film ends with the therapist sitting with an uncommunicative patient in a wheelchair. In a sense the film invites you to choose between two readings or, better still, to be suspended between two possible versions of reality. In one a man, traumatized by the loss of his family, has fled into a fantasy world of alien planets until, on the anniversary of his family's death, he becomes catatonic. In the other, Prot has occupied the man's body in order to complete his researches on Earth and, at the chosen date, returned to K-Pax leaving the body behind.

Yet things are not really that simple, for there is one problem with the first reading which may not at first be apparent to someone who does not have some knowledge of physics. Working out the motion of more than two bodies is a very complicated problem, and being able to calculate the orbit of Prot's planet would certainly be beyond the capabilities of any amateur astronomer. While it may not have occurred to the scriptwriter, that scene alone is sufficient to convince us that Prot, or at least the being who is controlling the body of the patient in the New York psychiatric hospital, is truly from the planet K-Pax.

The butterfly effect

The argument of this book is that the new realities revealed by science are gradually creeping into films. We have already met the veiled reality of quantum theory; another phenomenon is an implication of chaos theory called 'the butterfly effect.' This argues that, given the right conditions, a tiny disturbance can produce a major change. The term butterfly effect (or more technically, sensitive dependence on initial conditions) was coined by the climatologist Edward Lorenz who was making weather predictions on his computer. He wanted to double-check his calculation, but when he used a smaller number of decimal places in the input his computer came up with a totally different result. The reason is that this was what is known as an iterative calculation in which the output of one part of the calculation becomes the input for the next, and so a tiny error loops around and around, each time becoming a little larger. In 1963 Lorenz presented his findings at a scientific meeting using the title 'Predictability: Does the Flap of a Butterfly's Wings in Brazil set off a Tornado in Texas?'

Normally small causes result in small effects, but when a system is balanced in a very sensitive way a small cause, like a butterfly flapping, can produce an unpredictably large effect. A famous example is that of Rosa Parks who refused to give up her seat in what had been designated as the 'white' section of a bus. Her arrest led to the formation of a vast protest movement in Montgomery, Alabama, a bus boycott and, ultimately, the dismantling of racial segregation.

In the film *The Butterfly Effect* (2004), directed by Eric Bress and J. Mackye Gruber, Evan Treborn is a haunted person. He is traumatized by events in the past and has suppressed the memories of key events in his childhood, such as the time his friends placed a stick of dynamite in an elaborate mail box to watch it blow up but inadvertently caused a death. If only he could go back and change that tiny action a major disaster would be averted. Evan discovers that by reading his diaries it is possible for him to relive those memories, and in reliving them to actually change the pattern of events and so undo the mistakes he has made. Of course as we saw earlier in this book if someone were actually to venture into the past and change an event then it would also change the future, so that when that person returned to their own present it could not be the same.

In a particularly curious anticipation of Lorenz's 'butterfly effect' a short story, 'A Sound of Thunder,' written by Ray Bradbury back in 1952, deals with a time travel company that can transport people back into the age of the dinosaurs. Visitors are warned that they must stick to the track

so as not contaminate the past in any way, but one of them, Eckels, slips and his boot falls into the mud. On returning home he finds that the present has been transformed. Language has changed, buildings look different and a fascist is standing as president. He lifts his muddy boot and discovers that he has stepped on a butterfly.

This is what also happens to Evan in *The Butterfly Effect*. He corrects a mistake of the past and returns to a present only to find that it is even more undesirable than the one he left—not only for himself but also for his friends. Finally he goes back to the time when he was in his mother's womb so that he can wrap the umbilical cord around his neck and never be born alive.

II.
Psychology and film

In 1900 Sigmund Freud published his famous *The Interpretation of Dreams* which introduced the world to psychoanalysis. For Freud, dreams revealed themes and incidents from the personal unconscious that were being expressed in symbolic terms. The unconscious contained repressed memories of experiences that were too painful to be allowed into the conscious mind. For Carl Jung, however, there was an additional, deeper dimension, the collective unconscious that contained transpersonal material universal among humanity such as symbols of wholeness and a variety of archetypal figures that appear both in dreams and fairy tales.

Since cinema has often been called 'dreaming in the dark,' it is natural that films, like dreams, should excite the interests of psychologists and psychotherapists. Indeed there seems to be a particular affinity between Jungian analysts, or at least those who take a deep interest in Jung, and film. John Beebe and Chris Hauke are among several Jungian analysts who have written on film. Jean-François Vézina has not only written a book on film but uses it in therapy, asking a patient about a film that particularly speaks to them and then exploring the meaning of the archetypal figures that it portrays. For many years he was also the producer and host of the radio show *Projection* for CKRL-FM in Quebec City, which examined the relationship between psychology and the cinema.

Several directors have been influenced by the discoveries of psychology. One in particular that comes to mind is Fellini with his deep interest in the depth psychology of Carl Jung. Once Fellini, learning that a fellow dinner guest, Peter Ammann, was a Jungian analyst, said 'I must have you by my side while I am making *Satyricon*.' A person who understood the unconscious and the significance of dreams at a deep level was the very man that Fellini wanted close by. What is more, Fellini kept a big book for his drawings with accounts of his dreams, now collected and published as *Federico Fellini: The Book of Dreams*.

Those who know Fellini's films will understand the deep symbolism contained in them. Both *La dolce vita* (1960) and *Le notti di Cabiria* (1957) have symbolic trips to the sea. After all, Fellini grew up in the seaside town of Rimini on Italy's Adriatic coast. The sea can be a place of potential rebirth and as vast as the collective unconscious. At the very start of *Felli-*

ni's Casanova (1976) a goddess is being raised from the lagoon. The rope breaks, she is plunged back underwater and the lagoon freezes over. From now on Casanova will live in a world of ice, his heart frozen and the act of love reduced to something as mechanical as the clockwork bird he sets beside the bed of his conquests.

It is generally said that Freud discovered the unconscious. But this is not quite true because dramatists and novelists have always known this deep truth; indeed it goes back to the ancient myths and Greek drama. We tend to believe we are living conscious lives, making reasoned decisions, always saying what we mean, or if we make everyday mistakes they have no more significance than a temporary slip of memory. But in fact beneath this conscious surface lies a world of repressed ideas and experiences. Freud's notion was that painful experiences in early childhood were buried in the unconscious where they retained energy. At one level they may emerge as 'Freudian slips' when we speak. In some individuals a similar event—similar in the symbolic sense—to something repressed in early childhood may occur later in life and result in neurotic symptoms, illogical fears or bizarre behavior.

According to Freud, since the unconscious is made up of a series of repressed events that occurred in early life its content will be different from person to person. On the other hand, since most humans develop in the same way there can be certain universals, one of which is the famous Oedipus complex. Most children traditionally grew up with a mother and father. The infant is strongly attached to the mother, and in particular to the mother's breast. The father is therefore viewed as someone who displaces the child for the mother's affection. This leads to the unconscious desire to kill the father in order to possess the mother. In Greek tragedy it is manifested in the play *Oedipus*, and it occurs again as an underlying theme in *Hamlet*. For Freud this is the reason that these plays are so powerful. It is because they touch an underlying complex that many of us possess.

But on to Jung, who was a close follower of Freud, even to the point of being called the 'Crown Prince.' Jung was uneasy about some of Freud's findings, in particular Freud's view that incest was purely sexual in nature, whereas Jung also felt it had important symbolic overtones. In other words incest need not have a literal expression as close relatives having sex together but could involve, for example, an unhealthy psychic involvement of therapist and patient.

Like Freud, Jung also set great store by dreams, many of which are recorded in his autobiography *Memories, Dreams and Reflections*. On one occasion, for example, he dreamed he was in his home and descended the stairs to find a medieval level and below that a Roman level. He noticed a trapdoor, opened it and found himself in the sort of dwelling that Stone Age people would have inhabited. His dream was taking him down and

down into the remote past of our human ancestors. It was taking him from the level of the light of consciousness, through the personal unconscious of Freud, and down to what Jung came to call the collective unconscious—that is the deepest level that is common to all humanity, that level where the great myths and symbols dwell.

And that is where films come in, for the most powerful of them—be it a popular movie such as *Star Wars* (1977) or *Rocky* (1976), or some art house movie such as Cocteau's *Orphée* (1950) or Fellini's *8½* (1963)—have such an impact because they evoke universal symbols of which we are only dimly aware; symbols moreover that are charged with a powerful psychic energy. Tap into that energy and you have a film with universal appeal.

Jung called these the archetypes, which are 'the structuring principles of the psyche.' We never see the naked archetypes as such, only their manifestations in terms of symbols, stories and patterns of behavior. In terms of visual symbols, the circle and the mandala can be taken as symbols of wholeness. In terms of archetypal figures, a woman can be, for example, a pure virgin, nourishing mother, seductive whore or destructive witch. A man can be, for example, a hero on a journey; a *puer aeternus*—the eternal golden youth who never appears to age—or a *senex* who is wise but old before his time. They are found in all ages and in all cultures across the world.

Archetypes have both positive and negative aspects. The *puer* can be enthusiastic and creative, exploring new avenues and giving energy to those around him. Yet in his negative aspect the *puer* will jump from one activity to another, never quite finishing what he sets out to do. He may appear attractive to women, yet they can never pin him down because he is unable to fully commit to a relationship.

Individuals can at times be 'possessed' by an archetype, in other words trapped in particular patterns of behavior. A man feels resentment towards his boss at work then gets into an argument with a traffic cop. The particular situations are different but the underlying archetype is the same, involving conflicts with authority figures. A woman feels claustrophobic in a relationship and leaves her husband for another man, then after a couple of years breaks up and finds yet another man. This man looks completely different from the other two, has a different job and very different friends, but in the end that sense of claustrophobia occurs yet again. She is trapped in an archetypal pattern of behavior that will continue, in one way or another, until some aspect of her psyche awakens and transforms.

The great myths and fairy stories all involve archetypes, or archetypical situations such as a hero's journey or the solving of a riddle. All over the world there are a variety of such stories; they are told in different languages and with different events—but with more or less the same plot line.

A young man leaves home, sets out on a journey and overcomes great difficulties, be it slaying a dragon or battling with a giant. Finally he discovers a great treasure or marries the king's daughter.

Walt Disney intuitively knew the power of such stories when he made films such as *Snow White* (1937). Just think of the powerful archetypal forces in that feature-length cartoon. Grimm's version of the story begins with a pricked finger and three drops of blood, symbolic of menstruation. A young woman must face puberty but instead retreats to a forest where she lives with seven people who have not reached their proper height. In other words Snow White is the archetype of the *puella aeterna* (the female *puer*). Her stepmother is narcissistic: she seeks reassurance of her beauty from the mirror. She is the archetypal devouring mother figure, determined to destroy her rival stepdaughter. Snow White is given a poisoned apple and regresses back into sleep, a symbol of the death of the child within her. The woman within her is then awaked by the kiss of a handsome prince. Grimm's story was translated into the medium of animated film by Disney. (Bruno Bettelheim, who has written about the nature of fairy stories, critiques Disney's version. For Bettelheim the dwarfs are essentially undifferentiated beings, aspects of Snow White's regression. But Disney gives them names and individual characteristics which, in Bettelheim's judgment, weaken the psychological impact of the story.)

As to the *puer*, a good example is the character of Peter Pan in the novel of the same name by J.M. Barrie. Peter is a boy who never wants to grow up. He has the ability to fly and is the leader of a gang of 'lost boys' who have endless adventures on their island with fairies, mermaids, Indians and pirates. Flying itself is an archetypal situation, something that occurs in dreams. It can connect us to the world of spirit, and in its negative sense it means we no longer have our feet on the ground and could be subject to psychic inflation. Peter also visits the real world, in particular the home of the Darling family where he chooses their daughter, Wendy, to be his mother. Wendy is a child about to enter adolescence and, unlike Snow White, is willing to take responsibility and grow up.

Barrie himself is an interesting case in view of the subtitle to *Peter Pan—The Boy Who Wouldn't Grow Up*. When Barrie was six his elder brother, a favorite of his mother, died in an ice-skating accident. His mother was deeply distressed at the death and appears to have neglected Barrie who began to dress in his brother's clothes and whistle like him. In turn his mother comforted herself with the notion that because her son had died he would never grow up and leave her.

There has been some speculation that, as a result of the stress he experienced during this period, Barrie suffered from a disorder that has become known as psychosocial short stature (PSS), a condition in which stress pre-

vents children from producing sufficient quantities of growth hormone. The result is short stature and physical immaturity. According to his passport, Barrie was 5ft 3½ins tall. His marriage was never consummated.

There have been a number of movie adaptations of the story, in particular Spielberg's *Hook* (1991). Incidentally it should be emphasized that Barrie did not consciously choose the archetypal symbol of the *puer* but, as with all art and literature, he was touching powerful images from the collective unconscious. The same, however, cannot be said about Spielberg who was well acquainted with Jungian ideas. Spielberg's parents' marriage did not work out, and the two separated. Although his father was supportive of the young Steven's desire to make films, the boy's experience was that of an absent father. This certainly finds its way into many of his films such as *E.T.* where the adults, and not the alien, appear as menacing figures.

In *Hook*, Spielberg employs the plot device that Peter has left his island in order to grow up and have children of his own. But the adult Peter has turned into something of a *senex*, obsessed with work as a corporate lawyer and unable to relate to his son, Jack. When Captain Hook kidnaps Peter's children, Jack, rebelling against his father, becomes attached to the villainous pirate. Peter has to learn how to fly again and do battle with Hook in order to win back his son. And thus the relationship of son to father is played out in a film by the director who is supposed to have said that he made *Saving Private Ryan* (1998) for his father who filled his head with war stories as a boy.

As its title suggests, Jason Reitman's *Up in the Air* (2010) is also an exploration of flying and inflation. Ryan Bingham (George Clooney) works for a company whose business is in the downsizing of corporations. His work consists of flying to different cities to meet with employees and informing them that they are being 'let go.' Ryan feels himself a compassionate person, almost a Charon figure who has to ferry people across the river Styx from the security of employment to weeks or months of job searching. He suggests, for example, that rather than being a bleak situation, unemployment offers the possibility of starting a new life, even of following an earlier dream that was abandoned in favor of job security.

And so Ryan, armed only with a small carry-on bag, spends over three hundred days of the year in the air, flying from place to place. We also see him as a motivational speaker, one who suggests that each of us is weighed down by a heavy backpack, not only of possessions but also of friends and relatives. How much better it would be to dump the backpack and be totally free.

Ryan is a person perpetually in the air; indeed his ambition, which he achieves towards the end of the film, is to have flown ten million miles. Up

in the air there is nothing to ground him, no wife, no girlfriend, and only a tentative relationship to his sisters. Nothing, that is, until he meets another free-spirited traveler, Alex Goran from Chicago, in a hotel bar. He spends a night with her and they arrange to meet again when their flying schedules mesh.

Gradually Ryan, who has claimed that he would never wish to marry or have children, softens and appears more vulnerable. In the end he does the unthinkable; he breaks his schedule, flies to Chicago and drives to Alex's house. But when the door opens he realizes that she is not the free, unattached woman he imagined, but married with children.

In the final scene Ryan lets go of his suitcase, (which has become an almost Winnicottian transitional object—a security blanket!!) at an airport and looks at the flight board. We then hear his voice-over flying in the sky and saying that, while most people will be greeted home by a dog or children, he remains a wingtip light flying over their home. In the metaphorical sense he can never come down to earth.

Jungian ideas were also an important influence on George Lucas. Joseph Campbell's book, *The Hero with a Thousand Faces,* became a key text while Lucas was making his *Star Wars* series where Luke Skywalker is clearly on a hero's journey. He is taught by the wise Obi-Wan Kenobi about 'the Force' and, just as the heroes of fairy tales have their animal companions, so Luke has his two robots and Chewbacca. Likewise he must undergo a series of tests if he is to save the galaxy by battling the forces of evil as personified by Darth Vader (Death Father). As a boy Vader embraced the Force, but later turned against it and chose the path of evil. Inevitably he turns out to be Luke's father. (As for the robots, there was yet another influence, Akira Kurosawa's *The Hidden Fortress* (1958) which Lucas much admired. In the film two bumbling peasants find themselves escorting a general and a princess to safety.)

This archetypal hero's journey is the subject of many films and novels and of course dates right back to the world's oldest written story the *Epic of Gilgamesh* composed four thousand years ago. The *Odyssey,* attributed to Homer and written towards the end of the 8th century BC, centers on the Greek hero Odysseus (or Ulysses as he was known in Roman myths) and his ten-year journey home following the fall of Troy. In *Moby Dick* (1851) Herman Melville deconstructs this notion through Captain Ahab's search for the great white whale. Carl Jung considered it to be 'the greatest American novel.' It was first made into a silent film in 1926 but is probably best known in the 1956 version by John Houston. In the traditional hero's journey, the heroic figure must do battle with some great beast such as a dragon, defeat the monster and obtain his reward. Ahab, however, has become obsessed with his hunt for the whale to the point of madness. He

has had a previous encounter that resulted in the loss of his leg which could symbolically mean that he is no longer totally in touch with the ground and subject to psychic inflation; it could also be seen as a symbolic castration. And so Ahab, played in Houston's film by Gregory Peck, sees the whale as 'all evil personified.' The whale is a creature that spends most of its time under water, in the collective unconscious. It is also Ahab's shadow personified, the dark side of the captain's life. Ironically, however, this shadow happens to be white, not black. And so Ahab heaps all 'the rage and hate felt by humans since the time of Adam' upon the whale's back. Finally the whale is found, Ahab harpoons its back but then gets caught in the harpoon's rope and is dragged down to his death in the dark sea of the unconscious.

Another aspect of this notion of shadow can be found in Jean Cocteau's beautiful 1946 filmed version of the fairytale 'Beauty and the Beast.' A merchant, lost in a dark wood, finds shelter in a castle owned by the Beast. In return for his life he promises his daughter, Belle, to the Beast. The Beast falls in love with Belle and wishes to marry her. In Jungian terms the ugliness of the Beast represents the negative animus of Belle. In other words, it represents her refusal to acknowledge the masculine side of her psyche. Sick with love, the Beast dies, and when Belle sheds a tear over his body the Beast turns into a handsome prince—a symbol of the way the young woman is now able to integrate her animus within her psyche.

One could point to many other archetypes in films. The figure of the witch or devouring feminine comes to mind when we think of Adrian Lyne's *Fatal Attraction* of 1987 in which Glen Close, as Alex who after having a weekend fling with attorney Dan Gallagher (Michael Douglas), begins to stalk him, entering his home and even killing the family's pet rabbit and putting it in a pot on the stove. Her behavior becomes more and more uncontrolled to the point where she attempts to kill Gallagher's wife with a knife. Gallagher intervenes and drowns Alex in the bathtub. Then in a cliché from so many horror movies, at the moment when everyone can relax she jumps from the bath waving the knife! In the end she is shot by Dan's wife. In fact that was not the original ending to the film, which was that Alex disintegrates to the point where she kills herself by slashing her throat, but does so in such a way as to suggest that Gallagher may have been her killer (the original ending can be seen on a special edition DVD). Close stars as yet another witch-like figure—Cruella De Vil— in Stephen Herek's *101 Dalmatians* (1996).

Synchronicity: MAGNOLIA, CRASH and CLOSER

 One of Carl Jung's most interesting hypotheses was that of synchronicities—two events that when taken together make a meaningful pattern, generally one internal, (for example, a dream), and one external—and patterns are what *Magnolia* is all about. With so many people in the world and so many different events occurring, it is no wonder that hosts of bizarre coincidences occur. You may be seated next to a stranger on a plane and discover that you have a friend in common. This is generally pure coincidence; after all maybe several people on that flight are going to a convention in another city, so it is no surprise that they should have some contacts in common.

But suppose however you have been thinking about that particular person over the last few days, you have dreamed about them, spoken about them to your spouse, and then the person sitting next to you on the flight reveals that that person has been involved in a serious accident. Suddenly that coincidence strikes you in a profoundly different way—an event in your inner world of dreams and imagination connects with something significant in the outer world—the coincidence has a deep meaning for you. And this corresponds to Jung's definition of 'a meaningful coincidence.' And to distinguish these from ordinary, everyday causal connections he added that it was 'an acausal connecting principle'—without any material cause the inner and outer are connected in a way that is profound and numinous.

Paul Thomas Anderson's 1999 *Magnolia* begins with a series of remarkable coincidences. In the first, Sir Edmund William Godfrey, a resident of Greenberry Hill, London is murdered by three vagrants whose surnames are Green, Berry, and Hill. An unusual coincidence—but is it particularly meaningful?

In another, a young man decides to commit suicide by jumping off the roof of his apartment block. Downstairs his mother and father are having an argument. His mother raises a gun, fires and hits the boy as he falls past the window. While the incident itself is based upon an urban myth, it can be interpreted as a fictional synchronicity. The young man had been distressed by the constant bickering of his parents which escalated to the point where one of them would point an (unloaded) gun at the other. Several days earlier, in despair, the young man had loaded the gun with the notion that this time their threats would not be in vain. But now, as he falls past the window, he is shot by his mother. And so the connection is between parents and children—that the acts of the parents are visited on their children—and this is how the various synchronicities of the film *Magnolia* will have their origin, a meaningful connection between parent and child.

Following its pseudo-documentary start, the film explores nine separate but interwoven storylines that, at the very end of the film, will all link together through a series of remarkable coincidences. A high point of the film is also a series of scenes in which a rain of frogs descend from the sky.

One story revolves around Frank T. Mackey who gives high-powered seminars on dating called 'Seduce and Destroy.' Frank also gives an interview in which the interviewer begins to question some of the facts about his background involving his mother and father.

Another story concerns Earl Partridge, who is dying of cancer, and his wife Linda who married him for his money. The dying man would like to see his estranged son who has changed his name from Partridge to Mackey.

We see a quiz kid, Stanley, who is being pushed by his father to be number one on 'What Do Kids Know?' hosted by Jimmy Gator. During the show the boy is desperate to go to the bathroom, and in the end wets himself. The quiz show is also being watched in a bar by Donnie Smith, a former child star of the same show. Donnie has a crush on the barman and wants to get his teeth fixed, and so decides to rob his employer, Solomon Bros., in order to obtain the necessary money to pay the dentist.

Jimmy Gator, the host of the quiz, becomes ill during the screening, and we realize that Gator is dying and has been given two months to live. He is estranged from his daughter Claudia who is now a cocaine addict, but he wants to resolve things before he dies. When he visits her she becomes angry and neighbors complain about the noise. As a result the daughter's apartment is visited by Officer Jim Kurring who becomes attracted to her. Later that night, when chasing a suspect, Kurring loses his gun and his veneer of confidence is totally stripped away.

Now that the various stories have been set up, the film moves to its bizarre climax. Frank is prevailed upon to visit the father he dislikes. During the visit frogs begin to rain down from the sky. Earl Partridge's wife takes an overdose while sitting in her car. An ambulance arrives and it looks as if her life will be saved, but on the way to the hospital the vehicle skids on a road full of frogs and crashes. Donnie Smith, after robbing the safe begins to climb down the fire escape. Officer Kurring, his car smothered in frogs, skids to a halt in the same parking lot. Hit by the frogs, Donnie slips and falls. Kurring, rather than arresting Donnie, persuades him to return the money. Through a series of meaningful connections, or synchronicities, a degree of order is restored.

The genesis of the film is of particular interest. The director, Paul Thomas Anderson, is a fan of the singer Aimee Mann who became a close friend during the gestation of the film in 1997. While listening to some of her demos he was struck by the line from her song 'Deathly' in which a

woman, after encountering a man, proposes that they never see each other again. Anderson put these words into the mouth of one of the characters, Claudia. In the liner notes for the album of music from the film, Anderson writes that Claudia was the heart of *Magnolia* with the other characters branching out from her. Claudia's father, for example, hosts the 'What Do Kids Know?' TV show which, in turn, connects him to the dying Earl, the show's producer, and his family. Likewise the policeman, Kurring, who later helps Donnie return the money, is called to Claudia's apartment because of a disturbance and later goes out on a date with her. At the very end of the film Claudia looks into the camera, at us the audience, and smiles.

Mann's song 'One,' for example, is also used to establish the characters that appear in the film and shows how each one suffers from a form of isolation that will be disrupted through a series of encounters towards the end of the film. Likewise the song 'Wise Up' is a form of anticipation of these encounters as each character, still in isolation, joins in the song. The other form of highly significant linkage is John Brion's music that runs through the film and at times almost drowns out the characters' dialogue. Indeed, Anderson has written that *Magnolia* is not about a series of stories but just one story.

A synchronicity is something that lies beyond a trivial coincidence to reveal an underlying meaningful pattern—in the case of *Magnolia* the meaningful intersection of the life paths of the various characters. This notion of patterns within a series of relationships and meetings is characteristic of other films, such as Paul Haggis' *Crash* of 2004 in which characters interact through coincidental encounters or collisions: a detective with a younger brother who is a thief; a district attorney and his wife, a racist cop; two car thieves; a film director and his wife who come into conflict with the cop; a locksmith; a shopkeeper with a gun to protect himself. All interact over a two day period.

Mike Nichols' *Closer* (2004) concerns the overlapping relationship between two couples one of which meet through a chance encounter. There is a street scene in which Dan Woolf and a woman we come to know as Alice Ayers approach a crossing from opposite directions. They have never met before, and Alice, not yet adjusted to the fact that the British drive on the left, looks the wrong way and is hit by a taxi. Dan takes her to the hospital, and then they walk in a park that contains memorial slabs in a wall. At the end of the film Alice returns to the United States and we see the name Jane Rachel Jones on her passport. Dan returns to the park he visited at the start of the film and sees the name Alice Ayres on one of the memorial slabs. The film ends with Alice/Jane back in New York crossing a busy intersection against the 'Don't Walk' sign.

The projectionist and projection

As we shall see later in this book, many directors love the world of cinema to the point where they introduce the theme of cinema into their work. In several of Woody Allen's films, for example, the main characters go to the cinema. He pulls Marshall McLuhan from behind a poster in *Annie Hall* (1977); as a child in *Radio Days* (1987) he goes with his aunt to see a movie at Radio City; he takes his girlfriend to see Max Ophüls' *The Sorrow and the Pity* (1971). In *Hannah and her Sisters*, the protagonist is reeling from the trauma of believing he has a brain tumor and then discovers it was an error of diagnosis. His world is turned upside down until he happens to watch a Marx Brother's movie and begins to laugh.

Stardust Memories (1980) features a film festival which, as we shall see when we treat Woody Allen in greater depth, is also a homage to Fellini. But most of all, cinema features in *The Purple Rose of Cairo* (1985). Cecilia is a rather drab and unhappy housewife, someone who gets little support from her husband and spends her afternoons at the cinema, 'dreaming in the dark.' Then one fateful day the screen hero, Tom Baxter, actually leaves the film and enters the theater. Cecilia and Tom begin a romantic encounter together, wandering the city and even entering a nightclub, at which point Tom discovers that his film money is not accepted in the real world of flesh and blood. Tom's excursion into the world of reality causes concern to the other characters in the film who are not at all clear what they are to do next, and to the film company whose main character has walked out of a film that is being shown in cinemas all over the country.

Allen has created a film which explores, in a humorous way, what is in essence a philosophical problem about reality and illusion. In fact he was not the first to do so, for in 1924 Buster Keaton directed and starred in *Sherlock Jr.* in which he plays a cinema projectionist who dreams of becoming a detective. Buster arrives at the cinema worried about the way a rival called the Sheik has caused a rift between himself and his girlfriend. He runs the first reel of film and begins to doze. As the film progresses he begins to separate from his sleeping self and starts to watch the film. The two main characters in the film now turn into his girl and the Sheik. Buster is incensed and walks down the cinema aisle and jumps into the screen, from which he is abruptly thrown out again. When the Sheik exits through a door, Buster jumps into the screen again. Then follows a bizarre sequence in which he finds himself in a garden, falls and finds himself on a busy street, on a mountainside, in a cage of lions, on a rock in a desert, then the rock is suddenly in the middle of the sea and when he jumps off it, he is in snow and then back in the garden again. It is as if, once in the screen, he is

entering a wide variety of different films that exist in this projected space. Finally the scene shifts to the Sheik and the girl. The owner of the house finds that pearls have been stolen from his safe—of course the culprit is the Sheik—but the owner says no one is to worry for he has called in the world's greatest detective, Sherlock Jr. Now the dreaming Buster enters the film as an actual character.

In the scenes that follow, Buster, as Sherlock Jr., exhibits a considerable degree of physical skill and coordination as he moves through a wide variety of stunts in his attempts to track down the thief, the high point of which is a chase scene in which Buster is sitting on the handlebars of a motorcycle not realizing that the driver has already fallen off. At last Buster gets the girl and the pearls and they drive off together. When his car crashes into a lake the two begin to swim for the shore.

Finally we cut to sleeping Buster sitting beside the projector and making swimming motions until he falls off his chair. He looks at the screen and sees that everything is restored. The Sheik has been replaced by the hero, and the heroine has her pearls. Buster looks sad and dejected until his girl arrives at the cinema to say that she really loves him. He glances back at the screen and sees the hero about to take the girl's hands, Buster imitates the gesture and then looks for more cues, kissing her hands, putting a ring on her finger, and even giving her a peck on the mouth. The cinema screen fades to the couple with the husband holding two babies. At this point Buster scratches his head!!

Psychological projection

Now let's go one level deeper with Keaton's notion. A projectionist is a person who, in a darkened cinema, projects images onto a previously blank screen. But *projection* is also a term used in Freudian psychology. For Freud, projection is a defense mechanism whereby something undesirable in oneself is projected outward onto another person.

It is a defense mechanism because the conscious ego does not want to acknowledge an undesirable aspect within itself. But it becomes perfectly acceptable to project the trait onto a spouse or a friend and then condemn them for behavior or attitudes one finds unacceptable. When this occurs in a therapeutic setting, it may involve what is known as transference whereby a patient may project feelings he/she had for a significant other onto the

therapist. This could lead the patient to believe that, for example, they are in love with the therapist or to have strong feelings of anger.

A related concept is that of the shadow which can equally apply to an individual, an organization or even a nation. The shadow is that part of oneself that one attempts to deny, and it is a maxim amongst therapists that 'the brighter the light, the darker the shadow.' Because we do not wish to acknowledge the negative side of ourselves, we tend to project it onto other individuals or even groups of people. As a piece of pop psychology, it suggests that whenever we are angered or strongly repelled by another person it may be because they are displaying part of our shadow. Take, for example, the next-door neighbor in *American Beauty* (1999). He is an ex-military type who is repelled by the very notion of gays. He becomes increasingly disturbed when he notices his son spending time next door and believes that there is some sort of homosexual attraction going on with the neighbor, Leslie Burnham. In the end he goes over to the house, not to confront Leslie but to kiss him. When he is rejected he goes back for his gun and shoots Leslie in the back of the head.

THE DARK KNIGHT

 A particularly interesting aspect of the shadow features in Christopher Nolan's Batman film *The Dark Knight* (2008). Harvey Dent is the new, incorruptible district attorney whose vigorous pursuit of criminals has cleaned up Gotham City to the point where Batman considers he can now retire and settle down to a normal life as Bruce Wayne. However, a trickster figure, the Joker, is now on the loose, causing mayhem just for the fun of it. Naturally his major targets are Batman and Dent. At one point the Joker kidnaps Dent and Rachel Dawes, the woman both Dent and Batman love, and conceals them in two separate locations with charges that are timed to explode. He informs Batman of the two locations and tells him that he will only have time to save one. Seeking to free Rachel, Batman realizes that he has been fooled when he arrives at the address of Dent's abduction just in time to drag him away from the explosion. Rachel dies in her explosion and Dent is badly burned.

Consumed with rage at Rachel's death, and at Batman's inability to save her, Dent begins to embody his own shadow by turning into a ruthless vigilante. Because of his burns, one side of his face is normal the other is dark black. Thus Dent's face itself, like his character, personifies both the light and the shadow.

DEAD POETS SOCIETY

Another example of the light and the shadow is provided by Peter Weir's *Dead Poets Society* (1989). John Keating, a teacher in an exclusive boys' school, seeks to inspire his students with the love of poetry. In one key scene he attempts to break through the boys' natural reserve and encourage them to make spontaneous poetic utterances. A picture of Walt Whitman hangs in the classroom and the teacher finally urges one boy to come out with a striking phrase about the 'snaggle-toothed' poet. He also encourages the boys to 'seize the day'—*carpe diem*.

The boys are engaged by the enthusiasm of their teacher and learn that, when he was a student, he was a member of a secret society, the Dead Poets Society that used to meet in a cave at night. The boys decide to revive the society, but they are not so high-minded as the boys of Mr. Keatings' youth and begin to drink, smoke and bring girls to the cave. One boy, Neil Perry, has become particularly influenced by Keating and even decides to audition for a part in *A Midsummer Night's Dream*. But Perry's father intends his son to obtain good grades and become a doctor. Keating suggests that the boy tell his father how he really feels. Mr. Perry's response is to withdraw his son from the school and send him to a military academy. That night Neil commits suicide.

On the following day an investigation begins into Keating's relationship with the boys and the nature of the Dead Poets Society. Finally Keating is held responsible for the boy's death and dismissed. The headmaster takes over the English class and finds that the boys have studied poetry in depth but 'skipped over realism.' What is more, Keating had torn the Introduction from their class book in an effort to have them think independently. The Introduction had suggested that individual poems could be rated on a scale and given a number. And so Keating's light burned bright, but in the shadow was a boy's suicide.

A related story, which would make a great film, can be found in Donna Tart's novel *The Secret History* (1992). Here a university professor inspires his students with the world of the ancient Greeks. In this case the shadow emerges when the students become intoxicated with the story of Dionysus, the god of excess, and indulge in a ritual killing of one of their classmates. In a sense the film *Dead Poets Society* and the novel *The Secret History* both stand as warnings that, in becoming overwhelmed with the light, we may forget the existence of the complementary darkness.

Just like the cinema projectionist, so too an individual may be projecting all sorts of ideas and emotions onto what is otherwise the blank screen of 'the other.' And if this can go on in day-to-day relationships, it

must also be happening in the cinema. For a couple of hours one sits in a darkened room, or in front of a television screen, and moves in and out of the film, sometimes identifying with the protagonist, maybe feeling a strong erotic desire for one of the characters, or feeling intense dislike. And naturally scriptwriters, directors and actors know all about this. They can make use of strong archetypal figures in creating their characters. They can also place their characters in archetypal situations—the chase, great danger, a heady romance—all of which enhances the viewer's own act of projection.

HOUSE ON HAUNTED HILL and THE BLAIR WITCH PROJECT

 Projection lies at the essence of great horror movies such as *House on Haunted Hill* (1959). There are a host of films which involve ghosts, figures of evil or threatening aliens. We all know that feeling when we hear a sudden noise in a dark room or alleyway and our imagination runs riot at what may lie in wait for us. And so the director pulls out all the stops and creates a world of shadows, dark places and faintly heard sounds. The heroine feels threatened, we see fear on her face. She opens the door of the next room and moves inside. Now we see the room from her point of view, she moves forward into the darkness. A sound. She turns. A sudden close-up of her screaming face, and then we cut to...the ghost, or monster, or alien, or psychopath with a knife. And that is the high point of the film, the scene with the maximum scare value. But it also means that everything is downhill from that point on. We have seen what frightens the woman, there may be a chase, a struggle, the intervention of a heroic male figure, but all in all the dark force is going to be defeated and there is only one possible trick left in the book—the menace is destroyed. The hero embraces the heroine, they kiss; she is safe.

That's not what happened in *House on Haunted Hill* which calls on all our powers of projection. A group of people is offered $10,000 each by the eccentric Fredrick Loren (Vincent Price) if they will spend the night in an isolated old house which has the reputation of being haunted. As the night wears on there is more and more evidence that the haunting is real, and members of the group are now scared out of their wits. As expected there are plenty of shadows and dark corners, yet in the entire film we never see a ghost. The fears are all in the minds and imagination of members of the group, and in this way, by never showing an actual ghost, the audience can identify with the guests. They can project their deepest fears as to what may suddenly leap out of the shadows at them.

The formula was repeated with great commercial success by the low budget, *The Blair Witch Project* (1999). This purported to be a documentary film made by three students who are researching the supposed legend of the Blair Witch. Their search takes them into the woods at night where one by one the students disappear. Again, no actual witch is ever seen and all that remains as evidence is the film that is supposedly discovered in the woods a year later.

Ghosts

Since we have introduced the topic of haunting, why not take a brief look at two other films about ghosts, and in particular the convention of not lying to the audience but allowing them to create the story based on what they are told. This is the essence of M. Night Shyamalan's film *The Sixth Sense* (1999). Bruce Willis plays a child therapist who, near the start of the film, is shot by a patient who feels that the therapist has failed him. He has apparently recovered, for we see him around his house, with his wife, and in his office. Willis now seeks to redeem himself by undertaking therapy with a disturbed boy who, amongst other things, suffers from the delusion that he can see ghosts. The therapy is successful, and Willis gradually guides the boy back to health. It is only at the end of the movie that Willis realizes that he actually is dead and is one of those ghosts that the boy is seeing. This comes as something of a shock to us, the audience, for we are convinced that his wife and others have responded to Willis as if he were truly alive. It is only on seeing the film for a second time we realize that this is an assumption we have constructed for ourselves. The film has never lied to us. No other human being ever sees him or addresses him directly in the film. He is a ghost seen by the boy alone, and yet we have constructed a reality that assumes that Willis is a normal living being.

A related theme can be found in Alejandro Amenábar's *The Others* (2001) in which Nicole Kidman lives in a haunted house. Kidman feels a strong sense of otherness, that something is not at all right about the house, and that in some way it is haunted. It is only at the end of the film, when we witness a séance that we realize that it is Kidman who is the ghost, a being from an earlier time that still haunts the house. Again we have been given all the clues to allow us to create a particular reality yet were never deceived by the director, and on seeing the film a second time our reading totally changes.

The Persona

BEING THERE

 With the help of Hal Ashby's *Being There* (1979), starring Peter Sellers in the role of Chance, we can examine another area of psychology and film—the *persona*. Chance is a gardener who spends his time tending the garden for the elderly Mr. Jennings and wandering around the house watching the many television sets. From time to time he attempts to imitate people on the screen. In particular, when a news item about the President appears, he practices the handshake.

One day while waiting for his breakfast he is told by the maid, Louise, 'The old man is dead.' Chance, unmoved, is more interested in watching television. When prompted to speak, he observes that it may snow and then continues to watch *Sesame Street*. We realize that Chance is simple-minded and incapable of comprehending the events that unfold around him. Indeed, he goes into Mr. Jennings' bedroom, folds down the sheet that is covering the dead man's face, sits on the bed and they proceed to watch television together.

Following the funeral, lawyers for the estate arrive and are surprised to find Chance still occupying the house. They ask him how long he has been there, and he says he can't remember but he has been there since he was a child. They notice his smart suit and he tells them he is allowed to go into the attic to choose his clothes. He also tells them that he has never been out of the house. The estate papers make no mention of a gardener on the staff and, since he has no legal claim to the estate, they inform him that he must leave.

Chance packs and exits by the front door. While we have previously seen the elegance of the interior of the house, the well-cared-for garden and the shining vintage car in the garage, we now realize that this house is located in a derelict part of town, on a street strewn with garbage and discarded furniture, and with huddles of street people. In his elegant attire Chance walks into this new world.

To some depth psychologists a house has a particular significance. The façade and front door are what face the outer world. The exterior is all we know of a house we have never entered. This is taken as a metaphor for the *persona*. The persona was the mask used in Greek theater, and in psychological terms it represents the 'mask' we put on to face the world—it is a mode of behavior, a way of being in the world. The persona may be that of

the 'teacher,' 'doctor,' 'police officer,' 'faithful friend,' 'cynical barman,' and so on. It is a particular way of being we adopt when we leave the house and go out into our community and our work.

Behind that persona lives something richer which does not always show itself to the outer world; this is represented by the interior of the house that lies behind the front door. This is a person's inner world of dreams, fears and aspirations. If we wish to continue with the metaphor we could include the attic at the top of the house, which could represent the super-ego, the place from which Chance takes Mr. Jennings clothes that 'fit him perfectly.' There are the store rooms in the basement or cellar in which things are hidden away—the personal unconscious. Finally we come to the garden which is protected by a wall and is full of fruitfulness. It is brimming with life and is the source of *anima* which is both the soul and the living spirit in all things. This is the area that Chance cultivates in his daily work. It is the area of the collective unconscious that holds the archetypal forces of humanity.

(Another interesting resonance with the notion of the house as a representation of the self and the persona is Peter Greenaway's *The Cook, the Thief, His Wife and Her Lover* (1989) in which the restaurant serves as a metaphor for the body. We will meet this in the section on Greenaway.)

Chance has lived both in the garden and the house, but has never had need of a persona because he never went outdoors to face the outer world. In other words he is a blank screen upon which anything can be projected. Nothing will be rejected by him, nothing distorted. Without a persona he becomes exactly what another person is looking for, what they desire. Yet even if Chance is an essential blankness, he is also the one who is in direct contact with the garden—the deepest symbolic forces within each one of us. Chance is both vacant and filled, so we should not be too surprised when, at the end of the film, he wanders to the lake and walks on water.

And so Chance, the man without a persona, enters the world dressed in smart clothes, hat and rolled umbrella. At one point he passes a store with a large television screen and a camera that is showing images of the street. Chance sees himself on the screen and, deeply bewildered, steps back into the road where he is hit by a limousine. The owner, Eve Rand, offers to take him home where medical staff are looking after her sick husband. She asks his name and, during a fit of coughing, he says that he is Chance the gardener which she takes to be Chauncey Gardiner. This vacant character no longer even possesses his own name.

People begin to project onto him. When the doctor asks if he will make a claim against the Rands, Chance says he doesn't know what a claim looks like. So, for the doctor, he is a man with a great sense of humor. For Eve

Rand he is intense. For her husband, Benjamin Rand, he is an astute busi-nessman. When Chance says that his house has been shut down, Ben Rand understands this to mean that his corporation has been shut down by law-yers. When they ask him to stay, Chance says he would like to work in the garden. Eve sees this as a healing process after the trauma of 'the old man' dying and of Louise leaving. Ben sees gardening as a metaphor of the good businessman who makes something flower in flinty soil.

When we first see Ben he is in a glass-encased room so that additional oxygen can be pumped into the atmosphere, and he has requested 'fresh blood.' Ben suffers from aplastic anemia which, he points out, is a young man's disease, yet he is old. His personal doctor and his nurses are doing everything possible to keep him alive. But when Chance says that all that remains for him is 'the room upstairs' (Chance means the guest room he has been given), Ben thinks he refers to death and is contemplating suicide. But Chance points out that it is a beautiful room and we see how, as the film progresses, Ben comes to accept death because of the presence of Chance.

The President visits Rand for advice on an important speech he is about to make on the economy. Rand does not see eye to eye with the president and they turn to Chance for advice. Chance says 'as long as the roots are not severed all will be well in the garden,' and then speaks of the succession of the seasons and that new growth will come in the spring. When the Presi-dent next appears on television his major speech is based on the economy as a succession of seasons and he refers to the wisdom of Mr. Gardiner. The *Washington Post* attempts an interview by telephone while Chance is distracted watching television, and therefore takes him for a man who plays his cards close to his chest. He appears on a talk show in the place of the Vice President and continues to speak about the garden.

We see the reaction shots of those watching Chance on television. All are impressed by his remarks except for Louise, the former maid, who says he has rice pudding between his ears. In turn, political advisors are struck by the way he can handle the press and how he skillfully keeps his remarks at 'grade three level.' He is asked to set down his wisdom in a book, but says he can't write. This is taken as a joke; 'Nobody thinks they can write,' but they offer to provide him with secretaries. Chance says that he can't read, to which the reply is 'Of course you can't, no one has the time these days.'

He fills in for the Vice President in meeting the Russian ambassador. When the ambassador speaks of the gap between them, Chance points out that they are very close to the point where their chairs are almost touching. The ambassador is deeply impressed, and Chance soon develops a repu-tation for speaking eight languages and possessing two degrees. Since no

background can be found on him it is clear that an ex-FBI member has destroyed his files. He is obviously someone of the greatest importance.

Eve has clearly become attracted to him, with the encouragement of her husband who now accepts his imminent death. Chance tells Eve that young plants need special care and they do better if someone looks after them. She comes up to him while he is watching a TV program where two people are kissing. He imitates the action of kissing and spinning around with her. But when the scene ends he also stops kissing her. She is distressed, asks him what is wrong, and says that she doesn't know what he likes. He replies that he likes to watch and so, as he remains glued to the television set, she masturbates and afterwards tells him how she feels totally liberated.

Ben summons Chance to his bedside and asks if he will stay and look after Eve. Chance holds his hand and the old man dies. For the first time in the film Chance looks genuinely moved. Only the doctor now senses the truth that Chance really is a gardener.

At Ben's funeral the President gives the oration and the pallbearers, who are men of power, begin to whisper that the President will not be able to win the next election. They must choose someone else. In the end they agree that Chauncey Gardiner is the only chance for the presidency. But Chance himself has wandered away. He comes to a lakeside and clears dead wood from a small bush and straightens it. Then he walks to the water's edge and continues to walk...on water.

Sellers had risen to fame in the UK because of his weekly appearances, along with Spike Milligan and Harry Secombe, in a surreal BBC radio comedy called *The Goon Show* where he played a range of characters. Later he branched into films, playing such roles as Inspector Clouseau in the *Pink Panther* series. Kubrick used him twice, as the rival to Humbert Humbert in *Lolita* (1962), where he also employs a number of different voices, and in *Dr. Strangelove* (1964) where he plays three characters: the scientist Strangelove, the US President, and a British officer attached to a US airbase. In other words, Sellers was noted for playing a wide range of characters, each with their own unique voice (in terms of accent, delivery, etc). Yet anecdotes about his life suggest that he was to some extent a chameleon, or rather a blank slate, a person who only came alive through the characters he played. Jerzy Kosinski's novella on which the movie was based was said to be cherished by Sellers, and he strongly identified with the character Chance. While Chance was a man without a persona, Sellers himself appears to have been no more than an entire series of personas. (Incidentally, Sellers' given names were Richard Henry but the family called him Peter from an early age after his elder stillborn brother.)

PERSONA

 In thinking about the notion of persona, let us turn to a film of that very name, Ingmar Bergman's *Persona* (1966), and ask if there is a sense in which this film has something to do with the inner life of the director and the two personas that are projected onto the screen. Bergman held this film to be one of his most important; in his book *Images*, he writes: 'Today, I feel that in *Persona*—and later in *Cries and Whispers*—I had gone as far as I could go. And that in these two instances when working in total freedom, I touched wordless secrets that only the cinema can discover.' *Persona* is considered one of the major works of the 20th century by essayists and critics. Susan Sontag considered it to be Bergman's masterpiece. *Sight and Sound* (a monthly magazine published by the British Film Institute) conducted a poll in 1972 of the ten greatest films of all time; *Persona* was ranked at number five.

The film begins with camera equipment, the carbon arc light of the projector igniting and then turning off. This is followed by a series of curious images such as the sprockets of an animated film, film coming out of a projector, a lamb being cut open, a spike being driven into a hand, trees in winter, a boy in bed who sits up and stares at the camera then reaches out with his hand. We cut to an over-the-shoulder shot and realize that the boy is reaching out to a woman's face, that of Bibi Andersson who plays the nurse Alma in the film. At the end of the movie we see the boy reaching out again.

Symbols ask for an interpretation but, as with a dream, there can be no single interpretation, no clear answer. The opening and closing shots are about projection and film itself; the boy could well be Bergman reaching out from his past as a child. The opening shots of the sacrificial lamb and the pierced hand remind us that God's presence in the world is never far from Bergman whose own father was a pastor, just as was Carl Jung's. In this sense there is God as the symbolic father and the biological father as God's representative—yet as Freud well noted, there is always a degree of ambivalence on the part of a son towards this father.

The film concerns the actress Elisabet Vogler, played by Liv Ullmann, who suddenly stops speaking while on stage in the role of Electra (in the play Electra sends her brother away to avoid him being killed; when he returns, the pair kill their mother and her lover). Elisabet will not talk to her husband or her young son. She is sent to a psychiatric hospital where the doctor believes that a sympathetic young nurse, Alma, may be able to persuade her to speak and suggests that they spend time in Alma's house by the sea. (There is perhaps significance in the names of the two characters, Alma relating to 'soul' and Vogler to 'flight.')

Alma becomes very attracted to Elisabet and relates her life story while Elisabet listens with great attention. She tells of an orgy and of an abortion. The only time Elisabet has spoken up to this point is to suggest Alma should go to bed or she'll fall asleep at the table.

Elisabet writes a letter and places it in an unsealed envelope for Alma to mail. When Alma opens the letter and reads it she is shocked to see that it is about her and that her sexual experiences are being related. It is almost as if Elisabet is 'studying' Alma as a possible character she may play in the future. This is a turning point in the film. Elisabet becomes angry to the point where Alma threatens her with a pan of boiling water, at which point Elisabet speaks again 'No, don't!'—this completes a total of fourteen words she speaks in the entire film. As the film progresses we note the great physical resemblance between the two to the point where, in the final scenes, the two faces merge together. Alma packs her things and leaves the cottage alone as the camera turns away from the women to show the crew and director filming the scene.

Naturally a film that is so enigmatic attracts a great deal of attention on the part of critics and interpreters. Has Elisabet experienced a serious breakdown, or is she a highly narcissistic figure who is indifferent to the feelings of others and who leaves a string of broken relationships behind her—including her present behavior towards Alma? Is she perhaps a psychological vampire who simply draws what she requires from the figures around her? Is her withdrawal into silence deeply symbolic, or just another role that she is playing—a particular persona? Likewise we can ask at what point do we leave a totally objective view of reality and enter into the subjective. And if it is subjective, then for whom—for Alma, Elisabet or for us, the audience?

Elisabet's husband visits the cottage and speaks to Alma as if she were his wife, and even has sex with her while Elisabet watches. So are there two different characters or just two aspects, two personas, of the one person—one persona the silent observer, the other the extravert? Or are they aspects of Bergman's own anima? And if Elisabet has a child, then what of the actress who plays her—Liv Ullmann—who had a son by Bergman?

Catharsis

This book is about enjoying movies, revisiting favorite films, discovering new films we may like to see, and noticing the way films connect to all areas of life and culture. While this invokes ideas from science, psychology and philosophy it is not meant to be a heavy textbook or something to study; it's a book to pick up and enjoy. On the other hand, there are other sorts of film books intended for courses that bring all the force of postmodernist 'theory' to the area of popular culture such as film and television. And some of them are pretty hard on directors such as Francis Ford Coppola when he remade *Cape Fear* (1991) because of what they see as his sadomasochistic attitude and the way it portrays women as being complicit with the sexual predator. And it is certainly true that we do like to watch violence in the movies; we like to be frightened and shocked. So does that make us all sadomasochists?

Let's go back and see what an earlier culture had to say about this. Let us return to the very birth of it all, to the origin of theater which, in the case of Europe, begins with Greek mystery religions. Greek theater itself took two paths—one into the area of comedy, a device in which rules are bent, sexual identity is fluid, authority is mocked and events often end up in marriage. By contrast tragedy involves a significant character, such as a king or queen, who battles against the fates and is in the end destroyed. One of the most famous of the tragedies is *Oedipus Rex* in which the central figure, after solving the riddle of the Sphinx, is set on a course which leads him to murder his father and marry his mother. On discovering what he has done, Oedipus plucks out his eyes. For Sophocles this action of self-blinding occurs off-stage. But in Shakespeare's *King Lear* the blinding of Gloucester occurs on-stage. This powerful image of blinding continues to resonate. As we shall see later, the father in Robert Lepage's *The Confessional*, after confronting the terrible thing he has done, blinds himself by refusing to care for his diabetes. In Woody Allen's *Crimes and Misdemeanors* the murderer is an ophthalmologist who, as a child, was told that the eye of God was always on him. In turn the symbolic figure of his conscience, a rabbi, goes blind.

So if we sit in the open air of a Greek theater to hear about blindings, or watch them in the darkness of the cinema, are we playing out our masochistic feelings? And in turn, are directors indulging in their unresolved hostile feelings towards women when they have them pursued along dark corridors by axe murderers? What did the Greeks think about men who murdered their fathers, or women who killed their mothers? The answer was that it was seen as an act of healing that involved an emotional and

spiritual purging. Aristotle, in his *Poetics,* advances the theory of *catharsis* which, in turn, derives from the medical practice of purging a person in order to purify the body. In watching the drama, a person experiences both terror at the actions and pity for those who are destroyed. In the process the audience is purged of these emotions. In other words, from within the safe container of the theater painful emotions are experienced and projected outward onto the personas that the actors present. In this way the audience is able to envision a wider and deeper view of life.

Aristotle's notion of catharsis was important. Others took a simpler position that these were warnings of the dire consequences involved in carrying out certain actions. With Freud, catharsis became understood as the relief of tensions and anxieties that occur when repressed material is released from the unconscious. So film can act as a healing process as we project ourselves onto those fleeting figures on the screen.

The Other

We have met the notion of 'the shadow,' that aspect of our personality we deny by projecting it onto others. Thus a person or a group we dislike intensely, or the character trait we deplore in others, may in fact be an aspect of ourselves. In this way 'the other' can become dehumanized and seen without depth as a crudely drawn character—yet another example of the ways in which our 'reality' can be constructed.

During the Nazi rule *Der Stürmer,* the weekly newspaper edited by Julius Streicher, featured crude anti-Semitic cartoons, often of Jewish capitalists with exaggerated facial features. By dehumanizing a particular racial group it became easier to accept the 'final solution' to the 'Jewish question.' But suppose we turn this around by 180 degrees and examine what, on the surface, is no more than yet another Hollywood suspense movie, Robert Aldrich's *The Dirty Dozen,* (1967) which is described in Martin and Porter's DVD and Video Guide as '...terrific entertainment—funny, star studded, suspenseful and even touching.' Lee Marvin plays a US Army Major who is put in charge of what amounts to a suicide mission to wipe out a German headquarters in occupied France. Since it is unlikely that anyone will return from the mission, Marvin selects his team from a group of hardened soldiers who are awaiting execution on death row and trains them into an efficient fighting team.

Finally the group arrives at the chateau where German officers are having a dinner dance with their wives and children. Under attack the Germans seal themselves in an underground bunker which represents an ideal opportunity for the Dirty Dozen who pour cans of gasoline down the ventilation shaft which they then ignite with hand grenades.

I assume that this must be the moment that Martin and Porter describe as 'touching' when men, women and children are burned alive. Of course, by turning all Germans into 'Nazis,' they simply become the dehumanized 'other'—they are no more than a vehicle to further the plot. In fact, when people are treated as 'the other' to the point of being totally dehumanized, their role is diminished to nothing more than Hitchcock's MacGuffin—a device to further the plot but whose inner meaning is unimportant. Likewise the actual human nature of the men, women and children who are burned to death is irrelevant.

Ironically we return to a similar theme in Quentin Tarantino's *Inglourious Basterds* (2009) in which a group of Jewish-American soldiers form a hit squad dedicated to wreaking terror amongst the Nazis by scalping and torturing. Some of the 'Basterds' end up in a cinema in Paris where, unbeknownst to them, during a special gala showing to members of the high command and their wives, the Jewish owner has decided to seal the doors and burn the cinema to the ground. The underlying story was inspired by an Italian film, Enzo Castellari's *Quel maledetto treno blindato* (1978) released in the US in the same year with the title *The Inglorious Bastards*.

In the context of suicide missions into occupied France, I remember talking to a scientist who had been tasked with visiting a German post in France in order to discover just how advanced the enemy were in developing radar. He was accompanied by commandos who he assumed had been assigned to protect him. It was only after the mission was accomplished that they told him that their role was to shoot him if he was in danger of being captured because his knowledge about radar was too valuable to fall into German hands.

Of course, another group that were taken as 'the other' were the First Nations of North America who were portrayed sitting on horseback with bows and arrows, engaging in an ongoing game of warfare with cowboys or the military. In what was pure escapism, one in which the 'paleface' always won, there was little chance of seeing the representatives of the First Nations as rounded humans. And then there was the Lone Ranger and his 'faithful Indian friend,' Tonto—faithful being a term one could equally use to describe a pet dog.

But attitudes change, and 1970 saw the release of Arthur Penn's *Little Big Man*, based on Thomas Berger's novel, in which Dustin Hoffman played

the 121-year-old Jack Crabb, sole survivor of General Custer's defeat at Little Big Horn. Crabb, a white man, had been brought up by a Native American tribe, and we see sympathetic portrayals of life amongst the Plains Indians, in particular their Chief, played by Dan George who in real life was a chief of the Salish People of British Columbia. Exactly twenty years later came *Dances with Wolves* (1990), directed by and starring Kevin Costner. Following the American Civil War Dunbar, a cavalry officer, is assigned to a remote outpost where he befriends a wolf and becomes fascinated by the life of the Lakota people and their love of the land. In the end Dunbar throws in his lot with the Lakota and turns his back on the cavalry. The film was well received and probably went some way to sensitizing people to the culture that had existed in the North American continent long before the first Europeans arrived.

Nine years later, in 1999 Richard Attenborough's *Grey Owl* was released. The film was about one of Canada's first conservationists who, as an Ojibwaj chief, became a great hero when he toured Canadian schools to teach children about the traditional ways of the First Nations and their love of the land. (I can remember meeting older Canadians who had been deeply impressed by Grey Owl's presence.) Grey Owl wrote a number of books that promoted conservation, and even visited England where, dressed in his Ojibwaj clothes, he met King George VI and Princesses Elizabeth and Margaret.

Grey Owl died in 1938, and only after his death did his true story come to light. He had been born in Hastings, England, in 1888 as Archibald Stansfeld Belaney, and lived in England until the age of 18 when he immigrated to Toronto. From Toronto he moved to Northern Ontario where he took on the name of Wa-sha-quon-asin (Grey Owl) and, for the rest of his life, he assumed Ojibwaj identity.

Grey Owl's story also exposes a certain complex ambivalence that a city dweller may have towards indigenous peoples in various parts of the world. On the one hand there is the myth of the 'noble savage.' This is the notion that first 'civilization,' and more recently consumerism, have had a corrupting effect on cultures and individuals, while people who have lived for generations in traditional ways are somehow 'closer to the land' and their lives more authentic. On the other hand, there may also be a sense of guilt that the first Europeans who settled North America wiped out ancient cultures, originally through the spread of disease that may have eliminated up to 90 percent of the indigenous population. In addition there was the appropriation of land, massacre of the buffalo, and forced marches to reservations such as that experienced by the Cherokee people, as well as compulsory residential schools where children were forbidden to speak their native languages or use their traditional prayers. Add to this the ready availability

of alcohol and drugs, and Native American cultures were placed under great stress.

And so the result is that it is difficult not to romanticize life in a traditional culture. Take, for example, soapstone carving. The carving of small objects was a tradition amongst Inuit peoples, and today people will pay a good price to have a highly stylized sculpture or print of an animal, bird or fish in their home, or a piece of Inuit jewelry. For the collector it makes a connection to an ancient people and another way of life. But in another sense this is something of an artificial connection because it is the product of a market-driven industry, one that began at the end of the 1940s when the Canadian government and others realized that people like to buy such art. And so Inuit groups were encouraged to turn out prints—not part of their tradition—as well as a variety of soapstone figures.

And what of the other inhabitants of North America, those whose ancestors had arrived in slave ships? During the 30s, 40s and 50s they could be seen in the kitchen, waiting on tables or carrying bags at the train station. Blacks in movies were always in the position of loyal servants. Even when the great Billie Holiday appeared in Arthur Lubin's *New Orleans* (1947), she acted the role of a maid who gets to sing with Louis Armstrong and his band. Acting tended to be stereotyped with a great deal of eye-rolling, comic behavior, and all white men being addressed as 'Sir.' By the 1960s Eldridge Cleaver was denouncing Armstrong as an 'Uncle Tom,' and also turned his criticism to people such as Joe Louis, Harry Belafonte and Lena Horne.

The singer Paul Robeson had played in Dudley Murphy's *The Emperor Jones* (1933), but so disliked the patronizing attitude of Hollywood films towards black people that he decided to go to England instead and appeared in Zoltan Korda's *Saunders of the River* (1935). When he saw the way Africans were portrayed in the film he attempted to stop its release and walked out of the premier. He did go on to make other films but insisted on approval of the final edit.

Racism is also the theme of Joshua Logan's musical *South Pacific* (1958). The main plot-line concerns a nurse on a US Navy base who falls deeply in love with a Frenchman who has settled on the island as a planter. After several romantic encounters, he introduces her to two small native children. The nurse asks after their mother and is told that she died; she had been the Frenchman's wife. The nurse turns away in horror and later asks to be transferred to another base. Despite the love she felt for the Frenchman, she could not accept the notion of marriage between a white man and a native woman.

In a parallel subplot, a lieutenant falls in love with a young native girl. Everything seems fine until the girl's mother refers to the children they will have. At this the lieutenant turns away and says he cannot marry her. Later he makes an impassioned speech that the feelings he has are not natural, but the product of a society which he now rejects.

As for the ending, the lieutenant is killed while on a mission with the Frenchman, and thus the North American audience does not have to face the possibility of a mixed marriage. The nurse does declare her love for the Frenchman, but this will involve a totally acceptable marriage between an American and a European!

Audiences had to wait almost ten years before the possibility of a mixed marriage could be faced on the cinema screen. In Stanley Kramer's *Guess Who's Coming to Dinner* (1967), Katharine Hepburn and Spencer Tracy are the liberal parents of a daughter who brings a black man home to dinner—the man she plans to marry. In fact it is a rather patronizing film in which the suitor, played by Sidney Poitier, is made more acceptable by being a handsome, articulate, well-educated professional. What is more the engaged couple are never seen to physically touch. (Until June 12 of the year of the film's release, interracial marriage was still illegal in 17 Southern American states when it was legalized by the Supreme Court.)

In the same year Poitier portrayed a detective investigating a murder in a racist southern town in *In the Heat of the Night*. At one point when Poitier is questioning a rich citizen, the man hits him on the cheek. The script called for Poitier to turn and walk away, but the star insisted on a change so that he could hit back before exiting!

Today the attitudes of *Guess Who's Coming to Dinner* look particularly dated. There are several reasons for this. One is that black audiences form a significant percentage of cinema-goers, as well as renters or purchasers of movies on DVD. Another is that, for many young people, it is cool to be black. Finally, rather than white directors making movies about black culture, there are talented black directors such as Spike Lee, (*Mo' Better Blues* (1990), *Malcolm X* (1992), etc.) whose films examine race relations, urban crime, poverty and other political issues. In 2009 the movie *Precious* was nominated in six categories at the Academy Awards including Best Film and Best Director, (Lee Daniels). It won Best Writing and Mo'Nique won Best Supporting Actress. Today other noted black actors include Halle Berry, Thandie Newton, Denzel Washington, James Foxx, Will Smith, and Laurence Fishburne.

An interesting twist to the notion of 'the other' occurs in David Lynch's *The Elephant Man* (1980), based on the true story of John Merrick who was born with a badly disfigured body and exhibited in a Victorian freak

show. There he is seen by a doctor, Frederick Treves, who wishes to study him in order to present a paper to the Pathological Society. To Treves, Merrick remains no more than a curiosity, an object for scientific research at his hospital, until he overhears Merrick reciting from the *Book of Common Prayer* and realizes behind the distorted exterior lies a sensitive and intelligent man. Now Merrick ceases to be viewed as 'the other' and becomes someone Treves can relate to at a truly human level.

As noted earlier when it comes to film Philip K. Dick is never far away, and so we have Ridley Scott's *Blade Runner,* the 1982 version of Dick's *Do Androids Dream of Electric Sheep.* The film is set in a cyberpunk future where robots, which are called replicants and built by the Tyrell Corporation, have become almost human but are programmed to have a short life span. Following a replicant revolt on an off-world colony, they have been banned on Earth but a group have hijacked a space craft and come to Earth. Rick Deckard, a Blade Runner of the LAPD, is charged with locating and terminating these replicants. While visiting the Tyrell Corporation, Deckard meets Rachael, a beautiful young woman. He falls in love with her but then realizes that she is not human and that her memories of her past have been programmed into her. Rachael is a highly sophisticated replicant.

At the end of the film Deckard and Rachael leave the city and drive off into the landscape. Deckard can no longer see Rachael as 'the other,' even though her life has been programmed for only a short duration.

Today we also face the issue of political correctness which makes it unacceptable to characterize certain racial groups. Of course all this can be subverted in comedy. Jim Jarmusch's *Ghost Dog: The Code of the Samurai* (1999) features Forest Whitaker, a black hit man, who attempts to follow the ancient Japanese code of the Samurai. When the daughter of the local Mafia boss witnesses one of his executions the hit man becomes expendable. At a meeting the local Mafia boss asks for the name of the person involved. When told it is Ghost Dog he finds such a name hard to believe until he is reminded that rappers also give themselves curious names such as Snoop Dogg, Ice Cube and Q-Tip. These sound to the Mafia boss like 'Indians' who also call themselves by such strange names such as Red Cloud, Sitting Bull, Crazy Horse, Running Bear and Black Elk. After agreeing that 'niggers and Indians' are all the same, his lieutenant is ordered to bring in his assistants Sammy the Snake, Joe Rags and Big Angie!

And just when we assumed that the treatment of 'the other' had somewhat matured in cinema, the cat was set amongst the pigeons with the release of James Cameron's *Avatar* (2009) a film that generated considerable controversy, not only amongst film reviewers but also on a variety of blogs and websites. The term *avatar* is widely used in computer games to refer to

the alter-ego or visual representation of a player, and in turn is derived from the Hindu notion of the various earthly manifestations of a god.

Cameron's film concerns the fate of the planet Pandora and its indigenous population of blue humanoid creatures called Na'vi. The main protagonist in the film, a paraplegic Marine called Jake Sull back on Earth, is able to live on Pandora as an able-bodied avatar identity. There he learns of a 'corporation' whose aim is to exterminate the native population and mine the planet for its valuable materials. In turn Sully begins to bond with the indigenous peoples, falls in love with Neytiri,, and ends up fighting on the side of the Na'vi.

And so the controversy begins as people use the film as a blank screen on which to project their various beliefs, aspirations and prejudices. On the one hand the film is interpreted as being about the human desire to endlessly exploit the earth without any thought for the long-term consequences. On the other it is about the history of colonization and the exploitation of indigenous populations—to some, specifically the occupation of the Americas by Europeans, their treatment of native populations and the ravishing of the land. Yet to others it is a film made by a white man as an expression of white guilt, or about how 'white people' romanticize the first inhabitants of North America. Or is it an anti-war film and a comment on the military-industrial complex? Finally, and inevitably, the connection has been made between *Avatar* and *Dances with Wolves* (1990) in which, as we have seen, John Dunbar decides to fight on the side of the Lakota people.

In an article in the *New York Review of Books* (March 25-April 7, 2010), 'The Wizard,' Daniel Mendelsohn reminds us that James Cameron's favorite film is Victor Fleming's *The Wizard of Oz* (1939), a film about Dorothy's magical journey from the black and white world of her Kansas farm to the Technicolor land of Oz, and her eventual return because 'there is no place like home.' Here Mendelsohn notes that the disabled marine Sully does not return home at the end of the film but lives on in Pandora as his avatar. In Dorothy's case, however, the companions on her journey, the lion, scarecrow and tin man, are all avatars of the farm workers back home.

Mendelsohn's essay also refers to the story of Pocahontas, which he terms an 'ecofable,' but here the argument becomes more subtle. The popular story of the 'Indian princess,' the one that underpins such versions as the 1995 Disney movie *Pocahontas*, is of a white man, Captain Smith, who is about to be killed by members of the Pamunkey tribe. Pocahontas pleads for his life and the two marry. Again it is a romanticized version of a white man finding love with a 'native woman.' But what is the story behind this story? It is of the encounter of two profoundly different worldviews, and the version that most of us knew, until recently that is, was the one told by Smith himself.

Smith came from a culture that believed that human society had been created via a social contract in which individuals sacrificed some of their innate freedoms in order to bond together for mutual protection. The Pamunkey people, as with many other Native American groups, believed by contrast that the individual emerges out of the web of relationships within the group. The issue they face is how to integrate a stranger into the complexities of their tribe. Their solution was a symbolic death, rebirth and marriage so that Smith could become part of the complex web of relationships that is the Pamunkey tribe and its wider relationship to the land. It is so much an 'ecofable' as a deep reflection on the nature of society. (A fine analysis of the underlying story can be found in Paula Gunn Allen's *Pocahontas: Medicine Woman, Spy, Entrepreneur, Diplomat*, Harper, 2004.)

Aliens

The notion of alien civilizations gained a considerable boost when, at the end of the nineteenth century, the astronomer Percival Lowell, after studying Mars from his observatory at Flagstaff, Arizona, claimed that he had observed canals on the planet as evidence of an ancient civilization. In turn this inspired H.G. Wells to write *War of the Worlds* (1898), which was filmed by Bryon Jaskin in 1983 and again by Steven Spielberg in 2005. In Wells' book the apparently indestructible Martians die as a result of their lack of immunity to human diseases. An interesting variant on this theme can be seen in Ronald Emmerich's *Independence Day* (1996) in which the alien invaders are impervious even to nuclear weapons. Their weak link, this time, lies not in physical sickness, but a computer virus that is inserted into their communication system.

A sub theme to the film is that the character David Levinson who figures out how to defeat the aliens also has an obsession that the Earth, in the long-term, is being destroyed not by aliens but by humans who are indifferent to the pollution and environmental damage they are causing.

Frightening beings from outer space are certainly a staple of the comic book style of science fiction, but here I'd like to turn to something more paradoxical and subtle. When we think of aliens in more recent popular culture, and with the exception of *Independence Day*, it is not so much of creatures of mass destruction but the delicate figure of Spielberg's *E.T. The Extra-Terrestrial* (1982), a being that meant no harm to humans and was befriended and cared for by a young boy. But is this film really about aliens,

about beings from outer space, or more Spielberg's own reflections on the innocence of childhood and the complicity of adults? For it is the adults who are the frightening and menacing figures in the film, as reinforced by the various camera angles from which we see them, and it is the young boy and his friends who must escape the clutches of the adults in order to save the wounded alien.

Which brings me to a particular point about aliens: when we think of all the possible ways they could be treated in film and in fiction, we recognize that over the last decades they have undergone a transformation from a menacing Other to something more benevolent and, what is more, they hint at a particular longing for a spiritual element. We never see any aliens in Kubrick's *2001*, only their particular device of the monolith—located first on Earth, then on the Moon, then floating in space, and finally as the catalyst or doorway to the Star Child. It is as if the aliens, whoever they are, represent a highly advanced civilization that has been watching over the human race for tens of thousands of years and is now ready to guide them into a new life form, one that will take its place amongst others in the galaxy. It suggests that the entire galaxy is our essential home and this Earth is no more than a nursery. In this sense the films discussed in this section represent a reversal of the Eden story. Humanity was expelled from the Garden of Eden and cherubim were placed at the entrance. But in the modern mythology of the cinema, the human race yearns to re-enter this ideal place and so the cherubim are now transformed into beings that open the way to a new phase of the human race. This was indeed the theme of the Arthur C. Clarke's short stories 'The Sentinel' and 'Childhood's End' out of which the film *2001* evolved.

This theme of benevolent beings from the sky is repeated in another of Spielberg's films, *Close Encounters of the Third Kind* (1977), in which an advanced alien intelligence intends to make formal contact with the human race. Earlier encounters, we learn, have taken place over several decades, with humans being taken into flying saucers. In addition, it appears that all over the world aliens have been able to implant insights into people's minds that they are going to manifest themselves. Moreover, they appear to communicate using musical tones. Thus a great crowd in India chants and points upwards to the sky. The protagonists in the film have an intuition that the visitation will occur on a particular mountain. The plot is based upon theories of such UFO researchers as Alan Hynek, who makes a cameo appearance in the film.

The film itself has biblical overtones. To begin with, there are the visits to Earth by smaller flying saucers before we see the final appearance of the giant mother ship—are these perhaps to be seen as visitations by angels? Then there are the prophets, ordinary people who have had extraordinary

experiences and who foretell the appearance of the mother ship by means of the five-note theme and images of the Devil's Tower in Wyoming where it will land. Is it not too farfetched to argue that the notion of superior beings that descend from the sky should carry religious resonances? Or to put it another way, any civilization that is vastly more advanced than ours would indeed appear to us in the role of gods. It has often been argued that if Stone Age people encountered our modern technology they would view it as magic—what else could cell phones be?

A 'cargo cult' appeared in many traditional societies but particularly in the southwest Pacific islands, after contact with technically advanced cultures beginning in the 19th century. During World War II a number of these islands were visited by the US Air Force who built landing strips, erected huts and tents, installed radio transmitters and brought in stores—cargo. After the Americans left, a series of cargo cults developed where the local people would appeal to gods to bring them more cargo. This involved such things as building airstrips and lighting fires, creating mock radio stations, parading with sticks as rifles and writing the icon USA. By carrying out such rituals it was believed that eventually those beings would return, appearing out of the sky and bringing with them the precious cargo.

In other words, these encounters by Pacific peoples with technically advanced beings were understood as an involvement with the supernatural. This could suggest that there is a similar longing on the part of the human race today for contact with something greater than itself. Could it be that, after so many atrocities committed over the last one hundred years (ethnic cleansing, concentration camps, the extinction of species, climate change, nuclear annihilation and so on), that we are looking outside ourselves for salvation, because we feel incapable of escaping from the messes we have created? We know that we have the ability to feed the world and eliminate many diseases, yet we seem incapable of getting our act together. So do those visitors from the sky represent some sort of deep spiritual desire? Or are they a flight from the chilling reality that the dreaded Other is no more than ourselves?

Religious overtones are made even more specific in Alex Proyas' *Knowing* (2009). John Koestler is the astrophysicist son of a pastor who has lost his belief in a meaningful universe after the death of his wife in a fire. He now lives alone with his son Caleb and no longer contacts his own father. One day at Caleb's school a time capsule is opened, and each child is given a letter containing a drawing done by children at the same school fifty years ago. But in Caleb's case it is not a drawing but a long pattern of numbers written by one Lucinda Embry. Koestler tries to find a pattern in the numbers and spots 91101—the date of the attack on the Twin Towers in New York. Rapidly he realizes that the numbers refer to disasters that

occurred *after* Lucinda had written them down, and that they contain three more predictions for the near future including the latitude and longitude of where the disasters will take place.

In an effort to understand what is going on Koestler contacts Lucinda's daughter, Diana, who herself has a daughter, Abby who is about Caleb's age. As predicted, two of the disasters occur without Koestler being able to avert them. Koestler now realizes that the final disaster will be a solar flare of such intensity that it will destroy all life on Earth, and struggles to find a way to save himself and his son. But Caleb and Abby have been contacted by a 'whisperer.' Koestler takes the two children to the location indicated by the final numbers Lucinda has written. There the whisperers are waiting and a vast wheel of light, similar to that seen by Ezekiel in the Bible, appears in the sky. The children tell Koestler that they are the chosen ones, and at that point the whisperers turn into beings of light and the wheel of light ascends into the sky.

Koestler returns to his father's house and embraces both parents as the solar flare reaches and destroys all life on earth. The film ends with Caleb and Abby dressed in white and walking towards a great tree. The religious overtones of the film, of loss of faith, redemption and resurrection of the Earth could not be more explicit and again speak to a particular yearning of our times—the film grossed over $24 million in the first weekend of its release placing it first in box office rankings.

But there is one other point to be made about aliens, and that is that they may be not that new after all. Recently I was asked to read a PhD thesis that examined the historical accounts of encounters with fairies and little people that have occurred over the centuries in many different cultures of the world. Additional stories involved the appearances of angels. The author argued that these appear to be fairly universal to all cultures and have a number of features in common. In our modern age, however, it is not the 'little people' we encounter, nor visions of angels, but aliens who emerge from flying saucers or who even abduct earth beings for scientific study.

The author of this particular thesis did not seek to draw a definitive conclusion as to the underlying nature of the phenomena, but offered a number of suggestions. One involved the possibility that there were indeed connections with non-ordinary beings—although whether they had anything to do with angels or aliens is a different matter. Another was experiences of altered states of consciousness that were then translated into the social currency of the times—be it elves of aliens. There are also those states of temporary body paralysis that can occur at moments of waking or falling asleep. It is possible that the experiences during such altered states of consciousness may later be stitched together and confabulated into a memory of some sort of alien encounter.

Mental Spaces

A further aspect of movie-going is the highly creative role played by the viewer. Postmodernist theorists say that there is no single 'reading' of a novel, no one objective version of what the novel is about. A man reading *Pride and Prejudice* will 'read' a different novel than a woman. And, for that matter, a young teenager, a middle-aged woman and a grandmother will all pick out and amplify different aspects of the same text. Indeed it is never really possible to read the same book twice because you and your life experience have changed since you last read the book. So reading is always a highly creative act.

With tongue in cheek, Jorge Luis Borges wrote a short story called 'Pierre Menard, Author of the *Quixote*.' Miguel de Cervantes, the author of *Don Quixote* was a contemporary of Shakespeare. Today we read the book through modern eyes. So Borges creates his story whereby a contemporary writer rewrites *Don Quixote*. He is, of course, writing it through the eyes of a sophisticated thinker of the late 20th century, one who knows all that has gone before. In fact it turns out that the text is word for word identical to the one that Cervantes wrote, but modern readers, in this fictional work, marvel at the irony, the wit of the writing and the skill of the author.

Of course this is no more than a parody of postmodern criticism, and what applies to novels equally applies to film. We may revisit a movie and find it the same, laugh in the same places, be moved identically at others. Or we may see a very different film—because of other films we have seen in the meantime, or changes in our lives, or world events. For example, after *Wag the Dog* was released, Republicans used the phrase 'wag the dog' to describe Clinton's military actions in Afghanistan, saying he was using conflicts abroad to deflect attention from the domestic scandal. The movie could now be seen in a new light.

When we watch a film or read a book, we are not simply responding passively to information from the screen or page, but are actually helping to create the scene as it goes along. This, according to the linguist Fauconnier, is what happens when two people have a conversation. Conventional information theory reduces a conversation to bits of information being transmitted from the speaker to the listener who decodes them, just like digital information being sent down a telephone line between two computers. If the signal to noise ratio is good, most of the information is received correctly at the other end.

But, Fauconnier claims, this is not at all what happens when two people have a conversation, for as one person speaks the other begins to create a

'mental space' of what the speaker means. Suppose a friend says to you, 'I saw one of my favorite movies on TV last night, the one with Bogart and Bacall.' Your mind leaps to *Key Largo* and you say 'The one where they're on a fishing boat?' 'Yes,' the friend replies. And so you go on building your mental space of Bogart's role in *Key Largo* and your friend believes that your mental space is in accord with the one he has created. Everything proceeds to plan until your friend mentions a line about a dead bee. You are taken aback and can't remember anything about a bee in *Key Largo*. Then the penny drops—your friend is speaking about *To Have and Have Not,* another movie that starred Bogart and Bacall. Your mental space collapses only to be rebuilt much more in harmony with that of your friend.

And so conversations proceed in this way with both parties constantly building mental spaces, modifying them, rebuilding and reinforcing them. Films can work in exactly the same deliberate way. Hitchcock will supply a number of little hints that encourage you to create a mental space involving the nature of the character, or the particular plight of the protagonist, and then he suddenly pulls the rug from under your feet, so you have to begin to build again. The point is that you are totally engaged in the film because, in a sense, you are the projectionist who is playing the film in your own head.

In this context, note the clever way the detective novels of Agatha Christie are constructed—the reader is never deceived. Everything is told exactly as it happened. The trick, however, is to read the clues in exactly the right way. In the *ABC Murders,* for example, a series of murders occur in different locations, but each with an ABC train guide left beside the body and a note for the detective Hercule Poirot indicating the location of the next crime. The police are on the trail of a serial killer, but in the end it turns out that there is only one murder that was made for gain; the other murders are mere false trails to lead the police away from who should be the main suspect.

III.

Story

The very first films showed such things as workers leaving a factory and a train pulling into a station. They were documentary photographs that moved. Yet it was not long before a series of shots was spliced together to form what was in essence a story, and stories are something very fundamental to the human race. We humans feel a need to make sense of the vast reality that surrounds us via stories; they are ways we find order within chaos. We have the stories of our lives, of our parents, of how our ancestors settled in a particular part of the world. We have the stories of our community or our nation. These stories are deeply symbolic and bring a unity to our lives.

The Middle Ages needed the *Divine Comedy* of Dante in order to tell itself what the world was like and how people fitted into society. When Brian Swimme and Thomas Berry tried to write an equivalent for our contemporary world, they called their book *The Universe Story*. Likewise, as we have seen in the many examples above, film can tell us stories about such things as memory, time, dreams and the persona.

It has been said by many people that there are only a limited number of stories in the world, and that every novel, play or film is no more than a variation on one of those archetypal stories. One of them is the famous 'A Stranger Comes to Town.' In this there is a community with its sets of relationships and mutual understandings into which someone arrives from the world outside, someone with a different type of behavior, someone who may disrupt the current order in a positive or negative way. Many Westerns, for example, involve a stranger who arrives in town on horseback and changes everyone's life.

A famous example of the stranger film is Tay Garnett's *The Postman Always Rings Twice* made in 1946, and then remade by Bob Rafelson in 1981 with Jack Nicholson and Jessica Lange taking the main roles. The stranger in this case is a drifter who arrives and notices a vacancy at a diner, takes the position and then makes a play for the owner's wife. The story ends in murder, which is a classic way in which a stranger can disrupt a family or community.

Then there are films based on ancient myths and stories. Take, for example, Pygmalion who sculpted a woman who was so lifelike that he fell in

love with her. What is the plot of an up-to-date technology movie, Andrew Niccol's *S1m0ne* (2002), but this? A film director is searching for new talent and decides that the best he can do is create a digital simulation that will become the perfect actress. Simone, the name derived from the computer program Simulation One, is so successful that she develops a considerable following and even 'directs' a film of her own. But the more she is successful, the more her creator falls in love with her and feels he can't kill her off. Note that the actual Simone was created digitally for the film and based on Canadian model Rachel Roberts, but the director also acknowledges other actresses who have contributed to the character, including divas from the past such as Greta Garbo, Lauren Bacall, Marlene Dietrich and Marilyn Monroe

Joel Coen's *O Brother, Where Art Thou?* (2000) is the retelling of Homer's epic poem the *Odyssey*—with its central character named Ulysses Everett McGill. Three escaped convicts encounter Sirens that cause men to sleep, a one-eyed Cyclops, the Ku Klux Klan, a Blind Seer and a man who has sold his soul to the devil. Finally Ulysses finds his Penelope (Penny, played by Holly Hunter) who is waiting at home and pursued by a suitor. Sepia-tinted color stock is used to suggest an aging or remoteness in time.

Or take the TV series *Alias* (2001-2006) starring Jennifer Garner as Sydney Bristow. The plot has a number of threads mainly based on the premise that 'things are not what they seem,' such as the secret US government agency for which she works turning out to be run by 'the other side.' Maybe her father is a double agent? Maybe her mother is not really dead? But, all in all, these are just the underlying framework that allows Sydney to chase villains, engage in balletic fights and jump from tall buildings armed only with a pulley and rope. However, there is one consistent thread that weaves through the five years of the series, and that is the character Arvin Sloan's search for the secrets of Rambaldi.

Milo Rambaldi, artist, architect, engineer and mystic, supposedly lived in Italy between 1444 and 1496. He anticipated the discoveries of modern science and medicine, but went far beyond our current knowledge. In addition, he predicted the existence of Sydney Bristow as 'the chosen one.' His secrets are contained in a series of encoded manuscripts, as well as artifacts hidden in various parts of the world. In each of the *Alias* series we see the progression of Arvin Sloan's obsessive search for Rambaldi's secrets. Only in the final episode of the last series does he reach Rambaldi's underground chamber and reveals the final secret—the equivalent of Promethean fire—and achieves immortality. But Bristow's father has followed Sloan to the chamber and, in a final act of defiance, blows himself up and brings down the roof onto Sloan. Sloan has achieved the dream that obsessed him all his life. He can never die; even riddled with bullets, he is able to revive

himself. Yet he is doomed to live for all eternity trapped under a massive rock. In fact this is none other than the myth of Prometheus who stole the secret of fire from the God Zeus and, for his punishment, was chained to a rock for eternity. The old stories certainly continue to work their magic.

What really happened?

LOST IN TRANSLATION

Sofia Coppola's *Lost in Translation* (2003) is yet another variation on one of the oldest stories in the world—a man meets a woman. In this case Bob Harris, played by Bill Murray, is a world-weary actor who is in Japan making a commercial for a Japanese brand of whisky. Away from home, and somewhat disoriented by the language and the job, he sees a young woman, Charlotte (Scarlett Johansson) in the elevator and later begins to talk to her in the bar. Charlotte is also unhappy, being stuck in a Japanese hotel while her husband, a photographer on assignment, is off shooting every day. Both Bob and Charlotte are lonely and in need of company, and so a sympathetic relationship is set up between an older man and a very young woman—the actress was only eighteen when she made the movie, while Murray was fifty-three.

The relationship goes through a number of phases of tension and tenderness until it is time for Bob to leave and fly home to the USA. He is in a taxi on his way to the airport when he suddenly spots Charlotte in a crowd. We see him go up to her and whisper something in her ear before returning to his taxi. The film leaves us suspended. It is without any conventional resolution, and naturally people want to know what was whispered. They ask the director Sofia Coppola, they ask the actor Bill Murray, and of course the clear and most satisfying answer is 'We don't know.' We are not supposed to know. Or if you like, as we saw earlier with projection, we can project anything we like into that whisper. It could be a statement of love; it could be a special secret, a confession, a plan to meet again. It is an invitation for the viewer to do the work, to complete the story.

It recalls another unrevealed secret. At the start of E.M. Forster's *A Passage to India*, which was also made into a film by David Lean (1984), an Indian doctor, Dr. Aziz, asks if it is possible for an Indian to have a genuine friendship with a Briton. Later Aziz enters a mosque and finds an older Eng-

lish woman, Mrs. Moore, and is impressed with the respect she shows for his Islamic religious tradition. Aziz offers to take Mrs. Moore and her party to see the Marabar caves, but when she enters she becomes overwhelmed with claustrophobia. Aziz then offers to go on with Adela, a young female friend of Mrs. Moore. Adela also experiences a deep disorientation inside the cave and, when she returns to her English party, accuses Aziz of attempted rape. Aziz is arrested and must stand trial. It is only during the trail that Adela withdraws her accusation.

Many people asked Forster, 'What really happened in the cave? Was it a simple case of disorientation brought about by the claustrophobic echoes of the caves, or did Aziz in some way molest the English girl?' Forster would always reply that he did not know what happened. It was a device in a novel, an essential mystery that could be interpreted according to the racial prejudices of the characters in the community, in the courtroom and, most of all, by the readers of the novel. Or, in more recent times, by the viewers of Lean's movie. In a sense it is Hitchcock's MacGuffin all over again.

As with *Lost in Translation*, *A Passage to India* will not provide us with a simple resolution. It is not a detective story by Agatha Christie in which everything is resolved in the last chapter by Hercule Poirot or Miss Marples. It is something closer to life, something closer to ambiguity and to all the world's stories that are left to us incomplete.

PICNIC AT HANGING ROCK

 Another film in which the audience is left wondering what really happened is Peter Weir's *Picnic at Hanging Rock* (1975), one of the first of Australia's 'new wave' of cinema and one of the first Australian movies to be a major international success. But unlike *Lost in Translation*, in which Bob and Charlotte as characters know what was whispered even if we do not, the inhabitants of the school and community are equally perplexed at the fate of a party of schoolgirls. The girls of Appleyard School are primly dressed, just like Edwardian girls at a private school in England. Yet this is not the gentle landscape of a Wordsworth scene, but the strange Australian outback and, in particular, the rather eerie motif of Hanging Rock itself. Peter Weir is very sensitive to atmosphere, landscape and a sense of space. As an Australian he knew that there are two Australias: that of the Europeans who emigrated to the new land, and that of the original peoples, the Aboriginals, who believe that their land was created in dreamtime when the remote ancestors walked the land with their

songs and created the landscape with such magical places as Ayers Rock and Hanging Rock itself. Moreover, dreamtime is not some remote historical past as would be understood by Europeans with their edifices and temples, but coexists within the present. Dreamtime is still present, as are the songlines. Even the songs themselves live on, as they do for many Native Americans.

And so, on St. Valentine's Day 1900, a small party of girls from Appleyard School goes for a picnic at Hanging Rock. In other words, they leave their familiar Edwardian surroundings and venture out into a very ancient landscape. Weir's use of cinematography enhances this transition. In particular we see wildlife and the movements of ants and of flies. We have a sense of something that may just be seen out of the corner of the eye if only the head would move in time. We are also aware of the background music to the film played on the pan pipes. As the day wears on the girls doze, and a small group of them go on to explore the rocks. We see them climbing up into the light. Time passes and the girls do not return. By late evening the principle of the school, Mrs. Appleyard, becomes concerned. Then the carriage returns with the news that a teacher and three of the girls are missing. Next morning the hunt begins with the local police, dogs and an Aboriginal. Yet the girls are nowhere to be found, and no bodies are discovered. Finally one of the missing girls, Irma, is found, but has no memory of what happened to her or her companions. They appear to have literally vanished into thin air.

The film is particularly haunting and suggests that in some way the Rock possesses a life and a force of its own. For many viewers this was an eminently satisfying film, but for others there was a sense of frustration that the mystery was never revealed. For some people there must be a solution to every mystery; even if it is a matter of flying saucer abductions at least that *is* a solution—albeit farfetched.

Weir's film is based on a novel of the same title written by the Australian novelist, Joan Lindsay. At the time the book generated considerable interest, in part because of the mystery involved, but also because of hints, not always denied by the author, that it was based on a true story. Something similar occurred with *The Blair Witch Project* which was alleged to be a documentary made by local students who disappeared leaving their equipment behind. What purported to be a second 'documentary' featured 'interviews' with local inhabitants and historians about the Blair Witch. A great deal of 'factual information' accumulated around the film, such as a supposed book *The Blair Witch Cult*, published in 1809, and a certain Elly Kedward who was banished from the community in the late 18th century because of witchcraft. Then there were stories of missing children, all leading up to the notion of the three film students who decide to investigate the legend. The film was finally found in the woods and, so the accompa-

nying story goes, was considered faked by the police but the family claimed it and contacted Haxan Films who decide to release the footage. All in all, an excellent way to drum up publicity!

Returning to *Hanging Rock*, the original manuscript contained a short final chapter in which the nature of the mystery was revealed, but this was withdrawn by the author prior to publication. Lindsay's explanation was that the girls and the teacher were somehow overwhelmed by the mysterious power of the rock and, in a symbolic gesture, removed their corsets. They came across a hole in the rock and were transformed into small creatures that entered into the cavity which was then covered by another boulder. Only Irma was left outside and thus able to return to her Edwardian life. While a contemporary reader may think in terms of time warps and parallel universes, as in *Donnie Darko*, a more convincing explanation is that the girls have entered into dreamtime; they have merged with the ancestral nature of the landscape and can never return to their corseted European-style environment. They have truly vanished from the world in which they were brought up.

THE FRENCH LIEUTENANT'S WOMAN

 John Fowles' novel, published in 1970, attracted considerable attention and was featured on the *New York Times* bestseller list for a total of ten months. Inevitably it would be made into a film, but here the director, Karel Reisz, faced a particular problem because of the approach taken by Fowles in writing his novel.

The story is set in England during the Victorian period, and concerns Charles and his increasing obsession with the mysterious Sarah who goes under a variety of nicknames from Tragedy, the French Lieutenant's Woman, to the French Lieutenant's Whore. Charles is very much a man of his time, one who accepts class roles and distinctions. He looks for support, and an inherited title, from a rich uncle. His interest in fossils has brought him to Lyme Regis, a coastal town in Dorset, England, noted for the fossils found in its cliffs and beaches. As the book opens, Charles has just become engaged to Ernestina, the daughter of a successful businessman. While out walking with his fiancée, he notices a woman at the end of a rampart that stretches out into the sea. It is 'Tragedy' who, he learns, has been seduced by a French soldier and each day stands looking out to sea waiting for his return. The locals consider her half-mad but, as we learn more about her we realize that, in a certain sense, she could be seen as a liberated woman of the

twentieth century who finds herself trapped within all the conventions of the Victorian age. To complete the story there is a subplot of Sam, Charles' servant, and his attraction to Mary, a maid in Ernestina's house.

And so the story of Charles' increasing fascination with Sarah unfolds. At first sight this could simply be adapted into a period piece with actors in Victorian clothing speaking a somewhat formal language—yet another costume adaptation for the screen. But that would be to ignore a very important element in the way the book unfolds, for Fowles makes occasional interventions into the text to remind us that we are not actually reading a Victorian novel but one written in the mid-twentieth century. To take just one instance out of many: Fowles makes a passing reference to Bertold Brecht's alienation effect. The reader is therefore assumed to be knowledgeable about contemporary historical, political and intellectual developments, ones that would be totally unknown to the Victorian characters he/she is reading about. So how is one to bring about the same effect in a work of cinema?

Fowles' device is particularly marked in Chapter 13. The previous chapter concludes late at night with Sarah standing at her window with tears on her cheek. 'Who is Sarah?' the author asks as the chapter ends. Chapter 13 begins with the words 'I do not know.' Fowles refers to Victorian novelists who take a God-like stance above the characters they have created but, as he points out, he as author lives in the age of Roland Barthes and Alain Robbé-Grillet. He does not really know or control the characters he has created. Maybe Charles is the author himself. Maybe it is not really a novel at all but a collection of essays. And so the chapter meditates upon the nature of creating fictional worlds.

But to return to the story, Charles becomes ever more obsessed with Sarah and fears that the local doctor may have her confined to an asylum. In turn she asks him to meet her in a secluded place so that she can confess her story to him. The end result is that Charles gives her money and advises her to leave Lyme and go to Exeter. He later visits her in Exeter and overwhelmed by his obsession, carries her into the bedroom where they make love.

Charles is now on the road to disaster. He breaks off his engagement, at first claiming that he is unworthy of Ernestina, but when challenged invents a former attachment that has not dimmed. When he returns to Sarah's hotel he discovers that she had fled to London and so he hires detectives to look for her. Moreover his manservant, Sam, anticipating his master's ruin, has steamed open Charles' letter from Sarah and now reveals what has been going on to Ernestina's family. As a result Charles is discredited as a gentleman and leaves for the United States.

Time passes. Sam and Mary are now married and by chance discover where Sarah is living. At the birth of his second child, a son, Sam regrets the ruin he has brought to his former master and sends an anonymous letter to Charles' lawyer revealing Sarah's address. We are about to move towards the culmination of the novel with Chapter 60. But again the author intervenes.

Back in Chapter 43, Charles had arrived in Exeter from London. In the following chapter Charles takes a trip to Lyme to visit his fiancée where he makes a joking reference to Sarah as Tragedy. It is clear that his passion has been defused. He is going to marry and the couple will have seven children. And so the story apparently should end. But in Chapter 45 the author reveals that none of this actually took place; it was Charles' fantasy while on the train and he really is about to go Sarah's hotel in Exeter for the encounter in which he will sleep with her. But the author has not yet finished with his character. On the day following their encounter, when Charles discovers that Sarah has left for London, he rushes to the London train. A bearded man enters his carriage and stares at him. It is none other than the author himself, John Fowles, studying his creation and trying to decide how the novel could end. There seem to be only two valid endings therefore each must be given to the reader. But which will come last? Which will seem, in the conventions of a novel, to be more valid? The author in the train tosses a coin.

And so, according to the toss of the coin, Charles `enters the house where Sarah has been staying over the past years. It is the home of the artist Dante Gabriel Rossetti, a member of the Pre-Raphaelite Brotherhood, a movement of which Charles strongly disapproves. The two finally meet, and Charles is filled with anger when he learns that Sarah knew of his attempts to find her. For her part she explains that she is happy in a house with people who understand her need for personal freedom, and her desire not to be trapped in a relationship where she must play a particular role. For Charles this means that she has not only plunged a dagger into his heart, but is enjoying twisting it. He takes one last look at her and turns towards the door. But Sarah pleads with him to wait and meet a lady in the house who 'understands me better than anyone in the world.' Sarah leaves and a little girl enters carrying a doll. Charles takes her onto his knee and, when Sarah returns, he learns that she is his child. They embrace and one aspect of the novel ends.

The final chapter repeats the events of the penultimate chapter up to the point where Charles turns on his heel and heads for the door, but this time he continues out into the street. Sarah looks out of the window at the garden below.

So that is Fowles' novel. But how to turn it into a film? How to create the illusion of a Victorian life and characters but at the same time remind us that it is a film, and a film that will have two possible endings. This is the dilemma that faced Karel Reisz and his scriptwriter, the highly talented playwright Harold Pinter. I would argue that the answer had already been given by Ken Russell in a biopic he made for the BBC *Monitor* program in 1965. In that period, before Russell had worked for the big screen, he made some highly creative biopics for television working with a small crew. *The Debussy Film* was scripted by Melvin Bragg with Oliver Reed as Debussy and Vladek Sheybal as Pierre Louis, 'the director,' for we are watching a film within a film. Russell's film makes particular use of editing the action in ways that complement the music. But he also wished to evoke the ambiguous sense of tonality that is characteristic of Debussy's music by having the action proceed in two ways. In one we see incidents from Debussy's life being acted by Oliver Reed using the convention of the biopic. Yet in others we see 'the director'—himself an actor—discussing with the actor Reed how he will play the character in the next take.

This was the device that Reisz later adopted for his film of Fowles' novel. The film opens with a close-up of a cloaked figure. At first we don't see the face, but realize it is reflected in a mirror held by an assistant. The actress playing Sarah, Meryl Streep, adjusts her makeup and a voice asks 'Ready Anna?' We see a slate marked 'Take 2' held up to the camera, then the voice shouts 'Action' and we cut to an establishing shot of the sea-front as Streep begins to walk towards the Cobb which stretches out into the sea. As she walks away from the camera, we sense that we are entering a different time period—the Victorian era where the novel is set. As Streep stands looking at the sea we cut to the next scene of a busy Victorian street then to Jeremy Irons as Charles chipping at a fossil. He looks up deep in thought, then we cut to his visit to the home of Ernestina where he asks her if she will allow him to approach her father for her hand in marriage. She agrees and the two embrace. We then cut to a close-up of Irons in bed as the actor Mike. The telephone rings and as he answers, the camera pulls back to show Streep, as the actress Anna, naked in bed beside him.

And thus we realize that we are cutting between two time periods: one in which Charles becomes increasingly obsessed with the enigmatic Sarah, and the other in which the two people acting their roles, Mike and Anna, are having an affair, but an affair that may or may not end when the film is over.

For the bulk of the film most of the scenes are confined to the Victorian era, with occasional returns to the making of the film. Only towards the end of the film, when Charles must end his engagement to Ernestina, do we intercut with increasing speed between the two time periods. We see Mike's

fear that he will no longer see Anna, who is married, when the film is over, and we see Charles' search for Sarah after they have declared their love for each other.

And so we come to the two endings from the book. After a search that lasted for three years, Charles finally tracks down Sarah in the Lake District and their story ends as they are united, rowing on Lake Windermere. The other ending is at the final cast party where Mike, who had been pleading with Anna that they should stay together, is now looking through the set for her. He hears a car door slam, runs to the window and sees Anna and her husband drive away, for she is returning to America.

The scriptwriter as character

We have seen the role of story in film, so what about a film in which the story, rather than an actor or actress, is the main character? *Adaptation* (2002) is another of those films about film. It is by one of a new genera-tion of talented directors, Spike Jonze. Jonze's breakthrough film was *Being John Malkovich* (1999), with a script by Charlie Kaufman. Maybe the best introduction to Jonze's fame is from Jim Jarmusch's series of vignettes, *Coffee and Cigarettes* (2003). In one of these, Alfred Molina has arranged a meeting with the comedian Steve Coogan. Molina is excited about a po-tential film project, for he has discovered that he and Steve are related and suggests a film based on the parallels of their lives. Steve does not appear particularly enthusiastic about the idea and, when Molina asks him for his home telephone number so they can discuss the idea in more detail, says that as a matter of principle he does not give out his personal number.

But then Molina's cell phone rings and he begins a conversation with 'Spike,' afterwards mentioning that the two are very good friends. Steve as-sumes he is referring to the director Spike Lee, but when he discovers it is in fact Spike Jonze he says that maybe he could make an exception to his principles and give Molina his home phone number after all. Molina smiles and says, 'No,' Steve should stick to his principles.

So Jonze is the man to know. He is also, according to some interviews with Sofia Coppola, who was once married to him, the model for the pho-tographer husband in *Lost in Translation*.

Adaptation opens on the set of *Being John Malkovich*, where we see the neurotic Charlie Kaufman, played by Nicholas Cage, being told to move as

he is in the shot. Charlie is about to have a meeting about the adaptation of *The Orchid Thief*, a book about orchids and the fascination they have for orchid hunters. This happens to be a real book written by Susan Orlean, a writer for the *New Yorker*, played in the film by Meryl Streep. Charlie wants to be totally faithful to the book. It will not be a conventional plot, the usual sort of film one sees, but something totally different. It must capture the book's love of flowers and orchids in particular. It will be a film about flowers, a film that begins with the origin of the earth, the first life, and the appearance of flowers. It will not be a film about the conflict of characters and such things as car chases, but something genuine to the spirit of the book and totally original. It certainly will not have a Hollywood ending.

Charlie shares his apartment with his twin brother, Donald, who also has an ambition to be a screenwriter and thinks up a totally absurd plot about a man with multiple personalities who kidnaps himself and locks himself in a room, while at the same time driving round the city. The angst-ridden Charlie, in the grip of his writer's block, is driven to desperation by his brother's suggestions, and keeps asking him how on earth he proposes to show someone going round the city at the same time as he's locked in a room.

The plot of *Adaptation* hinges on film itself, on the nature of film plots, and on identity. The brothers are identical twins (both played by the same actor), and the film keeps moving between Charlie agonizing about the film he is trying to write and his actually being in the film itself, along with his twin, as the main protagonists. His brother takes a course with a man who claims he can teach the rules of screenwriting. Even when Charlie points out that there can be no fixed rules, in the end he compromises and attends the course where he is told such things as 'never use a voiceover,' and so we hear his own voiceover agonizing about using a voiceover. The other advice is that a successful film always ends with a bang, something to get the audience's attention. And so *Adaptation* ends with a chase in the Everglades and the shooting of one of the brothers.

Jonze keeps up this double layer of reality by crediting the two brothers with writing the script of the film. The final irony came at the Bafta Awards when the best screenwriting award was given to Charlie and Donald Kaufman—the latter being a fictitious invention, the device of a twin brother created by the real life screenwriter Charlie Kaufman. Charlie and Donald were also nominated together for an Oscar! No wonder Charlie Kaufman is someone who thinks deeply about the nature of reality! In addition to *Adaptation* and *Being John Malkovich* he also wrote *Eternal Sunshine of the Spotless Mind*.

Director or script: SUNDAY BLOODY SUNDAY

 Certainly the scriptwriter plays a vitally important role in creating a film. The famous *auteur* theory suggests that the true author of a film is the director, but there are also times in which character, plot and dialogue become the dominating features by virtue of an exceptionally well written script. Since the author Penelope Gilliatt published her screenplay (The Viking Press, NY, 1972), it is now possible to explore just how important her writing was, and what additional dimension to the 1971 film, *Sunday Bloody Sunday*, was added by the director, John Schlesinger.

The film involves a triangular love affair with the love object, a young artist, Bob Elkin, who makes a living with his kinetic sculptures and designs. The story begins on Friday. We are introduced to a middle-aged doctor, Daniel, who has been trying to reach a Mr. Elkin on the phone by ringing his answering service. A divorced career woman, Alex, is also trying to reach Bob Elkin and calls her telephone answering service, the same service that is being used by Daniel.

Alex, who is nearly ten years older than Bob, is working for a recruitment agency. As we see her in her apartment, we realize that she is not always in control of the daily practicalities of life. Alex and Bob spend the night together babysitting for their friends, the Hodsons who are intellectual 'modern' parents with precocious children. On Saturday morning Bob announces that he has to 'go to work,' leaving Alex to cope with the children. We cut to Daniel's consulting room, a patient is about to leave, Bob enters with his own key and Daniel embraces and kisses him. We now realize that Daniel is the third vertex in this triangle.

The film moves on through Tuesday, Wednesday and Thursday as we realize that, while Daniel and Alex both love the same man, their relationships with the fickle Bob are going nowhere. Daniel had been planning a vacation in Italy with Bob, but on Friday he is called to Bob's flat where he finds his lover has a fever. In the end Bob admits that he's had a vaccination and is leaving for America. On the following day, when Alex learns that Bob is going away she tells him the relationship is over, she just doesn't want to live like that any longer.

Finally we come to Sunday morning. Alex arrives at the Hodsons' house and sees Daniel inside with the family. When Daniel leaves, he and Alex meet for the first time. It is an embarrassed yet tender moment. Daniel asks if Bob has really gone; Alex shrugs and says she just got it from the answering service.

In the final scene we are back in Daniel's home where he is practicing Italian with a phonograph record. Suddenly Daniel looks directly at the camera, at us, and says that even though Bob never made him happy, and friends would say he's well shot of him, that he misses him. All his life he had been looking for someone who is resourceful and courageous, someone not like himself. Bob was not that person...but he was something. And he only met him because of his cough.

Fade to black.

And that is *Sunday Bloody Sunday* as the script tells the story. It was voted best screenplay of the year by the National Society of Film critics and the script got a tied first place from the New York Film Critics. In the published script Gilliatt mentions that the director Schlesinger and Joseph Janni worked on later versions of the screenplay, so clearly this is not the first version that she presented to the director but a version that would later be turned into a shooting script—one indicating specific camera angles and so on. So Gilliatt's script was the raw material out of which the film would be created. But what dimensions are added to the film, as a visual and aural medium, that go beyond the words in the screenplay?

The film is concerned with difficulties in relationships. The metaphor for this triangle of relationships is the telephone—a telephone ringing in an empty room, the sound heard in the earpiece of a phone ringing at the other end of the line, the lights flashing in a phone answering service, moving re-lays and snaking telephone lines. In some scenes the telephone itself visually dominates the screen, appearing even larger than a character's head.

The characters of Daniel and Alex are also contrasted visually—the neatness and order of Daniel's office and home as opposed to the sprawling mess in which Alex lives. As Alex leaves for work, for example, she makes herself a cup of instant coffee using water from the hot tap.

Audio and visual devices are used to establish the tense year in which the film is set—1969, a year of tumultuous events across the globe. Daniel driving in central London hears the news on the radio which reports a serious economic crisis, the Cabinet in session and the possibility of mass unemployment and strikes. We are at the end of the swinging sixties and things are going downhill. We see crowds of young people roller-skating through London, a group of drunks and drug addicts waiting at an all-night pharmacy. In another scene an *Evening Standard* newspaper is used as an umbrella, the headline glimpsed reads 'Eight million jobs threatened,' and again on the car radio there is news of an economic crisis and of leaders of the Trades Union Congress called in to a Cabinet meeting.

The film clearly establishes the period and location of busy central London which it contrasts with the greenness and elegance of Greenwich,

downriver from central London, where the Hodsons live. This is the area where Alex and Bob are acting as weekend babysitters. We see Alex and Bob walking past the Royal Naval College and looking down from the observatory in Greenwich Park. As they walk past St. Alfege's churchyard we notice another sign of the times—a youth with a piece of glass in his hand walking past a row of expensive cars etching their paintwork. (The boy in question was played by the 14-year-old Daniel Day-Lewis in his—uncredited—film debut.)

Finally, of particular significance in the film is the music, heard first on Daniel's record player and then throughout the film as a sort of leitmotif, from Mozart's *Così fan tutte*, 'Soave sia il vento'— sung by a trio!

BARTON FINK

 In *Barton Fink* (1991) the Coen brothers made a particularly satisfying satire on the condition of the Hollywood scriptwriter. The film opens in New York in 1941 where intellectual playwright Barton Fink has written a successful stage play and is hailed by the critics as a tough new writer concerned with the working class. Barton himself has visions of creating a new form of 'living theater' directed at the common man. However, his agent persuades him to accept a contract from Capitol Pictures. After all, by working for Capitol he can amass sufficient money to realize his vision of a new theater.

And so Barton moves to Los Angeles where he checks into the seedy Hotel Earle and sets up his Underwood typewriter. The next morning, he meets with the studio head and his fawning assistant who tells him that Hollywood is ready for 'that Barton Fink feeling' and suggests he begins work on a wrestling movie starring Wallace Beery.

Back at the hotel he meets his next-door neighbor, Charlie, who is a true 'common man'—an insurance salesman. When Charlie realizes that Barton is a writer, he keeps suggesting that he could tell him 'a thousand stories,' but Barton is so wrapped up in explaining his vision for the 'common man' that he has no time to listen to the real thing.

Barton's hotel is depressing; he hears noises from the other rooms, there are stains on the ceiling, and paper is peeling off the walls. Blocked in his writing, he seeks help from the film's producer who suggests that he talks to another writer. The writer in question, Bill, turns out to be one of America's great southern novelists—to some extent based on William Faulkner, who

in addition to being a great novelist also worked in Hollywood and was noted for his drinking binges. Similarly the fictional Bill is a raving drunk who is assisted by his 'secretary,' Audrey. In one encounter, when Barton goes on and on about writing from his inner pain, Bill replies that writing is just 'making things up.'

Barton, who is totally blocked, faces an early morning appointment with the studio head on the following day. In desperation he calls Audrey, who when she says that she 'helped' Bill with his scripts, actually means she wrote them and even wrote his last two novels. She agrees to help Barton with the treatment for his wrestling movie, but first they make love.

Barton wakes next morning to discover Audrey's bloodstained body beside him in the bed. In desperation he calls on Charlie who removes the body. Charlie announces that he is going to New York for a few days, and leaves a parcel in Barton's safe-keeping—a box that could contain a human head.

It is now eight in the morning and a desperate Barton must keep his appointment with the studio head, Jack Lipnick. Unable to come up with a story, he makes a last-ditch excuse that he finds it difficult to talk about work in progress. When the assistant points out that everything in Barton's head belongs to the studio, Lipnick berates his assistant and says that he must give respect to such a creative figure as Barton Fink and, in a surreal gesture, gets down on his knees to kiss Barton's feet.

Back at the hotel, detectives are waiting for Fink to tell him that they are looking for Charlie who is really Karl Mundt—Madman Mundt—a serial killer wanted for several murders. After shooting his victims, they explain, he decapitates them and keeps the heads. Barton's life is now in a total mess, but suddenly he finds inspiration and, in one burst, writes an entire film treatment and then goes out to celebrate for he feels that he has produced his very best work. On his return he is arrested, for Charlie has come back and killed again. Charlie, however, sets fire to the hotel and shoots the two detectives. When Barton asks why Charlie has turned his life into such a mess, Charlie replies that it is because Barton would never listen to him.

Barton escapes from the burning hotel to face his denouement. The studio head hates his treatment—it's supposed to be a wrestling movie, not a film about a man wrestling with his soul. And so his punishment is to remain on contract and continue to write scripts that will never be produced. Barton replies that he tried to give the studio something beautiful, to which Lipnick replies that he has twenty writers on his staff that could write the 'Barton Fink feeling.' Barton is therefore condemned never to leave the Hollywood he has come to hate. In some ways the ending is not dissimilar in

tone to that of Evelyn Waugh's *A Handful of Dust* where the protagonist, Tony Last, ends up captive in the Brazilian jungle, forced to endlessly read out loud the works of Dickens to his captor, Mr. Todd.

Hollywood endings

While the weather outside may change from rain to sunshine, from hot to cold, from dry to damp, what could perhaps be called the weather inside our bodies is always more or less the same. This is known as homeostasis, which means that body temperature, oxygen levels in the blood and so on, are all kept at the same healthy level. It was Carl Jung who suggested that something similar happens in the mind. In other words, Jung claimed that the psyche is self-regulating. Thus a person who becomes neurotic may do so because they have strayed from their true path. For example, they may have become intellectually arrogant, too extraverted or introverted, too influenced by others. An ambitious man who has overworked and neglected everyone around him may have a breakdown in midlife. This breakdown enforces a pause, a period when that person is forced to reconsider their life and where it has been going.

In a similar way we tend to confabulate in our personal lives. We construct stories about events in the past that satisfy us. In other words, while there may be times when we are willing to face a truly traumatic situation, there may be others when we construct a new story around events in an effort to reduce psychic tension. In a way we may have a tendency to envision our lives with the metaphor of 'the Hollywood ending'—that final account in which everything adds up and we fulfill our desire to live happily ever after.

So why not explore some film endings and ask if they always have to be 'Hollywood' ones?

BREAKFAST AT TIFFANY'S

 Let's take a look at Blake Edwards' 1961 film *Breakfast at Tiffany's*, as well as the story that inspired the film and its author, Truman Capote. *Breakfast* opens with a writer, Paul Varjak,

moving into an apartment building. By 'writer' we realize this means someone who wrote a book several years ago, and now has his typewriter sitting in pride of place on the table but minus a ribbon. In fact, Varjak is being supported by a rich older woman. But as he moves into a new apartment block he encounters a fellow tenant, Holly Golightly (played by Audrey Hepburn) and is swept into her world. The other inhabitant is a Japanese photographer, Mr. Yunioshi, played in a most bizarre—and which today would be considered racist—manner by Mickey Rooney.

Holly is a good-time girl who is constantly going to parties and who lives off gifts from her many male friends—'money to go to the powder room.' Holly nicknames Varjak 'Fred' after her brother. While they become close, Holly never wants to speak of her private life or of the time before she met 'Fred.' A particularly powerful link throughout the film is the background theme of 'Moon River,' and on one occasion we see Holly sitting on the fire escape and singing the song while she plays her guitar. (The song itself won an Oscar, as did the scoring.)

Fred clearly falls for her, but Holly for her part is totally focused on finding a rich man to marry. It is only part-way through the film that we learn of Holly's true past when a much older man, Doc, comes in search of her. Varjak discovers that Doc is in fact her husband, and that Holly was his child bride. Doc asks Holly to return home with him and, accompanied by Varjak, they walk to the Greyhound bus station. It is only when they are about to board the bus that she breaks the news to Doc that she won't be coming with him. She reminds Doc that he had a habit of bringing home wounded animals and birds with broken wings. The problem is that such animals can't be caged; they are, like Holly, wild things that must be set free once they are cured.

Holly never sought love or romance, just money and the good life. And if there is any love in her life, it is only for her brother, Fred, who is in the army. Whatever affection she may have for Varjak is indicated by the fact that she calls him by her brother's name. She has a pet cat but does not even give it a personalized name. It is simply 'Cat' since Holly says that she doesn't feel she has the right to give him a name because she does not want to own anything.

Towards the end of the film, Holly is arrested because of her association with a jailed mobster, Sally Tomato. (She had been visiting Tomato in prison and conveying coded messages about narcotics disguised as weather reports.) Holly decides to flee the country and, on the way, abandons Cat. Up to this point the film has reflected Capote's storyline and, to some extent, the characters, but now they part company. In the taxi, after dumping her cat, Holly of the novella has a moment of remorse and looks for Cat in vain. She then asks Varjak to promise to look after the animal and drives

on to the airport. The last Varjak hears from her is a postcard from South America with a lipstick kiss and the promise, never fulfilled, to send her address.

Holly of the novella is a hustler, albeit an attractive and vivacious one, whose only true affection was for her brother; everyone else who comes into her life is seen as an opportunity and a potential source of money to support her lifestyle. Certainly she enjoyed the company of Varjak, he was someone sympathetic to talk to and they had fun on the day they tried to do something they had never ever done before—including a shoplifting spree. In many ways they are, for a few hours at least, like two young teenagers escaping from the cares of an adult world. Indeed, in South America Holly probably had every intention of sending him her address but simply never got round to writing that postcard. Something else came up, possibly some rich man appeared in her life.

In the film, however, Holly does find Cat, and she and Varjak embrace as 'Moon River' is brought up in the background—a conventional romantic ending. And so the Holly of the film is eventually found to have a soft heart hidden beneath her tough, fun-loving exterior. This is certainly not the ending Capote intended; on the other hand there is no reason why a film, a totally different medium, should remain faithful to the ending of the novella.

It goes without saying that Truman Capote himself was not at all happy with the film, and in particular with the casting of Holly and the absurdity of Mr. Yunioshi being played by Mickey Rooney. While he admired Hepburn as an actress, he felt it was an act of 'high treachery' on the part of the producer to use her. The fictional Holly appeared to have been based on a woman Capote had known who was by no means the chic and slender Hepburn. Marilyn Monroe had been Capote's first choice, and later when Capote dreamed of a remake he had Jodie Foster in mind for the role.

On the other hand I must confess to having watched that film many times and to always being captivated by Hepburn. And there you have it. It is not so much that I am enthralled by the character of Holly or by a certain acting ability, but by the Hepburn that shines through the fictional character, by her joy of life, her sense of fun, the speed with which she moves through the film, her changes of mood, and that iconic image of Holly holding the long cigarette holder as she moves through the party in her apartment. (That image was also used by Edie Sedgwick in the film *Factory Girl*.)

But do romantic films really have to end the Hollywood way? One of the greatest and most loved is Michael Curtiz's 1942 *Casablanca* in which Rick does not get the woman in the end—she flies off with Laszlo, the man

who had heroically defied the Nazis, and Rick begins a life on the run with the former Vichy police chief. He tells the Vichy official, in what became one of the most memorable lines from the movies, 'Louis, I think this is the start of a beautiful friendship.' (In fact no one quite knew how the film should end, and it is said that three different endings were written. In the second version Rick 'gets the girl,' and in the third Rick, Laszlo and the woman go off together.)

In another of the great romantic films, David Lean's *Brief Encounter* (1945), Laura does not go off with the handsome doctor with whom she has fallen in love, but returns home to her husband. And in *Now, Voyager* (1942) the character of Charlotte decides that her life is more fulfilled by acting as a surrogate mother to a young girl than by a romantic future with the girl's father. In Sydney Pollack's 1973 *The Way We Were* the love relationship simply doesn't work out. So the Hollywood ending can at times be subverted.

What's more, a Hollywood ending is somewhat of a problem if one of the characters is already dead. At the end of Charlotte Brontë's novel *Wuthering Heights* Heathcliff is distraught at Cathy's death. That was how the 1939 film was shot by William Wyler with Laurence Olivier and Merle Oberon in the starring roles. But the studio, in the shape of Sam Goldwyn, was not too happy about this and wanted an upbeat ending. So why not show the two lovers reunited in 'the place above'? The problem was that the two stars had moved on to other projects and Wyler refused to touch his movie, so a new director was hired and a couple of body doubles were used to create that Hollywood ending—the spirits of Heathcliff and Cathy walking hand-in-hand!

But there is yet another point to make about the ending of *Breakfast at Tiffany's*. There is no reason why a film need be faithful to its literary source, but should it be faithful to the character it has created? Would the Holly, as created by Hepburn and the director Blake Edwards, really have stayed on to be involved in all the legal complications around her dealings with Sally Tomato, or would she have taken that flight and sought her fortune abroad? And would a sophisticated good time girl have really been so innocent as not to figure out she was being used as a stooge by Tomato to smuggle messages out of prison?

Capote's novella was the source for a film that was a considerable commercial success, as well as being Oscar-nominated for best actress, best script and best art direction, and winning two Oscars for the music. Capote himself was also the source of two other films: Bennett Miller's *Capote* of 2005, starring Philip Seymour Hoffman as the author, and Douglas McGrath's *Infamous* of 2006 with Toby Jones as Capote and Sandra Bullock as Harper

Lee. Both deal with the genesis of Capote's book *In Cold Blood*, which had also been made into a film in 1967.

On learning of the murder of the Clutter family in Holcomb, Kansas in November 1959, Capote and his childhood neighbor and lifelong friend Harper Lee, author of *To Kill a Mockingbird*, decided to visit the town in order to research a magazine article about the crime. In this task Harper Lee was very helpful by making friends with the wives of the people Capote wished to interview. Then, as weeks turned into months, Capote realized that his article was evolving into a much bigger project—and claimed he had invented an entirely new form of fiction—the 'nonfiction novel,' a literary genre which depicts real events with the techniques of fiction, which also became known as 'faction.' Today docudrama is a well accepted form in film and television, one in which real footage and real people are mixed in with actors and a script, but at the time Capote felt he was creating an original form of writing, a claim that was disputed by other writers, most notably Norman Mailer. In addition, while Capote boasted that he had an infallible memory and was able to reproduce long passages of dialogue so that every word of the book was true, some critics felt that parts of the book had been created for artistic effect. Both films, *Capote* and *Infamous,* show how Capote spent many hours with one of the killers, Perry Smith, to the extent that he became strongly emotionally involved with the young man.

In the two biopics Capote finds Perry a fascinating character, while his partner in the murder appears to be a brutal and uneducated person. For example, Perry's letters to Capote are filled with long words and elegant turns of phrase; in addition the young man draws in a sensitive manner. What about the killings themselves? In one case Perry provided one of the victims with a pillow so he could rest his head while lying on the floor, and also prevented his partner from making a sexual advance to the daughter of the house. Up to this point in the film one assumes that Perry was an accessory to murder, a somewhat innocent bystander in what had been intended as a simple robbery at gunpoint. It is only when Perry reveals that he killed each member of the family that we realize his capacity for murder, not out of rage or frustration at an aborted robbery, but simply 'in cold blood.'

After all his research and interviews Capote's book was almost finished but lacked an ending. It began with a murder and had to end with an execution, but lawyers were launching appeals and the two men were granted stays of execution. *Capote* portrays the author's deep moral dilemma, for there are two Perrys, the flesh and blood figure with whom Truman Capote formed an emotional tie and the fictional character of 'Perry' that Capote needed to kill off if his book were ever to be published. In a sense the films play with two realities—one is the objective reality of Perry's stays of execution and the other is the inner reality of a novel (albeit 'faction') in which

the killer must pay the price so that symmetry is restored. In the end the execution did take place with Capote as one of the witnesses.

In Cold Blood was serialized in the New Yorker in 1965 and published in hardcover the following year. As the film suggests, the book took a great toll on the writer who never again produced anything of substance but appeared on a variety of television chat shows as 'something of a character' with his high-pitched voice and camp manner. His personal disintegration proceeded via rehabilitation centers, drugs and alcohol, seizures and hallucinations. He died of liver disease in 1984 at the age of 59.

Mailer was correct in claiming that Capote was not the first to create 'nonfiction fiction.' *In Cold Blood* was first serialized in 1965, but Ken Russell had been experimenting with fictionalized television biographies in the early 60s. His film on Edward Elgar, which mixed documentary footage with actors portraying incidents in the composer's life, was aired by the BBC in November 1962. The producer, Huw Weldon, was concerned that the audience would be confused between the character on the screen and the real person. Indeed he insisted that a person dressed up as the poet John Betjeman be cut out of Russell's first biopic of 1959. Two years later he would only allow a shot of hands on a keyboard in the documentary on Prokofiev. So it was only with *Elgar* that Weldon finally relented and allowed an actor to appear as the composer throughout the film, but always in long shot. In fact Weldon was partly right, for a biopic is a convention that must be learned. I recall watching Russell's biopic on the composer Bartok with a number of people, one of whom exclaimed 'But that's not Bartok—who is it?' Russell continued with films on Debussy, Douanier Rousseau, Isadora Duncan and other figures in which their lives were illustrated by actors. Of course it is also true that Capote had been working on his book for a number of years, but clearly similar approaches to fictionalized biography were already in the air.

When it comes to fiction, many writers have explained that, once they have created a character on the page, that person begins to exert a will of their own. Indeed, even if the plot demands it, there are certain things that the author cannot make a character do. In the ancient myth, Pygmalion creates a woman of stone who then takes on a life of her own. Likewise, Rabbi Loew of Prague created the Golem to protect the synagogue and defend the Jews, but the Golem turned into a violent monster. So too, authors feel a responsibility to their characters and cannot force them into situations that are incompatible with the characteristics they have given them. But Hollywood is a different matter; while characters must behave in consistent ways there are other considerations, the most important of which is commercial success, which means satisfying the expectations of the audience.

The relationship of an author to his characters is the theme of Woody Allen's 1977 *Deconstructing Harry*. With three marriages behind him and a dependency on hookers and a variety of medications, Harry is unable to deal with life. He can, however, create order in his fiction using a largely autobiographical range of characters and events. Harry is to be honored by his old university, but even then he can't quite manage things, arriving on the campus with the son he has kidnapped from his divorced wife, a hooker, and a friend who has died in the car during the trip. At the ceremony he is applauded by all the characters he has created. 'I loved creating you,' he says, 'you taught me so much.' Too neurotic to function in life, he can only function in art.

SPLENDOR IN THE GRASS

 Elia Kazan's film, released in 1961, is another love story in which the lovers are not brought together in a romantic Hollywood ending. The film was made in a very interesting time period—the first year of the sixties. In fact the 'swinging sixties,'—a time in which, according to the poet Philip Larkin, 'sexual intercourse began'—did not really start until after the first few of years of the decade. It was only by the mid-sixties that London had begun to swing; it was the age of the Beatles and Rolling Stones, Mary Quant and fashion boutiques, and in the USA the era of psychedelics, counterculture and hippies. The real sexual revolution was brought about by the birth control pill, released in the early 1960s, which allowed young women to have sex without the fear of pregnancy.

Splendor is set in the 1920s, but the morality would be well understood by any young couple who watched it in 1961. It begins with a torrid scene of 'necking' in an open sports car beside a waterfall. The couple are not simply 'in love,' but also caught up in an erotic passion for each other. Bud, played by a very young Warren Beatty, would like to go further than just kissing but Deanie, played by Natalie Wood, protests, at which point Bud angrily gets out of the car. It was a situation that would be very familiar to couples who saw the film when it was first released.

We then see the influence of the two families. Deanie's mother keeps warning her that nice girls don't go 'all the way.' And if they do, they will probably get pregnant and be forced to have 'that operation.' Bud's father is a domineering oilman who dreams that his son will go to Yale and make good in the world. He simply will not listen when his son says he really wants to farm the ranch and marry Deanie, and that he doesn't want to

wait until after he has completed four years of study. In response Bud's father suggests that he should sometimes go with 'another kind of girl.'

In the end Bud can't stand the sexual frustration of only kissing, and suggests that they shouldn't see each other again—in that period people even referred to 'the strain of not being married.' But Deanie herself has begun to have sexual feelings to the point where she feels 'she has no more shame.' However, by now Bud has found a willing girl, at which point Deanie has a breakdown and is sent to a psychiatric hospital where she spends the next two years. Bud for his part is at Yale, and drinking heavily when a waitress in an Italian restaurant befriends him.

In hospital Deanie meets a young man who is qualifying to be a doctor and is clearly attracted to her and proposes marriage. Finally, released from hospital, Deanie returns home and looks for Bud. It turns out that Bud's father has committed suicide during the Wall Street Crash, and that Bud is now farming the family ranch. They meet and Bud introduces her to his wife, the woman from the Italian restaurant, and their young child. Deanie tells him she is getting married. When she returns to the car her friend asks her if she is still in love with Bud. In a voiceover she quotes lines from Wordsworth's 'Ode to Intimations of Immortality':

> Though nothing can bring back the hour
> Of splendor in the grass, of glory in the flower;
> We will grieve not, rather find
> Strength in what remains behind

At school she had been asked the meaning of those lines and she had replied that youth sees the intensity of things but, as you grow up, all you are left with is the memory of what you have left behind.

NEW YORK, NEW YORK

 Martin Scorsese was born in Queens, New York and grew up to know the city and its various streets and buildings well. But there was another New York, the one he saw in the movies. In his introduction to the DVD version of *New York, New York* (1977), Scorsese explains that to him it was like a parallel universe because it wasn't quite the New York he knew—the height of the curb on the sidewalks was never quite right and the extras were always too well dressed. But when he came to make *New York, New York* he accepted the convention of that parallel universe, but inserted two characters whose depth made them much

more real while at the same time inhabiting a somewhat artificial world. Scorsese designed the sets to be deliberately artificial-looking. Jimmy is a jazz saxophonist who, when we meet him, is hustling young women in a bar. At one point he hits on Francine who is rather shy and awkward. Jimmy's aim is to get a job in a band, but he is uncompromising about his music. His jazz playing is too hot for mainstream tastes, and he is not really willing to fall in with others. In fact, his entire character is aggressively directed along a single track. To his surprise he finds that Francine can sing, and the two are hired to perform together with the band.

Francine, however, already has a gig and simply takes off next morning. Eventually Jimmy gets a job with a bigger band and features as one of the main soloists. When he meets up again with Francine, and after some pretty hard talk on his part, she agrees to become the singer in the band. At first she is billed as the band's singer, but soon it is she who has the top billing and the band is merely her backing. Things appear to go smoothly until Francine, now pregnant, says that she no longer wants to tour but will return to New York and do studio work until the baby is born. Jimmy is angry and takes off with the band, abandoning her.

Time passes and Francine has signed a record contract, become a leading artist and even starred in a film. Jimmy has left his band in order to open a jazz club in New York. The two were brought together by music, but the pursuit of their careers took them along very different paths. Francine is now the big star; Jimmy has his club and is playing the uncompromising music he loves. Francine happens to be singing in New York and, at the end of her show, Jimmy goes backstage to talk to her. He tells her he will wait for her outside the stage door. We follow Francine as she walks from her dressing room along the corridor towards the stage door exit. She hesitates and then walks to the elevator. Outside Jimmy has been waiting. He suddenly turns and walks away. The camera focuses on the empty paving stones and the film is over.

THE WAY WE WERE

Like *Splendor in the Grass* and *New York, New York,* Sydney Pollack's 1973 *The Way We Were* is another love story in which the lovers are not united in the end. But it does share something in common with *Breakfast at Tiffany's* in that both films won an Oscar for the best song! The film's plot has a beautiful arc which stretches over several decades and could almost be said to be a dialectical movement

involving not only the attraction between opposites, but also the impossibility of opposites ever truly having a harmonious relationship. Also, as we shall see, there is a crucial omission in the final released version of the film which robs it of its climax, and also led to criticism that the film was too sugary and never really came to grips with one of its main themes—the crisis in Hollywood during the anti-communist witch hunt.

The film is set in different political time periods. We first meet Katie Morosky (Barbara Streisand) in 1944. She is at a club with a group of work friends when she spots an old friend from college days, Hubbell Gardner, a writer, who is perched drunk at the bar. We now flash back to the 1930s, a time when Hubbell, a jock, was the highly popular center of the in-crowd of sophisticated students who were joking their way through life. By contrast Katie, who could never be a member of their frat house because she is a Jew, is a student with deep political convictions, concerned about the Spanish Civil War and president of the Young Communist League, the sort of over-serious person who can so easily become the butt of other people's jokes. For Katie everything in life is a principle to be fought for, while for Hubbell and his friends people are more important and he is therefore willing to make a series of compromises in life.

Flash forward to 1944 where Hubbell wakes at the bar and recognizes Katie. She gives him her phone number and offers her apartment should he ever need a place to stay when he is in New York. She tells him she has read his novel and thinks the writing is 'gorgeous,' but that he always views his characters from a distance. Soon they are living together, and Hubbell has written a second novel with a chance to sell the rights to Hollywood. Everything seems perfect, except when Katie is with Hubbell's close friend JJ and his group. Katie sees them as being trivial and uncommitted, with the result that she simply cannot prevent herself from blurting out remarks that insult them. In the end Hubbell fears that their relationship is going nowhere since all that her politics amounts to is constant fighting and anger. She pushes too hard, she expects too much and simply cannot enjoy living.

We now move forward to 1947 when Katie and Hubbell are living in Hollywood, and he is working on a third draft of the script from his novel for the film that JJ will direct. Katie dreams of going to live with Hubbell in France where he will begin a new novel. She tells him that she is pregnant, and we also learn that there is trouble in paradise, for the anti-communist witch-hunt is focusing on Hollywood. Even the home of Hubbell's producer has been bugged. What's more, it looks as if JJ and his wife are about to split up.

In the movie a microphone is discovered hidden behind a Picasso in the producer's home. Screenwriter Arthur Laurents got the idea from a real

incident he had witnessed. During a Hollywood party, Charlie Chaplin, fooling around for the other guests, knocked a Matisse off the wall. A microphone was found concealed behind the painting—conversations in the room were being monitored.

Things quickly come to a head when Katie and her friends at the studio decide to go to Washington in support of the 'Hollywood Ten.' She suggests that Hubbell should go with them; in reply he asks her to stay home. For Katie it is a matter of principle. For Hubbell people come before principles, and so many people are going to get hurt, since by now rumors have begun to circulate that 'unfriendly witnesses' and other tainted individuals will no longer be hired by the studios. As if that wasn't enough, Hubbell is having problems at the studio where the producer wants to make changes to the script based on his book. In a tense scene the producer suggests that, with so many changes, Hubbell may no longer be the man for the job. His friend JJ sits in silence at the meeting and does not support him. Hubbell leaves the meeting to find JJ's wife waiting for him. She is leaving for New York next morning, but has some champagne if Hubbell wants to come over.

Finally Hubbell's movie is screened. When the others leave he is left alone with Katie who is unhappy with the way he has compromised his book in order to make the film. She also makes it clear that she knows he has slept with JJ's wife, yet all she wants is for them to love each other. It is at this point that the released version of the film, what in fact is the true 'director's cut,' falls apart. There is a brief happy scene in which Hubbell and JJ drink together on JJ's boat, and JJ says that, yes, his wife has left, but it's not as if it were Katie who was leaving Hubbell. Then we suddenly cut to Hubbell and Katie alone. She speaks as if their relationship were a thing of the past, and of the way decisions are forced upon one. She has only a single request: that he will stay with her until the baby is born before they go their separate ways. It is a scene that comes out of nowhere. One moment JJ and Hubbell are enjoying a drink and, despite the tensions between them, it seems impossible that Katie and Hubbell would ever split up, and the next that is exactly what they are doing.

According to director Sydney Pollack, the Friday night preview of the movie did not meet with much success and so he went through the film cutting it by seven minutes and eliminating five scenes that dealt with the political issues. On the following day the film was shown again and was more successful. As for the cut scenes, according to the writer Laurents one of them was the climax of the entire film. It was a scene in which Hubbell tells Katie that she has been named as a former Communist. For Hubbell this will be the end of his Hollywood career. If he is to continue the life he loves, the only solution that Katie can see is that they should divorce, and so the decision is forced on them.

We jump forward in time to New York in winter. Katie is a little older now, and spots Hubbell coming out of a hotel with a younger woman and about to get into a taxi. The two speak, and he tells her he is in New York to do a TV show—presumably yet another compromise, another step down the ladder. He asks about Katie's marriage. They embrace and then she walks across the road to hand out Ban the Bomb leaflets. She hears a voice, 'You never give up, do you?' It is Hubbell. They embrace again and he asks about his daughter. Katie says 'You would be proud of her,' and suggests that he comes over to see them, but he replies that he could never do that and crosses the road again to his taxi. Katie moves along the street handing out flyers; in a crane shot we rise above the street and soon lose Katie in the crowds, Streisand's voice singing 'The Way We Were' is brought up, and the credits roll.

For Pollack the cuts were justified since, by losing the political scenes, he kept the focus on the relationship between Katie and Hubbell. For the screenwriter, however, the climax of the film had been lost and he regretted the way decisions were made around a Moviola editing machine without a deeper consideration of the film itself. As for Streisand, 'It killed me to have those two scenes taken out.' The scenes she refers to are the climax where divorce is decided, and another scene in which she is driving past the UCLA campus and sees a young woman addressing a group of students. She stops the car to watch and, as she sees the passion with which the student speaks, she recalls her own uncompromised youth and begins to cry.

And the verdict of the critics who write the DVD guides you buy today? Yes, Streisand was right, the film glosses over a key era in Hollywood and does not treat the dilemma of the witch-hunt, and the compromised writers, actors and directors, with sufficient depth. Maybe what's needed is an actor's cut rather than a director's cut!! One other point: as we have seen with other examples, it is possible to make a moving love story in which the two characters are not united in the end.

Hollywood and anticommunism

HIGH NOON

 Another film that is sometimes associated with the anti-communist atmosphere of that period is Fred Zinnermann's *High Noon* of 1952, one of the all-time great Westerns written by Carl Foreman shortly before he was blacklisted. Will Kane, played by Gary Cooper, has reason to celebrate, for it is both the day of his wedding and his final day as town marshal. Tomorrow he will be leaving to start a new life with his bride. But then he is told that a man he sent to jail many years ago is arriving on the noon train and intends to kill him. When Kane turns to his friends for support they advise him that the best thing is to leave town at once. Even his wife, a pacifist Quaker, persuades him to flee.

With no one to assist him Kane waits for the noon train. Dramatic unity is beautifully maintained with the ticking clock in the marshal's office, the minute hand slowly moving towards 12 noon (the story is told in real time), and then the train in the distance as it approaches the station. Kane is a man totally alone, his friends have abandoned him and the clock is ticking to that moment when guns will be drawn. Like so many others who suffered the witch-hunts in Hollywood, and academia, his friends are too frightened to offer support.

ON THE WATERFRONT

 The post-war scenes of *The Way We Were* are clearly set against the background of the anti-communist witch-hunt which destroyed so many careers and lives in the United States. It was the time when some in the film industry were willing to save their skins by naming names while others, such as Joseph Losey, had to go into exile. Dalton Trumbo could only continue to write by using an alias on his scripts (albeit winning two Oscars under pseudonyms). One of those willing to give names was the director Elia Kazan. It was an act that was never forgiven in some quarters, and when he was given an Oscar for his lifetime achievement in 1999, some prominent personalities in the film industry refused to applaud. Kazan himself felt he had done the right thing and had made a film that attempted to justify his position—*On the Waterfront* (1954).

It concerns a young longshoreman, Terry Malloy, played by Marlon Brando, who had aspirations in the world of boxing but never made it to the top. It was the film that won Brando his first Academy Award. Malloy is befriended by the local mob boss, Johnny Friendly. This was the period in which there was enormous corruption and racketeering on the Manhattan and Brooklyn waterfronts, and mob rule was maintained by beatings and executions. When Terry's friend is killed, the local priest and the friend's sister persuade Terry that he must go against the mob, but for Terry this also means betraying Johnny Friendly.

No one who has seen the film will ever forget that scene in the back of Friendly's car when the two men talk together, or rather Friendly talks and Johnny mumbles—issuing the famous line 'I could'a been a contender.' In the end Terry is willing to testify against the mob. He becomes an outcast, like Kazan himself, and is badly beaten, but manages to get to his feet and walk to work. His courage inspires other longshoremen.

This was Kazan's attempt at justification for his own actions—the heroic informer—and in doing this he made one of the truly great movies with a magnificent performance by Brando. But one is left with a certain sense of irony, for the original screenplay had been written by Arthur Miller, himself politically suspect. Miller was replaced as writer by Budd Schulberg who had been a 'friendly' witness to the Un-American Activities Committee. Miller produced a reply to Kazan in his own play about a longshoreman, *A View from the Bridge* which presents a contrasting view and was first staged in 1955. In 1953 he had also made a thinly veiled attack on witch-hunts with his play *The Crucible* which examined the events surrounding the Salem witch trials in colonial Massachusetts.

IV.
Films about films

Our sense of what is real, concrete and hard and fast underwent some profound changes during the previous century and this is very much reflected in film. Indeed, at times films may even seem more real than the everyday world around us. And so films can indeed become the raw material of yet other films.

THE CONFESSIONAL

In 1952 Hitchcock shot *I Confess* on location in Quebec. It is a film in which a priest, Father Logan, hears the confession of a man who has just committed a murder. In the course of police enquires Father Logan himself comes under suspicion when they learn that a young woman has been blackmailing him (he had an affair with her before entering the priesthood). However, because he is bound by the seal of the confessional he is unable to clear himself. Hitchcock, a Catholic, chose to shoot in Quebec because he felt the location should be one in which the notion of the seal of the confessional would be taken seriously by the general community.

In 1995 the Quebec director Robert Lepage released his own film, *The Confessional (Le Confessionnal)*, which is also shot in Quebec and is a magnificent homage to Hitchcock. The film is set in two different time periods: 1952 while Hitchcock is shooting his film, and in the present when a young man, Pierre, returns for his father's funeral. In part it is a mystery about a man trying to discover his origins and the identity of his father, and in this context evokes the story of Oedipus. It is again the story of a priest who hears a confession, is bound by its seal, and then comes under suspicion. A further reference is to the condition of vertigo, which affects the lives of several of the protagonists, and points us to Hitchcock's *Vertigo*. It is also about the way the past can haunt the present, symbolized by Pierre painting over the yellow and white patterned wall of his boyhood home, first with two coats of red, then with a coat of green, only to have the original pattern always showing though the fresh paint.

The film opens in 1952 with Hitchcock, played by Ron Burrage, and his female assistant. We see the opening frames of Hitchcock's black and white *I Confess* with the camera pulling back to show the Quebec audience watching the premiere. We then cut to the present day when Pierre has returned to his deserted family home for his father's funeral and is concerned that his younger brother Marc has not turned up. He also wonders why his father never took control of his diabetes to the point where he allowed himself to go blind.

It is at this point we see the magnificent way in which Lepage moves between past and present. We see a shot of the father's coffin in the church from the congregation's point of view and then from that of the priest, and we realize there are only two mourners at the funeral—everyone else from the past has died. The camera begins to dolly down the church from empty pew to empty pew, to a person kneeling and on to filled pews for, without a single edit, fade or flashback, we are back in 1952. The camera stops at the end of the church and moves forward to the confessional box. In another church scene, set in 1952, we are at the end of the service; the organ plays, the priest leaves the altar, walks to the side of the church, switches off a CD player and takes out a CD of organ music, we are now in back the present.

As the film progresses we learn of Pierre's devoutly Catholic working-class family. We meet his mother's sister, Rachel, who works as a cleaner for the church and is living with the family. Pierre's mother and father are radiantly happy in the bath together until blood suddenly colors the water—she is having another miscarriage. She is increasingly distressed at her inability to bear another child.

We then see Rachel, in the confessional box speaking to Father Massicotte. She is desperate; she has done something terribly evil, something so horrible she can't speak about it. It turns out that Rachel is pregnant and rumors begin to circulate about the length of time she spends in Father Massicotte's confessional. Clearly he must be the father of her child, and in the end he is dismissed. After the baby is born Rachel commits suicide.

In the present day we learn of Pierre's search for his brother. He discovers that Marc has been seeing a man called Massicotte and suspects that he may be acting as a rent boy. When he finally does confront Marc, his brother explains that he did not come to the funeral because he was never close to his father; after all, he was adopted. He now wants to find his real father and Pierre recalls rumors from his childhood that the father could have been a priest. He becomes so upset that he has an attack of vertigo—a significant hint of what may come later.

Pierre encounters Mr. Massicotte, who now has business dealings in Japan. He asks why Massicotte doesn't leave his brother alone, for there are plenty of other young men who will service him while thinking of their girl-friends. For his part Massicotte tells Pierre he knows the identity of Marc's father, but cannot speak as he is bound by the seal of the confessional.

In a remarkable sequence at the high point of the film, past and present are further entwined. We see Massicotte and Marc in Japan, then Hitchcock setting up the scene in which Father Logan is going to walk to the back of the church and hear the murderer's confession. Hitchcock calls 'Action' and the priest begins to walk. The film cuts to the black and white confessional scene from Hitchcock's *I Confess*, to Pierre's mother holding the new baby, to Rachel putting on her coat and going out into the night, to the way paint from the past is showing through the fresh paint on Pierre's wall, to Marc sitting on the edge of the bath, to Rachel on the bridge, to the priest returning towards the camera on the set. Hitchcock shouts 'Cut' and Marc cuts his wrist. A Hitchcock-like overhead shot reveals the bath filling with blood, an overhead shot of Rachel in the river, which is also stained red, to Pierre speaking on the phone and screaming 'No! No! No!' to a black and white view of Hitchcock's film with the words 'The End.'

Hitchcock's film is over and the 1952 audience applauds. Hitchcock walks out of the cinema and gets into a taxi. The driver is Pierre's father. He begins to tell Hitchcock an idea for a film. This is intercut with Pierre confronting Massicotte; Marc's young son is also in the room. Pierre asks why Massicotte took his brother to Japan and why he killed himself. Massicotte remarks, 'Poor Pierre, you need a culprit.' Pierre is angry, he says that the young boy is diabetic, that his mother is a dancer and that he's just going to be dragged from bar to bar. Massicotte writes a check and, as Pierre is about to leave, asks him to take care of the boy and of his diabetes. He tells him that the first symptoms can begin with vertigo and that, if not treated properly, it can lead to blindness. He mentions that Marc himself never wanted to be tested because it is a hereditary disease.

We are back in the cab with Hitchcock listening to the story of a couple. The wife is increasingly depressed because she cannot have a child and doesn't feel like a real woman. Her sister is young and beautiful and full of life. The husband cannot resist her, and she becomes pregnant. In order to avoid distressing his wife they blame it on another man, a priest. But the sister feels guilty and kills herself. Hitchcock asks what happened to the man. Pierre's father says he could never love the child, and after seeing so much suffering he plucked out his eyes. Hitchcock says 'That's not a suspense story. That's a Greek tragedy.'

In a voice-over Pierre says that the present carries the past on its shoulders. Pierre has Marc's son perched on his shoulder. They come to the bridge

where Rachel committed suicide. Pierre says, 'Let's play tight rope. I won't let you drop.' The camera dollies along to follow Pierre, a man we know has vertigo, walking on the outer rail of the bridge, but then the camera moves ahead until Pierre is out of frame. The camera continues, the music increases in volume and we wait for a splash but the film has ended.

CINEMA PARADISO

In Giuseppe Tornatore's *Cinema Paradiso* (1988) a successful film director, Salvatore ('Totò,') learns of the death of Alfredo in his home town, and his mind goes back to those years in small-town Italy where he grew up. Alfredo, the projectionist at the local cinema, befriended Totò as a child, and we learn just how important cinema was in the life of Italians of that period. We see the reactions of the audience who call out to the actors. We watch as the priest censors the films by having scenes of kissing edited out. We realize that, to Italians, the comic actor Totò (Antonio de Curtis) had a reputation as great as Chaplin to Americans. Indeed, in one wonderful scene when the cinema is packed out and people are in the square clamoring to get in, Alfredo directs the projector out of the window so that Totò can be seen on the wall opposite.

The boy is deeply attached to Alfredo and looks up to him. He watches Alfredo work, and is even allowed to operate the projectors by himself. But Alfredo has bigger dreams for Totò; he must not cling to his village, but obtain a good education and see the wider world, even if it means that at times he must speak harshly to the boy.

There is conflict in the boy's mind about his relationship to Alfredo until a tragedy occurs. Those were the days of inflammable nitrate film stock. One day a fire breaks out in one of the projectors, Alfredo is badly burned, and part of the cinema is destroyed. This is also a marker in time, for from that period onwards the village itself begins to change; the close-knit life has weakened, and when the cinema is reopened it is a much more modern affair. And so the young man leaves his native village only to return many years later for Alfredo's funeral. So much is gone, yet one treasure, one memory of Alfredo, remains. It is a reel of film spliced together from all those tiny scenes that the priest had censored over the years, and so after the funeral Totò settles down to watch the past.

And here I would like to add a personal note. For over fourteen years I have been living in the small Italian village of Pari, and for one night during the summer a projectionist will arrive and set up the projector in the village

square and show us a film. People sit on benches or bring out their own chairs, some stand by the bar with a drink in their hand. The projector is switched on and we all enjoy the film together. Deep down film can still be something that brings people together, maybe a ritual that goes right back to the Greeks and the origins of theater. But now the reader might ask, 'This only happens once a year, what about all those other evenings? Aren't people stuck in front of their television sets?' Well not quite, for some men still go to the bar to play cards of an evening, and in summer women sit in a circle of chairs in the square. And television? Well it's true that it is watched. But a few people who switch on their sets in the summer months leave their front door open and place a chair on the street so that they can sit and watch but still feel they are part of the community! And the young people often assemble together to watch the television screen in the village hall.

But, like the village in *Cinema Paradiso*, and at around the same time, the village of Pari also changed. Once upon a time the village had a band that played for dances, festivals and even for outdoor opera staged in the village square. Then one day, fifty or sixty years ago, a villager visited the nearest big town and returned with a gramophone. Slowly the village band died out and the music-making ended.

Terence Davies: THE LONG DAY CLOSES and DISTANT VOICES, STILL LIVES

 Homage is also paid to the cinema in two films by Terence Davies. As with *Cinema Paradiso*, both portray a young boy growing up in a post-war world, but instead of Italy this time it is Davies' Liverpool. In *The Long Day Closes* (1992) we see the boy at home with his family, playing in a street of row housing, characteristic of working-class Liverpool, and finally sitting in the cinema. Davies, like Tarkovsky, is one of those directors who uses shots of exceptionally long duration. In one of them, for example, we actually see the light from the sun moving across the carpet. Snippets of movie soundtracks and popular songs from the period infuse the boy's drab existence. At the end of *The Long Day Closes* the boy is in the cinema watching a movie and voices sing the hymn 'The long day closes.'

Distant Voices, Still Lives (1988) portrays the same situation a few years earlier in time. Post-war Liverpool is a dirty and depressing place and the family situation is exacerbated by a rather brutal father. But one can escape through cinema and radio, and so the meanness of the city is contrasted with the escapism of the world of popular songs from the movies. In a way these are both autobiographical films, as are the opening pages of Davies' novel *Hallelujah Now*. It is almost as if the cinema was the one factor that saved his life that gave him a reason not simply to live, but to rise above a dark and depressing childhood of rationing, bombed-out buildings and a home where the father is an angry bully.

Davies' encounter with the cinema took place in post-war Liverpool and had a profound effect upon his life. But what effects could we expect on a young teenager today? Cinema, as a location, such as a multiplex, in which numbers of people sit together in the dark, will probably not be much of an influence. Rather teenagers are exposed to computers, Playstations, iPods and the unfolding world of virtual reality. Without ever having been taught, most pre-teens intuitively learn about a world that can be brought to them at the click of a mouse. And this is significant because the work of neuroscientists such as Eric Kandel has shown the high degree to which the brain could be said to be 'plastic,' that is, capable of rewiring as it experiences the world. Educators have now realized, because of the environment in which they grow up, the extent to which children's brains are wired in different ways to those of adults. In other words they learn in different ways and experience the world in different ways. In the next decade or two those children will mature and enter the world of entertainment and communication to produce—what? Movies, virtual reality bites, electronic experiences that may be very different from what we currently conceive as 'film.'

SUNSET BLVD.

 One of the great classic films about film is Billy Wilder's 1950 *Sunset Blvd*. (There is an interesting ambiguity about the film's actual title. The opening shot is of the street with its sign, 'Sunset Blvd.,' at sidewalk level followed by the opening credits. But the poster and trailer for the film, as well as its listing in the Oscars, refer to it as Sunset Boulevard.) It is a Hollywood film about Hollywood itself, and its depth comes from the remarkable nature of the casting. But first a rough guide to the plot. The film begins with a shot of police cars pulling into the driveway of a large house and police going round to the back where they find a body floating in the swimming pool.

We meet Joe Gillis, a screenwriter who has reached a low point in his career. Unable to sell a story, he is behind with his rent and pursued by two men with a court order to repossess his car. In desperation he turns into the driveway of what he supposes to be a deserted mansion on Sunset Boulevard. However, the house is not empty, but home to an eccentric fifty-year-old woman and her manservant, Max (played by the director Erich von Stroheim). Gillis recognizes the woman as Norma Desmond (played by Gloria Swanson), one of the great stars of the silent screen who has not worked in film for twenty years. She now lives surrounded by her photographs and memorabilia, and a screen in her living room where she watches her past successes. 'We didn't need dialogue,' she says, 'We had faces.' (Her role was inspired by Norma Talmadge who was also caricatured in *Singin' in the Rain* as Lina Lamont, an actress who could not adjust to films with sound, just as Talmadge's own career had failed with the introduction of talkies.)

The demented Norma, dreaming of a comeback and of the fans who are eagerly awaiting her return, persuades Gillis to work on a script she has drafted about Salome. Gillis moves into the house and, in essence, becomes Norma's toy boy. Finally the script is delivered to Cecil B. DeMille. When Norma does not hear from the studio she makes a visit to Paramount where DeMille greets her warmly but, because of their long friendship, is unable to let her down directly and so engages in some vague hints about working in the future.

Max the butler, we learn, was the director who discovered her as a young woman and made her first films. Meanwhile Gillis becomes involved with one of the studio readers, Betty Schaefer, and the two work together on a script at night. Naturally Gillis falls in love with Betty, and in the end decides to pack his bags and leave Norma's mansion. At this point Norma shoots him, leaving him dead as in the opening shots.

Norma is arrested and, as she walks down her elegant staircase, the press, including two news cameras, are waiting for her. As she descends, Max shouts 'Action' and directs her, telling her it is a scene from *Salome*. She makes baroque gestures and then gives a little speech to DeMille, who of course is not present, saying how happy she is to be back at the studios, and announces 'All right Mr. DeMille, I'm ready for my close-up.'

That is the plot, but what is truly remarkable is the casting. Gillis is played by William Holden who had starred in many films but was now at a low point of his career, very much like the character he portrays. As for Gloria Swanson, she had been virtually forgotten by a new generation of cinema-going public. While in the past she had been a very great star, her last film was something of a flop and she could no longer find work. Ironically Erich von Stroheim, who plays her butler, had in fact directed

this flop. Thus on one level it is a fictional film, yet on another those who present this fiction are in a sense playing aspects of their own lives. Even the roles of Cecil B. DeMille, Buster Keaton and Hedda Hopper are played by themselves.

V.
Documentary

Documentary is a term that suggests the sorts of things we see on television about the extinction of the dinosaurs, the D-Day landings, or the life of Einstein. Documentaries themselves range from attempts to present a purely objective report on a subject or situation to those in which the filmmaker sees events from his or her own perspective or presents a particular political point of view.

It is often difficult to achieve total objectivity and, at the same time, remain interesting. While the Lumière brothers' films of a train entering a station, or workers leaving a factory, were truly objective documentaries, they only occupy a few minutes of our attention. After this the filmmaker, no matter how objective he or she sets out to be, must be involved in selecting camera angles, editing shots together and adding a soundtrack, and this is where a more personal vision comes in.

There are people such as Michael Moore who have a particular point to make—some would say an axe to grind. In *Bowling for Columbine* (2002) it is not so much the availability of hand guns that is the problem in American society, according to Moore (a lifelong NRA member), but the culture in which they are used. Or in *Sicko* (2007) Moore's thrust is that health coverage in the United States leaves a great deal to be desired. Another documentary with a message was Morgan Spurlock's 2004 *Supersize Me* about the alarming results of a continuous diet of fast food. Mark Sachbar's *The Corporation* (2003) and Alex Gibney's *Enron: The Smartest Guys in the Room* (2005) explore the world of business. These sorts of documentaries can be valuable in exposing social problems, but may also come under criticism for being biased since, by adopting a particular point of view, they become selective in what they show and what they leave out. In fact the filmmakers make no claim to objectivity, but aim at being persuasive, eye-opening, even shocking.

This is also true of one of what is considered to be the first feature-length documentary, Robert J. Flaherty's *Nanook of the North* (1922), which tells the story of an Inuit hunter and his family in the Canadian Arctic. It certainly revealed a world that the general public knew very little about. Yet Flaherty was accused of staging some scenes, of picturing Nanook as 'the noble savage,' and of making the Inuit use spears whereas they were now

using guns for their walrus and seal hunts. Flaherty also exaggerated the peril to Inuit hunters with his claim, often repeated, that Nanook had died of starvation two years after the film was completed, whereas in fact he died at home, probably of tuberculosis.

So again we must ask, are we being given an actuality, an authentic slice of the real world, or is it something manufactured? Is the documentary in fact a confabulation, a creation of what we would like to see? One could assume that wild life documentaries are informative and authentic reports on the behavior of animals we may never see in the flesh. But, out of the months and years of a particular animal's life, just what has been selected? Has the drama been heightened, has that particular animal been framed in a somewhat artificial context?

I well recall the BBC wildlife documentaries of Armand and Michaela Dennis during the 1950s and 60s. They created the illusion that Armand and his wife were alone on safari with a Land Rover and technical equipment, having adventures, coming across wild animals, or viewing the curious habits of the 'natives.' Of course they were nothing of the kind, they had a film crew with them!

One of the greatest of all documentaries from a visual and technical point of view is Leni Riefenstahl's 1936 *The Triumph of the Will*. The problem is that its hero is Adolf Hitler, and the Nazis with their rallies and marches are shown as beings of heroic proportions. It is generally regarded as the greatest propaganda film of all time. Another film that dealt with the consequences of war, this time from the perspective of the French, was Marcel Ophüls' *The Sorrow and the Pity* (1971), which showed the variety of experiences of the French people under German Occupation.

There are also cases where the feature film and documentary dance around each other and play with each other's convention. Notice how, in a feature film, if some 'fact' about the past is to be established, it may be shown as a piece of black and white film with a strident commentary, as if to suggest that it is part of a newsreel and so is 'factual.'

Orson Welles' *Citizen Kane* (1944) in part adopts the convention that it is a documentary exploration of the life of Charles Foster Kane. After the opening scenes introducing Kane's death, with the snowstorm in a glass ball rolling from his hand, we cut to a supposed documentary film about Kane. That documentary ends, and we find ourselves in a screening room where groups of reporters are discussing how to get the true story about Kane.

A variety of other feature films employ the device of the mock-documentary. Fellini's *Clowns*, (1970), *Fellini's Roma*, (1972), *Orchestra Rehearsal* (1978), and *Intervista* (1987) are clearly works of great imagination, but 'pretend' to be documentaries, even to the point of having the

filmmaker interviewed. Larry Charles' 2006 *Borat: Cultural Learnings of America for Make Benefit Glorious Nation of Kazakhstan* adopted the convention that a filmmaker is making a TV documentary about American life and is interviewing unsuspecting bystanders. Some found the film extremely funny, while others found it offensive that Sacha Baron Cohen, in the role of Borat, was taking advantage of people's politeness and good manners. Yet others were suspicious that Borat's victims were not all that innocent of the fact that they were in a spoof documentary.

Then there have been documentaries about the making of films. Werner Herzog's 1982 film *Fitzcarraldo* is about a man who has the grandiose plan of building an opera house in the Peruvian jungle. In order to achieve his dream he must have a 320-ton steamship hauled over a mountain using the labor of local Indians. Fitzcarraldo becomes obsessed with the task, and Les Blank's 1982 documentary *Burden of Dreams* shows the way Herzog himself became victim of a similar obsession in order to get his film made. For nearly five years Herzog desperately tried to complete this ambitious project; *Burden of Dreams* is an extraordinary document of the film-making process and a unique look into the single-minded mission of one of cinema's most daring directors. Plane crashes, disease, mud and a war between the indigenous people of Peru and Ecuador are just some of the obstacles standing in the way of Herzog's completing one of the most difficult films of his career. And when Klaus Kinski (who played Fitzcarraldo) said he would walk off the film, Herzog threatened to shoot him.

Francis Ford Coppola's 1979 *Apocalypse Now* is based on Joseph Conrad's 1899 novella, *Heart of Darkness*, in which Kurtz is a European living in the depths of the African jungle; his last words are 'The horror! The horror!' In Coppola's film, Kurtz becomes a renegade American colonel who is running his own private war deep in the heart of Cambodia. Captain Willard, played by Martin Sheen, is given the task of tracking down Kurtz. Coppola's wife Eleanor shot an interesting documentary *Hearts of Darkness: A Filmmaker's Apocalypse* about the making of the film in which we see how an initial planned shooting schedule of three months extended to fourteen months as the crew experienced more and more difficulties, including extremely bad weather that destroyed several expensive sets. In addition, the release date of the film was delayed several times as Coppola struggled with self-doubt and how to come up with an ending as well as how to edit the millions of feet of footage that he had shot. Marlon Brando arrived on the set overweight and unprepared, Martin Sheen suffered a heart attack, and many cast members, most notably Dennis Hopper, were high on drugs for much of the time.

In discussing documentaries I'd like to single out one organization in particular for its long tradition of excellence, and that is the National

Film Board of Canada (NFB). It was founded thanks to the energies of the Scotsman, John Grierson, who was one of the pioneers of the documentary film. Indeed it was he who, in 1926, coined the term 'documentary' to describe a nonfiction film. He produced the 1936 film *Night Mail*, about mail traveling from London to Glasgow by train, that featured a score by Benjamin Britten and a verse narration written by W.H. Auden.

When Grierson went to Canada he met the then Canadian prime minister, William Lyon Mackenzie King. Mackenzie King's pet dog had died, and at moments of important decision he would talk to the spirit of dead dog. I well remember seeing an interview with Grierson in which he spoke about founding the Film Board and approaching King. When he learned that the prime minister consulted a dead animal, Grierson said 'That is the man for me!'

The NFB has made a wide range of documentaries. A particular talent was Norman McLaren who, at the invitation of Grierson, moved from Scotland to Canada to open an animation unit. Amongst other things, he painted directly onto raw film stock and created a soundtrack by scratching the area used for the optical soundtrack. He also filmed figures, such as the dancers in *Pas de deux* (1968), against a black background, and then used a system of multiple exposures so that the figures appeared to flow in and out of each other.

And at this point let me turn back to quantum reality. As we have seen, the development of quantum theory has caused physicists to question the nature of the hard and fast reality we see around us and, in particular, the nature of space and time. For a number of years I was associated with the theoretical physicist, David Bohm, who felt that quantum theory required a radical new order to the way we see the world, one that would replace the mechanistic order characterized by Newton's physics. He called the traditional way of seeing the ordinary world, the world of well-defined objects located in space and time, the Explicate Order. But behind that world lay something deeper which he called the Implicate Order. The reality we see around us is constantly unfolding and folding back again from this underlying Implicate Order. What is more, while in our everyday reality we take mind and matter to be two distinct and separate things, they turn out to be two aspects of one reality in the Implicate Order.

In discussing these ideas with Bohm, I asked him if he had an example that could give us an insight into the Implicate Order. He replied that the films of Norman McLaren such as *Pas de deux*, using multiple exposures, were the closest he had ever seen anyone come to capturing the spirit of his idea. I attempted to arrange a meeting between the two men when Bohm was spending two months in Canada. Unfortunately I was unsuccessful as both were suffering from ill-health.

Film creating reality

While this book is essentially about cinema it is interesting to look at another technological revolution involving film that changed the way we see the world. Up until the early 1970s most television news made use of film. But film is expensive, so camera operators would only press the camera button if they felt they could get a truly significant shot or record an important statement. What is more this film would then have to be driven to a laboratory for developing and, if the story was set in a remote location, then flown to the television studio. The result was that scenes of a disaster or demonstration were generally only shown on the news on the following day. But video was much cheaper and could be reused. And so with the advent of video news cameras 'the news' became a same day event and the public had the sense that they were now watching 'instant news.'

In *1968: The year that rocked the world* Mark Kurlansky makes another point about how film used in television news not only influenced our perception of reality but even helped to create that reality. Political leaders and demonstrators realized that a news film camera would only start rolling when something significant was happening. Reporters soon began to notice that in Senate debates, for example, someone would suddenly raise their voice. It was not because they happened to be making a more significant point but simply so the camera would be pointed at them. It was not long before figures such as Abbie Hoffman and Stokely Carmichael were learning how to take the next steps to grab media attention and manipulate the way a story was told. In this way the dramatic events that transformed society in 1968 were in part caused by the way television media worked.

VI.
Directors

Each of us sees the world in a different way. Present a person with a series of photographs and monitor their rapid eye movements as they scan the images. It soon becomes clear that each person is seeking out and extracting different pieces of information. In other words, they judge that certain parts of a scene are more important than others. The different ways in which we see the world arise in complex ways. In part they are determined by the manner in which we were brought up, the society in which we live, the sorts of relationships we have, the type of work we do, and even the language we speak. The Whorf-Sapir hypothesis suggests that there is an intimate relationship between our worldview and the language we speak. The Blackfoot language, for example, is very rich in its use of verbs and, not surprisingly, the world they experience is one of eternal flux and change.

So how does a particular way of seeing and experiencing the world on the part of an individual film director manifest itself in the films he or she makes?

HITCHCOCK

The name 'Hitchcock' conjures up images of suspense and the psychological thriller, of someone whose often mundane everyday life is suddenly disrupted by the unexpected and menacing, or of characters whose outward appearance and manner conceals something much darker. Indeed, Hitchcock is a something of a puzzle.

Suppose we take a piece of paper and, on the left hand side, write the names of the 'Great Directors' such Eisenstein, Welles, Antonioni, Kurosawa, Bergman, and so on. These are the directors who appeal to the patrons of the art houses. On the other side we write such names as Spielberg, Lucas, Coppola, Scorsese, etc. Those are the directors who fill the cinemas, appeal to a wide general public, and whose videos are the most borrowed. So where do we put Hitchcock? Surely on the right hand side as a maker of

movies with a highly popular appeal, someone who entertains but is not to be taken too seriously.

But that is not how the French intellectuals saw him. Directors of the French New Wave cinema (La Nouvelle Vague) such as Truffaut, Éric Rohmer and Claude Chabrol, writing in *Cahiers du cinema,* were full of praise for Hitchcock and used him as a cornerstone of what became known as the 'auteur' theory. This is the suggestion that the true author of a film is the director, such as Hitchcock, for it is he or she who is the authentic integrating principle behind a film rather than the scriptwriter, cinematographer or leading actors.

Hitchcock was taken seriously by the writers for *Cahiers,* and there are good reasons why they did so. Earlier I hinted that Hitchcock's ultimate appeal involves the creation and disruption of 'mental spaces,' of which he is a master. We have met the linguist Fauconnier's notion that, when we have a conversation (and this could equally apply to reading a novel, watching a film or going to the theater), we begin to create a 'mental space' of what the speaker, director or writer is pointing towards. It may be something to do with a relationship, a particular situation, or a place we have visited. As the dialogue continues we enrich that space, adding more detail and nuance. But then it may turn out that we have made an unwarranted assumption about this space, that we have jumped to a conclusion too quickly, or glossed over an important clue. At this point our mental space begins to disintegrate or becomes inconsistent, and we must retrace our steps to rebuild it.

This is exactly where Hitchcock's strength lies. He begins so many of his films in a gentle way, showing the protagonist in a relaxed situation and encouraging us to create our own storyline, our own vision of reality. And it is then that Hitchcock strikes. In a sudden twist, the innocent person is shown to be a killer, the sympathetic female figure to be deeply deceptive, the safe location to be filled with menace. Hitchcock tears down the defenses of our naive view of the world and shows us how easy it is to be lulled into comfortable self-deception. But Hitchcock's vision of reality has been there all along, it is we who are guilty of ignoring it.

Certainly if someone consistently makes films that appeal to a wide public and, at the same time, are satisfying to a more sophisticated audience, there is a deep reason. That director has to be tapping into some significant psychological vein. In Hitchcock's films the main characters and the plots all have an archetypical sense about them. There is, for example, the male protagonist, of which Cary Grant would be a model. He is urbane and witty, a long way from the sorts of characters who are involved in crime and menace—yet he will soon be fighting for his life or to prove his innocence.

Then there is 'the blonde.' Hitchcock's blondes are strong, beautiful, cool and smart, and played by such greats as Grace Kelly, Kim Novak, Marlene Dietrich, Tippi Hendren, Eva Marie Saint and Janet Leigh. There are a number of theories about the blondes in Hitchcock. One is that they fulfill a certain male fantasy, that they engage 'the male gaze in cinema.' Another is that women during World War II became important in the war effort, working in factories, on the land, and in the armed forces. Women gained power and gradually encroached on what was traditional male territory and so, according to some critics of film theory, the blondes in Hitchcock hint at the emasculation of the male protagonist. On the other hand, we should never forget that Hitchcock was a master technician who pointed out that blondes photograph better in black and white! (He also said that, 'Blondes make the best victims. They're like the virgin snow that shows up the bloody footprints.')

And what of 'the mother'? She is a far from sympathetic figure in *Strangers on a Train* (1951), and *Psycho* (1960), jealously possessive in *Notorious* (1946), and devouring as Mrs. Danvers in *Rebecca* (1940). Possibly the most curious relationship is that of the attachment of Thornhill (Cary Grant) to his mother in *North by Northwest* (1959). (In fact Mrs. Thornhill was played by Jesse Royce Landis who was the same age as Cary Grant.)

If Hitchcock is tapping into powerful archetypal forces—the endangered hero's journey, the emasculating female and the devouring mother—then what of Hitchcock's own psychology? As a boy he appeared to be devoted to his mother, particularly since his father had died when he was fourteen, and he lived with her until he was twenty-five. On the other hand there are stories that, if he had behaved badly, he was made to stand at the foot of her bed for long periods, sometimes hours, while she berated him. And in later life she even accompanied Hitchcock and his wife on their vacations. So was there a deeper resentment or ambivalence to being tied in this way to the mother figure?

Another recurring theme in Hitchcock's reality is the whole issue of guilt, suspicion and the innocent man who is wrongly accused. Did this originate in a key incident in Hitchcock's own childhood? At the age of five the boy was sent to the local police station with a letter from his father. The desk sergeant read the letter and immediately locked the boy in a cell. After a few minutes, the sergeant let young Alfred go, explaining that this is what happens to people who do bad things. Hitchcock has said that he was sent by his father on numerous occasions to the local police station with a note asking the officer to lock him away as punishment for behaving badly. It is said that after these experiences Hitchcock had a morbid fear of police.

Hitchcock is also known for the famous 'MacGuffin.' This is a plot element that catches the viewers' attention—a precious object, stolen plans, a secret code, anything at all around which the plot revolves. One side may be desperate to steal the MacGuffin, and the leading male may be trying to protect it. The point that Hitchcock wished to make is that the actual nature of the MacGuffin is totally irrelevant—it merely provides the focus for the hunt and chase because, whatever it is, it has to be important to the characters involved.

There is the famous remark attributed to Hitchcock that actors are like cattle. By this he meant that he often wished them simply to say their lines and be in the correct place, rather than seek a deeper, inner meaning to their roles. Hitchcock had also argued that a person's face does not always express what they are thinking, so while there are times when 'acting' may be required, there are also times when a neutral expression will suffice. (There was also a Russian experiment where a neutral actor was edited against different objects that thereby suggested different emotions to the audience.) In this sense it was not so much the actor who provided the emotion, but Hitchcock's choice of camera angle and editing.

Hitchcock was a complex man who loved to set himself problems. One of these problems was Henri-Georges Clouzot's *Diabolique* of 1955 which appeared to have 'out-Hitchcocked' Hitchcock in terms of suspense. In a key scene towards the end of that film, the 'dead' husband suddenly rises in the bathtub then removes the white contact lenses from his eyes. As noted earlier, the device of a supposedly drowned villain was repeated *in Fatal Attraction* (1987) many years later when Glenn Close emerges from the bathtub ready for vengeance!

Hitchcock's answer was to go one better and make *Psycho* (1960) with its famous shower scene. It is a sequence built totally out of creative editing and involving the juxtaposition of a series of very short shots. We begin with a relaxed scene in a room of the Bates Motel where Marion Crane has been writing down figures from an account at the Bank of Phoenix. She throws the piece of paper into the lavatory pan, takes off her clothes and steps into the bathtub. We see a brief shot of the shower head, then a relaxing series of shots of a woman under the shower, cut to a shadowy figure behind the shower curtain, a knife is raised, cut to the woman screaming, an extreme close-up of her open mouth, cut to the knife descending, to the woman. Now everything is in close-up, the descending knife, the woman's hand, her face, the knife touching her belly, her hand on the wall of the shower. The woman reaches out and grabs the shower curtain, cut to the metal bar from which the curtain is suspended, the curtain is ripped from his hooks one by one, a low angle view of the room from the victim's perspective on the floor, cut to the shower head, cut to the woman's feet, cut to water going

down the drain. Then a dramatic shot as the drain fills the entire screen and is replaced by the dead woman's eye. Then we survey the room again, cut to a shot of that ominous house located above the Bates Motel and the voiceover of Norman Bates screaming 'Mother! O God! Mother, mother! Blood! Blood!'

It is a scene that everyone remembers, maybe one of the most famous in cinema—and it is all created by editing. Seventy different shots have been seen in forty-five seconds. So what else could Hitchcock do? He made a film taking place in real time and put together so as to appear as a single continuous shot. *Rope* (1948), based in part on the Leopold-Loeb murder of the 1920s, also became the subject of Richard Fleischer's *Compulsion* (1959) starring Orson Welles as the defense lawyer. Hitchcock was interested in seeing whether he could find a cinematic equivalent to the play which takes place in the actual length of time of the story. To do this, he decided to shoot it in what would appear to be one long, continuous 'take,' without cutaways or any other breaks or edits in the action. (In fact there was a disguised break every ten minutes, as this was as much film as the camera could contain, but it was done in such a way that the cinema audience would not notice.)

Yet another problem he set himself was to make an entire film shot within the confines of a lifeboat. *Lifeboat* (1944) poses the technical problem of how to shift camera angles when everyone is seated in exactly the same position. The other was how to make his trademark cameo appearance. In this case he was reduced to a photograph in a newspaper seen in the lifeboat.

Then there were those micromanaged touches of Hitchcock. It is said that he knew his trade so well that he had no need to look through the camera viewer when a scene was set up. He would simply tell his cameraman which lens to use and where to place the camera, and then he would know exactly what would be seen on the screen. Indeed, those who saw Hitchcock directing claimed that he looked totally bored and that his mind appeared to be on other things.

There are some beautiful touches in *Suspicion* (1941), for example. The protagonist descends the stairs with a glass of milk that may well be drugged. We see the shadows of the balusters fall across him like the bars of a prison cell. And that glass of milk had a particularly menacing quality because Hitchcock had placed a light inside the glass so that it glowed. And when it was shot from the protagonist's point of view, a large wooden hand was made to hold a bucket-sized glass of milk.

NORTH BY NORTHWEST

 Traditionally darkness is used in film to evoke fears of the unknown and of threatening situations. It is accepted that we project images from our minds into shadows, confined spaces, narrow corridors and half open doors. So naturally Hitchcock was going to turn that on its head by having menace appear in the most unexpected place possible. The plot of *North by Northwest* (1959) concerns a man called Thornhill who is about to make a rendezvous at a crossroads on the prairies with a government agent named Kaplan. He alights from a Greyhound bus and waits, looking up and down the road. Flat prairie stretches all around him. The sun is blazing. There is no place where anyone could hide. No possibility of danger. He hears a car approaching, maybe it is Kaplan? But the car simply drives past. Later another car drives past and then a truck. No Kaplan.

A certain monotony is being established, a 'mental space' of safety. Thornhill is simply waiting, and nothing is happening. But then a car appears from the cornfield and drives along a dirt road to the highway. A man gets out. He stands on the other side of the road opposite Thornhill. The two men stare at each other until, in the end, Thornhill crosses the road and speaks to the man who says he is waiting for a bus. 'Then your name isn't Kaplan?' The man says that is not his name and gets on the bus. Thornhill is left alone again. In the distance he sees a plane. Suddenly the plane descends and comes right at Thornhill who falls to the ground. The plane flies away and then returns. Thornhill runs into the cornfield and tries to hide but the plane still comes after him.

Thornhill hears the sound of a truck, runs into the road, and tries to flag it down. The truck is braking but still coming towards him, and the plane is diving at him again. In the end the truck drives over Thornhill, not injuring him but acting to shelter him from the plane. The plane hits the back of the truck, and Thornhill and the driver run for their lives before the whole thing explodes.

In the previous scenes Hitchcock has taken us from a Chicago of shadows and darkness, a place of apparent menace, yet one in which nothing whatsoever happens to Thornhill. Now he has placed Thornhill in a bright, wide-open space where menace descends from the sky. What is more, Hitchcock has first lulled us with a long, bland sequence as Thornhill waits for Kaplan. And when the terror does come, we are forced to watch much of it through Thornhill's eyes—from his point of view. Yet again Hitchcock plays on the audience's expectations and then, in a single stroke, subverts them.

REAR WINDOW

 Rear Window (1954) has been much commented on from a variety of perspectives. Is it a film about voyeurism and the audience's complicity in this action? Is it about the male gaze on women? Is it about symbolic dismemberment?

The central character, Jeff, is a photographer who has broken his leg while on assignment. This at once sets up a particular tension in the film. It is a standing observation amongst photographers that they sometimes use the camera as a shield between themselves and the world. I have been in the company of professional photographers who have joked at the expense of one of their colleagues that he or she can't get involved in a deep relationship because they only see the world through the viewfinder. This seems particularly true of Jeff who appears passive and unable to make a commitment to Lisa, played by Grace Kelly. Additionally, the character of Jeff is played by James Stewart, a versatile actor who in previous years had been associated with a number of Westerns (*Broken Arrow* and *Winchester 73* in 1950, *Bend of the River* in 1952, *The Naked Spur* in 1953). He is now confined to a wheelchair in his room, and to total passivity. (Yet another example of the way Hitchcock liked to cast against an actor's established reputation for character.) A final point is the audience's identification with Jeff, for we too are sitting down, and will remain so (unless we pause the DVD and get up to make coffee!) until the end of the film.

So what can Jeff do? He can look out of the window into the apartments opposite. He can see the little dramas that are going on in his neighbors' lives. He is like a man with a number of television sets, each showing a different program. In his passivity he is forced to become a voyeur but, unlike during his work as a photographer, he is also confined to the immobility of a wheelchair. We too, as passive viewers within the cinema, begin to take an interest in these little dramas. One of these concerns Lars Thorwald and his invalid wife who seems irritated by her husband. And what is going on in Jeff's own apartment that the neighbors opposite could possibly see? He is visited by Lisa, a woman full of energy, with a career of her own, the opposite of the immobile Jeff.

As the film continues, Jeff begins to suspect that Lars has murdered his wife, and uses a telephoto lens to spy on Thorwald. Then, when Thorwald is out of the apartment, Lisa searches it, finds the wife's purse and discovers that it contains a wedding ring. No one would ever go on a trip and leave such items behind. But Thorwald returns and, in a clever move, Lisa slips the ring onto her own finger, places her hand behind her back and shows

Jeff that she has found the ring—she is indicating not only that Thorwald is the killer, but also taking the lead in symbolic marriage to Jeff.

Up to now Jeff has been the voyeur, the one who spies on the unsuspecting, but now Thorwald looks directly across at him. That means that he looks directly at us, the voyeurs who are complicit with Jeff. Until now Jeff's apartment has been a safe place, just as we in the cinema or at home in front of the television screen are in a safe place. But suddenly that space is being invaded as Thorwald arrives. Thorwald is about to attack Jeff, and Jeff's only weapon is his camera. By firing the flash bulbs he hopes to blind his attacker. At first this works, but finally Jeff is flung out of the window.

The film ends with both of Jeff's legs in plaster casts. He is rendered even more passive than before. Lisa on the other hand is dressed in pants and a jacket—ostensibly in men's clothing—and is reading a travel book. Jeff sleeps. While the best Jeff could do was watch, Lisa was the one who solved the mystery and could well be going off on the sort of long trip that Jeff enjoyed as a photojournalist.

And so a piece of entertainment can be read at many levels. Some have read it as a film about the male gaze at women, others as a woman's power and her relative independence with respect to her fiancé, and yet others as the complicity between the passive audience and the figure of Jeff. As usual Hitchcock's presentation of filmic reality cannot be reduced to a single reading, but conceals inner subtleties.

VERTIGO

 Vertigo (1958) is a complex film about mystery and obsession that demands a great deal of the viewer. It concerns John 'Scottie' Ferguson, a former detective who has left the force because of extreme vertigo. He is hired by Gavin Elster (who knows about his condition) to keep a watch on his wife Madeleine (played by Kim Novak, one of Hitchcock's cool blondes) who, he believes, has become obsessed with her grandmother (Carlotta Valdes) who committed suicide. While he is skeptical of influences beyond the grave, Scottie does discover evidence for an obsession; at one point Madeleine throws herself into the San Francisco Bay where she is rescued by him.

We, the audience, are becoming increasingly engaged because we are convinced by Madeleine. Maybe she really is in the grip of some sort of mental illness, yet we know that Hitchcock can sometimes turn the tables

on the viewer. There is menace, but where is it coming from? Who is menacing her? We also know that Hitchcock doesn't make the sort of films with ghosts and possession from beyond the grave.

Madeleine tells Scottie of a dream she has had, and he recognizes the setting as a Spanish mission south of San Francisco. He will take her there and free her from her obsessive dream. As Madeleine walks towards the mission church, she kisses Scottie and says that, even if she loses him, she will always love him. She enters the church and Scottie begins to follow her as she climbs the tower. For a moment he looks down and we encounter the famous 'Hitchcock zoom' or 'Vertigo zoom,' a sense of looking down the twisting stairwell at the floor and suddenly shooting upwards, the floor flying away from us. Scottie struggles with his vertigo. There is a scream, a brief glimpse of a body flying past the window, then the sound of Madeleine hitting the roof of the church below. And there, in one sense, the film should end, with the death of Gavin's wife.

Yet now Scottie himself has become obsessed, and returns to the places where he had seen Madeleine before—an art museum, a florist's—always seeing women whose dress or hair bears a resemblance to Madeleine. One woman strikes him in particular, but she is a brunette not a blonde. He follows her to her hotel where he tries to speak to her. She is very like Madeleine, but shows Scottie her drivers license with her name, Judy Barton, and tells him she has lived in the hotel for three years. She is certainly not the dead girl he yearns after. But in the end she agrees to go to dinner with him, and Scottie leaves.

It is at this point that Hitchcock overturns the mental space we have created. Scottie had not followed Gavin's real wife, but Judy Barton who was playing a role to set up the notion of an unbalanced and suicidal woman. Gavin knew that, because of his vertigo, Scottie would never be able to follow Barton to the top of the tower. In fact it was Gavin's wife that was thrown from the tower while Judy screamed. But Judy had made one mistake; she had fallen in love with the man who followed her and agreed to go to dinner and continue the relationship.

Now begins a period of extreme obsession on the part of Scottie. He is fascinated both by Judy and the dead Madeleine. He takes Judy to dress stores to select exactly the same dresses as Madeleine wore, and insists that she dye her hair blonde. At this point we can ponder on the male obsession of relating to a woman, not for who she is but in order to mold her, turn her into the woman of his fantasies, to be in the position of owning his own creation. *Vertigo* is an interesting study of the male domination of the love object.

But then Scottie recognizes the pendant Judy is wearing as the one that once belonged to Carlotta Valdes. He tells her they are going to eat in the

country, not in the city, and drives her to the mission. There he grabs her roughly and drags her to the stairs. She struggles as he pushes her up the tower. On two occasions he looks down, and we see the 'Vertigo zoom' again. At the top he confronts her about the necklace. It was her big mistake, he says, to keep a souvenir of the murder. She was Gavin's girlfriend all the time and Scottie had been a pawn from the start. Yet despite deducing the truth, Scottie is still obsessed with her. She tells him she loves him. They embrace. There is a sudden noise and a dark figure on the stairs. Judy screams and falls from the window. A nun appears and crosses herself. Scottie stands on the very edge of the parapet and looks down at Judy's body. His vertigo is cured.

Interestingly Hitchcock tips his hat at another director, Howard Hughes. In *Vertigo* Scottie notices a model of a brassiere in a friend's apartment and asks how it was designed. On the principle of the cantilever, he is told. Hughes, a former aeronautical engineer, spotted nineteen-year-old Jane Russell and signed her to a seven-year contract. Because of her voluptuous figure he decided to design a new form of brassiere based on the principles of a cantilever bridge. Russell, however, found it too uncomfortable to wear.

STAGE FRIGHT and the false flashback

 By the time Hitchcock made *Stage Fright* in 1950, the flashback had become commonplace and well accepted by cinema audiences. Hitchcock was about to challenge that convention. The film opens and closes with a theater curtain. In the first case the curtain is raised to establish that we are in London with St. Paul's cathedral in the background. The film then cuts to a sports car. 'Any sign of the police?' the woman driver says, then she asks what happened. She is Eve, an aspiring young actress and her passenger is Jonathan Cooper, played by Richard Todd and they are driving to her father's house. Jonathan explains that he tried to help Charlotte Inwood, his actress friend, when she came to his flat. At this point the flashback begins—it is only moments into the film, and lasts for an astoundingly long 14 minutes. We see Charlotte, played by Marlene Dietrich, standing at the flat door with a bloodstained dress. She tells Jonathan that she has killed her husband. Jonathan tells her that she must carry on as if nothing happened, and go to the theater as usual. He will go to her flat, get her a new dress and arrange things to look at if a robbery has taken place.

Jonathan enters Charlotte's flat, wearing gloves, and sees the husband dead on the floor. He returns the murder weapon, a poker, to the fireplace then smashes a window and disturbs the desk to make it look like a break-in. Suddenly there is a scream; the maid has arrived and sees the body. Jonathan runs out but is recognized, so now he is the prime suspect in the murder hunt. He drives to the theater school where Eve is rehearsing, and asks her to hide him. She takes him to a house owned by her father.

Eve decides to get a job as dresser to Charlotte, for she must do everything in her power to clear Jonathan. The actress is clearly the killer, but is shifting the blame onto Jonathan by claiming that he killed her husband in a jealous rage.

Only at the very end of the film, with the police searching the building, does Eve discover Jonathan hiding out in the theater. He now admits that he killed Charlotte's husband, and that he has killed before. He tells her that he made up the whole story of the flashback. (I recall watching this film with someone who, at this point said, 'But that's not true, we saw it happen!' The convention that a flashback reveals an objective historical fact is very compelling.)

Eve suggests he can get away with an insanity plea. Jonathan thinks for a moment and agrees that if he killed again, killed without any reason, it would be a clear case of insanity. He raises his hands as if to strangle Eve. She runs from him and, as Jonathan attempts to escape the police, the theater's safety curtain falls and kills him, creating a perfect symmetry with the raising of the curtain at the start of the film.

It was only when Hitchcock saw the complete edited film did he realize that he had made 'the second greatest mistake of his life.' (The first was in *Sabotage* in which a package being carried by a boy who had already engaged the audience's sympathy, explodes, killing him.) By using a flashback he was drawing upon a strict grammatical rule of cinema that this always represents real events that have actually occurred. The audience accepts this convention, and it is asking too much and generating considerable confusion to require them to suddenly switch their position and take the flashback as a piece of fictional deception. But not every critic agreed with Hitchcock. Some saw it as placing the audience in the same position as the female protagonist, Eve, who assumes that Jonathan will always tell her the truth about events only to discover that the truth was a total tissue of lies.

At all events, Hitchcock's take on reality is to present everything at face value to the audience, allowing them to draw their own conclusions as to character and motivation, and then to turn the tables by showing them that everything they had taken as real and factual was based upon a set of assumptions that had been made earlier in the film—such as the

blonde Madeleine being an innocent victim of a mental disorder in *Vertigo*. In other words, his approach is very much in harmony with the arguments of this book, that to a great extent, we create our perceptions of reality, filling in details, ignoring others, and confabulating where there is missing information.

STANLEY KUBRICK

Kubrick's vision could perhaps be characterized by an obsession with the image—with making the impact of an image as powerful as possible and exploiting all the technology available to him in order to do so—from the special effects of *2001: A Space Odyssey* to the candlelit scenes in *Barry Lyndon* which required the development of special camera lenses. It is therefore not surprising to learn that Kubrick's professional life began as a photographer that led to a staff position on the magazine *Look*.

As we have seen in our discussion of *Rear Window*, it is something of a cliché that photographers say, half in jest but also with a grain of truth, that each hides behind his or her camera; that they view the world, and the relationships in which they engage, from one step removed. Was this true of Kubrick? He certainly was reticent about his private life and something of a perfectionist at work, even to the extent of reducing Shelley Duvall to tears during the filming of *The Shining*. So could we take it as a working hypothesis that Kubrick approaches his work as if he is examining a new world through a microscope and then seeking the best way to display this world in all its manifest visual aspects?

In this sense I would like to compare him to the painter Piero della Francesca. While other painters of the period were using perspective as a way to render a landscape or interior 'three-dimensional'—using a naturalistic, or what we would later call a 'photographic,' approach to space, Piero was creating 'mental spaces.' In other words, he encoded spaces in a mathematical way so that the viewer was invited to enter into and unfold a 'space of the intellect.' It could almost be said that Kubrick was attempting something similar—to create a world of images that we could unfold in order to obtain some hint as to his own unique perception of reality.

Who was Strangelove?

With several earlier films to his credit, Kubrick's *Dr. Strangelove or: How I Learned to Stop Worrying and Love the Bomb* (1964) was the first to become a cult classic. But who was this archetypical 'mad scientist,' the great brain confined to a wheelchair and portrayed as the father of the H-bomb? In a way he is the merging of two figures: Werner von Braun and Edward Teller. Teller was a Hungarian-born physicist who became part of the US Manhattan project to develop the atomic bomb under the project leader, J. Robert Oppenheimer. Oppenheimer's vision was of a bomb based on nuclear fission. This involves explosively bringing quantities of uranium together to the point where a chain reaction is created and the uranium nuclei disintegrate releasing large quantities of energy—the 'atomic bomb.' But Teller vigorously fought for an alternative system based on 'nuclear fusion,' one in which an atomic bomb would be used to trigger the fusion of hydrogen nuclei to produce even greater heat and energy—the 'hydrogen bomb' or 'H-bomb.' Teller was overruled but continued to fight in vain for his project. It was only when the Americans learned that the spy Klaus Fuchs had passed on secrets to the Russians, including Teller's work on a potential hydrogen bomb, that President Truman gave permission for the project to go ahead, and the first H-bomb was exploded in November of 1952.

There is a chilling story associated with this explosion. It was to be carried out at Eniwetok atoll in the Pacific Ocean, and some scientists wondered if the fusion reaction would also ignite the hydrogen in water (as every schoolchild knows water is H_2O) and cause the ocean to ignite!! However, Teller did a calculation that argued that this could not happen. His next step was to appear before the 1954 security clearings and argue that America's nuclear program should be put in safer hands than Oppenheimer's, and so the latter's security clearance was removed. Many physicists never forgave Teller for what they saw as this betrayal.

Towards the end of *Dr. Strangelove*, when the bombs begin to explode, Strangelove addresses the President as 'Mein Führer,' and the film ends with a miracle—the physicist gets up from his wheelchair and takes a tentative step saying, 'Mein Führer, I can walk.' So who else could this scientist be in addition to Teller? None other than Werner von Braun. Von Braun had a dream of space flight, of humans going to the moon and beyond, which was to inspire his entire life's work. There were a number of early experiments with rockets, but who would contribute major finance to an all-out program to develop a space rocket? With the rise of the Nazis, von Braun saw that his opportunity lay with Adolf Hitler, and so sold him the dream

of a rocket that could deliver a warhead to London, or even as far as New York. The result was that von Braun joined the SS and headed a program to develop the V2 rocket.

When it became clear that Germany was losing the war, von Braun and a group of his colleagues decided that their interests would be better served by attempting to surrender to US troops rather than remaining at the Peenemünde laboratories and surrendering to the advancing Russians. Instead of being tried for being part of the Nazi war apparatus, von Braun was welcomed into the United States where he was soon chief of the US Army ballistic-weapon program and the key figure in putting an American on the moon. (At the time the running joke of the Soviet-American space race was 'Are our Germans better than their Germans?')

A CLOCKWORK ORANGE

 I have picked this film in particular, not only for the shocking and striking nature of many of the images, but also because of the differences in approach of Kubrick and of Anthony Burgess, on whose novel this film was based. In keeping with Kubrick's love of the image, the dramatic opening shot in *A Clockwork Orange* (1971) involves a close-up of Alex's face with a large false eyelash on his right eye. As we hear Alex's voice-over we pull back to see him and his 'droogs' (a gang of thugs) in a milk bar taking drugged milk. The scenery and costumes are stark black and white, and the droogs are clearly ready for some night action.

Then follows a succession of very striking scenes. The film cuts to a drunk lying in a tunnel. Alex and his friends appear at the tunnel entrance with the light behind them, and their shadows advance menacingly as they approach the tramp and then beat him up.

From this scene of violence the film cuts to a baroque ceiling and the music of Rossini's *Thieving Magpie*. We hear a scream. The camera pans down to show a stage where a young woman is being raped. It is violence, yet violence that is staged to music. Alex and his droogs stand at the back of the theater. They then engage in a fight with another gang that is highly balletic. We realize that, while this film will be exploring the extreme nature of physical violence, it will always do so in a distanced way, not glorying in violence for its own sake. Rather, it is at times almost a meditation on the choreography of evil which, what is more, is evil that is emerging out of a young man's innocence.

We now cut to Alex and his friends in a fast car in the night. They arrive at a house with the sign 'Home.' It is the home of a writer and his wife. The door bell rings with the chimes echoing the opening notes from Beethoven's Third Symphony. Through the door Alex pleads to use the phone as there has been a terrible accident. The wife opens the door, and Alex and his friends enter, grab the wife and kick and beat the writer. As Alex does so, he sings 'Singin' in the Rain,' synchronizing his kicking of the husband with the music. He then rapes the wife while the husband is forced to watch.

(In his autobiography Anthony Burgess, the author of the novel *A Clockwork Orange* on which Kubrick based his film, writes of the time his pregnant wife Lynne was raped during the London blackout by four GI deserters, and as a result lost the child. Burgess, stationed at the time in Gibraltar, was denied leave to see her.)

There is a considerable irony in the choice of the music. In the film *Singin' in the Rain,* Gene Kelly's character has declared his love and, in the pouring rain without a raincoat, he simply sings and dances, swinging on a lamp post and jumping in the puddles like a child. All the cares and responsibilities of adult life have been swept away, and he is not even going to be cowed by the appearance of an authority figure—a cop. And so at one level there is the counterpoint of a carefree song and dance being used in a scene of rape and violence. Yet it is a double irony, for we can also read it, as we will see below, as an indication that Alex is a child, someone untamed by civilization, someone who operates only with the most basic of instincts.

Of course the use of striking pieces of music to accompany strong images is another trademark of Kubrick; everyone remembers the use of Richard Strauss' *Also Sprach Zarathustra* from *2001: A Space Odyssey* (1968). In the case of *A Clockwork Orange* it is the final movement of Beethoven's Ninth Symphony—the 'Ode to Joy' in which the chorus sings of universal brotherhood. Following his night of violence, Alex is back in the coffee bar when a woman at one of the tables sings the 'Ode to Joy'. For Alex it is like a great bird; the hair on his neck stands up, it sends shivers down his spine. When Dim, one of the droogs, makes a rude noise, Alex hits him. This is the moment when Alex's droogs begin to plan rebellion against their leader.

Another motif in the film is the use of color. Alex's home is elegant, with red walls and shiny surfaces. This theme of color and mirrored surfaces continues until Alex's sudden incarceration in prison. A large image of Beethoven also dominates his bedroom, as well as a series of statues of Christ with the crown of thorns and nails in His hands and feet. Kubrick rapidly intercuts the rhythm of the music to the wounds, for Alex's passionate love of the Ninth Symphony is comparably connected to his love of violence.

When his mother calls to him to go to school, we are suddenly reminded that this is not a violent adult but a schoolboy. Indeed, as an actor Malcolm McDowell was really too old to play Alex. That evening Alex plans another robbery in the same way, but this time the owner is suspicious and phones the police. She is defiant and picks up a metal bust of Beethoven and attacks him with it, saying 'I'll teach you to break into real people's houses.' Alex hears a police car and exits the house where his droogs are waiting to waylay him. They hit him with a milk bottle, and leave him on the ground ready for the police to arrest him.

The second half of the film is shot in blues and grays, in contrast to the bright colors of the first half, for Alex is condemned to spend the next 14 years in prison. However, he soon ingratiates himself with the prison chaplain, and we see him reading the Bible. In his imagination he is one of the Roman soldiers who scourge Christ. He relishes the violence of the Old Testament.

Alex now learns about the 'Ludovico technique,' a form of aversion therapy which allows prisoners to be returned to society. He says he wants to be good, but the priest points out that you cannot be good if there is no freedom of choice; without choice you cease to be a man. Nevertheless, Alex is selected as an ideal candidate and enters hospital where the dull blues and grays are replaced by the hot colors of a red fire extinguisher and a board indicating directions to various facilities. Alex is given injections and told that he will be watching films—an irony to have a film about someone watching a film. We now see him strapped to a chair, his eyes clamped open. He watches a film of a man being beaten with blood coming from his mouth and nose. Alex remarks to himself that the colors of the world seem more real when seen on the screen. Now there is a scene of rape. Alex expects he will enjoy these scenes, but begins to feel nausea. The doctor remarks to his assistant that, as the drug takes effect, Alex will experience paralysis and a deep sense of terror which he will then associate with the images on the screen.

The next day he is back in front of the screen. This time it is shots of Nazis and there is background music—Beethoven's Ninth. Alex screams out and tells them to stop. They can't use that music. He shouts 'It's a sin. It's a sin.' The doctor continues the treatment, saying 'That is the element of punishment.' Alex protests 'It's not fair that I should feel ill when I hear Ludwig.'

Two weeks later Alex is cured and introduced by the Minister of the Interior to a number of observers. A young man walks onto the stage and insults him. When Alex tries to retaliate, he becomes violently ill and in the end licks his assailant's shoe. Then a naked woman approaches, Alex reaches up to touch her breasts and again becomes ill. The Minister points

out that Alex is cured, impelled towards the good. The priest objects, arguing that he has no choice, no moral choice. The Minister replies that he is now the true Christian who will turn the other cheek.

Alex is free, yet walks along the Thames on a grey overcast day looking down into the water as if to contemplate suicide. A tramp recognizes him and calls on his ancient friends to attack Alex. The police, who turn out to be his former droogs, arrive and give him a serious beating.

Alex is broken. He staggers forward in the heavy rain at night and comes to a house with the sign 'Home.' It is the house of the writer who is now in a wheelchair. His wife has died. Alex recognizes who it is, but because he was masked at the time of the rape realizes that the writer will not know his identity. But the writer *does* realize he is the man who had the Ludovico technique, and telephones his friends.

Alex relaxes in the bath and begins to sing 'Singin' in the Rain.' Suddenly the writer realizes the identity of this young man. At the dinner table the two guests, clearly connected to the opposition political party, question Alex about his reaction to Beethoven. Alex is given drugged wine and later wakes to hear Beethoven's Ninth (in the Wendy Carlos Moog synthesizer version) being played extremely loudly. He can't escape the music and so throws himself out of the window. (We see this from Alex's point of view, not via a Vertigo zoom but by Kubrick throwing the camera out of the window!)

This is followed by a sequence of newspaper headlines in which the government is blamed for using inhuman treatment. But Alex is not dead; he is in hospital in traction.

He tells the hospital psychiatrist that he has the strange impression that doctors have been playing about in his head. In turn, she shows him a series of cartoons with empty balloons and asks him to say what could go in them. His answers are all violent. Now he receives a visit from the Minister who clearly wishes to ingratiate himself. When Alex leaves the hospital he will have a well-paid job and, in turn, he will help the government to change public opinion. The Minister then presents him with a gift of an enormous sound system playing the 'Ode to Joy.' Alex's face begins to distort as the music plays, and he enters a fantasy of having sex while being applauded and watched by an audience. In a sarcastic voice-over the film ends with Alex saying, 'I was cured all right!'

The film and the novel

Kubrick's film was based on a novel written by Anthony Burgess. The copy that Kubrick had read was published in the USA, and did not have the original ending that Burgess had written in which Alex grows up to see the futility of mindless violence. So that is not what the cinema-going audience saw, since Kubrick was not aware that the final chapter was missing from the US editions.

Burgess' book involves the interweaving of several of his interests, in particular freedom of choice and the nature of sin. Burgess once wrote that it would be a sin to fart during Beethoven's Ninth Symphony, in other words to disrupt something that aspires to perfection. Likewise, during the aversion conditioning Alex cries out that it is a sin to make him no longer love Beethoven. Another point Burgess wishes to make is that, in spite of his evil ways, Alex has a passion for classical music, and to Beethoven's Ninth Symphony in particular, with its ode to universal brotherhood in the last movement. But Burgess argues that it is an illusion to believe in the redemptive qualities of great art. After all, some of the leading Nazis were music lovers.

A theme that occurs in his novel *1985,* as well as being one of the strands hidden within *A Clockwork Orange,* is the debate between St. Augustine and Pelagius over the nature of sin. Augustine taught that humans are born with the taint of original sin and do not possesses the power to overcome this taint by their will alone, but only by God's grace. In other words, humans have a natural predisposition towards evil. Adam wished to be free, and that means to be free to choose. But those with free will, by virtue of original sin, have a disposition to gratify their own wishes and not God's—thus Adam was condemning himself to divine punishment. On the other hand, Pelagius claimed that man is free to choose salvation or damnation. As far as the Catholic Church was concerned, this was a dangerous heresy.

Burgess saw this as applying to society in general. The Pelagian phase is characterized by a liberal regime that argues that humans are perfectible, a regime that does not seek to impose harsh punishment, for it believes that people have the ability to reform and choose the good. As that scheme begins to fail, the regime collapses and there is an intermediate phase—an 'interphase.' This is followed by a more authoritarian regime that believes humans to be inherently flawed, a regime that demands a strong police force and the jailing of criminals. But gradually the regime realizes that people are not quite as bad as they believed, and so the cycle goes round again.

The theme of choice, sin and divine intervention is also explored in Burgess' novel *Earthly Powers*. A former pope who performed a miracle is about to be canonized. While still an ordinary priest, he had been visiting a hospital when he heard the screams of dying child. The doctors told him that there was no hope, but the priest was able to cure the boy and this is taken to be miraculous. Ironically, however, the boy grows to be a figure similar to the Reverend Jim Jones and ends up causing the death of a large number of people. What then, the novel asks, is the nature of a miracle that saves a life in order to unleash a mass murderer into the world?

The main thrust of Burgess' book *A Clockwork Orange*, which is also emphasized in the film, is that morality can only exist when there is the freedom to choose between good and evil. Alex, in the first part of the film, is a free human agent who has chosen the path of evil—raping the writer's wife and killing an older woman during a robbery. But following his aversion therapy he no longer has the freedom of choice. He is not a 'better person' because he has no alternatives. For Burgess such a person is no better than a robot, a mechanical toy, or a 'clockwork orange.' This is a double pun for it refers not only to the cockney phrase 'queer as a clockwork orange'—but also to the Malay word for a human 'orang'—that is almost the same word as *orange*. Hence 'clockwork orang'—a mechanical human.

In the film Kubrick responds to Burgess' philosophy—the free human is surrounded by reds and oranges, the clockwork Alex by blues. Kubrick also described it as '...a social satire dealing with the question of whether behavioral psychology and psychological conditioning are dangerous new weapons for a totalitarian government to use to impose vast controls on its citizens and turn them into little more than robots.' Similarly, on the film production's call sheet, Kubrick wrote 'It is a story of the dubious redemption of a teenage delinquent by condition reflex therapy. It is at the same time a running lecture on free will.'

Other points can be made about culture and civilization. Alex has done terrible things, yet in another sense he is not a totally unsympathetic figure. To begin with, he is the narrator of his own story, and tells it quite openly without any guile; he simply enjoys the violence. What is more, he is very young, a mere schoolboy. We could almost take it that Alex is in a 'state of nature.' He is the pure, unconscious human being who acts on instinct without any sense of inhibition or morality.

In *Civilization and its Discontents* and other writing, Freud argues that there can never be true, unalloyed human happiness and contentment because so many of our underlying urges and aggressions are repressed by the demands of civilization. Each of us has a superego which acts as a censor of

our more natural desires. This is the product of civilization, and so each of us feels the burden of guilt about the presence of our underlying urges.

Such an argument would suggest that, at the start of the film, Alex is not burdened by a superego; he has not been 'civilized.' But society, in the form of the Ludovico system of conditioning, will give Alex that superego so that, while his natural urges remain—his desire for immediate sexual release and violent expression—their very presence makes him feel sick. It is only at the end of the film that Alex's superego is removed and he is freed from the burden of civilization. 'I was cured' also has the ring of 'Mein Führer, I can walk' from *Dr. Strangelove*. The futuristic civilization into which Alex was first released from prison is in Burgess' Augustinian phase, one with a government that recognizes the inherent sinfulness of human beings and so enforces excessively repressive measures by hiring the violent and brutal into the police force.

There is an interesting sequel to Kubrick's film in the form of another novel by Burgess entitled *A Clockwork Testament or Enderby's End*. The character of Enderby had first appeared in the novel *Inside Mr. Enderby*. Enderby is a poet who spends much of his time composing on the lavatory—Burgess said that he once had a fleeting vision of his character which inspired him to write his novel. This novel was followed by a sequel, *Enderby Outside*, set in North Africa. In this Enderby has an encounter with a film producer, and mentions 'The Wreck of the Deutschland' by the poet and Jesuit priest, Gerard Manley Hopkins. It is a long poem written after Hopkins learned of the shipwreck off the Kentish Knock in which five Franciscan nuns died. A film producer asks Enderby to write a script, and eventually the film is made, but it bears very little relationship to his script, or to Hopkins' poem for that matter, since it emphasizes rape and violence.

In *A Clockwork Testament*, the character of Enderby is now living in New York as a professor of literature, and working on a long poem about St. Augustine and Pelagius. But he has also become notorious since his name is prominently featured as the author of a film of unusual violence, one in which nuns are raped. What is more, he is now blamed for outbreaks of violence, and in particular that his film has encouraged rape. Enderby has therefore become famous for a film he considers 'bloody awful.' In much the same way the novelist Burgess had such feelings about the film that had made him renowned—his name appears on the opening titles in letters as large as that of the director—and about the director who had adapted his novel. Burgess came to hate the film, and was even blamed for an incident in which a nun was raped by someone who had seen the film. Just as with his character Enderby, Burgess received many phone calls protesting against the film. And so, with *A Clockwork Testament*, Burgess was able to get back at Kubrick. (Kubrick asked Warner Bros. to withdraw the film from

British distribution and, for 27 years, it was difficult to see the film in the UK until after Kubrick's death.)

Kubrick and literature

While I have argued that the nature of the image is a key to Kubrick, it is also true that his inspiration often arises from a work of literature. His final film, *Eyes Wide Shut* (1999), was inspired by a short story by the Viennese writer Arthur Schnitzler. *Lolita* (1962) was, of course, based on the novel by Vladimir Nabokov and, as mentioned earlier, probably his most famous film, *2001: A Space Odyssey* (1968) had its origin in the science fiction short stories of Arthur C. Clarke.

Kubrick sent a telegram to Clarke asking him if he would be interested in collaborating on a film project; Clarke replied that he would be delighted to work with an *enfant terrible*. While the two men worked on the script development, it is easy to see how the general idea emerged out of two of Clarke's stories *Sentinel* and *Childhood's End*. In the former, a monolith is discovered buried on the Moon. When uncovered it acts as a beacon to inform advanced intelligences in the cosmos that the human race had now evolved to a point where it has the technology to go out into space, and therefore presumably is now ready to take its place with other stellar civilizations. *Childhood's End* is a similar idea that moves beyond the premise of *Sentinel* by showing how the human race evolves with the help of more advanced beings.

In the film *2001*, the Earth has been visited at a period when the first primates evolved, and a monolith has been left that, when touched, sends out a signal and possibly even acts to trigger some evolutionary leap. The next monolith is encountered on the Moon, and triggers an expedition to Jupiter where another is discovered floating in space. As this point, the astronaut David Bowman appears to enter another world, a world partly created out of his own memories. As he lies dying, he touches the monolith and is transformed into a 'star child'—the next evolutionary stage of the human race as it reaches for the stars.

Following the production of the film, Clarke himself wrote a novelization of the film, and later wrote additional sequels showing the further development of humans in space.

DAVID LEAN

Although they are both associated with films shot on a grand scale, David Lean and Orson Welles came to the cinema by very different routes. While Welles arrived knowing virtually nothing about the technique of film, Lean worked his way up from the bottom. He began as a clapper board assistant, and passed through various stages of movie apprenticeship until he arrived at the position of editor, a profession at which he exhibited considerable stills. From there he went on to direct his own films. So we have a director who has an intimate knowledge of his craft, and from his experience of editing also an intuition about pace.

Eventually Lean would begin to think about the limits of the medium, how much he can fill the screen, and for how long one particular shot can be held. And inevitably, when we think of Lean we remember those great spectacular scenes in *Lawrence of Arabia* (1962), *A Passage to India* (1984), *Dr. Zhivago (1965)* or *The Bridge on the River Kwai* (1957). We were all struck, for example, by that moment in *Lawrence* when a tiny speck in the far distance of the desert rides towards the camera in a shot that goes on and on, or the scene where Peter O'Toole as Lawrence parades and swirls in his new Arab clothes. These were blockbuster films, yet Lean was not without his critics and, indeed, he suffered a long period of creative block after being mocked by Pauline Kael who wrote for the *New Yorker* that he should be made to return to black and white and forget about making epics.

But there was that other David Lean, the one who began his directorial life with a series of black and white films such as *In Which We Serve* (1942), *Blithe Spirit* (1945), and the period piece *Brief Encounter* (1945). This book is about 'film and reality,' and *Brief Encounter* portrays a particular 'British Reality' of that era—one of reticence, understatement, the importance of family life, and the dangers inherent in 'breaking the norm.' It is that same sense of reality that was earlier explored by the writer E. M. Forster in such novels as *Howard's End*: that while there may be undercurrents of great emotion in life, one should be careful about giving them rein, and that beneath a veneer of politeness and restraint there may be something approaching passion, and therein lies the danger.

Brief Encounter perfectly captures the repressed nature of middle-class England, one of good manners, small talk and uneventful daily life in the 1940s—an era well before the sexual revolution and the 'swinging sixties.' *Brief Encounter* excels not only because of Lean's direction and the metaphor he uses of the train station—a place of meetings and departures—but

also because of the performances of Trevor Howard and Celia Johnson, and the script of Noel Coward's play *Still Life* on which the film is based.

Laura Jesson is comfortably married to a rather unimaginative husband, Fred, and has a young child. From time to time she takes the train into town in order to change her library books and to meet one of her women friends at a tea shop. Then one day her routine is interrupted when she gets a speck of dust in her eye from a passing train and a young man, Alec, who happens to be a doctor, comes to her assistance. They meet again and go to the cinema together. Laura is captivated by Alec, a doctor of vision and dreams, someone so unlike her husband and the world of her daily life. Their meetings together are encounters she can dream about. So far the sexual element has not entered their relationship. Not, that is, until Alec asks if he can borrow his friend's flat and the two decide to sleep together. The consummation, however, never takes place because the friend returns unexpectedly.

Alec now explains that his dream of going to Africa has become a reality. He is leaving England and their relationship must come to an end. There is a final and painful meeting at the train station. They say goodbye, and Laura enters the compartment only to find one of her friends who chatters endlessly while she sits there with a broken heart. Finally she is home again with her husband. Rachmaninov's Second Piano Concerto, which has been the theme underlying the film, is playing on the radio. Laura looks up at her husband who says 'You've been a long way away.' Laura replies 'Yes,' to which Fred replies 'Thank you for coming back to me.' We realize that, although stodgily English, he has all the time realized what has been taking place. To put it in more negative terms, he is the strong silent type who has allowed his wife her brief taste of freedom, but now the bird has returned and we know the cage door is closed forever. Unlike Nora Helmer in Ibsen's *Doll's House*, Laura will never wander again.

MICHELANGELO ANTONIONI

Antonioni is one of those filmmakers who, like Andrei Tarkovsky and Terence Davies, is willing to engage us with shots of extreme length and action that is slowly paced. Whereas other directors are concerned with narration, Antonioni's key films are much more about character and introspection. *The Red Desert* (1964), for example, explores the inner life of the main character and, to make this exploration even more intense, the

director manipulates color throughout the film—a particular characteristic of Antonioni's art.

Antonioni's father came from a working class family who prospered to become well-off land owners. While his family circumstances were comfortable, Antonioni noticed the poverty around him and, as a young man, became a Marxist. The result, as a filmmaker, is to examine yet another of those aspects of reality we have inherited from the revolutions of the twentieth century. This time it is Marxist, a world in which religion is dead and the values of the bourgeoisie are to be questioned. And so the characters in Antonioni's films have pursued wealth and material goods, yet their lives lack any inner meaning or purpose. It is a world in which love is replaced by sexual seduction. Even the surrounding earth is barren, as in *The Red Desert*, for the dream of being reconciled to nature is no longer a possibility.

Films like *L'avventura* (1960) and *L'eclisse* (1962) were particular favorites with film lovers who would see them subtitled in art houses. Then came *Blow-Up* (1966), filmed in English and clearly based on the photographer David Bailey who documented the sixties so well. While the film deals with the challenging theme of the impossibility of objectivity and the truth of memory—something mysterious appears in one of the pictures the photographer happens to take in the park—it also captures much of London's swinging sixties. For this reason it became a commercial success, rather than yet another art house treasure. Today *Blow-Up* has become one of the iconic sixties movies, along with *If* (1969), *Easy Rider* (1969), *A Hard Day's Night* (1964), *Help* (1965), *The Graduate* (1967), *Midnight Cowboy* (1969) and *The Knack...and how to get it* (1965).

Another of his English-language films is *The Passenger* (1975), starring Jack Nicholson and Maria Schneider, which explores identity, alienation and the desire to escape from oneself. We first see Schneider as 'the girl' (she is never named) sitting on the steps of Bloomsbury's Brunswick Center—an architectural icon of the sixties—and will encounter her a second time in another icon, Gaudì's Sagrada Familia cathedral in Barcelona.

At the first encounter David Locke, a reporter, simply passes her without glancing. We next meet him in Africa on assignment. But when the man in the next room, Robinson, dies, Locke decides to switch their passport photographs and assume the dead man's identity. This extends to following his itinerary and even meeting the people he was scheduled to meet. It is through these meetings that Locke learns that Robinson has been involved in arms shipments to Africa. In turn Locke becomes the victim of a man hunt, not only by those interested in his arms but by Locke's wife who believes he may be still alive.

Travelling to the next assignment he meets 'the girl' who goes with him in his car. As Robinson he must keep a final appointment at a hotel in a remote area of Spain. 'The girl' sits at the window and, after asking her to describe what she can see, he tells her she must leave. The film ends with a remarkable seven minute-long tracking shot. First we can hear all the sounds of the square outside. Locke opens the double window so that he can see directly onto the square through the bars that cover each window. He lies on the bed and we see and, more importantly, hear the world outside his room. There is a sound of a car which then drives into the square. The girl walks into the square. The car drives off. We see and hear people in the square. Then another car draws up. Two men get out, and one walks in the direction of the hotel entrance. The other man walks over to the girl and draws her away to the other side of the square. We hear the sound of a motorcycle and the possible sound of a gunshot. We hear a door open and close and the car drives away. The camera goes up to the window bars and passes through them out into the square. A police car arrives. The girl walks to the hotel. A second police car arrives carrying Locke's wife. They enter the hotel and go into Locke's room. He is lying dead on the bed. Back in the square it is now dusk. A car drives away. Lights go on in the hotel.

In 1995 Antonioni suffered a stroke which robbed him of his speech and left him partially paralyzed. However, he continued to direct and, with the help of Wim Wenders, made *Beyond the Clouds* (1995).

KEN RUSSELL

I must confess to a partiality for Ken Russell, although many see his commercial work as that of a director totally out of control. My first introduction to Russell was via the BBC television arts program *Monitor* for which he and John Schlesinger had been hired. Russell's work included biographies of Elgar, Delius, Bartok, Debussy, the poet Rossetti and the dancer Isadora Duncan. *Watch the Birdie* (1962), a documentary about the photographer David Hurn, is said to have inspired Antonioni to make *Blow-Up*. Those biopics, with the possible exception of *Dance of the Seven Veils*, in which he portrayed Richard Strauss as a Nazi, were controlled and visually stunning. In *The Debussy Film* (1965), which was discussed in the context of *The French Lieutenant's Woman*, he used the device of filming the actor as himself discussing the film, and then in the role of Debussy, so

as to produce the shifting sense of reality and tonal ambivalence one finds in Debussy's own music.

From television he tried to break into feature films. His first two attempts, *French Dressing* (1963) and *Billion Dollar Brain* (1967), were not particularly impressive but these were followed by *Women in Love* (1969), based on the D.H. Lawrence novel, and *The Music Lovers* (1970) based on the life of Tchaikovsky. (He claims to have made the latter by presenting it to a producer as the story of a homosexual who falls in love with a nymphomaniac!) These films are characterized by a considerable visual impact, and Russell once said 'I'm consumed by the image.' It therefore comes as no surprise to learn that Russell began his professional career as a photographer but, unlike that other photographer turned filmmaker, Stanley Kubrick, he does not choose to view life objectively from behind the camera.

I would argue that in part Russell's approach to cinema revolves around his conversion to Catholicism in his late twenties. This led to his interest in the whole question of sacrifice and redemption which features in his biopic of Delius, *Song of Summer* (1968), and his sympathy towards Edward Elgar, *Elgar* (1962), whose mother also converted shortly before his birth. At this point I am focusing on the films he made for the BBC rather than his later work.

Some years ago, when I still lived in Ottawa, there was a festival of Russell films in the city which included a reception and a chance to shake hands with the director. At first I stood to one side and noticed the lineup of people who had probably never seen a Russell movie in their lives, so when it was my turn I began to ask him about the way he edited his films to music, as he had done for Debussy and other composers. He told me he had great admiration for the director and choreographer Busby Berkeley. We then discussed whether that sort of editing, those rhythms, could be sustained with speech alone. He said that he had a great desire to make Virginia Woolf's *To the Lighthouse* since he felt the book was essentially a shooting script. And so I had well over an hour of intense conversation. Later I spoke to him before the showing of his film on Strauss, *Dance of the Seven Veils* (1970), about the way he had used music and images in *Mahler* (1974). I planned to visit him on the set of his next film, but it didn't work out. He sent me a postcard saying that he was an irritable old bugger when directing anyway!

So with such an introduction to Ken Russell, what would I select? At least I'd urge the reader to purchase a new DVD release, *Ken Russell at the BBC,* which contains some of his best early biopics. You will notice Russell's strong obsession with the image; so many of those images stick in the mind. Let me give you one anecdote. I saw *Song of Summer* (1968) only once, when it was screened on *Monitor* that year. Ten years later I resigned

from my research post in Canada, and with my severance pay made a twenty-minute film called *Memories*. In that film there was a repeated shot of two hands touching. It was only in the late nineties that I obtained a copy of *Song of Summer* again. I watched it and to my great surprise saw the identical shot when Mrs. Delius meets the young Eric Fenby at the train station. It had stayed in my memory for ten years. Another image that I used in *Memories* was a particular gesture made by a woman as she touches her hair. I had used that gesture as a way of linking the identity of two female characters together. When I bought a copy of Fellini's *8½* (1963), which I had previously seen at a repertory theater, I discovered that this was the identical gesture made by Claudia Cardinale. So what does this mean; who was linking to whom, via a visual image?

FEDERICO FELLINI

One of the key influences on Fellini, which can be seen in all his films, was the depth psychology of Carl Jung. This book argues that a great deal of what we see on the screen has been influenced by the discoveries of the twentieth century, and the films of Fellini provide a good example of the way Jung's vision has also deeply influenced many writers, artists and filmmakers.

Federico Fellini was the son of a traveling salesman, born in the seaside town of Rimini in 1920. And so the sea features in so many of his films; a fictional Rimini is the setting of one of his most popular films *Amarcord* (1973). 'Amarcord' in the dialect of the area is derived from the standard Italian *mi ricordo* which means 'I remember.'

Fellini did not relate well to his somewhat repressive parents, but found escape in the circus, a small local theater, and the Fulgor Cinema in Rimini (the locations of circus and provincial theater feature strongly in so many of his films). Fellini even claimed that he ran away to join the circus, but with him it is often difficult to separate fact from fiction because of what the film critic Peter Harcourt, author of *Six European Directors*, called 'Fellini's little lies.'

Fellini left Rimini, first for Florence and then Rome where he made a living by drawing cartoons and even sketching customers in restaurants. The next stage in his career occurred when he met Roberto Rossellini following the liberation of Italy. Rossellini was about to shoot *Rome, Open*

City (1945), and Fellini helped him work on the script. The finished film became one of the landmarks in the new movement of *neorealismo*. After this, Fellini worked with Rossellini on the script for *Paisà* (1946), and when the director fell ill he directed a part of the film.

Fellini continued to work on scriptwriting and co-directed *Variety Lights* (1950) with Alberto Lattuada. Finally a producer, impressed with his work, offered Fellini his first film, inviting him to write and direct *The White Sheik* (1952) which was based on the sort of character found in the very popular Italian adult comic books called *fotoromanzi*—photographed cartoon strip romances. (It turns out that an initial treatment of this theme had been written by Michelangelo Antonioni!) In the film a woman indulges in a fantasy of meeting the dashing Sheik, played by Alberto Sordi, who she reads about in cartoon form. As a first film it did not do too well since, while it was supposed to be satirical, Fellini could not help being sympathetic to the woman who dreams of her sheik.

This was followed by *I vitelloni* (1953) which depicted young men who wander around a seaside town similar to Rimini. Next came *La strada* (1954), starring Fellini's wife Giulietta Masina as Gelsomina who dresses up in white face to accompany the abusive circus strong man, Zampanò, played by Anthony Quinn. It is here that we first meet the theme of innocence that was so characteristic of his films up to 8½. It appears again in *Nights of Cabiria* (1957) in which Masina plays an unsuccessful prostitute who dreams of escape. The poet Pier Paolo Pasolini, familiar with Rome's street life at night, accompanied Fellini when he researched the area where prostitutes waited for their pick-ups, and helped the director with some of the street talk. Pasolini had been noted for developing a new form of poetry, termed *poesia civile,* in which the language of the streets was used, rather than the more refined literary language that had hitherto been characteristic of Italian poetry.

Cabiria also introduces another of Fellini's themes, the innocent and even redemptive magic of the theater as opposed to the theatrical nature of the Catholic church. Cabiria joins in a religious procession, but her true liberation occurs when she is returned to her childhood by a hypnotist in a small theater. Likewise, after she falls for a man in the audience who proposes that they run away together, he simply robs her. Unbroken, she sees a group of youngsters on motorcycles who form a musical procession behind her, and she begins to smile again.

This tension between the magic that the theater can bring and the theatricality of the Church is highlighted in *Fellini's Roma* (1972) in which we see the innocent fun of the acts at a small theater contrasted with a vast circus parade of ecclesiastical fashions, each one more bizarre than the last—and the final appearance of the Pope with all the pizzazz of a pop star.

Interspersed between the *La strada* and *Cabiria* was *Il bidone* (1955), a film about post-war con men starring Broderick Crawford. A *bidone* is a drum for holding liquids: fill the drum with water and float a film of gasoline on the top, and the bidone can be sold to an innocent person as being full of gasoline—just unscrew the cap and smell it.

LA DOLCE VITA

 Finally we come to the film that shot Fellini to international fame, *La dolce vita* (1960). It also gave the world a new word. When Princess Diana died in a car crash, some blamed the *paparazzi* who had been following her. What most people do not realize is that this particular word was Fellini's creation: it is the name he gave to one of the figures in *La dolce vita*, Papparazo the photographer who is following Marcello around Rome.

The film opens with a spectacular shot of the figure of Christ flying over the Eternal City—a large statue that is being transported suspended from a helicopter. Marcello is a gossip journalist who aspires to greater things as a serious novelist, but who spends most of his days occupied with gossip in the bars, cafes and clubs of the Via Veneto accompanied by the photographer Paparazzo. (This famous street in Rome was recreated for the film in Cinecittà.) When the pneumatic blonde Sylvia, played by Anita Ekberg, arrives at the airport, Marcello is there to meet her and escort her through Rome. Finally, at night and in one of those great iconic shots of the cinema Sylvia steps into the Trevi fountain. Marcello joins her and, at the moment of their kiss, the fountains shut off— a metaphor repeated in *Fellini's Casanova* (1976) in which the goddess falls back into the sea and the water freezes over.

We note yet again the recurring theme of innocence versus organized religion when Marcello drives to the outskirts of the city where a supposed religious miracle has occurred. The press is out in force, and the two children who supposedly saw the Madonna keep pointing in different directions as the crowd follow in hopes of seeing the Virgin and, in so doing, wreak havoc on the plants and trees in the area.

There are two other key relationships in the film. One is with the intellectual Steiner who we meet at one of his parties and, on another occasion when he is playing the organ in a church. Steiner is everything that Marcello would like to be. Indeed, he is exactly what Marcello intends to be when he gives up journalism and turns to serious writing. The other relationship be-

gins in a small scene in which Marcello is writing in an outdoor café when he encounters the innocent young woman who waits on the tables.

But then Marcello discovers that Steiner has committed suicide after killing his children. His world is shattered, and he visits the house of a film producer where an orgy takes place and a woman begins to strip. Next morning the exhausted guests walk to the edge of the sea. The sea is so often a place of rebirth and redemption for Fellini, but this time it is to stare at a hideous sea monster sprawled on the beach. Marcello looks up and notices a young woman gesturing to him from the other side of a stretch of water. She is the same young woman who was earlier working at the café when Marcello was trying to write. When the wind catches her hair she is lit from the back and looks like an angel. In contrast to the dissipated partygoers around him, the young woman is fresh and innocent. She has a message for him, but Marcello is tired and the sound of the sea drowns out her voice, and so he makes a shrugging gesture with his hands and walks away. He will never know what message the anima wishes to give him. Like the creature on the beach, he is all washed up.

The film that followed *La dolce vita, 8½*, secured Fellini's reputation as one of the greatest of film directors.

8½

 The title indicates that this is Fellini's eighth and a half film as a director. His previous work as a director consisted of six features, two short segments, and a collaboration with another director, the latter three productions accounting for a 'half' film each.

One should always be careful in attributing an autobiographical motive to a work of fiction, particularly when incidents in a film or novel appear strikingly similar to events in the author's life. With this warning in mind, let us turn to Fellini's *8½* (1963), which is yet another 'film about a film.' By 'getting into the head' of the protagonist Guido, himself a film director, it illuminates certain aspects of the creative process and of a particular sort of director. Watching *8½* we become aware of the chaotic elements in Guido's life which form part of his creative process. But again a word or caution about the creator as 'Dionysian chaotic genius.' Some creators appear to work in a haphazard way, drawing upon chance occurrences, dreams and intuitions. Others plan with great care all the steps in their creation. (Hitchcock, for example, carefully worked out each shot and demanded that his actors carry out his instructions to the letter. In this respect he recalls Cé-

zanne who complained that his human subjects refused to sit as still as the apples he loved to paint!). Not so Fellini. Often he did not work with a detailed shooting script. In many of his films, he did not give lines to his actors to learn, but simply instructed them to count and dubbed in voices later. In this sense, what happens during *8½* has remarkable parallels with the actual making of the film itself.

As we have seen earlier in this book, Fellini was interested in the ideas of Carl Jung such as the collective unconscious, archetypes and the importance of dreams. We have already noted that in the opening scene of *Fellini's Casanova* that a goddess is raised out of the sea only to fall back again and the sea freeze over. Fellini said that this came to him in a dream that occurred after much of the shooting had been completed. Fellini simply *had* to shoot that additional scene, which cost his producers a great deal of money.

In the case of *8½*, Fellini had already scored an international success with *La dolce vita* and was aware that the critics could turn on him if his next film did not measure up. Indeed, in an earlier version of Fellini's script notes, rather than Guido shooting himself the critics lynch him. He had also intended to make a science fiction epic but abandoned the project, and this is another feature of *8½*, since we can see the rocket in some of the later scenes. In a creative turmoil Fellini delayed the shooting date of his film. He was even against the idea of a shooting script being printed and bound. He wanted to say to his producer, Angelo Rozzoli, 'I don't remember the film anymore.' In the end he decided to abandon the project altogether, and just two days before shooting was scheduled he planned to tell Rozzoli that there would be no film.

One story has it that on the day he decided to make this announcement, a group of workmen associated with construction for the film greeted him, or made a toast to him, during lunch. At this point Fellini realized that if the film was abandoned they would be out of work, and that he had a responsibility towards them. But we should note that Fellini told all sorts of stories about his work as well as about himself.

At all events, up to the first day of shooting Fellini claimed that he had no idea of Guido's occupation. Right from the inception of the idea for the film, Fellini deliberately wanted to keep the character vague. Like Guido himself, Fellini had taken a cure at a health spa in Tuscany and, in 1960, had written to his friend Brunello Rondi about an idea of a man at a health spa who realizes all the things that are weighing on his life which is without meaning. The central character, wrote Fellini, must be a professional man, maybe a writer or theater producer. There will be a mistress, a cardinal, two magicians who may hold a secret for him, and above all a beautiful young woman—Fellini specifically mentioned Claudia Cardinale.

In one sense Guido is a carryover from Marcello, the writer manqué of *La dolce vita,* and in the end Fellini decided to make Guido the director of a film. And so the real film began to evolve into its present form. And *evolved* is a good word for the way the shooting unfolded, since Fellini didn't even know how the film was supposed to end. In fact he shot two alternative endings—the one never shown has the various characters come together in the compartment of a train. (Note Woody Allen's homage to Fellini in the opening shots of the train scene in *Stardust Memories,* 1980.)

The film itself moves between Guido's fantasies and his struggles with his producer, the actors who want to be in the film, and the critic Daumier who is constantly denigrating what Guido wants to achieve in his film. In his fantasies he becomes a man with a whip who tries to tame all the women in his life. He has daydreams about Claudia who will star as the ideal woman in his film. At one point he even imagines hanging the critic Daumier. When he is seated with his wife in an outdoor cafe and his mistress arrives at another table, he imagines what it would be like if the two of them treated each other as the best of friends. While in reality his professional and private life is in chaos, all can be put right in the imagination. (Incidentally, the use of bleached lighting for the fantasy or dream sequences is a little heavy handed, but was forced on Fellini by his producers.)

There are also his memories, of his childhood with other children in the big Italian matrimonial bed. One of the girls makes faces at him and calls out 'Asa Nisi Masa.' Later in the film the magician and his companion read Guido's mind and write the same words on the blackboard. They are part of a children's game in which words are encoded by adding endings—take away the endings and you have 'A Ni Ma'—the *anima* which, for Italians, is the soul as well as the vital principle of plants and animals, and to Jungians is the feminine principle. For Fellini, *anima* is probably all these things, with a particular emphasis on the Jungian understanding.

In 8½ the anima has been transformed into Claudia, the artist's muse, the beautiful woman in white who offers him a glass of water at the spring. She is young yet ancient; she represents purity, salvation, cleanliness and order. Yet at one and the same time as she is the projection of an author's fantasies, she is also Claudia Cardinale, a real life star of the Italian cinema whose charisma cannot be bracketed out. So while all the other figures in the film are given the names of characters, Claudia Cardinale remains 'Claudia.' (Fellini used a number of non-professionals in his film. Pace, the producer, was the owner of the Strega distilleries, the magician Maurice is a playwright, La Saraghina was an American studying opera in Italy, and so on. Some of the priests who interrogate the young Guido are played by, in Fellini's words, 'women of a certain age.')

And so Guido muddles his way through the pre-production stage, with a visit from his mistress and an encounter with his wife and her sister. We see him watching the audition films, and his wife's reaction when various actresses are being cast in the role of the mistress. Finally Claudia Cardinale arrives, and Guido takes her for a car ride while she asks him about her role. They stop in front of a square—very reminiscent of the sorts of squares in the paintings of de Chirico. For a few moments Guido moves into fantasy as Claudia, dressed in white, lays a table for him in the square. When Guido finally reveals her role in the film 'She's beautiful... young, yet ancient... child, yet already a woman... authentic, complete. It's obvious that she could be his salvation,' Claudia simply laughs at him, guessing 'There is no part,' to which Guido replies 'There is no film.'

Now Guido is forced by his producer to attend a press conference, and in one of his fantasy sequences crawls under the table and shoots himself. Finally he has decided that the film will never be shot, and sits in his car with Daumier who congratulates him on his courageous decision to abandon the project. But then there is a tapping on the window, and Maurice the magician appears to say they are ready to begin. Guido takes the megaphone, shouts instructions, and all the characters walk down into a circus ring to create a vast circle of life. Even his wife takes his hand. However, Claudia is not present since she is real and would never agree to become a part of his fantasy in the film. And so the film ends in a circus ring. It is now night, the tiny circus band walk around the ring followed by a young boy. The spotlight goes out.

While the film itself met with great critical appraisal, Pauline Kael did not agree. She argued that all the confusion shown in the film is in fact irrelevant to the creative act and felt that the portrayal of a artist 'coming to grips with himself' and 'facing himself' as a precondition to creativity was too close to what she termed 'a hack's notion of Freudian anxiety and wish fulfillment'—although for Fellini the key figure would have been Carl Jung.

An interesting homage to Fellini's *8½* was made by the British director Peter Greenaway in his 1999 film *8½ Women* which contains a number of direct references to Fellini's original. We will meet Greenaway later in the Directors section.

Fellini's later films

Following *8½* Fellini made *Juliet of the Spirits* (1965) and then the section *Toby Dammit* in the 1968 film *Spirits of the Dead* (known in the UK as *Tales of Mystery and Imagination*) based on a short story of Edgar Allan Poe. After this Fellini's films began to go in different directions and the themes of innocence and redemption simply faded away. Peter Harcourt, who has written about Fellini in his book *Five European Directors*, believed that Fellini's greatest films ended with *8½* but admitted that other critics found his later films better.

Toby Dammit starred Terence Stamp as a drunken and drug-addicted actor who is in Rome to appear in a film with a Catholic theme. He is troubled by visions of a little girl, who he takes to be a satanic figure, playing with a ball. Following a reception Toby leaves in his sports car and approaches a bridge. He notices the girl on the other side and attempts to cross over to her, but does not see a wire stretched across the road and is decapitated. The girl drops the ball and picks up Toby's head. For Peter Harcourt this was the turning point in Fellini's career, for the female, whether a girl, young woman, or prostitute, had always been a symbol of incorruptible innocence. But now that figure had been turned into a thing of evil, and Fellini too had lost his innocence.

But for most other cinemagoers the best was yet to come with *Amarcord* (1973), the revisiting of his childhood in Rimini, a time of innocence but also of the rise of fascism. Then there were the fictional documentaries such as *Fellini's Roma* (1972), *The Clowns* (1970), and *Intervista* (1983). There was the spectacular *Fellini-Satyricon* (1969), and his meditations on the great lover in *Fellini's Casanova* (1976).

City of Women (1980) upset some critics. The protagonist, Snàporaz, gets off a train and, like Dante's pilgrim, is lost in a dark wood. But instead of entering purgatory, he emerges into a convention of feminists. He then escapes to the house of Dr. Katzone (in Italian slang, 'big penis') who has seduced 10,000 women. Finally the women bring Snàporaz to trial, but he escapes holding onto a balloon shaped like a woman. Someone shoots at the balloon.

The Orchestra Rehearsal (1978) is a metaphor for the political situation in Italy in which governments are constantly changing. In this case it shows the German conductor's attempt to get the various instrumentalists to cooperate in order to play together. In *Ginger and Fred* (1986) Fellini takes a poignant look at two aged dancers whose act was based on Ginger Rogers and Fred Astaire, and at the same time pokes fun at the limits of

television. After many years in which they have not seen each other, Ginger and Fred are reunited at a television studio for a show in which a wide variety of guests have their few minutes of glory. When it comes to the turn of the two dancers the studio lights fail, and their contribution is never seen.

His final film, *The Voice of the Moon* (1990), was based on a book *Il poema dei lunatici* by Ermanno Cavazzoni, a fantasy in which people hear voices coming out of wells. The main character is played by Roberto Benigni. The film involves a series of dream-like and surreal episodes, including one in which the Moon is brought down to Earth. On its release it was not well received by the critics and Fellini found it difficult to obtain funding for any further films. In 1993 he was given an Oscar for his lifetime achievement. After a bypass operation he went to the Grand Hotel at Rimini, the same hotel that is featured in *Amarcord*, where he suffered a stroke and died. His body was laid in state at Cinicittà. In *Intervista* there is a scene where two men, suspended high in the air are painting a backdrop. It is a backdrop of the sky and we can't help seeing them as angels. Fellini's coffin was placed in front of this backdrop. Marcello Mastroianni died in Paris three years later. As a tribute, the Trevi fountain where he had kissed Ekberg, was draped in black and the water turned off.

ORSON WELLES

Could someone who knew nothing whatsoever about the technical aspects of film making make a good movie? Would it not be a disaster? One would assume so, but I do recall hearing a talk by a physicist who had won a Nobel Prize. It is often said that the best work in science is done when a person is young, but the speaker suggested that it was more to do with a mind coming afresh to a new subject and being willing to ask questions. In his own case he had changed fields in mid career. He was not young when he came to his new topic, but his mind was open and he was willing to question what others were doing, and so he produced work of Nobel Prize quality. And so it may have been with Orson Welles who walked into a film studio with no preconceptions of what could or could not be done.

Welles had shot to fame in 1938 with his famous Mercury Theater broadcast of a radio adaptation of H.G. Wells' *War of the Worlds*. The first two-thirds of the 60-minute broadcast were presented as a series of simulated news bulletins which led many listeners to believe that Martians had invaded Earth, and caused people to flee an area of New Jersey where the

supposed landings were occurring, while others believed they could smell poison gas or see flashes of lightning in the distance.

Welles was only 25 when he began *Citizen Kane* (1941)—the story of a newspaper magnate, Charles Foster Kane—but he was experienced in acting, writing and directing radio plays. When he decided to move from radio to cinema, the Hollywood stars of the day were not willing to work for a man who had no experience of the medium, and so he turned to his fellow actors in the Mercury Theater. And thus what is often judged as the greatest film ever made was shot with relatively unknown actors by a director who had never made a film previously. Maybe in some ways this was an advantage, because there was no one around to tell Welles 'this won't work.' He decided what he wanted to do and just did it.

His experience in radio can be heard on the soundtrack that is particularly innovative, since Welles sought to create a sonic equivalent for each visual shot. What is taken for granted today was ground-breaking in 1941. Close-ups, for example, had crisp and loud sounds, while the sound in long shots was more remote. When figures were filmed from a low angle, the sound appeared low-pitched, with the reverse for high angle shots. He also accompanied abrupt cuts between scenes with sudden noises. In his next film, *The Magnificent Ambersons* (1942), he allowed dialogue between different characters to overlap, a technique that was later employed to great effect by Robert Altman. In fact, overlapping dialogue was not really Welles' invention. It had occurred earlier in Howard Hawks' film about newspaper reporters, *His Girl Friday* (1940). Hawks noticed that when people talk, particularly when they are excited, they tend to talk over each other. This was to be the style for his movie which gave it the impression of being very fast-paced.

Citizen Kane is innovative in many other ways. Take the scene when the reporter is interviewing Kane's second wife, Susan Alexander. We are above the nightclub looking over roofs. We move towards an open skylight and pass right through it and down into the club itself. Each time I see that shot I ask myself, 'How did Welles do that?' (The nightclub roof and skylight were models; the interior of the nightclub was a real set.)

Welles was assisted by an outstanding cameraman, Gregg Toland, who had been experimenting with lenses and lighting, and in particular with increasing depth of focus. In one shot, for example, we see a bottle of poison close to the camera then, in the middle ground, Kane's wife lying on the bed and in the deepest level of focus, Kane walking into the room. All the elements are co-present, thanks to deep focus, rather than requiring three different shots edited together—the oppressive figure of the powerful Kane, the wife who may have committed suicide, and the means of her attempt—the poison that symbolizes her marriage to Kane.

Kane's last word was 'Rosebud,' and the reporters researching Kane's life believe that a man's last word may contain the key that will unlock that life, so they are sent to interview Kane's friends and associates. At the end of the film we are told that maybe the word is not that important after all. We are in the basement of Kane's mansion, and various effects are being consigned to the furnace. One of these is the sled he had as a boy, at a time when he was taken from his mother and put in the hands of the Kane estate's lawyer. As the sled is thrown into the furnace we see the name written on it: 'Rosebud.'

Despite its reputation, *Citizen Kane* was not without problems for Welles. One of Kane's first acts as an adult was to take over a newspaper and run it as editor. In this and subsequent scenes, Kane's life had strong parallels to that of the magnate William Randolph Hearst who had an enormous influence on journalism in America and became associated with a form of sensationalism termed 'the yellow press.' He was particularly concerned that the Spanish should leave Cuba, and that his newspaper should carry images of the Spanish-American war. When his reporter telegraphed that there was no war, Hearst was said to have replied, 'You furnish the pictures and I'll furnish the war.' Hearst himself denied the story, but it is reflected in the film when a reporter asks if America will go to war and Kane replies that his newspaper has already declared war. This, and many other parallels, angered Hearst to the point where his newspapers and radio stations began a campaign to prevent the film being released. He also offered a considerable sum to the studios if they would destroy the master and all copies of the film.

WOODY ALLEN

It is perhaps not surprising that Sigmund Freud, the man who brought us the 'Oedipus complex' and the 'death wish,' should also have written *Wit and its Relation to the Unconscious,* for wit, comedy and joke-telling can be a serious business. Indeed, there is the old cliché about the broken-hearted clown. Take, for example, one of the great British comedians of the 1950s, Tony Hancock. He was a man full of self-doubt, and during the sixties lapsed into depression and alcoholism that ended in his suicide. There are many great comedians who have manifested a range of neuroses, affective disorders, psychoses and substance problems, for example: Lenny Bruce, Jim Carrey, Graham Chapman, John Cleese, Peter Cook, Rodney Danger-

field, Spike Milligan, Dudley Moore, Richard Pryor, and Woody Allen himself. We should also not forget that in many cultures the clown is certainly not there just to make people laugh and feel comfortable, but to ask us to question both who we are and our assumptions about the world. In some Native American groups the clown will mock a serious ceremony. In this way the clown's role can appear unpleasant and even frightening, but is also carrying out something for the continuing good order of the society by, in a sense, turning people's expectations on their head.

Allen began as a gag writer, and was then a stand-up comedian, before turning to acting and directing. If he reflects the reality of his times, then it would be through the existentialism of the first half of the twentieth century, which in turn had its roots in Nietzsche ('God is dead') and Kierkegaard. And so Allen asks: What should be our behavior if we wake up to find ourselves in a vast meaningless universe? And what is our basis for ethics and morals if there is no God? And again, how is it that men and women can fall in love, but that so often, according to Allen at least, it does not lead to a lasting and satisfying happiness? Comedy, in Allen's hands, may make us laugh, but it is also serious stuff.

His output is prolific, and at the latest count is well over 40 films as director, so how are we to find our way through them? Possibly the best clue is to be found in *Annie Hall* (1977) where Allen gets stuck in a movie line-up behind a man who is going on and on about Marshall McLuhan. Exasperated, Allen wishes he had a large sock of horse manure—itself a reference to the Marx Brothers' suggestion that heads of state resolve international disputes by engaging each other in a battle employing sacks of horse manure. Allen speaks to the man, saying that he doesn't know anything about McLuhan. 'Really? Really?' the man replies. 'I happen to teach a class at Columbia called TV, Media and Culture, so I think that my insights into Mr. McLuhan, well, have a great deal of validity.' At this Allen pulls out McLuhan himself from behind a large cardboard advertisement, and allows him to demolish the academic. So what do we have? A serious side but also one that is willing to poke fun at that same seriousness.

There is a great deal of biographic material in some of Allen's movies. *Annie Hall* refers to the relationship between Diane Keaton and Allen. The title was originally to have been *Anhedonia*—the inability to experience joy from pleasurable situations associated with depression. The final title, however, does stress the biographical nature of the film since Keaton was born Diane Hall and her nickname is Annie.

Not all of Allen's films are alike. The earlier ones are pure comedy, *Manhattan* (1979) and *Annie Hall* are romantic, yet others such as *Crimes and Misdemeanors* (1989), *Interiors* (1978) and *September* (1987) take a serious look at the human condition. It is clear that Allen also tips his hat

to those directors for whom he had deep respect. Both Bergman and Fellini have had an enormous influence on him. *Stardust Memories* (1980) is very much a homage to Fellini that to some extent evokes *8½*, particularly in the opening scene where the characters are on a train—the alternative ending for *8½* that was not used. Certainly he pays his respects to Bergman in such films as *September*, which is mainly shot inside a set representing a summer house near the sea. He even uses Bergman's cameraman, Sven Nyquist, on several of his films. Yet at the same time he can also poke fun at the things he loves about Bergman. Bergman's *The Seventh Seal* (1957) features a chess match between a knight and Death, with Death suitably dressed. So in *Deconstructing Harry* (1997) he has Harry borrow a friend's apartment for an evening with a young woman. The doorbell rings and he eagerly goes to the door only to find Death. Death has come to take him, but Harry frantically tries to explain that Death has made a mistake, that he is not the man Death is looking for, and that he has simply borrowed this apartment for the night. But Death is not convinced—he's heard that one before.

ALICE

 Woody Allen's *Alice* (1990) is one of his best films, and evokes the Alice of Lewis Carroll when the protagonist is given a magical substance to drink—in this case Chinese herbal medicine. Up to this point, like a princess in a fairy story she is imprisoned, or like Snow White she is living her life as if she were asleep. This time the prison is wealth, a rich husband too busy to take notice of her, empty friends, unlimited shopping sprees and expensive lunches. Her life is a void, and she feels a certain pain that may be relieved by going to a Chinese doctor who listens to her story and prescribes a series of herbs. In this fashion she falls down the metaphorical rabbit hole, and on her journey meets a man who is attracted to her. At one point she even becomes invisible and realizes that her husband is cheating on her. In the midst of all her wealth she also fantasizes about volunteering with Mother Theresa who works among the sick and poor of Calcutta.

In the end, thanks to her journey, Alice wakes up and decides to leave her husband and join Mother Theresa. But even this is part of her dream; a rich woman's fantasy about devoting herself to the poor. The film ends with a flash forward. Alice has returned home; she doesn't need a man in her life, she doesn't need to justify her existence with works of charity. She simply takes an apartment with her two children, and is last seen happily playing with them in the park.

CRIMES AND MISDEMEANORS

 Do we live in a totally empty and meaningless universe, or is there an underlying moral order? The message of *Crimes and Misdemeanors* (1989) is bleak and uncompromising—if we live in a world in which we can get away with murder, there is no hope for us.

Judah Rosenthal is a highly successful ophthalmologist who has been having an affair with Dolores, a flight attendant he met on a trip. He certainly has no intention of destroying his family life or his career by going off with this woman, but she is now becoming more insistent and demanding, and so he turns to his brother for help. His brother suggests that, for a sum of money, the problem can be resolved but, above all, Judah need not know the details. In other words, a contract killer will be involved.

Judah recoils at this. He remembers his own upbringing and the meals around the table where his father would insist that the eye of God is always upon us. He turns to a patient who, in a sense, acts as his conscience, a rabbi who happens to be going blind. And so the motif of the eye is everywhere in this film.

Finally, when the woman threatens to contact his wife, Judah makes the fateful call to his brother and Dolores is killed. Judah visits her apartment to retrieve letters and cover his tracks, and sees his murdered lover lying on the floor with her eyes open and staring. In the following days he is wracked with remorse.

The film also has a parallel story in which Woody Allen, playing a second-rate documentary director, Cliff Stern, is making a film about an arrogant but highly successful director, Lester. While making the film, he is befriended by Halley and tells her about a project he is really passionate about, a documentary on a philosopher. Together they watch footage as the philosopher, who appears to be based on the child psychologist Bruno Bettelheim, speaks about the moral order to the universe. In a moral universe there must be an order and balance in which the crimes one has committed must in some way be paid for. The message is clear: Judah must in some way be punished, or at least atone, for the terrible crime he has committed. (Bettelheim, by the way, had already been given a cameo part in Allen's *Zelig*, 1983.)

But Cliff then learns that the philosopher has committed suicide, and the documentary that would have given him great satisfaction, and certainly helped his career, will never be made. How, he wonders, could a man who gave such a positive message to the world have taken his own life?

The best he can do is to sabotage the film he is making on Lester and, in the process, ruin his own career. (Ironically Bettelheim himself committed suicide the following year.)

The film now jumps forward in time. Halley has married the arrogant director, Lester, and Cliff is still a small-time documentary maker. Finally we meet Judah. What has happened in the intervening years? Nothing. He is still happily married, and has gone from success to success. And as to the murder, that is almost forgotten. He feels not a single ounce of remorse or guilt. Judah is the contented inhabitant of a meaningless universe, one that is devoid of any moral order. If there is a God, then He is as blind as the rabbi.

PETER GREENAWAY

Greenaway was first trained as an artist before becoming a director. It is said that at the age of sixteen he saw a film by Bergman which convinced him that filmmaking would be his future career. In 1980 he released his first feature length film, *The Falls*. In addition to filmmaking he has produced a number of books, exhibited his paintings and curated exhibitions. In a certain sense, while his films are mainly shown in art houses, he is something of an exception to this list of directors whose perception of the world reflects the major changes of thought in the twentieth century, for if we look to Greenaway's influences then they are clearly from the world of classical art, in particular Flemish and Renaissance paintings. These sources show up in the way figures are arranged, as well as in the composition and lighting of each scene. In *The Draughtsman's Contract* (1982), for example, as in a Renaissance painting, there are strong contrasts between the nude figure and others that are elaborately clothed.

THE DRAUGHTSMAN'S CONTRACT

 The contract in question is drawn up between the wife of the owner of a country estate and an arrogant young artist, Mr. Neville. The artist is tasked with making a series of drawings of the house, outbuildings and gardens. It is 1694, the period of William

and Mary, in which people dressed in wigs and employed elaborate locution.

And so the draughtsman begins his work, and in the process also has sex with the owner's wife. Each setting has been carefully defined according to the contract so that, for example, no smoke is to issue from the chimneys. However, each setting for the drawings also exhibits a curious new detail, one that was not present at the draughtsman's original inspection: a ladder beside an open window, clothing thrown over a hedge, a pair of boots—almost as if they were clues which, when taken together, would point to some event or crime.

The film is beautifully photographed, and among the striking camera work is an outdoor dinner where the camera very slowly dollies along the table and back again. There are measured intervals between long shots, and close-ups of people talking and whispering together, so as to enhance a sense of suspense, of something that may take place. And at the end there is the killing of the draughtsman, an event in which the meaning of the various incidentals in each of his drawings finally come together.

THE COOK, THE THIEF, HIS WIFE AND HER LOVER

 In *Being There* we met the notion of the house with its front façade, interior, back door and walled garden as an image of the persona, the self and the unconscious. Greenaway adopted another metaphor for his 1989 film *The Cook, the Thief, His Wife and Her Lover*. The restaurant has an impressive doorway—the face—and an elegant dining room, which could stand for the mouth where biting and chewing take place. Then we come to the kitchen, where cooking, beating and mixing occur to the accompaniment of the high-pitched notes of a boy soprano—which could correspond to the stomach. Finally there is the area outside the kitchen, a place of roving dogs and refuse, a place where violence can take place and where a truck full of rotting meat is parked. No prizes for guessing which part of the body this corresponds to. (There are also some brief scenes in the women's washroom.) And so the action takes place in a series of distinct settings, each with its own characteristic color.

And of the characters themselves?

» The Thief is an ignorant, bombastic and violent man, clearly arrested at Freud's 'oral stage'—the oral fixation with speaking, eating and biting as displaced into rage and violence.

» The Cook is an artist working in the kitchen of a restaurant owned by the Thief.

» The Wife is increasingly repelled by her husband, the Thief, and becomes attracted to the Lover.

» The Lover is an educated man who is more interested in reading than in eating.

And so, with the collusion of the Cook and the kitchen staff, the Wife and the Lover begin an affair in the various areas of the restaurant. Indeed in one scene, to avoid being caught, they are put into the truck containing the rotting meat—indicated by high pitched sounds on the soundtrack.

Finally their affair is uncovered, and the Thief cries out that he will kill the Lover. The Lover is tracked down and murdered through eating—pages of a book are stuffed into his mouth until he chokes. But the Wife is to be given her revenge and she speaks to the Cook. And so we arrive at the final scene. The Thief is about to eat dinner—but what is he served? The Lover, prepared with all the Cook's art, and the Thief is commanded by the wife to take his knife, cut into human flesh and eat.

DROWNING BY NUMBERS

Drowning by Numbers (1988) is about many things. It is about counting as a way of putting things in order. It is about life and about death. It is about man and wife and, above all, it is about games. The film begins with a girl skipping and naming the stars. By naming we can bring order into the world. Indeed, some of the world's creation stories begin, not with light and life emerging out of nothing, but with a pre-existing world in which the act of creation involves giving each thing a name.

Another way of ordering is by numbering things, and so there are one hundred numbers in the film, and if we watch carefully we see objects bearing a number starting with the number one and ending the sequence with 100. Three women feature in the film—grandmother, mother and daughter—and they are all called Cissy Colpits. The first Cissy, the eldest, drowns her drunken husband who had been sharing a bath with another woman. She must then enlist the help of Magwitch, the local coroner. The middle Cissy has her husband drown in the sea, and the youngest Cissy has her husband drown in a swimming pool. In each case Magwitch must collude with them on the cause of death.

Then there is Magwitch's son who plays elaborate games in order to control the world. He fires rockets when he comes upon dead animals. He has intricate counting games, and other games to ward off unpleasant things. There are also games that the Colpits play with Magwitch and his boy—a throwing game. There is a complex game of cricket, and a group of sheep that are supposed to indicate the turning of the tide. There is the boy's symbolic and literal circumcision after looking at a picture of Samson and Delilah.

Finally, Magwitch himself must go. The three Colpit women row him out into the middle of a lagoon in a rowboat with the number 100. Magwitch must take off his clothes, the plug is removed from the bottom of the boat, the women swim away and we see and Magwitch passively allowing himself to drown—one more number, the final one in the film.

Greenaway also pays homage to Fellini in another of his films *8½ Women* (1999), in which the protagonists watch Fellini's *8½*. In his version of Shakespeare's *The Tempest,* entitled *Prospero's Books* (1991), all the parts are spoken by the actor John Gielgud.

THE COEN BROTHERS

And what of the Coen brothers—Joel and Ethan? While their films do not appear to draw from the intellectual earthquakes created in the first decades of the twentieth century, they are very much of their time. In an earlier book, *From Certainty to Uncertainty* (2002), I argued how our view of the world had changed from the claim, made in 1900 by the President of England's Royal Society, that in principle everything that could be known was already known. But this was the same year that the notion of the quantum was born, and later chaos theory with its limits to prediction and control. In such an atmosphere the traditional form of storytelling, one in which the author assumes a god-like figure who sees into the mind and actions of all his characters, was doomed. We have seen how John Fowles played with this notion in his novel *The French Lieutenant's Woman* (1969). Something related is afoot in the Coen Brothers' films, with their plot twists and bizarre characters which suggest that we live in a puzzling world in which the unexpected may be the norm.

Like the Wachowski brothers of *The Matrix* series, the Coens share in the production and direction of their film. And again they are true auteurs

in that they put their characteristic mark on each of their films. These are movies in which so often it is not the plot or storyline that is important, but the characters, and how odd they can be. No one who has seen *Fargo* (1996) will ever forget that tiny scene in which a police officer, Gary, speaks to a neighbor, Mr. Mohra, on his front lawn who answers with a series of deadpan 'Yaaah...yaaah's'—Minnesota's Scandinavian accents feature throughout the film. And in a way the plot doesn't really matter—when a body is being fed into a woodchopper, the Police Chief, Marge, appears totally unperturbed.

In *Fargo* Jerry, a car salesman, is in financial difficulties yet frustrated because his wife's rich father, Wade Gustafson, will not help him out. In the end Jerry arranges for his wife to be kidnapped by two deadbeats, Carl and Gaear, so that he can obtain ransom money from Wade. Of course the kidnapping goes badly wrong, and more characters are thrown into the pot—a couple of hookers that are interviewed by Marge, and her meeting with a former school friend, Mike Yanagita. To Marge this is simply a meeting between old friends, but to Mike it is a date. When he is rejected he tells her a heartbreaking story of how his wife died of leukemia. When Marge later finds out that the wife is in the best of health, she can only remark in a deadpan way 'Yaaah...that's a surprise.' Indeed the joy of the film lies in the various intersections of this conglomeration of bizarre and unusual characters.

O Brother, Where Art Thou? (2000) presents yet another collection of characters including the protagonists who also bill themselves as the Soggy Bottom Boys. *The Big Lebowski* (1998) has Lebowski as a totally cool character, 'The Dude,' who appears unperturbed by such events as his house being raided, his carpet stolen and so on. His sidekick is forever getting everything wrong including exacting revenge by smashing in someone's car—but of course it's the wrong car—attempting to 'prove' that a man in a wheelchair is simply faking it, and confronting someone else who turns out to be in an iron lung. When he refuses to help Lebowski by driving his car, pointing that he is unable to because it is the Sabbath, the Dude has to remind him that he is not Jewish.

ALAIN RESNAIS

Constructing our Reality

Deconstruction, often associated with the name of Jacques Derrida, was an influential movement in philosophy and literary criticism that argued, amongst other things, that there is no definitive reading of a text, that one cannot point to a passage and say 'the author meant this.' Thus reading a novel, for example, is highly creative, for the reader has the responsibility for actually creating the work, and revisiting the same novel will reveal a subtly different story. Of course, all this was already in the air in France with the appearance of the *nouveau roman* in which the writer wished to engage in new ways with the reader. Inevitably this new movement was to find its way into the nature of how films are constructed, and Alain Resnais' *Last Year in Marienbad* (1961) turned out to be a milestone.

Resnais had already established his reputation with *Hiroshima Mon Amour* (1958), with a script by Marguerite Duras, one of the *nouveau roman* authors. After this Resnais turned to another writer, Alain Robbe-Grillet, to create a film that asks questions about how we construct reality, about memory, and about the nature of the space we live in and move through.

After several collaborative discussions on the nature of film, Robbe-Grillet set out to write the script which was then more or less filmed as written, by Resnais. The basic premise of the film was to 'trust the audience' to accept what they see on the screen and not attempt to reduce it to a linear narrative that unfolds in time. In a sense the principle character in the film is space itself—the rooms and corridors and the formal gardens of a large chateau or hotel in Germany. (We have met this concept of space in film before with *Picnic at Hanging Rock*—or rather two spaces, that of the European settlers and that of the aboriginal Dream Time.) For Resnais it is a space through which the camera is constantly moving, past silently standing servants, entering rooms filled with guests, moving past highly decorated walls, turning corners. Of course one is never clear as to the geography of the house. It is possible that one could move down a long corridor, enter a room, and continue moving in the same direction along another corridor only to enter the same room again. The conventions of Euclidian space do not apply in this space of Marienbad. Just as Einstein threw out our common-sense notion of space and, for that matter, time, so does Resnais.

In our journey we meet three figures. We begin with the voice of a narrator who appears to have been a guest at the hotel at an earlier date—last year he was in Marienbad. We come upon the heroine and another man who may be her husband. These figures have no names and no identity. We know nothing of their past, if they even have a past, except that the narrator attempts to convince the woman that they have met before. He tells her that they were both in the same hotel last year, and may even have had an affair. The woman at first resists, but then appears to agree that such events may indeed have happened last year in Marienbad. Yet the audience has no way of ever knowing what happened in the past or what will happen in the future.

In writing about his collaboration with Resnais, Robbe-Grillet makes a number of points about cinema. One is that cinema has advanced to the point where the linear convention of storytelling can now be bypassed. We hear a telephone ring and see a man walk to the receiver, pick it up and begin to talk. We cut to a public telephone in a bar, a woman is speaking. Back to the man who writes something on a piece of paper, picks up his hat and exits from the room. We see him leave from the front of his house and get into a taxi. The taxi pulls away; there is a brief shot of it on the road. It pulls up outside the bar. The man gets out, pays the taxi driver and enters the bar where the woman is waiting. This is the conventional approach to telling that particular element of the story. But according to Resnais, our minds are quite capable of jumping ahead. We don't need all that detail. We don't need to see every step. And indeed Resnais was proved right, and film makers since the sixties have enriched the grammar of film by finding ways to move a story ahead more rapidly—as with Goddard's jump cuts.

The other point made by Robbe-Grillet is far more important, and it is that film always takes place in the present. Thanks to the tenses used in our languages, a novel can switch time with ease. Traditional novels use the form, 'John *went* out of the house and *walked* towards his work.' Earlier events can be illustrated by the pluperfect, 'John *had gone* out of the house and *had walked* towards work,' and one can invoke the future or even combine tenses in the same sentence. 'Before leaving his house John *had* telephoned his wife to tell her he *would not be back* in time for dinner as he *was going to* take a major decision that would affect their life together for the next ten years.'

But in film we see events as they are happening. Even if it is a flashback, we are not actually looking at the past but at an event happening in the here and now. So film is all about the present, about what is unfolding on the screen 'now.' This is a convention we are all willing to accept. But this means that we can do a number of very subtle things with time and, as we saw with the architecture of the chateau, also with space.

We can construct events, movements, encounters and relationships that are valid for the moment in which we see them unfold before our eyes. Yet there does not necessarily have to be a linear, causal connection between other events in the 'now' that we saw in the same cinema five minutes earlier.

So in making their film Robbe-Grillet and Resnais decided to trust the audience. Viewers could, if they wished, attempt to link the events they were seeing into some sort of linear narrative, in which case they would find the film 'difficult' and avant-garde. Or they could accept the flow of images, the dialogue, the changing relationships without seeking to impose some external order on them.

Last Year in Marienbad broke new ground and opened new doors. Filmmakers walked through some of those doors and cinema was changed. Other doors they ignored. There will always be someone around to find a new door into the imagination.

DAVID LYNCH

The Freudian slip

It is the argument of this book that the remarkable discoveries of the 20th century have changed the way we view reality. One of these changes has been brought about by the exploration of what lies beneath our conscious level of awareness: material that can surface in dreams or in forms of behavior that, to our conscious mind, appear irrational. In cinema one of the most influential of these explorations has been through Jungian psychology and, in particular, the appearance of archetypal figures in films. We have already seen how Lucas relied upon Joseph Campbell's writings while making the *Star Wars* series, and how the Batman movie *Dark Knight* (2008) features The Joker as the archetypal Trickster while the Shadow is explicitly manifest on one side of the district attorney's badly burned face.

But what of Sigmund Freud? Here we would invoke David Lynch, one of those filmmakers who work away from the mainstream and produce highly characteristic movies. In fact Lynch's films often have a dreamlike

quality that is different from our normal everyday experience of linear time and causality. As Freud famously remarked, in a dream everyone is the dreamer, so in Lynch's films the various characters sometimes have aspects of each other and, at times, as in *Inland Empire* (2006) and *Mulholland Drive* (2001), actually merge into each other.

A particular feature of Lynch's films is his use of the visual metaphors for internal states, for example, the light bulb which begins to flicker as if a person's psyche were under threat, the garden hose under pressure for an artery that is about to erupt in someone's brain, or the almost artificial displays of flowers in a garden to symbolize an innocent beginning, a world without original sin, an unstained childhood. And now we begin to slide into pop psychology which makes me uneasy, because that is the royal road to oversimplification and providing what appears to be 'the answer' to what, in reality, are subtle and complex situations. On the other hand, with films such as *Blue Velvet* (1986) it is difficult to avoid that pathway.

The famous 'primal scene' of Freud involves the psychic trauma associated with a young child, even at the infant stage, witnessing his parents' sexual intercourse. As Freud later argued, this may not necessarily involve an actual act of seeing, but in some cases involves fantasies of what may be happening when parents are together in bed. Nevertheless, Freud argued, during psychoanalysis such scenes should be discussed as if they were real. For Freud, the primal scene produces an excitation with the act of seeing; something which could then be played out if a person chose the route of a film director or visual artist. The child's psyche is overwhelmed by such experiences, their defenses are breached, they may feel excluded and rejected, and the act itself will be seen as a sadistic one, but also with masochistic elements—in this sense the child senses that both parents pose dangers for each other. The legacy of the primal scene is played out in later relationships and in shifting identifications. And one additional point: the primal scene is also related to the great mysteries of birth and death, origins and ends.

There is yet another connection to mystery, and that is the solving of a riddle. As we have seen, the primal scene can involve a sort of psychic incest—in the sense that children begin to identify with their fantasies about the psyche of the mother and the father. The child projects into the mind of the father and into the mind of the mother. And that is where the riddle comes in, because the anthropologist Claude Lévi-Strauss discovered that, in many cultures the incest taboo is surrounded by a riddle. The riddle is a warning sign—solve the riddle and you enter into a forbidden area. Oedipus, for example, solved the riddle of the Sphinx only to kill his father and marry his mother. One of the literary masterpieces of the twentieth century, James Joyce's *Finnegan's Wake,* abounds in riddles with the motif HCE. These are also the initials of the dreamer of the book—the publican

Humphrey Chimpden Earwicker (Earwicker = earwig = insect = incest) who had committed some dark act in Fiendish (= Phoenix) Park.

So we have a mystery to solve, a riddle to uncover, which may indicate undercurrents of what we could call psychic incest. (Here it is important to note that this does not imply an actual sexual violation but, more like a psychic violation that could occur, for example, between a patient and therapist.)

BLUE VELVET

 Blue Velvet (1986) opens and closes in a symbolic Garden of Eden, a world of innocent childhood. In between there is a world of darkness, violence, eroticism, terror, mystery and fascination, all stemming from what we can only assume is the director's own take on the primal scene.

The film opens with the title over blue waving curtains, a shot of roses against a white picket fence with a bright blue sky, a fire truck with the fireman smiling and slowly waving, tulips against the fence, children crossing to school—an idyllic morning in Lumberton. Tom Beaumont, Jeffrey's father is watering the lawn. The film cuts to the hose's connection to the faucet—the pressure must be high because water is spraying out. The hose is twisted. Tom clutches the side of his neck and collapses from a stroke.

The idyll has ended, and now the camera moves inward towards the grass and enters the underworld of insects—a metaphor for all those fears and suppressed memories within the unconscious. So the journey into darkness begins with insects, and the film ends when the bird of happiness perches on the windowsill with one of those insects trapped in its beak.

We see Tom in hospital with his son, desperately trying to tell him something. A breathing mask is over his nose and we will meet this mask again in the film. On his way home, Jeffrey discovers a human ear and takes it to the police. Later he visits the home of the detective in charge, John Williams, who says he must ask no questions about the case— thus establishing a prohibition and a mystery—again characteristic of the primal scene.

Outside he meets the detective's daughter, Sandy, who tells Jeffrey she has overheard something about a case that involves a singer, Dorothy Vallens. The next evening, Jeffrey goes to Dorothy Vallens' apartment and, while snooping around, hears her enter and hides in the closet. He has now

established himself in the role of the voyeur—the one who watches. She answers the phone and speaks to someone called Frank. (Frank, it turns out, has kidnapped her husband and son to force her to perform sexual favors.) She speaks to her son, saying, 'Mummy loves you,' and so the older woman is established as the mother figure. From now on Jeffrey will move between two worlds, one of his dangerous erotic attraction to the mother figure and the other to the innocence of his first romance with Sandy.

Jeffrey watches Dorothy undress, but when she hears him make a noise she takes a knife, opens the closet door and confronts him. Excited by his voyeurism, she then tells him to get undressed. 'I want to see you'—another version of the act of seeing. While she touches him she says 'Don't look at me' and 'Don't touch me'—again the prohibition.

Now Frank (Dennis Hopper) arrives, and Jeffrey hides in the voyeur's closet again, from where he will watch a symbolic enactment of the primal scene which include gas inhalation/asphyxia with a mask, dry humping, and masochistic acts. Frank is an extremely foul-mouthed, violent sociopath whose orgasmic climax is a fit of both pleasure and rage. He tells Dorothy to spread her legs but 'Don't fucking look at me.' He puts on the breathing mask and cries 'Mummy...Mummy...Baby wants to fuck... You fucker...Don't fucking look at me...Mommy...Fucking look at me... Daddy's coming home.'

After Frank leaves, Jeffrey tries to comfort her. She says that she is frightened. Then 'Do you like me?' She asks him to touch her, then says 'Hit me. Hit me.'

During the day he discusses with Sandy how to solve the mystery, but that night he is back in Dorothy's apartment. She asks him if he is a bad boy and will do 'bad things.' Then she says 'I want you to hurt me.' She starts to cry, animals noises are brought up on the soundtrack, and in a struggle he hits her. Suddenly Frank bursts in and takes Jeffrey 'for a ride.' In the car Frank puts on the breathing mask and says 'Don't you look at me, fuck,' and then 'You're like me'—again a metaphoric identification between son and father. Jeffrey is dragged out of the car and Frank kisses him, leaving lipstick all over his mouth. Roy Orbison's 'In Dreams' plays on the car radio while Frank mimes to the words 'candy-colored clown,' particularly ironic as Frank also tells him 'I'll send you straight to hell.' But in the end Jeffrey is beaten and left on the road.

The climax of the film is reached when Jeffrey returns to Dorothy's apartment and finds two bodies—one is Dorothy's husband with his ear missing, and the other is Detective Williams' partner. When Frank arrives, Jeffrey first hides in the voyeur's closet as Frank looks for him, then takes

the gun from the dead detective's pocket and shoots Frank. Symbolically light bulbs burn out.

We are returned to the Garden of Eden. We see a close-up of an ear, a face, the recovered father watering the garden, the picket fence with flowers, the fire truck and the fireman slowly waving. A bird perches on the windowsill with the insect in its mouth, Dorothy and her son are playing in the garden.

MULHOLLAND DRIVE

Mulholland Drive (2001) is another of Lynch's film which has a dreamlike quality and shifting identities. As a film it has developed a long-standing cult following rather than being a rapid money maker at the box office. It also had an interesting genesis as a 95-minute pilot that Lynch shot in early 1999 for a projected ABC television series. The company, however, rejected the pilot and abandoned the series. A year later Lynch decided to turn the whole thing into a feature film where the essential items in the pilot would make up the first part of the film.

In a dream-like way the film follows two women, Rita and Betty who, at times appear to be aspects of the one person. This is again something characteristic of dreams, according to Freud. After the opening titles we see the woman, who will later name herself Rita, being driven along Mulholland Drive. One of the men in the car points a gun at her, but at that moment the car is hit by joy-riders. Rita is thrown out of the car and suffers amnesia. She sees the lights of Los Angeles below, and walks down the hillside and sneaks into a vacant house. That same morning, innocent, cheerful Betty Elms arrives from Deep River, Canada to stay at her aunt's house and try to get a break into films. When she enters she discovers Rita in the shower and asks who she is. The woman, having noticed a poster of Rita Hayworth, says that her name is 'Rita' and explains that she has lost her memory. The two young women try to track down what has happened, and discover in Rita's purse a roll of bank notes and a blue key.

While their search progresses, a number of subplots that will eventually tie together emerge, as with the films *Crash* and *Magnolia*. A man in a diner tells of a nightmare of a strange menacing figure that hides behind the diner; the waitress in the same diner has a name tag 'Diane Selwyn' which Rita later believes could be her name; a film director is being strong-armed

into casting a certain actress in his latest film. A fourth subplot involves a contract killer who is trying to trace a woman called Rita.

After a successful audition with the director, Betty accompanies Rita to the apartment of a certain Diane Selwyn where they find her rotting corpse. Rita believes that the people who did this are also after her, and puts on a blonde wig as a disguise—which also evokes the dyed blonde hair in *Vertigo*.

After the two women have sex together they go to a theater where a performance takes place with instruments and a singer. Yet when the singer collapses on the stage the song continues—in a sense a comment on film itself where visuals and sound are often created quite independently. The performance ends with the words *silencio*. Betty discovers a blue box in her purse which can be opened by Rita's key.

Now the figure we have previously known as Betty appears to be named Diane Selwyn and is a failed actress, while the woman we have known as Rita is a successful actress, Camilla, who is dating the director we met earlier. A limo arrives to take Diane/Betty to a party at Camilla/Rita's place along Mulholland Drive at which Camilla announces she is going to be married. Diane/Betty encounters the hit-man we saw earlier in the film and pays him to kill Camilla/Rita.

Back at her apartment, Diane/Betty finds an ordinary blue key—recall Rita's blue key and blue box—which indicates that the execution has been successful. In the final scenes Diane/Betty appears to become insane and shoots herself, becoming the corpse that Betty and Rita discovered earlier in the film.

And so the critics and bloggers now have a field day asking what all that was about, as if it were possible to reduce a dream to a series of scenes all logically connected to form a coherent whole.

Lynch followed *Mulholland Drive* with *Inland Empire* (2006), another title that refers to an area of Los Angeles. But now the storyline, if there is one, becomes even more dreamlike, with figures and locations shifting and Laura Dern playing a number of different characters.

LINDSAY ANDERSON

The Politics of the Cinema

It is difficult to separate Lindsay Anderson and his films from the social and political conditions of his time. Post-war Britain was to some extent dominated by what was known as 'the Establishment,' an unofficial clique of individuals in politics, business, education, the Church of England and so on, who came from a particular class, had attended Public Schools (top fee-paying schools such as Eton and Harrow) and maybe Oxford or Cambridge universities. They tended to speak with 'upper-class' accents and come from the Home Counties (those counties that border London). Such people, for example, Terence Rattigan, also had an influence on film and theater. Thus, with some exceptions, when people from the north of England were portrayed in films of that period, or people from the working class, they tended to be minor characters portrayed as stereotypes rather than in depth.

But then in the mid 1950s a new movement, called the Angry Young Men, emerged. These were mainly young writers who rebelled against the ethics of an older generation and the power of the Establishment. They were epitomized by John Osborne's 1956 play *Look Back in Anger* in which working-class Jimmy Porter unleashes his anger and frustration on his upper-middle class wife. Another of the Angry Young Men was Colin Wilson who, without any formal education, slept out at night on Hampstead Heath and read and wrote all day in the reading room of the British Museum to produce his bestselling analysis of alienation, *The Outsider.* By the end of the decade many novels were appearing that dealt with working class life. What is more, by 1960 film audiences began to see actors from the north of England, with regional accents, in leading roles—Albert Finney, in *Saturday Night and Sunday Morning* (1960), Rita Tushingham in *A Taste of Honey* (1961), Tom Courtenay in *The Loneliness of a Long Distance Runner* (1962) and *Billy Liar* (1963), and Alan Bates in *A Kind of Loving,* (1962).

Lindsay Anderson was immersed in this significant social change within British theater and cinema. In fact Anderson himself came from a privileged class, the son of a British army officer in India, educated at a public school and at Magdalen College, Oxford. But this was the very system which Anderson chose to critique. He began as a film critic and a writer for the *New Statesman,* a left wing newspaper that had been founded by members of the

Fabian Society. One of his articles, 'Stand Up, Stand Up,' argued for a new future for British cinema. He then went on to make a series of documentaries within the Free Cinema movement, a group which sought to liberate cinema from what they saw as class snobbery and to portray working-class people in more authentic ways. It was out of this movement that a new form of social realism emerged which led to feature length films such as those mentioned above, and Anderson's own *This Sporting Life* (1963). He made his Mick Travis trilogy, starring Malcolm McDowell, *If...* (1968), *O Lucky Man* (1973) and *Britannia Hospital* (1982). In addition to his film work, Anderson also had a significant career as a director at the Royal Court Theatre.

If. . .

If... begins with a portrayal of life in an English public school which could be taken as a metaphor for the sort of hierarchically structured society in which Lindsay had been brought up, and against which he wished to protest. In fact the film itself was shot in Anderson's former school, Cheltenham College. While there are, of course, a headmaster and masters, the real authority lies in the hands of senior boys called 'whips.' Under the head whip Rowntree, the whips use younger boys to run errands for them and even to warm their lavatory seats! This was the British 'fagging' system—younger pupils acting as personal servants to older boys. Against all this is set the rebel Travis who has contempt for the whole system. Naturally he, and some of his friends, are in conflict with Rowntree and the whips—with the result that Travis is given a severe caning.

Parents and a General visit the school on Founders Day. While the General is giving a speech, Travis and his friends break open a cache of weapons they had discovered earlier and, when the parents emerge from the chapel, the rebels open fire from the roof. Even the Headmaster, a representative of benevolent totalitarianism, is shot. The film ends with a close-up of Travis' face as he shoots down into the crowd. The metaphor is clearly that of the need for revolution. This would be enacted in a less violent way across several European countries and on many American campuses in the same year, 1968, with its famous student rebellions and counterculture movement. The film won the Grand Prix at Cannes the following year. Critics have pointed to a certain irony in Anderson's vision for, while he sensed the need for revolution, he believed it would come from the left whereas the great political upheaval in the United Kingdom came from the right with Margaret Thatcher!

O Lucky Man (1973) follows the picaresque adventures of Travis as a coffee salesman. In fact it was born out of McDowell's own early experiences. Travis comes to learn that corruption is rife around him, and that the road to success involves a series of compromises. Of particular interest are the cuts to a studio setting where Alan Price sings at the piano to comment on the film. The film ends with Travis attending an audition with the director, Anderson, who hands Travis some school books and then a machine gun. Travis smiles and the entire cast engage in a party. The trilogy ends with *Britannia Hospital* (1982), a rather heavy-handed commentary on the state of Britain employing the metaphor of a badly run hospital with strikes, demonstrations and a final riot taking place as the Queen Mother is about to arrive to open a new wing.

DOGME 95

Dogme 95 ('dogme' is the Danish word for dogma) is the name of an avant-garde filmmaking movement that began in 1995 with the signing of the Dogme 95 Manifesto by directors Lars von Trier and Thomas Vinterberg. They were later joined by other Danish directors. Amongst the rules were that all shooting was to be done on location with no additional props, the sound was to be recorded on location rather than being added later, and all action had to take place in 'the here and now.' A hand-held camera was to be used with no additional lighting, filters or other optical aids. What is more, the director was not to be credited.

A number of low budget films were shot according to Dogme rules. One, created by Lars von Trier, is called *Idiots* (1998). In this, a group of people agree to act as if mentally retarded in a variety of public places such as a factory and a restaurant. The film then observes the reaction of the general public, waiters and so on to the group's behavior. The film was nominated for a number of awards. Possibly other groups of filmmakers will follow on from von Trier's request, that, for example, the camera operator balance on one leg, or the actors all stand with their backs to the camera.

DEREK JARMAN

The artist as film maker

In *Hollywood Ending* (2002), Woody Allen plays a film director who develops a form of hysterical blindness but feels compelled to complete his film. Of course he has no idea where the camera is pointing or how the actors are performing, so when it is released to the fictional American audience, the film is panned as making no sense. However, in the end the director triumphs because in France it is regarded as a masterwork!

Of course the notion of a blind film director is a joke—or is it? Because that was Derek Jarman's condition when he made his final film, *Blue* (1993). Like Peter Greenaway, Jarman was an artist before turning to directing. His first involvement with film was as a set designer for Ken Russell, after which he went on to make films of his own including *Jubilee* (1978), *The Last of England* (1988), *Wittgenstein* (1993), and *The Garden* (1990). *Caravaggio* (1986) is an interesting biography of the eponymous painter.

Jarman was gay and, in his 1991 *Edward II*, he changed the ending of Marlowe's play about the king who earned the dislike of his barons by appointing his lover, Piers Gaveston, to high office. In the end Edward was deposed in favor of his son, and died violently. According to Sir Thomas More, Edward was murdered by forcing a piece of red hot metal into his anus where it burned his intestines. Jarman would have none of this. He protested 'Not another film in which a gay person dies,' and provided an alternative ending. Jarman also made a strong reference to Margaret Thatcher in his portrayal of Edward's wife, Queen Isabella, having her carry the famous 'Thatcher handbag.'

Jarman developed AIDS and, towards the end of his illness, became blind. One of his last contributions, before he made *Blue* was the book *Chroma* written while he was undergoing treatment at St. Bartholomew's Hospital. The book is part autobiography and part an examination of different colors—their properties and related pigments. In the chapter 'Into the Blue' he records the destruction of his retinas and the onset of blindness. With his film *Blue* we see only a blue screen but hear the sound of a voice reading the text of 'Into the Blue.' It is truly a film by a blind man. Jarman died early in 1994.

VII.
Creators and creation

In a book that explores film and its relationship to reality, why include a section on films about creators and the creative process? The answer, I feel, is because such people help us to see and experience the world in special ways. It was the English painter, Patrick Heron (1920-1999), who argued that art helps us to see the world. Naked vision would be no more than a jumble of sensations, he suggested, but through art we learn how to order the world and, when a school of art, a particular convention of visual ordering changes, we begin to see the world in a different way.

That may be true for our visual senses, but how could music present reality to us in a different way? A great deal of research has now established that music can help bring order to the brain. If school children are given extra music lessons, they do better in mathematics than a control group that is given extra mathematics lessons. Likewise the AI pioneer, Marvin Minsky, in his 1988 book *The Society of Mind* argues that the human mind is built up out of a large number of functioning 'agents,' none of which themselves possess consciousness. It is the harmonizing of these various agents into a 'society of mind' that produces the human mind and consciousness. One of the ways in which this harmonizing occurs is via music, most infants being exposed to their mothers' bedtime songs.

In this section we will meet creators and explore the creative process— from the creator as 'special genius chosen by God' (*Amadeus*) to the creator who descends into the world of madness (*A Beautiful Mind*), or alcoholism (*Pollock*), and with *Death in Venice* we encounter the blocked creator and the theme of the gods, Apollo and Dionysius who represent two aspects of creativity and order within the world.

DEATH IN VENICE

 There are, in essence, three media that treat the theme of *Death in Venice*: Thomas Mann's original novella, Luchino Visconti's 1971 film version and Benjamin Britten's opera of the same name. In each case different aspects are highlighted.

The particular events that occur to the central character, Gustav von Aschenbach, in Mann's novella are in part based on Goethe's infatuation with a young woman, and in part on the composer Mahler. When Mann himself stayed at the Lido in Venice, the guest book of that period contained the names of a Polish family, including a young man whose name was remarkably similar to that of Tadzio, the youth to whom Aschenbach became attracted.

In the novella, Aschenbach is an author with a limpid, classical style who has encountered a writer's block. (In the film he is a composer.) He decides to take a vacation in Venice, a city where sky and sea meet, where distinctions and boundaries dissolve and taboos melt away. In the north of Europe he had been in the grip of the Apollonian order, but now, as he enters the south, his soul is torn between the gods of Apollo and Dionysus— the latter being the god of intoxication.

In an earlier book, *The Blackwinged Night,* I argued that Apollo and Dionysus not only underlie human creativity but could be taken as the archetypal structuring principles of the cosmos. The former is the principle of order and uniformity, the latter of diversity and fertility. For example, the Dionysian expresses itself in the large number of different chemical elements—uranium is number 92 and there are several elements beyond that which can be produced in the laboratory. The Apollonian enters when we realize that all these elements can be grouped into just a few families. Likewise there is an Apollonian order that underlies the large number of different elementary particles—the deeper nature of that order is still to be discovered.

In human creativity the Apollonian order could be the sonnet form or the fugue—but, as poets like Keats and Wordsworth or composers such as Bach attest, there is an entire universe of Dionysian creativity that can emerge out of these fixed forms.

After he arrives at the Lido, Aschenbach becomes attracted to a young man, and at first pretends to himself that this is the pure and chaste love of an older man for one younger and fantasizes about the friendships of ancient Greece. But when Tadzio smiles at him—'no one should be smiled at like that,'— Aschenbach is forced to admit that he has fallen in love.

The blocked writer/composer and the beautiful young man stand as a metaphor for Eros entering into a life, and should certainly not be confused with the story of 'an old pederast who fancies a young man.' Tadzio is a symbol of something that has been missing in Aschenbach's life that will free him from the pull of Apollo. Yet there is one aspect about the young man that hints at Aschenbach's doom, one flaw that is not shown in the film—Tadzio has bad teeth.

There are other symbols in the book and film. As Aschenbach arrives in Venice, he notices a man in late middle-age whose hair has been dyed black and who wears rouge and lipstick. Later Aschenbach himself will submit to rouge and hair dye in order to appear younger. When he asks to be taken to the ferry station from which he can then take a boat to the Lido, the gondolier is blind to his protests and insists on taking him all the way—a reference to the ferry man who would take the dead across the river Styx. There is a scene in which street musicians enter the outdoor dining lounge and appear to be mocking Aschenbach. There is also the metaphor of the spread of infection in the city that causes people to leave. Even Aschenbach has his bags packed and leaves for the station, but finally relents. In the end he is able to whisper the words 'I love you' and, in the final scene, sits in a deckchair watching Tadzio playing with other boys. His body is still, the creator has died.

In the film, Visconti makes a more specific identification with Mahler. The writer of Mann's novella has now become a composer, and Mahler's music is heard in the background. Visconti has also added scenes (not particularly effective to my taste) in which Aschenbach and a colleague argue about the composer's approach to music.

As regards the creative block, it is often assumed that such a block has its origins in an unresolved psychological conflict within an individual. Rachmaninov's First Symphony did not have an enthusiastic reception, and the composer fell into a depression which left him unable to work until he was 'cured' by a hypnotist-doctor. Likewise, the film director David Lean was unable to work for 14 years following negative remarks by the critic Pauline Kael. Mahler himself was dogged by the superstition that if he completed a ninth symphony he would die!

These stories certainly suggest that a creative block can be caused by a contemporary event that triggers some earlier, deep-seated trauma, for example painful criticism or even the fear of success. On other hand, the noted British novelist Beryl Bainbridge was convinced that a creative block always has at its root some technical issue. A person is blocked because they are writing or painting in the wrong way. They may have been working in a particular vein for the last few years, but now the block is telling them to pause, to wait, and discover a new way of doing something. Maybe a particular literary form is inappropriate, for example. In this sense Pauline Kael's criticism of Lean may have been valid. She believed that his early films such as *Great Expectations*, *Hobson's Choice* and *Brief Encounter* were exceptional. However, in his later period (*Doctor Zhivago* 'stately, respectable and dead' and *Ryan's Daughter* 'gush made respectable by millions of dollars tastefully wasted') he favored the big screen, lavish staging and large crowd scenes which she found overproduced and somewhat

hollow. She suggested that Lean should only be allowed to use black and white and a 16 mm camera for his next film!

Mann's novella also inspired an opera. *Death in Venice* was Benjamin Britten's last major work, and there is a DVD available of the opera house performance. The theme of the novella had a particular appeal to Britten, and the way he treats Mann's various characters at the musical level is of particular interest. The boy Tadzio is not a singing part, but is played by a dancer. The god Apollo is played by a counter-tenor to give his voice an other-worldly character. All the other characters Aschenbach encounters are played by the same singer.

Britten happened to be a homosexual who had a long-term relationship with the singer Peter Pears. In his creative work he also appeared to have had something of a fascination with sadomasochism. In his first opera, *Peter Grimes*, the brutal outcast Grimes beats his boy assistants ('Grimes is at his exercise'), yet is also a dreamer who sees beyond the confines of the Borough. Then there is the handsome midshipman who falls foul of the brutal Claggart in the opera *Billy Budd*, and let's not forget the children in *The Turn of the Screw*. In his final work Britten explores Aschenbach's love for the young Tadzio.

What is of particular interest in the opera is the way Britten treats the themes of Apollo and Dionysus which come to occupy a central place in the work. Britten himself leaned towards the Apollonian in his composing. Yet the poet W.H. Auden felt it limited his work. He told Britten that he was too respectable, and that at times art needs a little spice of bad taste—creativity cannot always lean towards respectability and reticence. Maybe, in his final opera, Britten himself was attempting to come to terms with this aspect of his approach to creativity.

Mathematics: The language of nature

According to Galileo, 'God's book is written in mathematics,' while Plato said 'God ever geometrizes,' sentiments that have been repeated by mathematicians down the ages. It is the notion that the deepest truths about the world are mathematical in nature. What is more, the deepest mathematics is known as 'pure' mathematics as opposed to 'applied mathematics.' Sir James Jeans felt that God was a pure mathematician. Carl Jung handed his associate Marie-Louise von Franz a piece of paper and asked her to continue his work. On it was written One, Two, Three, Four, and so

she wrote *Number and Time* and argued that 'even the elementary particles can count.' And so in this sense mathematics is the link between the divine mind and the physical world. Yet another saying amongst mathematicians is 'God invented the numbers, all the rest is man's.' But maybe today, after seeing *Proof* (2005), people would care to add 'and woman's.'

There is yet another mystery surrounding mathematics and that is what the Hungarian physicist Eugene Wigner called 'the unreasonable effectiveness of mathematics.' G.H. Hardy, the great English mathematician of the twentieth century, used to say that the greatest mathematics, the most pure, had absolutely no utility in the world. It stands with no reference to anything other than itself. It is created out of pure beauty, aesthetics and economy of means. But Wigner pointed out the curious fact that, decades after its discovery, a particular branch of mathematics may turn out to be very useful indeed. In the 19th century mathematicians such as Riemann asked what geometry would be like if they reversed one of the axioms of Euclid and allowed parallel lines to meet. The result was called non-Euclidian geometry, created out of pure intellectual curiosity. Yet decades later, when Einstein needed to describe the curving geometry of space-time this geometry of Riemann was exactly what he needed. Likewise David Hilbert, again for aesthetic reasons, had worked with what are known as infinite dimensional vector spaces. Decades were to elapse before quantum theory appeared on the scene, and 'Hilbert space' was exactly what the theory required! So again there is some mysterious connection between abstract logical beauty and the nuts and bolts of the physical world.

And what of mathematicians themselves? They are a curious breed; like lyric poets, theirs is a young person's gift, and generally their greatest work is done when they are in their twenties. Hardy was writing down numbers in the millions at the age of two and factorizing the numbers of the hymns in church. Years later, when visiting his colleague in hospital, he happened to remark that the number of his taxi, 1929, was not particularly interesting. 'No,' his friend replied 'it is a very interesting number; it is the smallest number expressible as the sum of two cubes in two different ways.'

So mathematicians have the gift to see patterns in numbers, and a deep appreciation of such things as elegant proofs and economy of means. They also feel that they are the guardians of an important road into the heart of reality. In discussing the films below we have the chance to enter into a mathematician's world; we shall meet two mathematicians with the ability to see patterns in numbers, and another who illustrates that great mathematics is a young person's game.

PROOF (2005)

 And who was that patient that G.H. Hardy's visited? It was another exceptional mathematician, Ramanujan, who was self-taught. Ramanujan wrote to several mathematicians from his home in India. The letter contained a number of theorems, but only Hardy appears to have recognized Ramanujan's genius for, while several of the theorems were already known, some were quite original. Hardy invited the Indian to Cambridge where they worked together until Ramanujan's early death.

The interesting thing about Ramanujan is that when he arrived at Cambridge, he didn't really have a good concept of what was meant by proof. Important mathematical patterns, equations or truths just came to him; in fact he said they were given to him by a goddess. However, he had never really thought about the need for rigorous proof of what he had discovered. And by 'proof' I mean a series of logical mathematical steps that begin with one of the basic axioms of mathematics and move to a conclusion—the result that Ramanujan had intuitively obtained.

There are a number of outstanding proofs in the history of mathematics. In 1637, for example, the mathematician Fermat wrote in the margin of a mathematics book that he had a 'truly marvelous' proof of a theorem about numbers, but that there was not room in the margin to write it down. Trying to prove this theorem occupied the best mathematicians for generations until it was finally solved by Andrew Wiles in 1995.

So proof is something of great importance in mathematics, and is also the subject of Madden's film starring Anthony Hopkins as Robert, the mathematician father, and Gwyneth Paltrow as Catherine, his daughter. It is a story told through flashbacks that illustrate the point that for most, great mathematical creativity occurs in the young. What is more, it illustrates the assumption of a university culture that the young people in question will all be male!

By his early twenties, Robert had achieved very significant results in several areas of mathematics, but then his creativity left him and, at the same time, his mental state became confused, although he did have occasional periods of lucidity. He had also become an obsessive writer, or rather scribbler, filling well over one hundred notebooks. Catherine begins to study mathematics at university, but has to return home to look after her father who now appears to be in a lucid state that lasts for several months. He has begun to work again, and believes he is on the verge of discovering something of great importance, something that will revolutionize mathematics. Catherine herself is prone to what appear to be periods of depression, but

takes one of her father's notebooks and begins to work on her own with a mathematical idea she has had, an original theorem and proof.

With her work completed she takes it to her father's study to show him, but he has no time to listen to her for he announces that he has just made an astounding breakthrough. His proof is completed, and now father and daughter will go through it line by line. When he hands her his notebook, she is horrified to discover that it is pure nonsense; set out as a proof, it contains such arguments as the number of bookstores approaches infinity so they can never be filled except in September when the number of books approach infinity. In tears she takes her own notebook and locks it in a drawer of her father's desk.

Some years later Robert dies, and a mathematics student, Hal, is reading through the notebooks in the hope that he can find at least one small original contribution that has been made over the years. He has, of course, an ulterior motive: that he will gain fame as the discoverer of Robert's late work, and that this will help his academic career. When he talks to Catherine, he refers to his 'math geek' friends and what 'the guys' are working on. Catherine stops him and asks if there are any female mathematicians; he agrees there may be but can't remember any names.

A brief love affair develops, and finally she gives him the key to the drawer in her father's desk. Hal is amazed to find Robert's highly original proof, until Catherine tells him that it is her own work. Hal simply cannot believe that this is possible, and it is only after the proof is discussed by other mathematicians at the university that it appears that Catherine is speaking the truth, for the proof draws upon mathematical techniques that were developed after Robert ceased to work creatively.

At the end of the film Catherine repeats what he father had once told her: she and Hal will go over the proof line by line to refine the argument. But, she adds ironically, Hal will have a great deal to learn first.

A BEAUTIFUL MIND

 A Beautiful Mind, the 2001 Ron Howard film, is based upon the tragic life of the mathematician John Nash whose work on game theory turned out to have important applications in economics and earned him the Nobel Prize. After a highly promising early career, Nash began to suffer from psychotic mental illness. The director made the brave decision not to offer any hint that this was occurring, but rather

to allow us, the viewers, to enter Nash's world and experience it at first-hand. He did this by introducing a character as Nash's roommate; we first see him with a terrible hangover. Nash will also encounter a young girl.

The roommate spends a great deal of time with Nash, but it is only much later in the film that we realize that this character does not really exist. He and the girl are products of Nash's delusions and hallucinations, as are aspects of the military decoding project into which he is drawn. But by seeing an apparently normal Nash befriend his roommate, we take that person to be just as real as Nash's wife. We experience him just as Nash experienced him.

Except that this is not quite the way it happened in real life. Nash didn't 'see' figures in the room with him. His hallucinations were aural, and at times he believed he was being contacted by aliens. (Just as we have seen Philip K. Dick who, at times, believed that he was receiving direct communications from a vast alien intelligence, or God, or that he was simply deluded.)

What is not mentioned in the film is that by the 1980s Nash was working creatively again and contacting other mathematicians by email. When they realized they were corresponding with *the* John Nash, several of them approached the Nobel Prize Committee, and in 1994 he received the Nobel Prize in economics.

Substituting visual for aural hallucinations is in no way a critique of the film, for it would have been difficult to do this in any other way without revealing at the start that these figures were not real. But there are a few tiny inconsistencies in the film. A Nobel Prize winner does not give a public speech during the award ceremony at which the King of Sweden is present, but at another location at a later date. Neither does Princeton University have a ceremony where academics are honored by being presented with fountain pens. On the positive side, the way in which, as Nash looks at an array of numbers, some of them begin to stand out and glow does, I feel, give a sense of how patterns and connections of numbers may appear to mathematicians.

I recall that, while on a sabbatical with the mathematician Roger Penrose, someone brought in a formula, involving such numbers as *pi*, *e* and so on, that was supposed to give the value of what is known as the fine structure constant. Penrose looked at it for a moment and said that it was the intersection of a light cone (in maybe seven- or eight-dimensional space) with a sphere (in a space of another dimension). As you will see, I can no longer recall the number itself or the number of dimensions involved, all of which goes to show that I am not a pure mathematician by nature. But I do recall my amazement that Penrose should be able to see the connection so rapidly.

At the time of writing this section, John Nash was still at Fine Hall in the Department of Mathematics of Princeton University, and posting on his website in the field of logic, game theory, and cosmology and gravitation; with his most recent posts just a few days before I wrote this paragraph.

Pi

 In many ways *Pi* (1998) is unique, not so much for its story but for the very fact that it was ever made at all. At the time its director, Darren Aronofsky, had just graduated from film school. Moreover, he had no big producer or backer behind him, and simply sought out small donations from friends and family—these are acknowledged at the end of the film. And so his film was made with an incredibly small budget of around $30,000, but grossed several millions, mainly in DVD sales.

Pi is about the ubiquitous ways in which numbers appear in our world so that truly 'all is number.' At least that is how the universe appears to Maximillian Cohen, a mathematical genius who, with the aid of his home-made supercomputer, obsesses about the power of numbers to represent the world. After all, something as simple as the Fibonacci series, in which the next number in the series is equal to the sum of the previous two—1, 1, 2, 3, 5, 8, 13, and so on—describes everything from the growth of rabbit populations, the pattern of seeds in a sunflower, the twists of a sea shell, to…much, much more. Cohen is also examining the sequence of numbers on the stock market in the hopes of discovering some universal pattern that underlies them

In fact Cohen's interest in the stock market is not unusual, since many of North America's top graduate students in mathematics and theoretical physics are going into the money market, where they can profitably use the tricks of chaos and complexity theory, rather than turning to academic research.

One other factor that Cohen shares with some other brilliant minds (but certainly not all!) is his obsession and reclusiveness. Such individuals are concerned with their research at all costs, to the point that they seem incapable of relating at a human level. Indeed, it has become the fashion to label such people as having an autistic spectrum disorder. I well recall one researcher telling me that he preferred to work with computers than with other human beings because computers don't have feelings. In addition to his obsession, Cohen suffers from crippling headaches.

One day Cohen's supercomputer prints out a 216-digit number along with some impossible stock market predictions. However the next day he discovers that the stock predictions were correct and somehow his computer has learned the deeper pattern that underlies the market. Cohen has also met a Hasidic Jew and his colleagues who are researching the number significance of the Torah. According to the Kabalah, every letter in the Hebrew language has a number equivalent and the Torah is one vast book encoded by God. The 216-digit number printed out by Cohen's computer could, therefore, be the name of God which, if pronounced, will issue in the Messianic age. But Cohen refuses to give them the number and, in the end, feels that the number is now working within his brain and so drills into his skull where he believes his mathematical genius is located in a desperate attempt to erase it. At the end of the film he is sitting in the park when a child with a calculator asks him a question about arithmetic. Cohen says he does not know the answer.

POLLOCK

 And now we leave mathematics aside and move to art. At the start of this section on creators we learned of Patrick Heron's proposal that artists help us to see the world in particular ways, and that when the nature of art changes, so too does our perception of the world. Jackson Pollock was one of those painters who produced a revolution in art, and of our way of seeing when, in 1945, he moved from New York City to a house and studio barn on Long Island. For the next ten years he produced his remarkable drip, or action, paintings.

Among creators, *Pollock* is a particular type, the almost clichéd version of the drunken genius. While there have been drunken writers such as the Welsh poet, Dylan Thomas, and the Irish novelist and playwright, Brendan Behan, as well as the opium-taking Coleridge, the drunken creator seems particularly American. Think of how many of the great American writers— William Faulkner, F. Scott Fitzgerald, Ernest Hemingway, Raymond Carver, Dorothy Parker, Truman Capote, Eugene O'Neill, Tennessee Williams and others, have been either alcoholics or very heavy drinkers.

Why should that be? Maybe the creative person drinks in order to dull psychic pain, maybe to escape into another world, or perhaps because they believe it will lead them to some transcendental place. In Bertrand Tavernier's *Round Midnight* (1986), the alcoholic tenor saxophonist Dale speaks of the psychic pain of having to produce something beautiful every night.

Carl Jung also pointed to the double meaning of the word *spirit*. At all events the film *Pollock* does underline one lesson: that Pollock could not paint well when he was drunk. (Dylan Thomas also said that he couldn't write poetry when he had been drinking.) It is only when Pollock's wife persuades him to come off the sauce that he produces his outstanding series of action paintings.

Thus a sub theme to the film is that of sacrifice. Lee Krasner, Pollock's wife, was a talented painter (note how Pollock puts her down in an unthinking way as being 'a damn good *woman* artist'), but devoted her energies to supporting Pollock. Another film which deals with sacrifice is Ken Russell's 1968 *Delius: Song of Summer* which tells the story of the young composer, Eric Fenby, who sacrificed his health and talent to serve the aged and blind Delius. Delius' music was sublime, yet Fenby was to find the composer to be an irritable and particularly unpleasant man. Nevertheless, Fenby persisted, and possibly sacrificed his own career. Without Fenby we would not have Delius' later compositions but, Russell asks us, was that worth the sacrifice? After Russell's film was made, it was given a special showing for Fenby who subsequently had a breakdown.

Pollock sticks very closely to Pollock's life, and highlights two important statements made by him. One occurs when his wife asks if he is abstracting from nature, and Pollock replies 'I am nature.' The other occurs during a radio interview, when Pollock claims that in his painting 'there are no accidents.'

So while earlier art had been about representing the world—albeit it in sometimes stylized ways, or what the art critic Ernst Gombrich called *schema*, Pollock was now displaying the event itself; nature's process as it flowed through his body into a complex web of drips of paint. According to the art critic Clement Greenberg, the canvas itself had become the arena where events take place.

So let us bring this back to Heron's remark about schools of art and their relationship to the way we see the world. Before the Renaissance people lived in a fairly hierarchical way, they fitted into the society around them, they had their specific roles to play and all lived within the cycles of a living time. One representation for this was Dante's *Divine Comedy*, another was the way painting was stylized with colors, gestures, expressions encoded in ways that could be read by their audience.

With the Renaissance came the rise of reason, a time when the authority of the church was weakened and 'man' became the 'measure of all things.' This change can be seen in the difference between the Sienese painter, Duccio and the Florentine, Giotto. The figures of the pre-Renaissance Duccio are stylized while those of Giotto have become more naturalistic. The device

of perspective has also been developed; this depicts an event frozen in time and seen by an objective observer. Then, at the dawn of the twentieth century, we have color broken into the dots of pointillism immediately before Planck's hypothesis of the quantum. Time re-enters art with 'Cézanne's doubt,' the possibility of reading a scene from more than one angle at the same time. This continues with Picasso and Braque's cubism which was born a few years before Einstein fractured space and time with his general relativity. And now with Pollock we see how the coding of nature's forms on the canvas has been abandoned in favor of nature's direct actions, nature as process on the surface of the canvas, which becomes close to the way quantum theory favors process over object. In addition, when fractal images began to be produced via computer calculations, people were struck by their resemblance to Pollock's paintings.

Maybe in the case of Pollock it was something about the anxiety of the post war period in America with its Cold War, threat of nuclear attack, and the memories of all that had happened in the years before that caused people to see the world in less secure ways. They no longer felt that the art of the period was speaking directly to them. But Pollock, and others such as de Kooning, had found a visual expression for what the world was feeling and for its lack of an undying faith in reality.

What is particularly impressive about the film is the way Ed Harris has got into the skin of Pollock, even to the extent of reproducing the act of painting. It also captures the atmosphere in New York when artists, such as Stuart Davis and members of the Ashcan school, would meet together in bars to drink and talk.

A key scene in the film is when Pollock finally goes back to drinking and we realize that his career is about to be over. This occurs after he has completed work with a filmmaker who persuaded Pollock to paint on a sheet of glass while the camera was placed underneath. With the filming complete, Pollock felt himself a fraud and unleashed an outburst of anger against the filmmaker, then headed for the drinks cabinet. Tensions also increased between Pollock and his wife who eventually left him. Pollock took up with a young woman and, at the end of the film, the two of them are driving, along with the woman's friend, when Pollock, under the influence of alcohol, skids off the road and is killed along with the friend.

A number of other films have been made about artists including Derrick Jarman's *Caravaggio* (1986), John Maybury's *Love is the Devil* (1998) about the painter Francis Bacon, and Peter Webber's *Girl with a Pearl Earring* (2003) about Vermeer. Back in 1936 Charles Laughton played Rembrandt in Alexander Korda's film of the same name. In 1956 Kirk Douglas played Van Gogh in Vincente Minnelli's *Lust for Life*, Robert Altman explored the relationship between the artist and his brother Theo in his 1990

Vincent and Theo, and a year later *Van Gogh* was directed by Maurice Pialat.

FUR: AN IMAGINARY PORTRAIT OF DIANE ARBUS

 The notion of the photographer as someone who sees life from behind the shield of the camera, has been mentioned several times in this book. But what of a film that takes as its starting point the work of a real photographer, or rather the genesis of a unique photographic vision? Steven Shainberg's *Fur: An imaginary portrait of Diane Arbus* (2006), despite the film's subtitle, caused considerable confusion amongst audiences, and even film critics, who assumed that they were watching a film about the life of the photographer Arbus. Rather than calling it 'an imaginary portrait' it would be closer to say that this heavily symbolical film is more like a dream someone may have after watching an exhibition of Arbus' photographs and wondering about the gestation of her approach.

So who was Diane Arbus? She was the daughter of rich parents who owned a Fifth Avenue department store. At the age of 18 she married Allan Arbus, and the two ran a commercial photography business with Allan as photographer and Diane as his art director. After several years Diane began to study photography under Berenice Abbot and Lisette Model, and developed her own very distinctive style of bizarre photographs involving what could generally be described as deviant and marginalized people, as well as the curious and bizarre isolated images that can sometimes be found in a big city. While she was the first American photographer to have her work displayed at the Venice Biennale, Susan Sontag attacked her in a review of a retrospective at the New York's Metropolitan Museum as being a 'voyeur from the Upper West Side.'

So how did the sheltered daughter of rich parents come to be known for her images of what Arbus herself termed 'freaks'? *Fur* sets out to provide a dream-like answer. At the start of the film we see Diane with her husband and parents at a fashion show of fur coats hosted in her apartment. Diane, who wears a tightly buttoned white dress, is clearly dominated by her mother and father, and is inarticulate when asked about her own work. We also see her as the supporter of her husband's fashion photography and learn that, while he once gave her a camera as a gift, she has never used it. She is presented as the 'rich girl' with an empty life.

But on the same day as the fashion show she learns that someone has moved into the apartment above her. She is fascinated by the idea of this stranger, and that night stands on her balcony and opens the front of her dress.

Now the film engages in considerable symbolism as Diane begins to investigate this stranger—symbolism that involves metaphors of the unconscious and the journey of Alice in Wonderland. Her encounter begins with a drain blocked by thick matted hair which has clearly come from the apartment upstairs (cleaning the drain as unblocking her creativity!). She visits the basement, where she sees articles from a freak show and a woman without arms. Then, donning an Alice blue dress rather than her white one, she decides to investigate the upper floor. But here it is not only a matter of walking up the stairs, but of then climbing a spiral staircase. There she enters a magical kingdom complete with white rabbit, key, an invitation to drink from a cup and a doorway into a tiny room. There is even the rabbit hole expressed in terms of an imagined journey along the air vents of the apartment building. As for the metaphor of looking, there are many shots where Diane is peering through small apertures—although as a photographer she did not look through a viewfinder but used a Rolleiflex camera where the image could be seen on a ground glass screen.

And who does Diane encounter in this upper apartment? Lionel, a man whose face and body is covered in thick hair. So what do we take from this? In part it is a reworking of 'Beauty and the Beast,' in part showing that the self-effacing Diane must finally come to terms with her animus—the hairy male part of her psyche. This animus will now introduce her to a world of freaks. Each night she will leave the marriage bed, taking her camera with her, to explore Lionel's bizarre world. (Incidentally, as she does this her husband both begins to distance himself from her and grow a beard!) At one point Diane even unscrews a trap door in the ceiling of her apartment, pulls down a folding staircase, and allows Lionel's world of freaks to invade her own space.

And as for the ending of the film? Lionel, who has told Diane that he is dying, asks her to shave him and then accompany him to the sea. There he swims away from the shore to drown. Yet more heavy symbolism—Diane has returned the animus figure to the unconscious and, in turn, he has left her the gift of a cloak of hair. Her animus is now activated, and she will begin her life as a photographer of strange and haunting figures. And if we'd like just a little more symbolism, just before dying Lionel has inflated a rubber mattress; Diane can now release the seal and breathe in his spirit!

If film, art and artists can sensitize us to new ways of seeing reality, then certainly Diane Arbus should feature, not only for exposing us to a world

few of us ever see in our everyday lives, but also for some of her other work that shows us the strangeness that can also lurk in the familiar. And if there is a shadow side to Arbus, although it does not really appear in the film, it lies in Sontag's criticism that she was exploiting, in a voyeuristic way, the subjects of her photographs.

AMADEUS

 Milos Foreman's 1984 film *Amadeus* is based upon a stage play by Peter Shaffer, a writer who tends to handle 'big' themes. *The Royal Hunt for the Sun*, for example, deals with the conquest of Peru, and *Equus* is about a boy who blinds horses. Both were later made into films, and both deal with gods and transcendent ideas. In *Amadeus* he approaches the character of Mozart, and in particular the jealousy felt by the older and more financially successful Salieri who is portrayed in the play and film as a somewhat second rate composer given to petty gluttony. In fact, Salieri could not have been that bad a composer; he was also the teacher of Beethoven and Schubert. For whatever reason, Salieri disliked Mozart and a story, possibly made up by Pushkin, circulated that he poisoned the younger composer.

What is certainly true, and is shown in the film, was that compositions came to Mozart more or less as a whole and were written down without the need for later correction. In addition, he was capable of hearing someone else's composition on only one occasion and then being able to recall it totally. Mozart's middle name, Amadeus, means 'loved by God,' and the theme of the film is that God communicated directly with Mozart.

Mozart is therefore portrayed as a vehicle, a medium through which something else acts. Many creative people feel this way about writing, painting, playing music, acting or composing. They feel that their own ego is not operating during these acts. There may even be periods in which they are not aware of what they are doing, yet paint is going onto the canvas, words are being typed onto the computer screen. Jungians may talk about the archetypes and the unconscious. Others would talk in terms of possession. The British composer Sir Michael Tippett even talked about invoking the gods. For Tippett music is something that enters the body, where it must be held until it is ready to be written down. At times, for Tippett, this could become a long and painful interval in his life.

In the film Mozart is the vehicle of God. God manifests himself on Earth in the form of music via the medium of the young composer. In this sense

we are shown creativity as the province of very special people called 'geniuses.' As with van Gogh, Jackson Pollock or the fictitious Dale in *Round Midnight*, they are also destroyed by their own creativity: it is something too large for them to contain. In keeping with this rather romantic view of creativity, the film portrays Mozart the man as a somewhat trivial and empty vessel. And it is certainly true that the historical Mozart loved games and his letters can be quite scatological.

Amadeus is a film that asks us to reflect on the nature and source of creativity, yet at the same time perpetuates the notion that ordinary people cannot really be creative and that true creativity is the province of the genius. In *The Blackwinged Night* I attempted to argue that creativity is ubiquitous throughout the universe, and that each one of us is inherently creative. Children, for example, learn to speak and then produce entirely original sentences that they have never heard before. Their speaking is creative, their play is creative, their early drawings are highly creative. And if that inherent creativity does not continue throughout their lives, it is often because it becomes blocked by such things as an educational process which attempts to set standards to which each child must measure up, one that may reject a drawing because it is 'too childish.' It is when children begin to compare themselves to others, when they learn that certain ways of writing, drawing and behaving are rewarded with praise or high marks, that they begin to learn how to conform to the expectations of adults and their older children.

So maybe there is a lesson in *Amadeus*, and that is to remain childlike and express an attitude of innocence to the world that allows creativity to continue to flourish. And recall that film which was judged as one of the greatest, *Citizen Kane*. It was made by a director who had never made a film in his life, someone who had never been told 'you can't do that, you must do this.'

ROUND MIDNIGHT

 I must admit that *Round Midnight* (1986) has a particular appeal to me, not only because I like jazz but because I once sat in that very same setting of the Blue Note jazz club in Paris. The film is filled with atmosphere and jazz, and paints a compelling picture of the clubs and aficionados of the early sixties.

Round Midnight is based on the life of the pianist Bud Powell, one of the innovators of the bebop movement, who played with Charlie Parker

and Dizzy Gillespie. While he was one of the most influential jazz musicians of his day, Powell had a troubled life. He was an alcoholic, and in and out of psychiatric hospitals. In 1959 he left New York for Paris where he was befriended by Francis Paudras and enjoyed a considerable revival, making some notable recordings. After his stay in Paris, where he played regularly at the Blue Note club, Powell returned to New York where he soon lapsed into alcoholism and died.

In the film, directed by Bertrand Tavernier with a title taken from the Thelonious Monk composition that has been one of the most recorded tunes in jazz history, the character of Dale Turner is not a pianist but a tenor saxophonist played by one of the great jazz tenor men, Dexter Gordon. Dale is befriended by a young Frenchman, called Francis Borler in the film, who has been spending his nights outside the club listening to Dale play. Francis tries to help him with his alcohol problems, even allowing him to stay at his house. Dale is passionate about his music, and in one telling scene Francis finds him practicing in a vacant lot behind the club. Dale is trying to play, but can't remember the words to the song. In order to play and improvise he must recall the words.

Dale makes friends with Francis' daughter, and even visits Francis' parents. It is a film rich in jazz that gives an intimate feel of jazz clubs of the period and the tension faced by musicians that are expected to produce something beautiful and original night after night. When you look at the history of jazz, it is filled with stories of musicians who had periods of addiction to drugs or alcohol—Miles Davis, Charlie Parker, Stan Getz and Chet Baker among others. For a time Baker was jailed in Pisa, Italy for drug possession, and there are stories that people living near the prison could hear the mournful sound of his trumpet as he practised in his cell. Finally Dale returns to New York, and we learn of his death. Again it is another window into the life of a creator.

So why does the film have a unique appeal for me? In my teen years I was attracted to two things in addition to science; jazz and French poetry—Baudelaire, Verlaine and Rimbaud. I knew many pieces by heart and can still repeat them. Or maybe it wasn't even French poetry as such, but the notion of France as the home of the Impressionists, of the romantic story of Baudelaire and his mistress on his sea trip, of Rimbaud abandoning poetry and going off to Africa. It seemed an alternative to what I felt was the stuffy Britain of my father's generation at a time when we were being constantly told to 'just look what your generation has become.'

And so I was determined that I would go to Paris for a short vacation, and booked a room at the Hotel Blanche on the rue Blanche in Montmartre. I spent my days visiting such places as the Louvre and Museum of Modern Art, but in the evenings it was jazz clubs. And thus one evening I walked

into the Blue Note. In addition to the tables in the body of club itself, there were two or three tables on the stage, and I sat at one of them and ordered a drink. A little later Bud Powell came onto the stage with his drummer and bassist. And now I was listening to one of the giants of jazz—but to my chagrin the patrons who had paid for their expensive drinks were still talking to each other. For my part I listened, totally fixed on the music. At the end of the first set I applauded with great enthusiasm. Bud raised himself from the piano stool and bowed to me. My day, my entire week was made. And many years later I saw the film *Round Midnight* and thought 'I was there, I saw it. I heard it…firsthand.'

BABETTE'S FEAST

 Can a creative act change an individual or even a community? That is the premise of Gabriel Axel's 1987 film *Babette's Feast,* or rather the short story by Isak Dinesen on which it is based. So far we have seen the creative person as a composer, mathematician, painter or musician, since creativity is generally thought of in terms of producing something concrete, for example a painting, statue, book, performance, published theorem or musical composition. But creativity can manifest in many other ways—a relationship, caring for a garden, bringing up a child, making someone smile and, in the case of Babette, cooking a meal. And so, in her creativity, Babette transforms a repressed, austere and puritanical village through the medium of French cuisine.

The film follows Isak Dinesen's short story very closely, including some of the dialogue. Dinesen sets her story in Norway, while the film places its action in Jutland on the west coast of Denmark. Babette has arrived from France to find herself in this puritanical village where she acts as a servant to two elderly sisters. Their late father, a pastor, had made a great impact on his community, yet at the same time fettered the lives of the two sisters. In their youth, a young man fell in love with one of them, but when he realized that he had no chance of marrying her he entered the army with great success.

One day Babette receives news that she has won a large sum of money on the French lottery. The sisters assume she will return to France, but Babette says that first she wants to cook a dinner for the sisters and their friends—the congregation of their late father. Throughout the day a lavish amount of food and wine appear at the house, and the sisters are particularly perturbed. Throughout their life they have followed their father's puritan ideals. How can they allow such food, such wines and spirits, to be

served at their table when most of their meals have been based on a type of bread soup? They meet with other members of the congregation who agree that they will maintain their comportment throughout the meal. 'We will act as if we had lost our sense of taste.'

And so the guests assemble around the table as the first dishes are brought in. As they eat they pretend to ignore what they are eating, and speak of other matters. It is only the General, a former suitor of one of the sisters who happens to be in town, who praises the food and wonders how it is possible to be served such dishes since he had only tasted them before in a particularly important restaurant in Paris.

As the meal progresses the guests begin to forget their vow, and gradually they are transformed; they smile at each other, take more wine, relish the food that has been set before them. By the end of the meal the community has totally changed.

When the meal is over the sisters thank Babette and ask her what she will do with the rest of her money. She admits that she has spent it all. After all, she says, what do they think a meal like that would have cost in a restaurant in Paris? In turn, she thanks the sisters for allowing her to exercise her creativity one last time in her life.

And so, at the end of the dinner with the food and Babette's money gone, does anything remain? Are the people really changed, or will they go back to their old traditional ways? Will anything remain of Babette's gesture? Will it even exist as a dim memory, an event that happened many years ago? Or was that moment, those few hours of joy all that mattered?

Even within the world of the arts, creativity does not necessarily imply a material product. One of Hamlet's soliloquies, or a musical performance, may find its way onto a CD, but in general it is performed for a more limited audience and then it is gone—not forever, but always to be minted anew at the next performance. Artists also produce intangible things—happenings, performance art, conceptual art or objects that will never be seen, such as a metal rod buried underground. There is also a strong Art and Environment movement today where artists are working in minimal ways with the natural world, or even cataloguing the species of trees and plants in a city. Environmental art of the past involved strong ego statements, generally by male artists, but today their work is more delicate.

MODIGLIANI

 Finally there was Mick Davis' *Modigliani* (2004) in which Andy Garcia gets a chance to 'act' at being an Italian, and other actors get to act at 'painting a masterpiece.' But despite this there is one golden moment in the film, a short scene in which Picasso drives Modigliani into the country to meet the aged Renoir. Renoir is played by Theodor Danetti with particular delicacy and intelligence, so that the scene rises above everything else in the film. And if you, the reader, happen to enjoy that scene then it is well worth reading Jean Renoir's book, *Renoir: My Father*.

VIII.
Adaptations

There are many adaptations in cinema, with novels and plays being turned into films. But in this section we shall look at adaptations of films from one language or culture into English-language movies. The linguists Benjamin Lee Whorf and Edward Sapir argued that there is a deep connection between the language of a particular country or culture and their worldview, in other words their particular experience of reality is to a certain extent enfolded in their language. A much quoted example is that of the Inuit who have many different words for snow because their lives are lived within an environment of snow, and so for the purposes of hunting and travel it is important to discriminate between snows of different characteristics. Likewise part of the task of becoming a doctor is that of learning the names of different parts of the body. For most of us a hand is just fingers, thumb and the palm, but for a medical student it is 27 distinct bones alone.

But the connection between reality, or worldview, and language goes much deeper than just a collection of nouns. Deeper indeed than just language as spoken communication, because it also involves gestures, the nature of relationships and a host of other things. Naturally one way a culture expresses itself is through film, and it could be said that a culture's values, attitudes and aspirations are all enfolded within a film. That is why it is interesting to see what happens when a film in one language and culture is re-made in another. Take for example Akira Kurosawa's *Seven Samurai* (1954). In 16th century Japan a village is under attack by bandits. The villagers are poor and have no weapons, but a village elder suggests that they seek out Samurai warriors who will agree to protect them. Translate this into a North American context and you get John Sturges' *The Magnificent Seven* (1960) in which a poor Mexican village is threatened by bandits and seeks out seven guns for hire who will protect them. These two films contrast the hierarchy and formality of Japan with the American West and its wide open spaces and cult of individualism.

The Magnificent Seven is set in a period when the Wild West is becoming 'civilized,' as one of the characters puts it, and the role of the traditional gun for hire is coming to an end. The film adopts a common formula—one we have already met in *The Dirty Dozen*. It involves a problem which can be solved if the right man can be hired. This man must now recruit

others, which allows the film to introduce a series of individuals, each with a particularly easily recognized characteristic. The climax will be the final encounter in which some of these characters are sacrificed, and the final resolution with the central hero safe and able to ride or drive away. A particular feature of *The Magnificent Seven* is the notion that the farmers, the inhabitants of the village, represent a way of life that endures for generation after generation, putting up with hardships and backbreaking work. Their defenders, however, are no more than the wind that blows in its season and clears the land of locusts. And so at the end the hero is able to say that it was the farmers who won, and the gunmen who lost.

Since most foreign films can be rented with subtitles maybe you, the reader, would be interested to see for yourself what happens when a film is transformed and translated from one culture and language to another. The following are a few to choose from.

Erik Skjoldbjærg's 1997 *Insomnia* is set in Norway, land of the midnight sun, where the detective in a murder investigation becomes disoriented by his inability to sleep in so much light. Christopher Nolan moved the action to Alaska for his own version of *Insomnia* (2001).

We have already met Hitchcock's *Psycho* (1960) that was made in response to Henri-Georges Clouzot's *Diabolique* (1955) in which an apparently dead husband suddenly sits up in the bathtub. His motive is to frighten his wife, who has a heart condition, so that she will die of a heart attack. In *Psycho* Hitchcock makes a wry reversal of this plot. The apparently live mother, who supposedly commits the murder in the shower, turns out to be dead. She has been dug up and stuffed by her son. 'Mother' is really the son dressed in her clothes.

Jean Renoir's *Rules of the Game* (1939) is considered one of the greatest films ever made; it certainly inspired Robert Altman, who used many elements from the original in his 2001 *Gosford Park*.

Chris Marker's avant-garde French film *La jeteé* (1962) was created entirely out of still photographs, and involves survivors of World War III who select a slave to time-travel to the past in an effort to reconstruct their world. This film inspired Terry Gilliam to make *Twelve Monkeys* (1995) in which a convict travels back in time in an attempt to prevent the release of a virus that has destroyed his world. Of particular interest is the fact that Gilliam used Marker as co-author of the film's script.

And while it is not an adaptation of a film but of Shakespeare's play, *King Lear*, Akira Kurosawa's *Ran* (1985) involves three sons, rather than daughters, who do battle after the abdication of their father, the Great Lord Hidetora Ichimonji. In fact Kurosawa claimed that the idea came to him from the abdication of a warlord with three sons who all happened to be

loyal. The director asked himself what would have happened if they had been more ambitious and then, learning of Shakespeare's play, he began to develop the script of *Ran*.

Then there are those adaptations or 'remakes' when a Hollywood director decides to make a new version of one of his own country's classics. We have already seen one example, the controversial remake of J. Lee Thompson's *Cape Fear* (1962) by Martin Scorsese in *Cape Fear* (1991) that was condemned by some critics for being overly sadistic.

While generally in a remake the director decides to take the same basic story, but to film it according to their own sensibilities and in ways that reflect their own particular attitudes to cinema, there is also a newer variety which could be termed 'reproductions.' Gus van Sant's 1998 version of *Psycho* sticks to the original shooting script, and uses the same camera angles. Of course the performances can never be the same, particularly as acting styles change over time.

Now let me end with one film in particular that has not been so well received by the critics, and this is Cameron Crowe's *Vanilla Sky* (2001), based on the Spanish film *Abre los ojos (Open Your Eyes,* 1998) directed by Alejandro Amenábar. I would argue that *Vanilla Sky*, which sticks strongly to the plot of the original, does have some valuable additions.

The plot is a simple one. The film opens with a wealthy young man, David Aames, in bed being woken by the voice of his girlfriend, Julie, saying 'Open your eyes.' He wakes and drives into downtown Manhattan. But the city is empty. He gets out of his car and begins to run, then screams at the sight of a deserted Times Square. Suddenly he sits up in bed. It has been a nightmare, and in reality David is still in bed with Julie. And so the motif of a dream, and a dream within a dream, is established. It is yet another indication that films are more and more reflecting our unease with what we used to take as the hard and fast nature of reality.

We see David at work as a successful businessman, and with his close friend Brian at a party. An attractive young woman, Sofia, catches his eye and maybe he spends the night with her, or maybe it is only his fantasy. At all events, next morning an angry Julie drives him in her car. She drives off the road into a wall. Julie is killed, and David is in a coma. Another dream or illusion follows as David meets Sofia in the park and explains what has happened to him. Because of the accident he is so badly disfigured that he must wear a mask. We see a scene with David, Sofia and his friend Brian at a bar. Sofia decides she will walk home alone, Brian also leaves. David decides to run after them, only to discover the two embracing. He collapses on the sidewalk. We see him in the same position in the morning sun. It is at this point that new elements in the soundtrack occur—they appear to be

processed voices, faint and distorted. A clear voice says 'Open your eyes,' and we see Sofia leaning over him, telling him that she loves him.

It is only later in the film that we realize that this was the breaking point for David, that he went home to commit suicide and, at the moment of death, was held in suspended animation for 150 years by a company called Life Extension. From that point on, everything that occurs to David is in a dream-like state, and this is reinforced by the soundtrack. In real life while dreaming, noises in a room may wake us, or we may incorporate them into our dreams. So sound in a dream can be a symbol of intrusion from the outer world, or a signal that is it time to wake. This is what happens in *Vanilla Sky*. There are sounds similar to a muffled bell, and other processed sounds, that appear at particular moments when the paradoxes of the dream—or the life extension experience—are particularly disturbing. It is as if David's unconscious is subverting Life Extension's program and attempting to warn the sleeper that this is not the real world, but a simulation created in a dream. This I feel adds an important new layer to the film that was not present in the Spanish original.

David goes about his life with Sofia, but now events become more distorted. There is a poster of the film *Jules and Jim* on his wall—the Truffaut film of the story of two friends who are in love with the same woman, Catherine. Sofia takes on certain aspects of Catherine in Truffaut's film. On another occasion, as David and Sofia walk along a street, they adopt the identical pose to the couple on the album cover of *The Freewheelin' Bob Dylan*—again we see how elements from David's memory are being used to construct his world. He is asleep in bed with Sofia when the soundtrack again brings in the distorted voices. He wakes and realizes it is not Sofia, but Julie. He then finds himself under arrest for murdering Julie and being evaluated by a therapist. His lawyer tells him he must wake up to the predicament in which he has been placed—and at that moment a bell begins to ring on the soundtrack. He is also disturbed by a man he sees in a variety of locations, and who seems to know him.

Finally, along with his therapist, David visits the Life Extension Center where he learns that he died after taking an overdose and is now frozen at the moment of death. The reality around him was supposed to be a pleasant dream but has now turned into a nightmare. He can choose to awaken or continue to sleep, but if he does return to reality it will be 150 years into the future and Sofia and his friends will be long dead. David decides to return to life, says goodbye to the dream Sofia, and throws himself off a high building. As he rushes towards the ground we see a montage of the various events of his life, from being a young boy, a red balloon (a reference to the French film *The Red Balloon*), the pop songs of his teen years and so on. It makes a satisfying ending as a symbol of both renouncing a past

that will by now have been long dead, and an awakening to a new world in the future. In this sense I feel that new and creative elements were added to the remake.

While David is being warned that reality around him is no more than a dream, the same support is not given to the humans in *The Matrix*. These are in a state of suspension in artificial vats with their brains plugged into a matrix so they all share the same complex illusion of, for example, walking the streets of New York, working at their jobs, talking to their friends. At one level it is pure entertainment, at another both films are making philosophical points about reality that go back to Kant, or beyond into Eastern philosophy. Is the world real or is it a persistent illusion? Can we ever know the essence of something, the 'thing in itself,' the numen, or are we left only with the phenomenon—the reality that we create out of our own minds as we view and interact with the world? In this sense, is the world of those who live within the Matrix or the Life Extension dream any less real than the world we ordinary humans inhabit?

MARIE ANTOINETTE

 The previous section discussed the issues around Hollywood adaptations of foreign films. This section touches on the issue of 'period drama,'—films that attempt to reproduce what it was like to be in Troy, Ancient Rome, at the crucifixion of Christ, the Battle of Waterloo, and so on. Again it is a matter of viewing the past through the lens of a particular culture in the present, so that a period drama made in the 1940s would be very different from one made in the swinging sixties or in the 21st century with its awareness of postmodernism and deconstruction.

Sofia Coppola's *Marie Antoinette* (2006) met with a mixed reception and was booed by some sections of the audience at Cannes. Ostensibly it is the story of the historical Marie Antoinette, her move from her native Austria at the age of 14, her immersion in the formal French court, her squandering of money, and the way the French rose against their rulers at the start of the Revolution. But since it is a film made in the 21st century, it cannot get away from the fact that it is being watched by young women of today who can fantasize about how they would react in similar situations. Coppola accepts the basic premise that you can't travel back in time and shoot a film in the 19th century, partly in French and partly in German. So what do you do? Dress up contemporary actors and actresses in period cos-

tumes? And do you give them all English accents because, in some curious way, that sounds more 'European' to American ears? And do you give them rather stilted and formal diction and lines? Or do you insert distancing effects? When Ken Russell was making his biopics for the BBC, he was accused of not strictly adhering to accuracy. In one instance there is a formal meeting where a number of composers are being introduced. 'And this is Strauss.' 'Johann or Richard?' 'No, Levi.'

Likewise Coppola begins by adopting in part the convention that these are all characters living in the past, but as the film continues she begins to subvert this premise. As Marie Antoinette begins to spend more and more time with her entourage, its members start to adopt some of the manners of Valley Girls with rich daddies. As the camera pans along her collection of shoes, for example, we notice a pair of white sneakers. One friend says 'cool,' and at times they appear to be smoking dope. (In fact the Valley Girl approach had been used by Amy Heckerling in her 1995 *Clueless*, set in Beverly Hills but based on Jane Austin's *Emma*.)

More generally, this device goes back to Brecht and his Alienation Effect—used in his dramas to remind the audience that they are watching a play. They are not, for example, really seeing Luther on stage, they are not witnessing elements from Luther's actual life, but are seeing something constructed by a German writer from the 20th century and played out by actors on the stage. In actual fact it doesn't quite work the way Brecht intended, for the audience are constantly moving between being drawn into the fantasy of seeing Luther and then pulled back by being reminded they are seeing a play. From my own experience that movement is somewhat more dreamlike, rather than alienating as Brecht intended. Likewise in Coppola's movie, the audience are drawn in to identify with the young Marie Antoinette and then pulled back when they hear 'Fools rush in,' see a pair of sneakers on the floor, or hear one of her friends say 'cool' when looking at clothing.

Indeed, Coppola's approach is not new in film. *The Scarlet Empress* (1934) by Josef von Sternberg is the story of Catherine the Great, yet it portrays a reality imagined by the director, since the costumes and décor do not correspond to those that actually existed in Russia of the 18th century. Von Sternberg preferred to create realities in the studio, and use his own vision of what had occurred, rather than film in authentic settings. When asked why he preferred to work with studio sets rather than historic locations, he replied 'Because I am a poet.'

CABARET from book to film to film

 Christopher Isherwood, whose name is often coupled with that of Auden—both immigrated to the USA at the start of World War II—went to Berlin in 1930 as an English teacher and spent time in the city during the rise of the Nazis. It resulted in two novels, *Mr. Norris Changes Trains* and *Goodbye to Berlin*. In the latter we meet a variety of characters, such as the 'divinely decadent' Sally Bowles who sings in a local nightclub, a rich Jewish heiress, a gay couple Otto and Peter, and many others based on people Isherwood met in Berlin. The book itself opens with the famous sentence 'I am a camera...' as if the author simply records without judgment what is happening around him, the decadence of the society and the danger that people such as a gay couple or a Jewish woman will face with the rise of the Nazis. While the narrator himself is gay, he is also drawn to the extravagant energies of Sally Bowles.

Isherwood's novel later became a Broadway play, and was then turned into Henry Cornelius' successful 1955 film *I am a Camera* with Laurence Harvey as Isherwood and Julie Harris as Sally. Inevitably the film gave birth to a musical and, in turn, that musical was made into a film. Bob Fosse's *Cabaret* (1972) stars Liza Minnelli as Sally, and a remarkable Joel Grey as the Master of Ceremonies. The musical closely follows the storyline of the earlier film and original book. There is one notable scene in an outdoor beer garden where a member of the Hitler Youth with a particularly beautiful voice begins to sing, and is joined by all the other patrons who stand to sing of the fatherland. One is again reminded of Burgess' comment that beautiful music does not redeem, and that many leading Nazis were passionate music lovers. The film ends with a chilling scene in the nightclub where the camera leaves the stage and pans around the audience, giving us a premonition of what they will all become.

The Titanic: One disaster—two films

The sinking of 'the unsinkable' *Titanic* in 1912, with the loss of 1,500 passengers and crew, was a true disaster that conveyed a sense of hubris when the power and ambition of human creations are overwhelmed by the forces of nature. There was also a curious synchronicity about the *Titanic*. The American writer Morgan Robertson published a novel, *Futility*,

in 1898 about a ship that hit an iceberg in the north Atlantic on her maiden voyage. There were not enough lifeboats on the sinking ship for the passengers to survive. The name of the boat was *Titan*!

Several films have been made about this disaster, but it is particularly interesting to compare Roy Baker's *A Night to Remember* (1958) with James Cameron's *Titanic* (1997). While Cameron both wrote and directed his film, Baker had the advantage of an excellent writer, Eric Ambler, who produced the script, and the active participation of Joseph Boxhall, a fourth officer who survived the sinking. Baker was also working in black and white which meant that he could seamlessly edit in actual footage of the *Titanic* itself.

In terms of the range and depth of characterization, Baker's film is clearly superior to Cameron's, even if at times it shows too much of the British stiff upper lip in the face of disaster. The film begins with the *Titanic's* launch, and then the preparations for her maiden voyage, so that it clearly establishes there will be three classes of passenger: the rich and aristocratic who will travel First Class, the less affluent Second Class passengers, and those who will be confined to the lowest decks in Steerage—mainly Irish emigrants. In addition the characters of the second officer (played by Kenneth More), radio operator, steward, stokers and ordinary seamen are well established in a series of vignettes.

We sense the mounting tension as the *Titanic* approaches pack ice and does not heed a radio warning from another ship that has decided to wait out the night before advancing further. Finally the ship hits an iceberg and a large part of her hull is ripped open, giving her about one hour more of life. The characters who have been well established can now play out their various roles. The captain and officers are at pains to avoid panic as the women and children are lowered into the boats. We also see the anger of the steerage passengers when they are ordered to remain below; the orchestra players who seek to maintain everyone's spirits; the couples who refuse to be parted; the rather brash American lady who takes charge of her lifeboat and encourages the women to row; the few men who attempt to take their place beside the women. One particularly telling vignette is that of the professional card sharp, a shady character who has been making a great deal of money off the other passengers. When offered a place on one of the last life boats, he turns aside and allows someone else take his place.

While the film was made using what the producer termed 'composite characters,' the American woman who encouraged the women to row was clearly based on Margaret Brown, a daughter of Irish immigrants who became involved in women's rights, literacy and children's education, and who came into great wealth when her husband's mining efforts struck a

rich seam of ore. After her death she earned the nickname 'The Unsinkable Molly Brown.'

With all the boats launched, many passengers who remained took their chances by jumping into the icy water. When the final count of survivors is made, we see that the true disaster was allowing such a boat to sail with so few lifeboats for so many passengers. And so *A Night to Remember* is convincing in its great attention to character and to detail—even to the menu served at the captain's table.

By contrast Cameron's *Titanic* was a very costly enterprise involving the painstaking reconstruction of the ship, only slightly smaller than the original, and the use of a vast water tank. As far as Hollywood was concerned it was a triumph, with rewards at the box office and a total of eleven Oscars. Its commercial success sprang from its being several films in one—most notably a conventional boy-meets-girl love story and an all-out disaster movie.

IX.
The Musical

Reality is the topic of this film book, but there are times when we may want to escape from realty, times when the world outside is simply too brutal or depressing to endure. And what better way to escape when dreaming in the dark than with a musical? Musicals are one of the great delights of the cinema and, while there were always stage shows with music and dancing, the musical is a pure, original creation of cinema. When we think of musicals we think of names like the director and choreographer Busby Berkeley of the early 30s, and dancers such as Fred Astaire and Ginger Rogers in *Top Hat* of 1935. It is no coincidence that the heyday of musicals coincided with a period in which the USA suffered the economic depression that followed the infamous Wall Street Crash. It was a time of unemployment and belt-tightening, but also of Roosevelt's promise of the New Deal. Set against those depressing times was the pure escapism of watching Astaire dance. It was something effortless, it lifted people's spirits, and at the same time it brought a touch of sophistication into their lives. And in admiring Astaire we must never forget Ginger Rogers who was supposed to have commented, 'I did everything he did, only backwards in high heels.'

To Astaire were added the talents of Gene Kelly and, along with a variety of sidekicks, they danced through the 40s and into the 50s with such great movies as *Easter Parade*, *Top Hat*, *Holiday Inn*, *An American in Paris*, and *Singin' in the Rain*. But with the advent of rock n' roll, Elvis and Little Richard, musical tastes had changed, and many of the musicals that were produced in the late 60s and early 70s were economic flops. It looked as if the musical was dead, but great ideas do not die out that easily and a new generation of musicals has proved they are as popular as ever.

Two of the treasures from the past were *Singin' in the Rain* and *Carousel*. *Singin'* (1952) was co-directed by Stanley Donan and Gene Kelly, and is not only one of the truly great musicals but also, yet again, a film about film. Gene Kelly plays Don Lockwood who got his break into films by acting as a stunt man and is now a star in silent films. Then one evening, at a party given by the studio head, a bombshell is dropped. The studio head wants to show them a short film. The lights are dimmed and a face appears on the screen, the mouth is moving and people can hear words. There is a great sense of shock. Maybe someone is hiding behind the screen? But no, it's a film with sound, and to some the result is quite offensive.

The film that Lockwood is working on must therefore be transformed from a silent film into a talkie, and so we see all those difficulties that were experienced in the early days of sound. Because of the noise made by the mechanism of the camera, the cameraman is enclosed in a soundproof box. To capture dialogue a large microphone is sewn into the corsage of the leading lady, Linda Lamont, but every time she turns her head her voice fades. It soon becomes clear that this actress simply cannot adjust to the world of sound.

There is also a scene in which the birth of dubbing is suggested. Lamont, the heroine in the film, is incapable of working with sound and particularly with singing. But Lockwood's friend, Cosmo Brown, gets an idea. He has Kathy Selden—Lockwood's love interest—mouth the words of a song while he stands behind her singing. In one stroke, the major problem of the new film is solved. Lamont won't need to bother about sound, she'll simply move her mouth and the sound will be added in later. This is exactly what happened with Alfred Hitchcock's *Blackmail* of 1929. Because sound had come along, Hitchcock had to reshoot some of the film with dialogue but his lead, Anny Ondra, had a very strong foreign accent. Hitchcock's solution was to have Ondra mime the words while an English actress stood out of the camera range with a microphone and, in a manner similar to Kelly's girlfriend, dubbed her own voice onto the final film.

The film is a perfect combination of dance and song, yet at the same time constantly reminds us about the nature of film itself—several of the scenes are set in the film studio—and the way in which we can move so smoothly from the realistic actuality of actors working on a film set to fantasy sequences. Thus, when Lockwood wants to woo Kathy, he takes her onto the film set and adjusts the lights for moonlight and in this artificial setting sings to her.

We also see Lockwood's close friend, Cosmo Brown, suggest a new idea to the studio. Why not a film where the action itself is shown in sound? In other words, a musical, and so we move into some of the key scenes of the film, including an incredible dance sequence with Gene Kelly and Cyd Charisse that was choreographed by Kelly. It involves long diagonal movements across a stage, and the use of a wind machine so that Charisse's long white veil makes a perfect diagonal that fills the whole screen. Then there is also that wonderful scene where Kelly, so much in love, sings 'Singin' in the Rain' as he dances in a downpour of rain.

Finally the resulting film is shown—the star takes her bow and is asked to sing. Kathy stands behind a curtain while Lamont mouths the words. It is at this point that Lockwood and Cosmo raise the curtain so the audience can see who is the real singer and star. It ends with Lockwood and Kathy in a car driving past a poster for their next film together.

CAROUSEL

 Musicals are about escapism, falling in love, joy and romance. But what about a musical which begins when the central character has been dead for 15 years? It is hard to imagine how any studio would have approved a script centered on Billy Bigelow, a reprobate who falls on his own knife when he attempts a robbery, and almost messes up his one chance to return to earth and help his daughter.

Billy is an unrepentant bum who never did anything to redeem himself during his life. Nevertheless there must have been something about the character, because his story had been told first as a play, *Liliom* by Ferenc Molnár (1909), then a silent film directed by Michael Curtiz in 1919, and again a 1934 version directed by Fritz Lang.

The 1956 version, starring Gordon MacRea and the music of Rogers and Hammerstein, was given the title *Carousel*. We first meet Billy in heaven where he is polishing the stars. He learns that his daughter, Louise, who was born after he was killed, is in trouble, and asks if it would be possible to return to Earth for a day. The Guardians listen to his story: he was a carousel barker, a rough and ready single man with an eye for the ladies, and good at attracting business. But then he fell in love with Julie, and was forced to give up his job at the carousel since the female owner was jealous. And anyway, a man with a steady girlfriend is not the sort of person who will attract young ladies to ride on the carousel.

Now they are married, but he is unable to find work and mopes around the house becoming increasingly irritable and unhappy. On occasion he hits his wife. He also has a very shady friend, Jigger, who tries to persuade him to be a partner in a robbery. When Billy learns that Julie is pregnant he walks by the sea, singing and fantasizing about life with his son... then he stops short because he realizes that the child may be a girl. Since he badly needs money to support his family, he agrees to join Jigger. But the robbery goes wrong. Billy is killed and, on entering heaven says that he never wants to return to Earth—there is nothing for him to go back to.

However the Guardians allow him to return for one day. He can meet his daughter, but will remain invisible to everyone. On Earth he learns how unhappy, Louise has become. She doesn't fit in with the other girls, she has no friends, and thinks badly of herself, particularly when people remind her that her father was a no-good thief. Billy attempts to speak to her, and for a few minutes Louise's need for love is so strong that she is able to see her father. They talk, but Louise can be sullen and, in a sudden flare up of temper, Billy slaps his daughter's face. Louise runs into the house crying.

This is an important day at school since Louise and the older girls are graduating. They all stand together and sing 'You'll never walk alone,' but Louise does not join in the singing. Finally we see another side of the unrepentant Billy, the way in which he is so filled with a desire for his daughter's happiness. At that moment Louise begins to smile and joins in with the other girls. His daughter will be fine, and it is now time for Billy to return to 'the place upstairs.' And so the combination of a strongly etched character, albeit a rather negative one, and Rogers and Hammerstein's music, made *Carousel* an unusual perennial.

There is one line in the film that would certainly shock audiences today and shows how radically our attitudes have changed. On being hit by her father Louise says that it didn't hurt—it was more like a kiss.

Return to Earth

The notion of a dead person's return to Earth has been the subject of a number of other films, such as Spielberg's *Always* (1989). Probably the most successful is Anthony Minghella's 1992 *Truly, Madly, Deeply* which has been described as '*Ghost* for people who can do crosswords.' Nina and Jamie were once very much in love, but Jamie dies and Nina is left alone, deep in grief, and in a house overrun with rats. Then one day, when she returns home, she finds Jamie in the house. He has returned to comfort her, but as time goes on he begins to fill the house with more and more of his dead friends who are generally watching television and getting in the way. Nina is also starting to rediscover her own life and meets Mark, the sort of man who can make her laugh. In the final scene Mark and Nina are standing outside the house, in love. We look at this from Jamie's point of view; his work is over, Nina is deeply involved in a new life and a new relationship, and it is finally time for him to go.

In real life there is a particular irony about this film, for the character Jamie has died after complications following a throat operation. Many years later, in April of 2008, Minghella himself was diagnosed with cancer of the tonsils. The operation was apparently successful, but several days later he suffered a hemorrhage. The doctors were unable to stop the bleeding and the director died.

BLACK ORPHEUS

 Although not strictly a musical, the Brazilian film *Black Orpheus* (1959) does have music as its central theme, and evokes both the Greek myth and Cocteau's film *Orphée*. As to the myth itself, Orpheus was the musician and poet whose songs could charm wild beasts and coax even rocks and trees into movement. When Orpheus' wife, Eurydice, is killed by the bite of a serpent, he goes to the Underworld to bring her back. His songs are so beautiful that Hades, ruler of the Underworld, allows Eurydice to return to the world above. However, Orpheus has to meet one condition: he must not look back as he returns with her to the world of the living. But he does glance back, and Eurydice must return to the Underworld forever. Orpheus is later torn apart, but his head continues to sing.

In the film Eurydice arrives at the house of her sister Serafina at the time of the Carnival in Rio. A boy, Benedito, tells Eurydice about Orfeu whose guitar bears the legend, 'Orpheus is my master.' Orfeu makes the sun rise with his music and, as with the Greek legend, the many animals in his shack appear to listen to his music. Orfeu says that there was an Orfeu before him, but he is now the master.

It is now the day of the carnival and Serafina, as Queen of the Night, is to dance with Orfeu who carries a large golden sun. But Serafina puts her costume and veil on her sister, Eurydice, instead. And so Orfeu and Eurydice dance and profess their love together. A motorcycle passes—an echo of Cocteau's *Orphée*. But now the figure of Death appears, and Eurydice runs and hides in a trolley car station. To avoid Death she hangs from one of the trolley wires. Orfeu, searching for her in the dark, switches on the power to bring on the lights. The resulting current electrocutes Eurydice—as with the original myth she is, in a sense, stung by a serpent.

Orfeu goes to a Macumba temple where he is told to sing. An old woman speaks with the voice of Eurydice, saying that she will always be with him but he cannot see her. Orfeu insists on seeing her, but Eurydice says 'You are killing me' and that he will never see her again.

Orfeu returns home carrying Eurydice's dead body. He stands at the edge of the cliff, stumbles, falls and dies.

The boy Benedito runs with Orfeu's guitar and tells his friend Zecca that he must make the sun rise. Zecca plays, a little girl gives him a flower and begins to dance, the sun rises and Orfeu is reborn.

The film was also responsible for introducing the music of Rio into North America. The score for *Black Orpheus* included several melodies by

Antonio Carlos Jobin that broke with the traditional approach to Brazilian music, and introduced the bossa nova or 'new thing.' Soon jazz musicians, including the tenor saxophonist Gerry Mulligan, were recording Jobin's music and included Jobin's friend and colleague, the guitarist and singer João Gilberto, in their combo. Several tracks were recorded in New York, but since João only sang in Portuguese the producer, Creed Taylor, asked the guitarist's wife, who spoke a little English, if she would be willing to sing a few lines even though she had no professional experience. When Creed decided to release a single from the session he edited out João's singing and included only the English verses. 'The Girl from Ipanema' rapidly became a smash hit and launched Astrud Gilberto on her singing career!

THE UMBRELLAS OF CHERBOURG

 The unique feature of Jacques Demy's 1964 *Les parapluies de Cherbourg* is not that it contains spoken dialogue interspersed with song or dance, but that the entire film dialogue is sung to Michel Legrand's score. The film features Catherine Deneuve as the 17-year-old Geneviève in love with Guy, a young mechanic. The two plan to marry, but Geneviève's mother objects that they are too young and that Guy has not even done his military service. They do, however, sleep together until Guy is drafted to serve in Algeria. Geneviève, now pregnant, is persuaded to accept a rich man, Roland Cassard, a favorite of her mother, as her husband, a man who promises to raise the child as his own.

Guy, after being wounded in Algeria, inherits money from his aunt and buys a service station, Escale Cherbourgeoise (Cherbourg Stopover). One night, in a deeply moving scene, a car draws up to the service station and Guy realizes that the driver is Geneviève. Very little is said (or rather sung), but it is clear that there is much tenderness and great regret for the life they could have led together. The scene is considerably enhanced by the return of the theme music 'I will wait for you.'

As the film critic, Jonathan Rosenbaum, has pointed out the word 'Escale' is etymologically related to 'escalier' which means stairs—in other words, a bourgeois step-up. So the service station for Guy was a way up from his life in a mechanic's shop to the owner of a business. He may have lost the first love of his life, but he has gained a great deal in prestige. Yes, there is regret at the end, but is it total regret?

The Next Generation

Along with *Top Hat, Silk Stockings* and a host of others, *Carousel* and *Singin' in the Rain* were great musicals of the past. But what of singing and dancing in a more modern world? In recent years we have had *Ray*, the story of Ray Charles, *Dreamgirls* that appears to be strongly based on the Supremes, *De-lovely* on Cole Porter, *Mamma Mia* based on the songs of Abba, and *Beyond the Sea about* Bobby Darin.

DE-LOVELY

 Cole Porter was heir to a large fortune inherited from his grandfather, a coal and timber speculator. Like many Americans of that period (Fitzgerald's 'lost generation'), Porter led a somewhat dilettantish life in Europe. His songs were memorable, in particular for the lyrics with their brilliant word play characterized by lists such as in 'You're the Top' in which 'an O'Neill drama' is rhymed with 'Whistler's mama,' or the constant questioning about the nature of love in 'What is This Thing called Love,' or the cynicism of 'Love for Sale.' And no one will forget Frank Sinatra's slight pause and a sniff after the line in which cocaine features in 'I Get a Kick out of You.' The song originally featured in the 1936 movie *Anything Goes*, but the line about cocaine was changed to 'perfume in Spain' as any reference to drugs was prohibited under the Motion Picture Production Code of 1930, commonly known as the 'Hays Code.'

So how to express his life? As a musical, perhaps? In *De-Lovely*, the aging Porter is sitting at the piano when he is visited by an angel, 'Gabe,' and is transported to a theater where his life is to be portrayed on the stage. It is in part a staging of his life, intercut with Porter's own flashbacks; the meeting with his wife, his early success, the jokes made at his wedding about his gay proclivities.

And all this is conveyed through song...and that's where the problem arises. Porter was one of the most sophisticated songwriters of his day. His 'Night and Day,' for example, is difficult to sing because it is written almost on a single note. His songs were marvelous vehicles for the singers of the 1930s such as Fred Astaire, Gertrude Lawrence, Ethel Merman and Mary Martin, and were embraced by the later generation of Sarah Vaughan, Ella Fitzgerald, Peggy Lee, Dinah Washington, Frank Sinatra and a host of

others. But *De-Lovely* was released in 2004, and it is a great shock to find that so many of the 'top singers' of today simply can't sing Porter. They are unable to do justice to one of the great songwriters of the past. That's not to say that there are no singers around today who *could* do justice to Porter, but just that they were not used in the movie. So what about *De-Lovely?* I enjoyed the film but wasn't too struck on the singing. The same criticism could not be leveled at Kevin Spacey's (2004) *Beyond the Sea* in which he, as Bobby Darin, does an excellent job with Darin's numbers.

X.
No conclusions

Part way through writing this book it occurred to me that it could have no ending. Surfing the Internet or turning the pages of a magazine, I would come across the report of a new film or that a particular director was launching a project. My reaction would be 'Hold on, I've got to see this and include it in the book.' But then it struck me that with such an attitude the book would never be finished.

So this book has no end and no conclusions. Yet it seems to me entirely appropriate that a book on film and reality should have no real conclusion because that is also the condition of reality itself, at least the nature of reality as presented in physics. Of course there have been speculations that one day physics will discover the 'God Particle,' the 'ultimate equation,' and formulate 'the theory of everything.' Yet the closer we approach these apparent goals the more elusive they become.

I recall how my friend and colleague, David Bohm, once told me about his discussions with Einstein. Einstein had faith that 'the Good Lord is subtle but not malicious.' In other words, it may take us a long time to puzzle out the laws of nature, but in the last analysis everything will be above board and there will be no tricks or deceptions that will lead us in endless circles. Thus, for Einstein, if physicists continue in their pursuit of knowledge, the laws of nature will finally be discovered and we will know all the secrets of nature. But Bohm did not agree with Einstein. He pointed out that the quantum theory had lain undiscovered for over two hundred years since Newton had proposed his laws of nature. Bohm argued that it had taken that amount of time because the quantum world was concealed in such a subtle way beneath the world of classical physics. Likewise, there would be another level hidden beneath the quantum world that we would eventually discover. And beneath that, yet another level. It was Bohm's considered opinion that the levels of reality were limitless and increasingly subtle. So physics would never come to an end.

Likewise our contemplation of the relationship between film and reality can have no end. It is said that throughout the world's cultures there are only a limited number of plots, yet the number of stories are limitless. A few years ago, I would have written that sentence in a slightly different way by concluding that the number of novels still to be written will be

limitless. And by that I would have had a clear understanding of a novel as something you take down from a shelf and open to read. But now we have ebooks and hand-held readers. We switch them on and see a mixture of text, images, sound and video.

Likewise who knows what we will mean by the word 'film' in ten or twenty years from now. Already the medium is moving in so many different ways. One direction is actually taking people back into cinemas because some films have such striking effects that they can only really be appreciated in that environment. Another is the concept of a 'movie' as a story that lasts for 90–120 minutes and rounds off with an ending. Now I meet people who tell me that they no longer rent or watch films on their TVs, for they have become addicted to watching the many series that are being produced by television channels, mainly in the US, series such as *Mad Men, Breaking Bad, Boardwalk Empire, The Wire* and so forth.

And so we live within a reality that slowly reveals itself to us as having endless levels of subtlety and, as I have been arguing in this book, the medium that we currently call film has always been engaged in a creative play with these levels. In turn that medium itself is evolving in ways we may try to guess at, but cannot completely imagine. These changes will challenge the creative minds of the future and so I can only end this book with a ?

Appendix:
The grammar of film

In order to enter the world of movies we have already made many unconscious assumptions about how cinema works. In short we have learned how to 'read' a film, how to enter into a different reality, but without ever consciously having made an effort we simply understand the 'grammar' of films.

Grammar is something we pick up as we learn to speak, and then refine it through lessons learned at school. Having rules of grammar enables people to communicate clearly and resolves possible ambiguities. Tenses, for example, are important if we wish to distinguish past, present and future, and it is useful to have rules about plurals in order to talk about more than one object. All this seems fairly obvious, but it is far less clear when it comes to film because the grammar of film was something that had to be created as films themselves evolved. Also there was no 'school for audiences' to teach cinema-goers how these rules worked, so people had to figure all this out for themselves. In other words, directors and audience had to work out these rules together as the history of film evolved.

Time travel and the flashback

The very first films made by the Lumière brothers were 'actualities,' documentary footage of actual people, places and events. Each film was generally less than two minutes long and took place in 'real time.' But when we are telling a story, we like to jump over the boring bits and speed things up. What is a director to do if it is not just a matter of speeding up by a few minutes, but by days, weeks or months? In those old black and white movies, when a jump in time was required—the show is going out on the road, for example—one convention was to display a calendar with the pages being torn off. That was a pretty easy transition to understand, but soon audiences became sufficiently sophisticated to accept that films could jump forward in time without the need to make elaborate transitions.

Time in a film is always moving forwards as the story develops, except for those cases in which we need to establish something that occurred in the past using a flashback. At first this was indicated by such devices as a close-up of the character's face with a voice-over saying 'I remember when I first met him...,' or the scene suddenly going hazy and wobbly. Today the flashback is a well established convention, albeit one that goes in and out of fashion. But there is an important grammatical rule or convention about the flashback: it should not go on for too long, otherwise people will tend to forget where the 'real present' is being set. Therefore when long flashbacks are needed for a story to unfold, we are occasionally reminded that they are in fact about past events by a brief cut to a character in the present relating that part of the story.

Another rule is that flashbacks refer to some past actuality, to some real event which occurred in the past. The one significant exception to that rule occurs in Alfred Hitchcock's 1950 *Stage Fright*. Critics still argue about that flashback, some saying it was a major mistake, others that it was a touch of genius. Certainly it is the most notorious flashback in the history of cinema.

An interesting use of flashbacks occurs in Steven Soderbergh's *The Limey* of 1999 in which Terence Stamp plays a rather menacing cockney ex-con who arrives in Los Angeles to avenge a crime. Back in 1967 Stamp had also starred in a Ken Loach film, *Poor Cow*, so why not use shots from that film to act as flashbacks in *The Limey*? Rather than having the actor made up and airbrushed, and wearing clothing from an earlier period to suggest an event in the past, Soderbergh uses footage from a film made 32 years earlier! In addition, the narrative structure of the film is staged in flashbacks by Stamp's character during the plane trip back to England but, because his memory is imprecise, the story is presented in disjointed and out-of-sequence scenes.

Another significant flashback occurs at the end of Neil Burger's *The Illusionist* (2006). The film begins in *'media in res,'*—in the middle of affairs, a story-telling technique in which the narrative begins either at the mid-point or at the conclusion rather than the beginning, and therefore setting, character, and conflict are established via flashback.

The story features a stage magician, Eisenheim, who wishes to bring about the destruction of the Crown Prince of Austria. As a boy Eisenheim fell in love with a young girl, Sophie, from a social class far above his own. The boy grows up to become a stage magician and, when he next sees Sophie, she is the fiancée of the Crown Prince. He pleads with her to leave the Prince, but she refuses. Later that night she argues with the Prince and leaves on horseback. Her dead body is later found in a lake.

Eisenheim has aroused the interest of a police inspector who had once asked him how a particular trick is performed. He now incorporates a séance into his act in which the dead Sophie returns. At one point the police come to arrest Eisenheim during his act, only to find that he too is an illusion. But all this means that Eisenheim has created interest in Sophie's death to the point where the inspector begins to uncover a series of clues that suggest the Crown Prince is the murderer. When confronted, the Crown Prince commits suicide.

Now Eisenheim is leaving town by train, and sends a small boy with a book that contains the secret of one of his tricks as a gift for the inspector. The inspector follows Eisenheim to the station where the magician gets on the train. Then, right at the end of the film and in a montage of very rapid flashbacks, the inspector realizes that he has become the victim of Eisenheim's illusion. There has been no murder; Sophie has simply drugged herself to appear inanimate, and all the clues that the inspector had carefully pieced together to incriminate the Crown Prince were created by the Illusionist himself.

The close-up

For centuries people had seen actors on the stage. Early films tended to be shot in a similar way with the camera showing all the characters together in a room. It was D.W. Griffith who created the innovation of the close-up. Rather than always showing a character in long shot, he realized it would be far more dramatic to cut to a close-up of the face.

The first close-ups were a little shocking because audiences had to learn how to read them—it was a new piece of film grammar. Henry Marvin, one of the partners of American Mutoscope and Biograph Company (America's oldest motion picture company, founded in 1895), on seeing the first close-up said 'We paid for the whole actor, Mr. Griffith. We expect to see all of him.'

The early convention was first to establish the characters in their location, then maybe cut to just two of the characters. We then see a full body shot of one of the characters, and finally the close-up. When that grammatical convention had become well-established, it could then be broken. And so some films today begin with an extreme close-up of an object, maybe the flaring of a match, then cut to another object so that the audience are immediately disoriented as to what is going on. The director has grabbed our attention, something is happening. But what? We need to know more; we

are desperate to put all these close-ups in an overall context by moving to an establishing shot to reveal the relationship between all those individual close-ups.

Perception

In inventing the close-up, Griffith was really imitating the way the eye and brain see the world. The back of the eye, the retina, contains receptors for detail and movement that send information along the optic nerve to an area of the brain called the visual cortex, and so we see the whole scene in front of us. But if something in particular attracts our attention, the brain sends a message to the muscles around the eye to move the eye so that this particular piece of detail will come into focus on what is called the *yellow spot*—a tiny region of the retina that is particularly dense in receptors for detail, rather than movement. In this fashion the brain gathers enormous detail about that region of the visual scene—in essence the brain has the ability to form a 'close-up' of particular objects. A suggestion of this book is that filmmakers developed an intuitive sense of the ways the eye-brain works, and in this way created a visual grammar whereby, as with human vision, more detail can be shown of a particular scene via the close-up. (Something similar could be said about painters who realized that in twilight the receptors of the eye become less sensitive to color, and thus suppressed color when they wanted to suggest an evening scene.)

Shots and angles

Early silent cinema used fairly conventional forms of storytelling. A typical story goes like this: 'Once upon a time, in a village in the valley, there lived a woodcutter, his wife and their beautiful daughter...'

A highly conventional film would begin with a shot of the valley, then one of the village, and then a shot of the house. These would be followed by an establishing shot of the family seated around the table, and finally a close-up of the daughter. In other words there are long shots or establishing shots, then medium shots which may be two-shots (showing two people) or three-shots (with three people), then shots showing the individual and finally a close-up. When two people are talking, there will typically be an establishing shot showing both figures, then a shot of one of the figures talking, often with the camera placed just behind the shoulder of the person who is listening, and then a reaction shot of the listener.

But as audiences became more sophisticated they no longer had the need for all the pieces of the story to be filled in for them, and so they could accept a faster pace of storytelling. In addition, the advent of sound as dialogue also allowed for jumps in story-telling.

Of course, sometimes actors have busy schedules so that they may have to shoot their scenes later, even when the other actors have left. Probably the most famous example of this is the way Béla Lugosi 'starred' in Ed Wood's *Plan 9 from Outer Space* (1959), which now has a cult following as the worst film ever made. Lugosi was actually dead when the film was shot, so Wood not only used a double but also spliced in shots from other films in which Lugosi had acted!

Crossing the line

A particular variant of the reaction shot is used in documentary interviews. The person being interviewed never looks at the camera, but at the face of the reporter or host. The camera is set up just to one side of the interviewer and, when filming of the interview is completed, the camera is moved to a location behind the interviewee to take shots of the interviewer nodding and apparently listening (known in the trade as 'noddies' or 'noddy shots'). The reason for this is that, during editing, certain sections of the interview may be removed, or the order of remarks juxtaposed. If all this were simply spliced together, it would look rather strange because a person would appear to suddenly move as in a jump cut. Thus each time a cut is to be made, the editor inserts a shot of the interviewer 'listening' while we hear the voice of the person being interviewed.

When scenes like this are shot, be it for a documentary or in a movie, there is a rule about not 'crossing the line.' Imagine a line that joins actor A to actor B. The camera can be placed anywhere on one side of the line and, when two-shots and close-ups are all edited together, the scene will appear perfectly naturalistic with the two people looking at each other while speaking or listening. But if in one of the shots the camera were to be placed the other side of the line, it would give the disconcerting effect of the listener looking away, in the opposite direction, from the speaker.

Obeying the rule of not crossing the line is fairly simple when two people are present, but becomes more complicated when a larger group is involved. This was the problem faced by Hitchcock when he filmed *Lifeboat* (1944) in which all of the characters are confined to one small space.

Yet another variant of crossing the line occurs in films in which a mirror is present. Sometimes the speaker is filmed directly, and at other times we

see their face in the mirror, but the convention must be established that the character appears to looking at the same person or object.

Another convention was created in the early days of silent film when D.W. Griffith filmed a battle between two armies. Figuring out who is fighting whom can be quite confusing, so Griffith established the rule that one army will always move from left to right across the screen, while the other side will move from right to left. This convention generally persists right down to the present day.

Zooms, cranes and dollies

As film technology improved, a wider variety of shots were added. One was the zoom, which bypassed the need to edit from long to medium to close-up. All that could now be done in one smooth movement. The zoom can also be used for dramatic effect, as if the viewer is plunged into the scene, as we have already seen in the 'Vertigo zoom.'

Crane shots enable the camera to move up and down in space and shoot a scene from low to high angles. Shoot actors from a low angle, and they appear taller and more impressive. Shoot them from a high angle and they are diminished. Hitchcock employed very high angles in some key shots in which the camera takes a God's-eye view and looks down on the characters, as if to judge them.

Orson Welles is noted for the way he includes ceilings in his film, *Citizen Kane* (1941), by means of low angle shots. While such shots sometimes show Kane as the giant he had become, they also hint that he is trapped. The ceiling that dominates him anticipates his end as a friendless old man, trapped in the very castle of Xanadu that he has created as a symbol of his power.

When the camera is mounted on a dolly (small wheeled platform), it can move in and out or across the scene. Finally, with Steadicam, the camera operator could walk through the scene and suggest, for example, a character's point of view as they enter a room or walk through the city.

Directors today have a wide variety of methods with which to work. Woody Allen's *Husbands and Wives* (1992) employs an approach in which the camera is constantly moving around the scene to mirror the confusion of allegiances between the various couples. Bertolucci's *Besieged* (1998) is an excellent example of intercutting between fixed and moving camera.

Speed

If the camera runs at a higher speed than normal, the action will appear in slow motion when the film is projected at normal speed. This device has become a cliché, such as when two lovers run towards each other and then meet and embrace in slow motion. Again this was a device that was pioneered by D.W. Griffith who wanted to change the tempo of some of his scenes—slowing down the action for love scenes and speeding it up to suggest vigor.

In those days the projectionist worked a crank to show the film, and in some cinemas the film was actually speeded up so they could get it over quickly and bring in a second audience. Such an approach ran into trouble when sound was first introduced, because of the problems of synchronization of dialogue with the action. Indeed, the first sound films sometimes appeared dull to audiences because they were used to silent films in which the tempo varied.

Aspect ratio

The shape of the screen on which we see a film is also something that has changed during the history of the cinema. Indeed, it is part of a long evolution that began with paintings on canvas. Just what should be the ratio of length to width of a canvas? That depends on the subject: is it a landscape, a panorama, the interior of a room, or a portrait of a person standing? Then there was also the notion of the Golden Mean, that unique ratio in which a line is divided in such a way that the ratio of the smaller to the larger part is identical to the ratio of the larger part to the whole line. The Golden Mean was particularly satisfying to artists, and often determined the ratios in their canvases.

With the advent of still photography, a convention had to be established for the most pleasing ratio of height to width. This same convention was adopted for the first films, a ratio of three to four. When sound was first introduced, it was by means of wax cylinders whose speed of rotation was synchronized to the visuals on the screen. But this synchronization was difficult to achieve with accuracy, so a soundtrack was printed optically onto the film stock. This meant that the area used for the visual material was reduced and, for a few years, the cinema screen was almost square. But then the convention was adopted of restoring the old ratio by slightly masking the top and bottom of the image, while at the same time enlarging the image on the screen.

Then other innovations occurred—Cinerama, Cinemascope, Todd-AO, VistaVision and the like. The image became much larger and more detail could be seen, but to many this was gained at the considerable cost of compromising the quality of composition of each scene.

First and second unit

Often in the film credits there will be reference to a second unit, and even to the director of a second unit. While some films are mainly shot on location, most are shot in studios involving rooms created without a fourth wall so that the camera can move in and out of the scene. All of this is under the supervision of the director of the film, since it is in these rooms that the actors will be working most of the time. However, some scenes may be filmed outdoors, often in long-shot. Outdoor shooting may be scheduled for a period after the studio work is completed. When key outdoor scenes with dialogue are not needed, this work can be left to the second unit, and even doubles may be used if characters are only seen in long shots.

Lens flare

Lens flare occurs when a camera is pointed towards a strong source of light such as the sun or an automobile headlight. Normally this is an undesirable effect that the camera operator is at pains to avoid. However, in *Punch Drunk Love* (2002) the director, Paul Thomas Anderson, made it an essential aspect of the film. Barry Egan is a small time businessman and total loser in life. His moods are in part suggested by Jon Brion's soundtrack, and in part by having him emerge from the partial darkness of his office into intense sunlight. At one point a young woman, Lena, turns up in the street outside his warehouse, and what appears to be lens flare, or possibly a computer-generated effect, touches her with an intense yellow finger of light. Later, when he is attempting to reach her from a payphone in a busy street, the booth lights up when he hears her voice, and his whole face is illuminated. A similar light is seen when Barry plays the harmonium he finds in the street outside his warehouse. Flare, this time of a blue band of light, is also used when they first kiss.

The use of large expanses of glass also suggests that Barry is in a certain sense trapped in life, like a rat in a cage. Indeed, when he is searching for the door to Lena's apartment, running along endless corridors, he is very much like a rat trying to find his way out of a maze. There are many other subtle

uses of light and of color during the film in which the nerdy Barry is finally transformed by love to the point where he can, quite improbably, take on a series of thugs in a fist-fight.

Sound and voice-over

The sound of voices can be used as straight dialogue which moves the story along, or as multiple tracks of speech which have more the effect of music or mood setting than of conveying linear information. Robert Altman is noted for this effect. He frequently allowed the characters' dialogue to overlap in such a way that it is sometimes difficult to make out what each of them is saying. He claimed he wanted the audience to pay attention and, while filming, he used a headset to make sure everything pertinent can be heard without drawing attention to it. There is also the use of the voice as a narrator. Billy Wilder's 1950 *Sunset Blvd.* begins with narration by the man drowned in the swimming pool, who recalls the events that lead up to his death. Then there are sound effects which can be used naturalistically, or to intensify mood and produce a sense of dread, elation and so on. Finally there is music which existed in cinemas long before the appearance of sound on film. Many cinemas had a Wurlitzer organ that would rise out of the orchestra pit; some had a small orchestra, while others could only afford a piano. And so a musician would improvise along to the film, selecting music that was appropriate to each scene—a kiss, a parting, a chase. Silent films were never truly silent.

With the innovation of optical sound printed on the side of film, it became possible to use a much richer selection of music. Stanley Kubrick, for example, is noted for the wide range of genres of music he employs in his films. In *Barry Lyndon* (1975), Schubert is chosen for those scenes in which Barry is shown in his rich country home, and it is difficult to hear Richard Strauss' *Also Sprach Zarathustra* without thinking of the key scenes in *2001: A Space Odyssey* (1968). The 'Blue Danube Waltz' of the other Strauss, Johann, is used when we first see a space station rotating against a black sky. *A Clockwork Orange* (1971) resonates to Beethoven's 'Ode to Joy' from the Ninth Symphony. *Dr. Strangelove* (1963) ends with the outbreak of atomic war and repeated shots of mushroom clouds, accompanied ironically by the song 'We'll meet again.'

One of the great collaborations between a director and a composer was that of Eisenstein and Prokofiev on *Alexander Nevsky* (1938), a film in which each shot is accompanied by a corresponding line of music. Eisenstein referred to this as 'vertical montage,' because movement within the

screen was accompanied by a similar movement in the music, for example, ascending or descending notes.

Then there are those films in which a particular song is repeated throughout the film as a leitmotif. *Breakfast at Tiffany's* (1961) has the haunting 'Moon River.' The song 'The Way We Were' plays a similar role in Sydney Pollack's 1973 film of the same name. Probably the most famous is 'As Time Goes By' in Michael Curtiz's *Casablanca* (1942) in which Bogart, contrary to popular belief, does not say 'Play it again, Sam' to the pianist, but 'You played it for her, you can play it for me...'

Another interesting use of sound appears at the end of the Italian film, *Il postino* (1995) by Michael Radford. The noted poet Pablo Neruda, has sought refuge in Italy from the regime in Chile, and befriends the local postman, Mario. The latter is a simple person, in love with a young woman whom the poet helps him to court. When Neruda returns home, Mario wishes to present him with a gift but does not have any skill with words, so instead sends him a poem in sound. With a tape recorder he travels around the area recording the sound of the sea, the wind and so on.

In one of Laurel and Hardy's first films with sound, Stan Laurel, who was the ideas man, came up with a brilliant idea that it may be more interesting to hear the sound than see the action. In *The Music Box*, for example, Stan and Ollie struggle to deliver a piano, a task which involves a major effort to get it up a long flight of steps. Finally the two men, totally exhausted and out of breath, stand at the top of the steps with the piano behind them. We watch it slowly begin to slide backwards. The camera then focuses, not on the piano, but on the faces of the two men as we hear a thump, the sound of the piano strings, and additional thumps and sounds that diminish as the piano slides back down to the bottom.

This device has been used by filmmakers ever since, for what you don't see on the screen can be filled in with all the power of your imagination. Hitchcock used it in *Vertigo* when the woman plunges from the church tower. The protagonist is climbing the stairs, we hear a scream, we have just a brief glimpse of the woman falling but then focus on the man's horrified face until we hear the final thump of the body hitting the ground.

Editing and montage

Editing gives a sense of pace to a film. In many ways the edits and dissolves have a similar quality to transitions in a musical composition.

I have edited sound for radio plays and documentaries and, on one occasion, had the fun of editing my own film *Memories*. In the earlier days of radio, sound was recorded on magnetic tape, and documentaries were created by physically cutting the tape on a metal block with a razor blade, removing the unwanted section, and then taping the two remaining ends together. In this way not only could different parts of an interview be edited together, but a cough or long pause could be edited out. It was also important to record a couple of minutes of silence, because the 'silence' of different rooms and locations—the ambient sound—is quite characteristic. So if the editor wished to add a slight pause between one part of the interview and the next, a second of silence would be edited in to make the pause appear seamless. Conversely, if an abrupt change in ambient sound was unavoidable, a cough could be added in between the two sections.

Today most film editing is done electronically, but the same underlying principles of editing are used. In the traditional approach an editor would work with a Steenbeck or Moviola and several reels of shot film. In addition there would be a reel of magnetic tape containing the actors' voices, and additional reels containing sound effects and theme music.

Generally speaking the age of Steenbecks and Moviolas has passed. Sound and visual information can now be digitized and edited on a computer. Nevertheless, even if most editors don't physically cut into the film, the same principles of editing apply. Take, for example, the combination of visual events and the sound that accompanies them. In the film *Memories* that I edited, there was a scene in which a champagne cork is popped in close-up. My assumption had been that the sound of the cork should be spliced into the soundtrack at exactly the same moment as we see the cork flying out of the bottle. But when I came to look at that particular edit, it just didn't seem right. It was only after I had spliced in the sound of the pop a few frames after the image of the cork flying from the bottle that the whole thing felt right. The reason for this is that the brain processes visual and sound material in different ways. Likewise, in Thordold Dickinson's *A Discovery of Cinema* (Oxford University Press, London, 1971), the author describes a film he edited in which the audience sees a performance of a piano concerto in London's National Gallery. It involved an edit to a long-shot of the orchestra from above. The author discovered that this switch of angle should not be exactly synchronized with the music, for it took the brain time to process the new visual material. The sound itself therefore had to be delayed by two frames, one-twelfth of a second.

Yet another event involving sound is that of an explosion. Suppose a tank blows up in the distance. In real life we would first see the explosion and then, several seconds later, the sound would reach us because light travels much faster than sound. On the other hand, when seen in a movie

the image and sound are generally simultaneous, creating the effect that we are observing the explosion at a distance, but are also right there in the heat of the moment.

So far we have been dealing with the practicalities of editing. D.W. Griffith had invented the close-up for dramatic effect but V.I. Pudovkin and other Russian filmmakers believed that the effect could be taken further. For Podovkin, Griffith's close-ups were merely an amplification of the long shot; in other words they gave more detail of a face that had already been seen in a full-length shot. In short, the close-up was an elaboration of something already seen, but carried no new meaning in itself. Was it possible to rethink the whole process and use editing as a way to create something new that was not already contained in the individual images themselves?

Another Russian, Lev Kuleshov, had made an interesting experiment in which he shot a close-up of an actor with a neutral expression on his face. He then intercut the same close-up with a bowl of soup, a coffin and a girl playing. When shown to an audience the reaction was to praise the actor for his ability to express the emotions of hunger, sadness and happiness. In other words, the meaning emerged out of the juxtaposition of shots rather than the meaning of the individual shots by themselves. This was the point that Podovkin was trying to make.

The next step lay with Eisenstein, and was very much in harmony with the philosophy that lay behind communism—the dialectical materialism of Karl Marx. In turn, Marx's ideas were derived from Hegel who saw history as a movement of the Spirit and argued that this movement could be represented by what he termed the dialectic. Suppose you state some important premise about the universe, or about society—in other words posit a thesis. ù examination will suggest that this thesis contains within it its own contradiction—the antithesis. And thus you are left with a duality—thesis and antithesis—much as with Podovkin's juxtaposition of two images. But for Hegel the process does not stop at this point, for that duality between thesis and antithesis can be transcended through synthesis. For Hegel, and then for Marx, this movement was an ongoing process.

Suppose, for example, you posit the notion of pure 'being' as your starting point. As you examine that concept you realize that it also implies that there must be something which is not 'being'—'nonbeing,' which is the very antithesis of being. So what is the synthesis? What can go beyond being and nonbeing? The answer, for Hegel, was 'becoming.' So the forward movement of the dialectic is from being to becoming.

This same dialectic was used by Eisenstein to go beyond the mere juxtaposition of two different images. For Griffith, A could be enlarged into A+ via a close-up. For Podovkin there was the juxtaposition of two shots, A

and B, but Eisenstein wanted to go further so that something new emerged, C, that was not contained in either A or B. It was at this point that mere editing was replaced by the term 'montage,' from the French—to assemble or put together.

Eisenstein's montage involved juxtaposing many tiny elements to produce something far beyond their individual meanings. Probably his most famous and influential sequence is that of the Odessa Steps sequence from *Battleship Potemkin* (1925). (In more popular culture, as noted previously, a tight series of short shots makes up the famous shower sequence in Hitchcock's *Psycho*, 1960.) At the Odessa Steps we see soldiers with rifles, soldiers' feet, fixed bayonets, a woman with a baby carriage, a close-up of the woman screaming, the carriage starting to roll down the steps, the woman collapsing, a crowd running down the steps, the pram moving faster and faster with close-ups of the baby, a close-up of a woman with a pair of spectacles, a student, a soldier with a raised sword, and a close-up of the woman with spectacles but now with a bullet hole where her eye should be. It is made even more remarkable because of the dialectical contrast of light and darkness, long and brief shots, extreme close up and long shots, and static shots with traveling shots. In short, the Odessa steps sequence amounts to far more than the meaning within each individual shot. The painter, Francis Bacon, was so obsessed with images from Eisenstein's sequence that he painted a series of screaming faces in which one eye had been shot out.

This sequence had a great influence on cinema, and many directors have referred to it in their own films. In *Lisztomania* (1975), Ken Russell portrays the composer and pianist, Franz Liszt, in the manner of a modern pop star who is mobbed at concerts. In one sequence Liszt is playing when the film cuts to a baby carriage which begins to move backwards and is about to fall off the stage. Also Brian de Palma's *The Untouchables* (1987) pays homage to the same sequence. In Terry Gilliam's *Brazil* (1985) a floor polisher falls down the steps, and Woody Allen's *Bananas* (1971) has a baby carriage going down steps. Probably the most successful, and certainly the funniest, parody occurs in Luciano Salce's *Il secondo tragico Fantozzi* (1976). Fantozzi is a humble and dull accountant, played by Paolo Villaggio, who features as the main character in a series of comedies. His boss is a film fanatic who often commands his employees to return at night to watch such films as Carl Dreyer's *Day of Wrath* (1943) and Flaherty's documentary, *Man of Aran* (1934). On the evening of a particularly important televised soccer match between Italy and England, the employees are called in to watch, yet again, *The Battleship Potemkin*, while all the time they are desperate to know the score. In the end Fantozzi can stand it no longer and shouts out in despair '*Per me, la corazzata Potemkin, è una cagata pazzesca!!!*' ('As far as I'm concerned, The *Battleship Potemkin* is a stupid

piece of crap!') His fellow workers also revolt and burn the boss' copy of the film.

As a punishment, each weekend until their age of retirement, the accountants are forced to return and act out the Odessa Steps sequence, with Fantozzi performing the role of the infant in the baby carriage. Other disasters face the oppressed Fantozzi who, in the end, can only find employment as a human lightning conductor on the office roof.

While Eisenstein's concept of montage, has been of enormous influence, not everyone agreed with his theory. André Bazin, while he admired what Eisenstein had done, was not totally in sympathy. Bazin pointed out that, while the novel and painting act to represent the world, the camera is capable of presenting us with reality directly, and that this reality is complex and multifaceted. When one employs montage and expressionistic techniques, one is imposing one's own limited vision onto a reality that is full of subtle ambiguities. So in Bazin's view, editing should be controlled. In other words, a careful balance should be kept between an artist's personal vision and the inherent complexity of the real world. Certainly film should not be pure documentary, such as a newsreel, since at times it must be necessary to heighten effects, but this should be done in such a way as to preserve the delicate balance between artificiality and the chaos of reality.

There is another point to be made. Not all film editing is done on the basis of Eisenstein's montage, for there may be strictly practical reasons why different shots are edited together. For example, a man may walk into a restaurant and sit down at a table. In some cases this can be filmed as a continuous shot, but suppose that the table is near the window and the character sits with his back to that window. His face would now be in shadow because of the light streaming through the window. And so the character is filmed approaching the table and reaching for the chair, then the scene is relit to illuminate his upper body and we see him sitting down. Editing in this case does not involve a tense juxtaposition, but something so seamless that we are not even supposed to notice it. There are yet other ways in which editing can be used. Making each particular shot shorter and shorter can increase tension. In other cases the editing may need to harmonize with, for example, the rhythm and movement of the background music.

Jump cut

Until the year 1959 films obeyed a logical sequence of actions. A woman walks along the street to a front door, opens the door, walks up the stairs and enters her room. But in *Breathless* (1960), starring Jean-Paul

Belmondo, the director Jean-Luc Goddard decided to dispense with this convention and introduce the jump cut. Goddard had had enough of the linear way of telling the story. We really don't have to fill in every gap for the audience, he argued. In everyday conversations, people are always filling in gaps by themselves and jumping over steps in an argument. Why not do the same thing in film? The woman goes to the door of her house. That's fine, but we don't really need to see her open the front door, walk up the stairs, open the door of his apartment and walk inside. Just have her approach her house, and then cut to her inside a room. The logical next step was the jump cut in which two sequential shots of the same subject are taken from camera positions that vary only slightly. This type of edit causes the subject of the shots to appear to 'jump' position in a discontinuous way. At first it appeared a little disjointed to an audience who had been brought up on smooth unobtrusive editing, but pretty soon it became part of film's new grammar.

Breathless is a key film in the development of cinema and, as with other iconic films, directors sometimes pay homage to it. The final scene in Polanski's *Frantic* (1988), for example, mirrors Belmondo's death in *Breathless* as he staggers along the street and collapses.

But did Goddard really invent the jump cut? Back in the late 1940s the artist and writer Jean Cocteau made a series of highly experimental films involving such effects as people going through mirrors and the film running backwards. Included were what people today would call jump cuts. Yet Goddard deserves the credit because of his consistent use of the device as a way of focusing and condensing the action in a way that is similar to our own experiences of reality as we interact with others.

Voice-over

The voice-over, either that of a protagonist or an anonymous narrator, is a device that can be used in a number of different ways—to jump over time, fill in an element of the plot, give a character's view on an event, or present what is going on in a character's mind. In this last sense, the voice-over was, in fact, invented by the Elizabethan playwrights. Shakespeare's plays are full of monologues—speeches which are in essence a character's private musings—Richard III's desire for power or Hamlet's thoughts of suicide, for example.

In Spike Jonze's *Adaptation* (2002), the writer Charlie Kaufmann is desperately seeking ways of turning a book about orchids into a film and, as a last resort, he swallows his pride and attends a course on screenwriting where

he is given the advice that he should never use the cliché of a voice-over. With great irony we hear his own voice-over agonizing about this very point.

While voice-overs are used in a wide variety of ways on occasion they can become a central aspect of the film. Take Kubrick's *A Clockwork Orange* for example. The film begins with an extreme close-up of the central figure, Alex, and the sound of his voice telling us what he and his droogs are doing in the Korova milk bar. This is to be Alex's story, and throughout the film we see the world, and the violence he unleashes on it, through Alex's eyes. The voice-over acts to set up a certain sympathy with Alex since, despite the terrible things he does, we realize that, as a youth without any sense of morality or sympathy for the feelings of others, he is at the same time being totally honest to us about his joy in sex, violence and Beethoven. Without this voice-over *A Clockwork Orange* would be a very different film.

Another interesting use of the voice over, in Sam Mendes' *American Beauty* (1999), is that of Leslie Burnham, a rather undistinguished 42-year-old man married to an ambitious real estate agent and with a teenage daughter. His life is transformed when he becomes infatuated with his daughter's friend, Angela. When he hears Angela say that, if he had more muscle, she would 'totally fuck him,' he begins a regime of weightlifting. As a side story, the boy next door has been videotaping Leslie's daughter, and eventually the two plan to run away together. In particular, the boy shows her something he considers very beautiful—a video of a plastic bag blowing and twirling in the wind.

When Leslie finally has his opportunity to be alone with Angela and attempts to seduce her, he learns that she is a virgin. Instead of the sex he anticipated, he makes her a sandwich. Now, by himself in the kitchen and looking at a photograph of his family, he seems to be happy for the first time in the film. At that moment a gun is put to the back of his head, and he is shot. The effect of the voice-over has been to lull us into the sense that Leslie is alive and talking to us, that he is telling us his story which is moving towards some kind of satisfying resolution. But now we realize he has been dead all along. The film ends with the video of the swirling plastic bag, almost as if it is Leslie's soul, as he says 'I can't feel anything but grati-tude for every single moment of my stupid little life. You have no idea what I'm talking about, I'm sure. But don't worry... you will someday.'

Color

While cinema is always advancing and new technologies abound, there are two milestones that really separate the old from the new. One was the

appearance of sound, and the other the use of color film stock. In both cases their first use was naturalistic, but only later, in the hands of innovative directors, were sound and color used in more creative ways. And in both cases there were those who resisted the new innovations since they felt they would compromise the purity of cinema and restrict the creativity of the director.

Think of that magical moment in Victor Fleming's *The Wizard of Oz* (1939). The film opens in black and white as we are introduced to the various characters we will meet later in the Land of Oz, characters who will become the wizard, the wicked witch, the lion and the scarecrow. Then the storm begins and Dorothy hits her head. She imagines that the house has been sucked up by the storm and is now spinning in the air as the wicked witch flies past on her broomstick. The storm is over, the house settles, and Dorothy opens the door to find herself in the Land of Oz. It is a land of color, for suddenly the film switches from black and white to rich color. In a way it recreates that moment when film-goers in 1932 saw the first color film—Walt Disney's animated short, *Flowers and Trees*.

In fact the use of color raises far more issues than that of sound. Some directors still insist on using black and white for some of their films. Woody Allen used it for his nostalgic look at his native city in *Manhattan* (1979), and Martin Scorsese used it for *Raging Bull* (1980). One of the advantages of black and white is that it can bring a uniform tone to an entire film. It can present a world of shadows, ambiguity and uncertainty, or a world of stark contrasts as in the earlier German Expressionism. Then there are those films in which the director inserts a black and white sequence because, in a curious way, black and white *is* more *real* than 'natural' color. So many of the iconic images of the twentieth century came in the form of newspaper photographs—raising the flag at Iwo Jima, a Vietnamese man being executed by a shot in the head, or as black and white news footage such as the assassination of President Kennedy, a man setting foot on the Moon, Hitler at the Nuremberg rally, and so on. Within our unconscious mind is the notion that the black and white image represents the truth about the world.

But what of color? Anyone who is in the design, publishing or print business will tell you that color is a nightmare. Design a page of text and you get exactly what you expect when the printer sends you the proofs. But design a cover and you are involved in a battle to get the color just right. In this there is a significant paradox. On the one hand, color in most films is used purely for realism, yet on the other that color may also distort the very reality the film is attempting to portray.

In other words, color presents a new challenge for a creative director. One such filmmaker was Michelangelo Antonioni who was so dissatisfied

with the way color was being used that he was not willing to use color stock until he had spent some years studying the medium. His first film in color was *The Red Desert* (1964) which, in part, uses color to express the disturbed state of the central character's mind. The film concerns a sensitive woman who lives surrounded by an industrial atmosphere. The color in the film can almost be smelled—it could be compared to the odor from burning electrical insulation, from a chemical factory, or hot metal. Antonioni uses greens, yellow, pinks, and grays, and even goes so far as to paint the contents of a slag heap and a bowl of fruit. Yet when the woman begins to tell her daughter a story, we move to bright and cheerful colors. Color for Antonioni is no literal record of the external world, but represents the world as perceived by the woman, and it almost becomes the central character in the film.

This particular use of color continues in Antonioni's *Blowup* (1966), a film that is strongly based on the sixties photographer, David Bailey. A key element in the film takes place in Maryon Park, in Charlton, an area of London where the photographer Thomas is taking a series of shots. Only later in the darkroom do his images reveal a mystery. For these scenes Antonioni had the grass painted a more vivid green. Other scenes take place in the Holland Park area of London where Antonini repainted shop fronts, and even the red of a London bus, in order to give an enhanced sense of reality.

Yet another director who has employed color in a creative way is Krysztof Kieslowski who made a trilogy of films based on the colors of the French flag, *Blue*, *White* and *Red*. The films are also linked together though the various characters who move between the trilogy. *Red* (1994), as the name suggests, employs a series of red objects to unify the film—the young woman, Valentine's red telephone, for example, plays a key role as a means of communication. A large street hoarding shows Valentine against a background of red material—she works as a model. This acts as a leitmotif throughout the film, and links to the final scene in which she is rescued after a cross-channel ferry sinks, and is helped into the lifeboat by a man in a red jacket. At that point the image becomes identical with the advertisement on the hoarding. Red is also an archetypal expression for the story of the film itself. The young woman has a chance encounter with a retired and embittered judge who has more or less cut himself off from the world; through contact with her the judge's heart begins to melt, and thus red represents emotional warmth.

Distortion of color for emotional effect goes back as far as 1958 with Rogers and Hammerstein's musical, *South Pacific*, directed by Joshua Logan. When the nurse on the airbase begins to fall for a French planter, a number of effects are used. One is the use of voice-overs from each character to

express their inner feelings, another is the appearance of mist from the sea, but the most striking is the sudden change of color from the naturalistic greens, blues and reds of the island to a golden glow that enrobes the characters. At one point when the nurse is suddenly brought back to reality, the gold vanishes abruptly and naturalistic colors return.

In Kubrick's *A Clockwork Orange* (1971) it has been noted that the first half of the film is shot with bright, hot colors—reds and oranges—to accompany Alex's violent life style. After committing a murder, Alex is sent to prison where he is now is surrounded by cool blues and grays.

The image

There is clearly a great deal of power in an iconic image. Barry Levinson's *Wag the Dog* (1977) is based on the notion that an entire war can be reduced in the mind of the public to just a few key images. Corporations traditionally identified themselves with their 'mission statement' that was always given a key place in an annual report policy document. Later, in a more negative light, as something that had once been written down by the founders of the company. Since that period times and attitudes had changed, but the new directors were still stuck with their old mission statement.

Today the emphasis is on 'branding,' on getting the identity of a company across in something as short as a single sentence; and along with that statement a single image that tells us what that company is all about. As soon as you see the image you think of the brand. For McDonalds it is 'i'm lovin it' and the famous golden arches symbol.

Films can also be branded—a single image tells us the whole story of a film. Brando on a motor bike is *The Wild Bunch*. Marilyn with her skirt blown up by an air vent is *Some Like it Hot*. A man's eye with an artificial eyelash is *A Clockwork Orange*. Jack Nicholson's face at a broken doorway is *The Shining*. Audrey Hepburn with a cigarette holder is *Breakfast at Tiffany's*.

And as for that last image, let's look for a moment at the role it plays in George Hickenlooper's *Factory Girl* (2006). Edie Sedgwick is a vivacious young socialite who becomes involved with Andy Warhol at his 'Factory'—the studio where a variety of artists and strange characters hung out while Warhol made his films and silk screen prints. Some of Warhol's films were made specifically for Edie who was 'all things to all men' and created her own particular style of fashion. She covered her brown hair with silver spray to produce an effect similar to that of Warhol, and wore black leo-

tards, mini dresses, and large earrings. At one point in the *Factory Girl* film she says she was inspired by the image of Hepburn and her cigarette holder, which seemed the height of fashion. She knows nothing more about the iconic image, and certainly had not read Capote's novel on which the film was based. If one looks at photographs of the real Edie taken in the Factory, or with Warhol and the Empire State building in the background, one gets a similar impression. She had become a brand, a source of iconic images. Yet Edie was dead at 28, probably through a combination of alcohol and prescription drugs, rather than suicide. And in regard to that iconic image, in the film a friend tells Edie that Capote's novel is interesting because the real Holly Golightly is a working girl, while Edie was an heiress. The implication was that, in a way, she had simply become a brand, and very little existed behind it. Edie was all energy and enthusiasm, yet only seemed to exist on the surface.

Yet another reflection on the notion of the image comes from Jocelyn Moorhouse's *Proof* (1991). Martin was born blind and feels that his mother has rejected him because of his condition. As a young child his mother described the world to him, and in particular the garden that could be seen from their window. She mentioned a man raking leaves, but Martin did not trust what she said because he couldn't hear the sound of the rake. As an adult he takes photographs which he says will act as 'proof' of his experiences. For example, through touch, smell and sound he is able to build up a picture of the room he is in, as well as the people in it. Then he will take a photograph, and later ask someone to describe what they see in the photograph. For him, these are acts of proof of what he experienced, yet the key to this proof of Martin's take on reality is that the person describing the image should not lie, that they should be trusted.

Through a chance meeting with Andy, a man who works in a local restaurant, he finds someone he can trust and who will describe his photographs to him. Yet there is one photograph, taken in the park, which would compromise the young woman who acts as Martin's housekeeper, and in this case Andy hides the truth. When Martin discovers that Andy has lied to him his world collapses, and he severs his connections with Andy and the housekeeper. At the very end of the film, however, Andy turns up outside Martin's house, and he asks Andy to do one last thing, to describe the very first photograph Martin took as a boy. Andy tells him it is of a garden; that it is fall and a man is raking leaves. And so Martin finally learns that his mother did not lie to him, and his first photograph is proof of her truthfulness.

In a deeper sense Martin's position is not so very different from our own in the face of reality. Martin senses the accidents of the world—sounds, smells and textures—and uses them to build up a sense of reality which, in his case, he believes is essentially visual. Likewise Immanuel Kant argued

that we have access to phenomena—to evidence of our senses—and use them to build up a picture of the noumenon or 'thing-in-itself' which is independent of any observer and whose deeper essence remains unknown. Indeed, we have already seen two examples of this in the films *Waking Life* and *A Scanner Darkly* in which animation is superimposed on real actors. Thus we see a surface simulation, but sense that a deeper physical reality, a noumenon, lies beneath this surface.

Kant's philosophy can be seen in a new light within the quantum world which, as we saw earlier, d'Espagnat described as a 'veiled reality' since all we have is the result of observations which themselves depend upon the context in which questions are asked of nature.

Semiotics

Semiotics was one of those trendy philosophical movements that emerged out of France and is associated with such names as Jacques Derrida, Roland Barthes and Jean Baudrillard. It is the study of signs and symbols, that is the notion that an object can convey a message and we can read these messages as clearly as we follow a conversation or read a subtitle.

Next time you go through your collection of favorite DVDs, think about the various symbols that stand in for particular meanings. A favorite of mine occurs at the end of *Casablanca* where Bogart, as Rick Blain, and the French police officer, Captain Renault, walk away together—a variant on the two lovers who walk into the sunset. Rick remarks that it's 'the start of a beautiful friendship,' while Renault throws the bottle of water he has been drinking into a garbage can. The film affords us a brief glimpse of the bottle—it is Vichy water. In accompanying Rick, Renault is rejecting Vichy France and its collaboration with the Nazis

The Hays Code and those cigarettes

The Hays Code was set during the heyday of black and white films in an attempt to place restrictions on what could be shown on the screen. For example, a couple was never to be seen in bed together. If shown on a bed, one of them must have their feet on the ground. Yet restrictions such as this allowed the erotic to be displayed in much subtler forms. One of these was the cigarette as a symbol of a successful sexual encounter. A particular potent symbolism was when the male figure lit two cigarettes, smoked one and handed the other to the woman.

While Freud claimed that 'sometimes a cigar is just a cigar,' we must admit that a cigarette can also stand for other things. It is something placed between the lips and substitutes for a kiss, or even for oral sex. And that word 'oral' also applies to a Freudian stage of development—the oral stage in which the child wants to gather everything into its mouth. A cigarette, in particular, can substitute for other things, such as talking and eating. Neuroscientists know that during the day the brain's activity switches between oral and non-oral activities, the former being eating, snacking, talking and smoking. Finally, during World War II and the immediate post-war years, smoking in public became a symbol of female emancipation, while for men it was a symbol of masculinity. Leonard Bernstein was always seen with a cigarette in his mouth, as was Jackson Pollock. (When the US Postal Service issued a Pollock stamp they had the cigarette removed from the image.)

The most famous exchange of cigarettes occurs in Irving Rapper's *Now, Voyager* (1942), but has since been much imitated. When we first see Charlotte Vale, played by Bette Davis, she is totally withdrawn and under the spell of her domineering mother. Her only symbol of rebellion is to smoke in her bedroom, but she hides the evidence, and her only creative act is to make cigarette boxes. Inevitably Charlotte must seek psychiatric help from Dr. Jacquith—an action which Charlotte's mother strongly opposes as it will bring shame to an old Bostonian family. To emphasize the theme of smoking, Jacquith's entrance is heralded by the sound of him emptying his pipe. The presence of the pipe establishes Jacquith's character; he is a man who is solid and reliable.

As the film progresses, Charlotte begins to come out of her shell and develops a relationship with a man called Jerry. The high point of this relationship occurs when he lights two cigarettes and hands one to her. The film ends with Charlotte's emancipation, yet it is not through marriage to Jerry, but by relating to his daughter—his wife had left him—who she sees as being similarly repressed to her earlier self. Charlotte finds love and satisfaction as a surrogate mother, and expresses her new self by smoking openly in public. This ending is interesting, for it suggests that a person's self realization can occur through the act of loving and caring for another which, in the case of a woman, need not necessarily come from finding and marrying a man. In other words, it is a Hollywood ending, but without a 'Hollywood ending.'

Another aspect of the Hays Code was that too much focus should not be placed on criminals and lawbreakers. For example, they should not be seen as the central characters in a film, or their exploits made to appear engaging. From now on the law enforcement office would take a central role, and thus *film noir* was born, the sort of film in which a Sam Spade or another hardboiled detective is on the hunt for a killer or master criminal.

It was only with the relaxing of the Hays Code that the criminal could return as the central character, and thus a range of Mafia movies was to hit the screen, including the *Godfather* trilogy, *Goodfellas, Prizzi's Honor,* and so on.

Index

L

M

Pari Publishing is an independent publishing company, based in a medieval Italian village. Our books appeal to a broad readership and focus on innovative ideas and approaches from new and established authors who are experts in their fields. We publish books in the areas of science, society, psychology, and the arts.

Our books are available at all good bookstores or online at **www.paripublishing.com**

If you would like to add your name to our email list to receive information about our forthcoming titles and our online newsletter please contact us at **newsletter@paripublishing.com**

Visit us at **www.paripublishing.com**

Pari Publishing Sas
Via Tozzi, 7
58045 Pari (GR)
Italy

Email: info@paripublishing.com